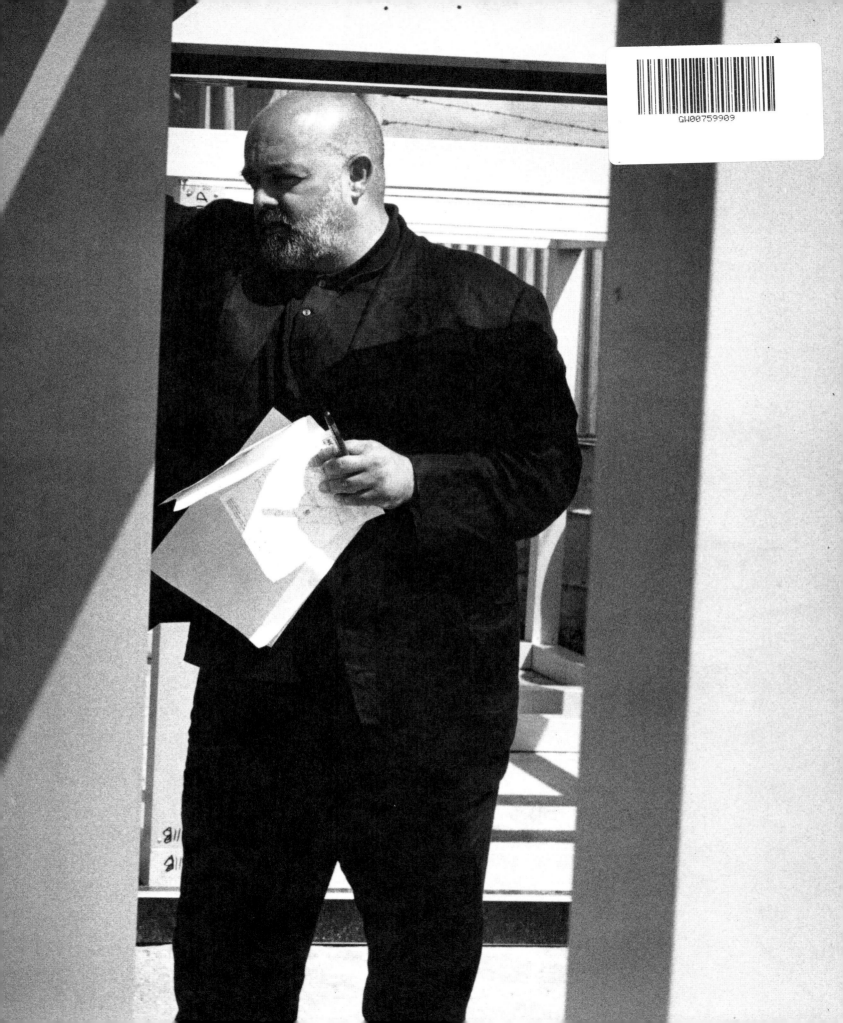

£35·00

PEDRO CABRITA REIS

Cabrita 04

22.11. 04 , London

PEDRO CABRITA REIS

HATJE CANTZ PUBLISHERS

I believe that in any Artwork what is to be perceived is that very
particular, brief and silent moment when one experiences Intelligence, an
absolute and total Intelligence through which everything comes together…
Being a revelation of all our fears, Art neither changes life nor explains
death. Such magnificent inability to provide a destiny makes Art different
from Science, Religion and Philosophy.
As an attempt for meaning/sense, this might as well be (why not?) a search
for Beauty. I like to see my work as a part of this method of thinking…

PEDRO CABRITA REIS

BETWEEN POETRY AND PROSE: SOME REFLECTIONS ON PEDRO CABRITA REIS

MICHAEL TARANTINO

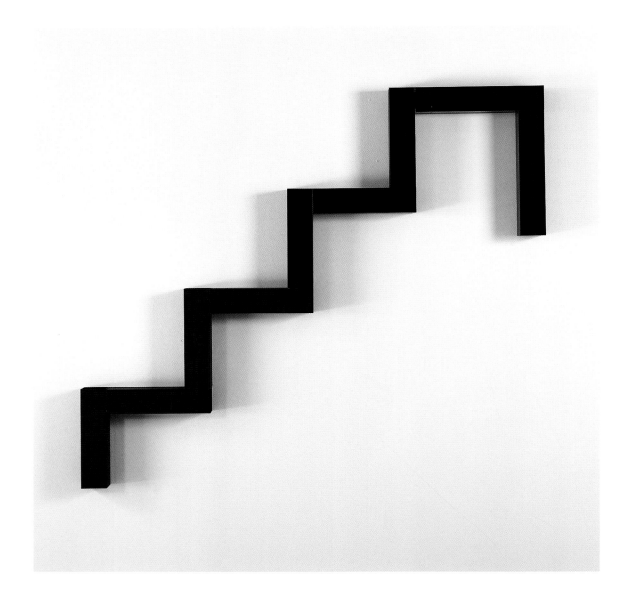

I. HE WAS IN A CITY HE DIDN'T KNOW. | He had just returned from an all-night bout of drinking. It had started with a dinner that quickly became a "menu de dégustation". There must have been at least twenty courses. Each time he thought the meal was winding down, another plate arrived, another bottle of wine, another element to taste, to savour. Despite the bloated feeling he had for about two hours, everything was too good to turn down. The timing was amazing. At the slightest appearance of hunger, the next plate arrived. ("Dégustation" is a strange word, after all.) Finally, after a few *Armagnacs*, they left the restaurant.

He was in a city he didn't know. His host suggested they go for a "last drink" at a nearby bar. Why not? He was so full, he didn't want to go back to his hotel just yet and try to sleep. A last drink would do the trick. They went into a very crowded bar, one that seemed to have opened in the mid-eighties and never closed. Some people were dancing (to *New Order*!), mostly men. P forced his way up to the bar and ordered a couple of whiskies. This was not England, so the servings were generous. They continued their conversation from the restaurant, even though neither one of them could hear a word that was being said. After a few more rounds, they left.

It felt good to be out in the street, enveloped by the summer's evening heat, by the hundreds of people drinking and leaning against cars. Another venue was suggested, but he was starting to feel tired. He resisted, but was finally won over by the gentle insistence of his host. They hailed a cab. If the previous bar seemed lost in a time lag, this one felt like walking into a television set. In particular, like being in a bar just beyond the forest of *Twin Peaks*. It was nothing more than a small wooden bar facing a stage, bordered by red velvet. The floor was checkerboard, black and white. However, where David Lynch sent out a male midget who sang and danced backwards, this place featured female midgets (is "dwarf" a kinder, more politically-correct word?) who paraded out, one after another, and strip-teased the audience. (The "audience" consisted of the two of us, a family of four who could have been dropped in from a farm in Canada and two businessmen, definitely not locals.) We asked for double whiskies, which, of course, looked like quadruples. It was approaching 3:00 am. I couldn't take another sequined *bra* coming off at the level of my knees. And I was afraid that the lap dancing was about to commence.

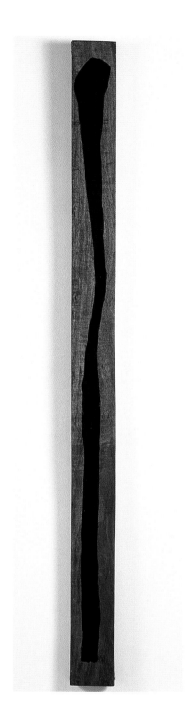

So we left. Another cab. This time I really wanted to go back to the hotel. It was at this point, however, that I realized that I was in a horrible fix. I didn't know the language and I had forgotten the name of my tiny hotel, which didn't even have any business cards. Only P remembered. And he was intent on getting to the next place. He turned around from the front seat of the cab and said, "Just one more place… I've never been there before, but I think it's the perfect place to round off our evening." It was curious: as I was feeling more drunk, more exhausted, P was gathering energy, becoming more lucid, craving the next stop on this never-ending tour.

The cab pulls up outside a nondescript looking building with a group of about twenty people cueing to get in. P gets out of the cab, rushes up to the doorman, who greets him like a long-lost buddy, and motions for me to come in. Curious behaviour for one who has never been in this place before. True to form, it's another jump in time as we pass through the heavy black curtains. This time, it's *Saturday Night Fever*. Flashing 60-watt light bulbs, men in white suits and vests, disco-dancing which made me wish the midget strippers were back.

3. UNTITLED, 1988

4. UNTITLED, 1988

And, seated at certain tables around the dance floor were drop-dead gorgeous women, ranging from 18 to 70. I'm guessing at the latter's age, but, believe me, she was just as striking as any of her younger companions. And they all looked so cool, so distant. They would not make eye contact with any of the men in the club until a gesture had been made towards them. Everything was discrete. Only then would they look up and, eventually, make their way over to the table.

This ritual was never a possibility at our table, of course. P would have liked to, I suppose, but he was now playing the innocent, there just to watch, to impress me, the out-of-towner. Somehow, he missed the fact that I was nearly catatonic. So we watched the little cat and mouse game unfold, like a narcotic screen slowly passing over all that had gone before that evening.

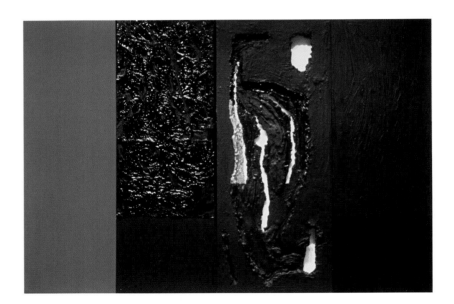

5. UNTITLED, 1985

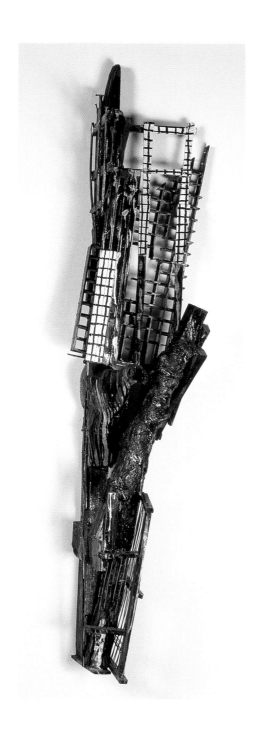

6. **UNTITLED**, 1986

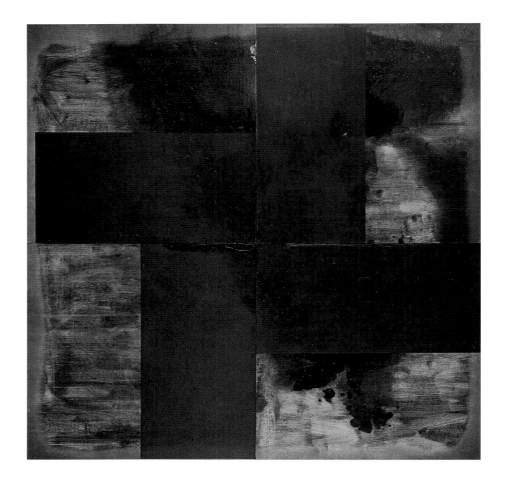

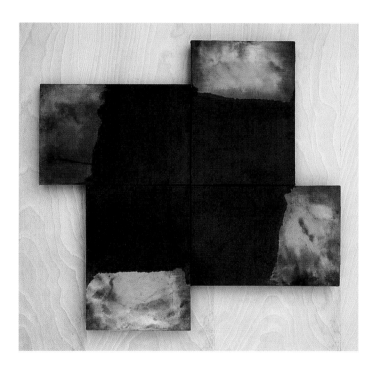

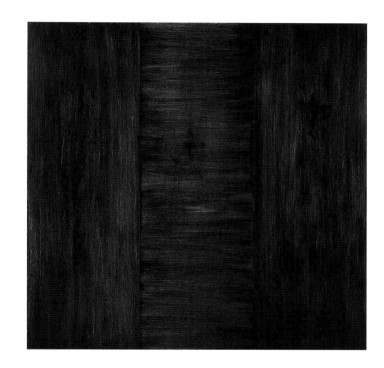

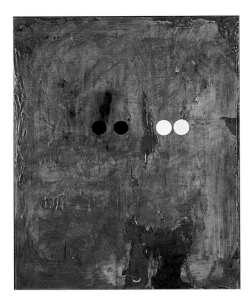

Our waiter came over. (He had nothing to do with the décor, with the seventies. His time lag went even further back. He looked like he had come from waiting on one table in 1945 to ours, without missing a beat, without acknowledging any change that might have taken place. He was inscrutable, impeccable.) I asked for a mineral water. He looked at me as if this was the most remarkable thing that had happened to him in five decades of waiting tables. Yet he didn't say a word. He took Pedro's order for a whiskey (what else?) and came back with two of them. No sign of water. I felt it was best not to argue. And I dutifully drank up.

As we lingered on towards 6:00 am, there was not the slightest pressure to do anything more than nurse our drinks. Finally, a remarkable feeling came over me. The fatigue had vanished. I was not drunk. I was famished. I mentioned this to P and it was like he had been waiting for me to say something for the past two hours. "That's exactly what I was thinking." And off we went. We dined on *steak-frites* and Bordeaux. It was glorious. However, after the whiskey to finish it off, I was begging for the name of my hotel. P was obviously weakening. Perhaps the thought of dropping me off and continuing

the night had occurred to him. But that thought only lasted for a second. Just as he was about to instruct the cabbie on how to reach my hopelessly obscure hotel, another thought came to him. "Just one more place… you've got to see this place. And then to bed."

The next thing I remember was looking out of the window of the cab. It was around 8:30 am. P was standing in front of a green door of another non-descript house. He was arguing with the person inside, who kept gesturing to his watch. P's heart didn't seem to be in it. Finally, after shaking hands with his interlocutor, just to show that there were no hard feelings and that he would be back (maybe that night), he returned to the cab. (At this point, the thought occurred to me that we might have been too early.) In any event, back to the hotel.

Not even a slightly askance look greeted me when I walked into the lobby. People were coming down for breakfast. The sun was rising. I took the steps and, as I started to climb the final steps to my room, which was in an alcove at the very top, I had a kind of mini-panic attack, in which I had no idea where I was. There were only the steps leading to my door. And, in front of that door was a pitcher of water. Had it been left there by the new inhabitants of the room, who had taken it over when I didn't show up last night or this morning? Was it left for me? Had it been there these last few days and I just hadn't noticed? Not wanting to ponder any of these possibilities, I took the jug and emptied it, drinking it all in one go. Suddenly, I remembered every event of

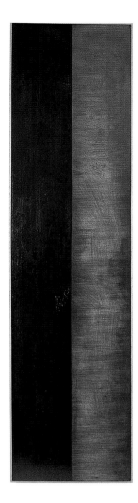

11. A SOMBRA NA ÁGUA #8 and #9, 1988

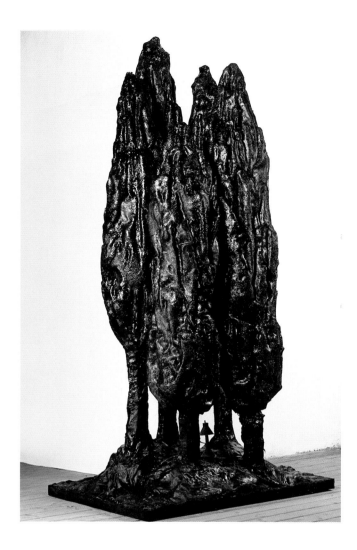

the preceding twelve hours. I remembered where I was and how I got there. I put the jug down, went into the room and went to bed.

At around noon, I woke up, having to piss terribly. The room was pitch dark, one of the "advantages" of staying in hotels in Spain or Portugal. You can close the shutters so tight that not a ray of sunlight enters the room, thus allowing you to go to sleep and wake up at any hour thinking it is the middle of the night. I stumbled towards the bathroom, took a wicked leak and stumbled back into the bed. I was still woozy from the night before. I awoke again six hours later, ready to turn over a new leaf. Never again. I slowly peeled open the shutters and basked in the rays of the sun. I felt better already.

Upon going into the bathroom to shower, I noticed something strange. I must have left my cosmetics case in the bidet when I checked in, as there wasn't much space on the shelves to lay things out. After showering and drying myself off, I reached into the case to get my hairbrush. The case was sopping wet. The shower? Unfortunately, no. Urine. Tons of it. And there, in a yellow pool at the bottom of the bag, was my toothbrush. I felt like a fucking degenerate. Fucking P. But... I certainly knew Lisbon a lot better this morning than I did yesterday. First things first...I must get the address of this hotel.

II. LIVING IN THE HOUSE OF SILENCE | Ten steps lead upwards from the floor. They are white and look as if they have been put together from cardboard. In fact, they are made of plaster. Steps are made to support the weight of the people traversing them, to safely transport them from one place to another, above or below. But these steps look like they would collapse under the weight of a child. They are fragile, almost ethereal. They lead to a kind of claustrophobic balcony, barely extended from the wall. A wall extends from the right step to the wall in which this structure has been situated, immediately creating a "first floor", dividing one space from another. It is also white, although we can see, along one of its borders, the strip that marks where it has been cut. It too seems like a temporary cut in space, white on white.

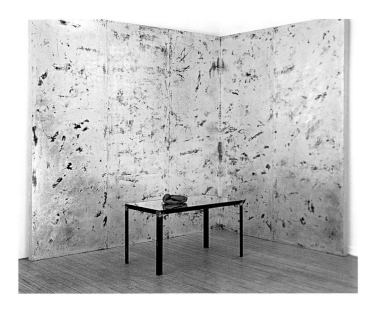

There is only one element, which breaks (and, at the same time, reinforces) the symmetry of this construction. It is a jug of water, resting at the top of the last step. Half full or half empty. This space, this sculpture, this enigmatic, ghost-like structure is called *The House of the White Silence*. Even the title seems non-descriptive, puzzling. For, our first impression is that this is a part of a house, a detail from a larger reality, one which has been embellished through the reduction of its context (the rest of the house, the room, the surroundings) and the addition of a narrative-inducing object (the jug of water). If this is a house, it is one in which we must imagine 99 % of it, imagine what this tableau suggests.

The "white silence". What does it mean to designate one absence with another? For if white is the absence of colour, silence is the absence of sound. But an absence is also something to be filled, to be projected upon. For John Cage, silence was "music", whether composed artificially by a particular piece, or naturally by the sounds that constantly surround it. Silence was potential. Just as whiteness is. Think of the film screen before the projector is turned on, the canvas before the paint is applied, any surface before it is covered (with an image or another colour). So, a "white silence" seems to imply a double potential, a house in which anything is possible, in which thoughts, events, images and sounds are both apparent and non-existent. The

house, as a stage where private & public activity combine, becomes the meeting point between poetry and prose. You can describe it all you want, but in the end, you just have to imagine it.

Look at another house, *The House on the Roof* (1970). In fact, this drawing is one of the earliest works of Cabrita Reis, yet its title, its subject and the way in which it is represented all point to an interest in a kind of visionary architecture, in which, like the white silence, anything is possible. In this case, the house on the roof, one house on top of another, represents another kind of doubling, of repetition. For, at first glance, one might say that this was merely a mansard, an atelier, an addition to a pre-existing house. The title, of course, precludes this type of speculation. This structure, complete with windows, curtains and chimney, is unique. It is a house. And it is on top of another one. Don't ask why or how. That would be beside the point. There are even a couple of plants in front of this house, resting on the roof of the other house, as if it were the ground. And for whoever lives here, with pants and scarf hanging from a line to dry, it probably is the ground. But where is the door?

III. IMPOSSIBLE RELATIONSHIPS | "Portugal had aqueducts at Coimbra, Tomar, Vila do Conde and Elvas all functioning in the seventeenth century. The new Spring Water aqueduct built in Lisbon between 1729 and 1748 took water to the outlying square of the Rato. The water of this fountain was much sought after, and it was here that the water carriers came to fill the red casks with iron handles which they carried on the backs of their necks." (1)

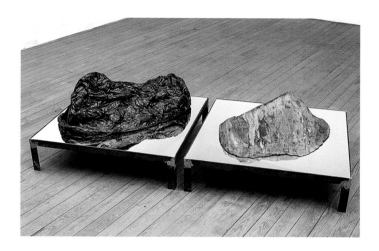

14. **AS APARÊNCIAS**, 1988

A work from 1990, entitled *Silence and Vertigo*. Cabrita describes the work:

"A church on a river bank. On the other bank a seven hundred year old university. The river flooded the church and today, out of the waters inside it, there appear seven arches.

"On these arches something 'false' (an installation which proposes the simulating of a system of water courses) takes on meaning through its impossible relationship (connecting it to the water is inoperable) to something 'real' (the water inside the church).

"There is a metaphorical connection between the passing of the river and the transforming and passing of knowledge.

"Silence (implosion of all sounds/Totality) and Vertigo (movement in direction to an origin) form the nature of the search for knowledge. The place – a place which is now emptied of its initial sense." (2) .

Like the house on the roof, Cabrita's combination of the "false" with the "real" produces a combination, which encourages the viewer to once again imagine the impossible. On a basic level, an aqueduct is a system that ensures that water goes from one place to another. These various sites of transport are often marked by cisterns or wells, which mark the presence (or absence) of this precious fluid. *Silence and Vertigo* (and all of the artist's works which utilize the same structures) mark, not only the objects, but the process, the energy. The aqueduct is but the physical manifestation of a process that is invisible to the naked eye. It is a link, a bridge, which enables us to connect disparate spaces. And disparate levels of reading.

Again we find the word "silence" in the title, here defined by the artist as an "implosion of all sounds/Totality". The positive connotations of the term are stressed, the sense that a silence is a trace of something else, an evidence of what has gone before. It is a totality of emptiness, a void filled to the brim. Likewise, the definition of "vertigo" as a "movement in direction to an origin" is much more ambiguous than just saying, "a fear of heights". For what is that fear if not a wish to fall, to hurl ourselves from a dizzying peak, to "return" to the place where we started, to die. Silence is possibility. Vertigo is stasis, always poised between stasis and flight. And, as Cabrita's "impossible" structures rest on the arches beneath a church, we must imagine the balance, the juxtaposition, as another kind of poise: silently waiting to fall. Resting in place.

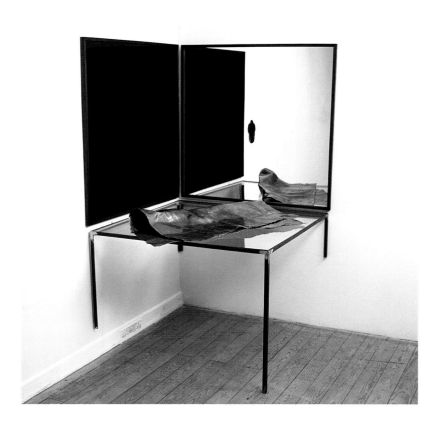 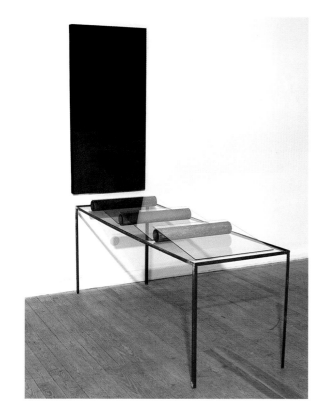

15. MAGNIFICAT, 1988

16. COCTEAU, 1988

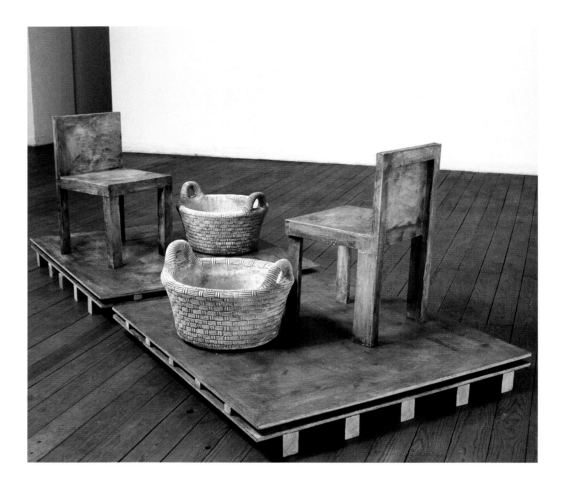

IV. DESIRING BEAUTY | "In fact it happens also in chemistry as in architecture that "beautiful" edifices, that is, symmetrical and simple, are also the most sturdy: in short, the same thing happens with molecules as with the cupolas of cathedrals or the arches of bridges. And it is also possible that the explanation is neither remote nor metaphysical: to say "beautiful" is to say "desirable," and ever since man has built he has wanted to build at the smallest expense and in the most durable fashion, and the aesthetic enjoyment he experiences when contemplating his work comes afterward. Certainly, it has not always been this way: there have been centuries in which "beauty" was identified with adornment, the superimposed, the frills; but it is probable that they were deviant epochs and that the true beauty, in which every century recognizes itself, is found in upright stones, ships' hulls, the blade of an axe, the wing of a plane." (3)

Look at the media employed in *Dans les Villes #2*: aluminium, plywood, wrapping tape, enamel, masonite & coloured plexiglas. An industrial structure (aluminium) has been scraped clean of colour, so that a milky, blue cloud seems to cover its surface. It is a collection of disparate rectangles and squares, curved in the centre. In fact, the different sections look like blank (one could even say silent) frames or canvasses. One area, however, is not blank. Fitted over the empty surface is a pair of sliding windows. One is painted black, the other red. The apparent chaos of materials is belied by the symmetry of the work. Its references are as varied as the means it uses to

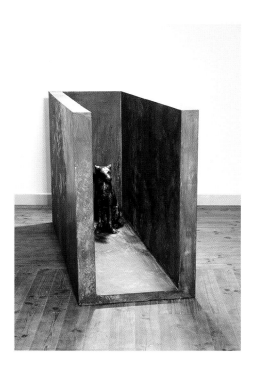

denote them: painting and sculpture are but the most apparent. And, just as Levi finds a bridge between chemistry and architecture through reflecting on the notion of a "simple beauty", so does this work combine opposites through its surprising combinations. It does not seem like a mass of incoherent materials. It is, like a view one could see on a stroll "in the city", an amalgam of different unities, which is both singular and part of a wider, coherent scheme. (The latter is evidenced in the way Cabrita works in series, developing an idea, a combination of elements, a form, a colour through a succession of stages, each work being a continuation and a rupture from what preceded it.)

V. THE IMPOSSIBLE COLLECTION | "Works belonging to the genre of *cabinets d'amateur* were detailed pictorial descriptions of rooms filled with artworks and other precious objects. Often these paintings served as precise inventories of real collections, as is the case with David Teniers' *La Galerie d'Archiduc Leopold* (1651–53) or Hieronymus Francken II's 'La Boutique de Jean Snellinck' (1621). At other times, the view was imaginary, bringing together well-known artworks to form an ideal collection. A work by Jan Breughel of 1615–18 is an example of this second type which used an art gallery as a setting for an allegory of the sense of sight." (4)

The Breughel painting depicts the gallery filled, from floor to ceiling, with paintings. There are even some that are set on the floor itself, occupying every available space. A woman sits at a table, pondering what could be a miniature painting, what could be a mirror offering up her own reflection. A bouquet of flowers climbs up a pillar, as if mimicking the subject for a still life. A chandelier hangs above the corridor that separates the rows of paintings. And a stream of light enters from above, as if coming from one of the paintings itself, one of those we cannot see on the right corridor wall. At the end of the corridor is an open door, leading to the outside. Or is it another painting, leaning against the wall?

In fact, the painting is entitled *Sight and Smell*. It is not just a catalogue of visual opulence, of the infinite possibilities of creating "views": it is a veritable "still life", in which all of the senses play a part: the paintings which direct the eye from one part of the canvas to another, the smell of must and flowers, the touch of the artist revealed in each work on the wall, the echoes produced by an enclosed space, etc. This is a space that is completely idealized and imagined, i.e. the perfect collection and, at the same time, teeming with the mundane experiences of life. The posture of the woman at the table reveals everything: a fashionable slump, as if one had had too much to drink, too much to see.

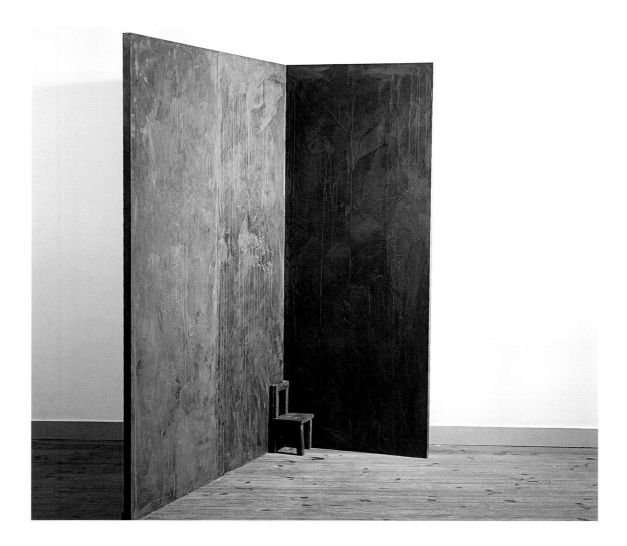

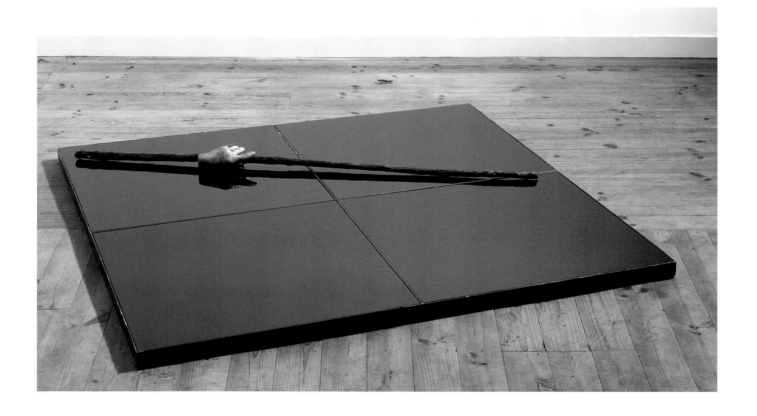

Catalog #1 (red): six shelves on a white wall. On the left a set of three, one above another, extend to the corner. On the right, also extending to the corner, the shelves are shorter and do not join with those on the left, each being about ten centimetres higher. On each shelve are a series of red shapes. They are, broadly speaking, rectangles, squares and circles, of different sizes. There is no apparent order.

At first glance, Cabrita's *Catalog* may be compared to the *Cabinet d'amateur*. Both are collections of objects (paintings & forms). Both appeal to the sense of sight as unlimited in potential. And both represent a kind of ideal collection, the possibility of the next element miraculously appearing on the wall or the shelf. Both point to a greater volume, beyond what is pictured. (In the case of *Catalog*, one may also cite Allan McCollum's series of *Surrogate Paintings*, in which the process of repetition and variation pointed to a notion of excess, of painting reduced to ground zero.)

There is, however, a vital difference between Cabrita's catalogue and Breughel's collection. The former is a series of blank, abstract objects. Its "subject" is geometrical form and the colour red. Breughel, on the other hand, reproduces a series of figurative paintings, including recognizable artists such as Rubens, while adding his own figurative scene below. One artist seemingly rejects narrative and identification, while the other revels in it. Breughel's gallery may be an allegory for the sense of sight, but it is also an illustration of a kind of pictorial envy: the more images we consume, the

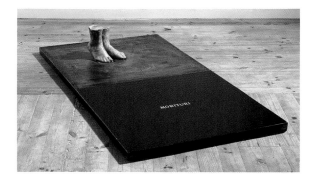

22. **MORITURI**, 1989

more we want. The more perfect, the more erotic, the more colourful a painting or collection is, the more we want it to be. Each image engenders the next. And if we don't have it, we have to get it.

Cabrita's catalogue of forms is much more finite. If the *Cabinet d'amateur* is expansive, this is reductive. One colour. Three forms. One has the impression that these objects could easily constitute a unity, a complete set. One object, in fact, composed of multiple parts. It seems to be a "catalogue" of a moment in time, a thought, a suggestion. It seems to be, once again, between poetry and prose.

VI. GLASS | I was walking along a street, near the train station. Nearly every other window I passed featured a woman sitting on the other side. They were all "storefronts", huge panes of glass where, formerly, one might have found a cobbler, a butcher, a seamstress, etc. One could pass by, look in and see what was happening, what was for sale. Now, it's pretty much the same, only these women are selling themselves. Once the "sale" is concluded, a curtain is drawn across the window and our vision is turned back upon the street. In this case, I had just gotten a view of a beautiful woman who looked very familiar. And yet, I couldn't place where I knew her from. However, just as I turned to look again (dangerous, these second looks), the curtain was

drawn. A client. Conveniently, there was a bar across the street, where I took a table behind another storefront. These tables are always the most prized, as you are off the street, yet have a kind of invisible visual access to what is going on outside. I ordered a beer and waited.

After three of them, the curtain was still drawn across the window across the street. And yet, it kept moving, billowing, as if there was a figure inside it. Had someone requested sex in front of the window, with only the curtain separating the act from the passers-by? I remembered a scene in the film made from Marguerite Duras' *L'Amant*, where the young heroine has sex on the floor of her lover's flat in Saigon, with the noise of all the shopkeepers just outside the door dominating the scene. One could even see legs pass by outside, between the slats of the wall. Was some scene like that taking place across the street? I ordered my fourth beer.

After another half an hour, a woman came out of the building, dressed in black leather, with sun glasses. I knew a lot of women who looked like this, but I couldn't place this one. Five minutes later, two men in overalls came out. The curtain remained where it was. I went home.

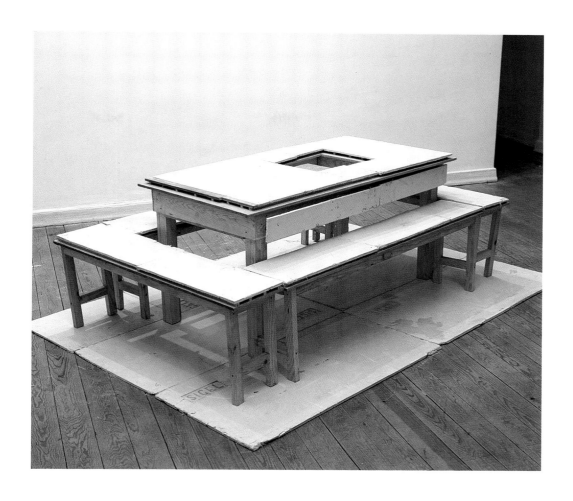

23. **A CASA DA POBREZA**, 1989

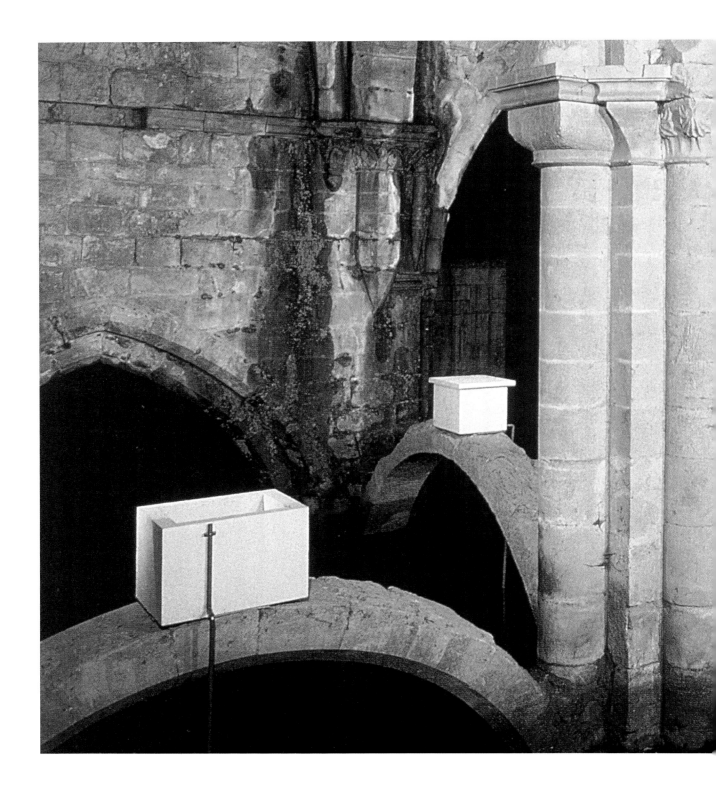

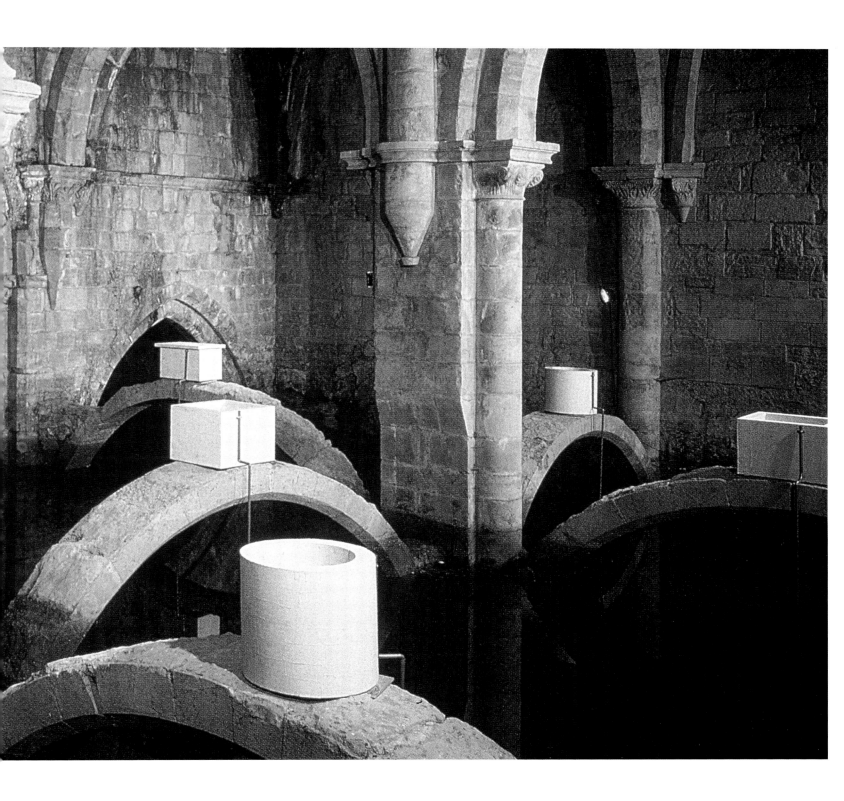

The next morning, I was back in the same bar, at the same table. At around 10:00 am, a man went into the apartment. He pulled back the curtain. The window was painted black. All that one could see were the red letters, ADULT FILMS. I paid for my coffee, crossed the street and went in. After all, no one could see me.

Cabrita's paintings on glass refer to any number of media. Because they are simply paint applied onto a viewing surface, we may call them paintings. Because they are not applied to canvas, paper or the wall itself, but are applied to a surface that is thick and traditionally repels paint, we may call them sculptures. In addition, they may be suspended from the ceiling (Stockholm) or leaning against the wall (Venice), thus encouraging us to think of them as "more than painting". But these are not just works that are situated between painting and sculpture. The use of glass, and all of its inherent properties and associations, points to architecture as well, as a means of dividing public and private space. Which, of course, relates back to the houses and the representation of structures such as stairs, shelves and aqueducts. Each element, each reference, engenders another. The artist provides us with a starting point: an object, a title, a set of codes to borrow from. The rest is up to us.

Take another example: *Wrapping Tape Landscape #1* (1999). In this case, the title is brutally direct.

At least the part about the materials. The tape completely covers a rectangular structure that extends from the gallery wall. But the subject, while the word "landscape" leaves no room for doubt, is elusive. As it is meant to be. Yes, one can spot lines and patterns, which could be interpreted as a horizon or a clump of trees. What they are, of course, are clumps in the application of the tape, but they can still be read as details of a landscape. They can also be read as "paint", as a rough, textured covering of a surface, a monochromatic wash with tactile edges. Or a "combine" sculpture, in the way that one surface is juxtaposed with another. Or…

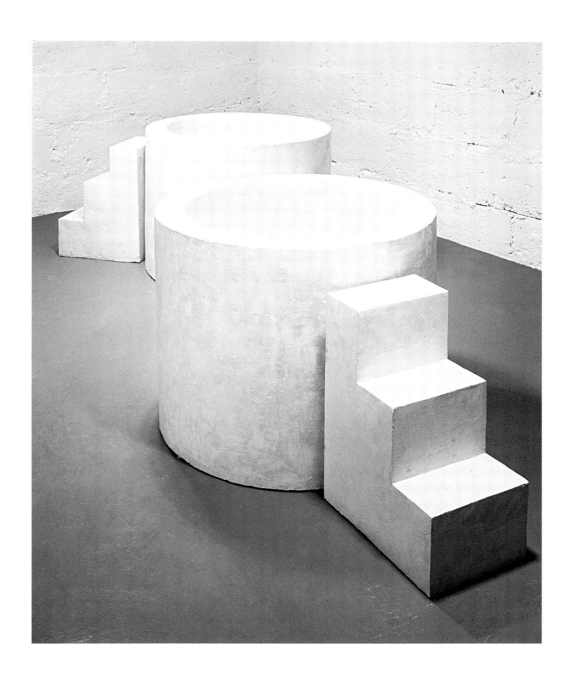

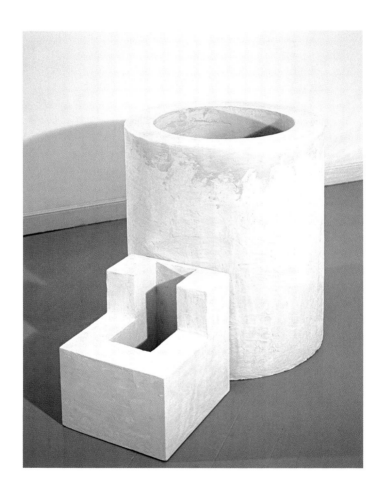

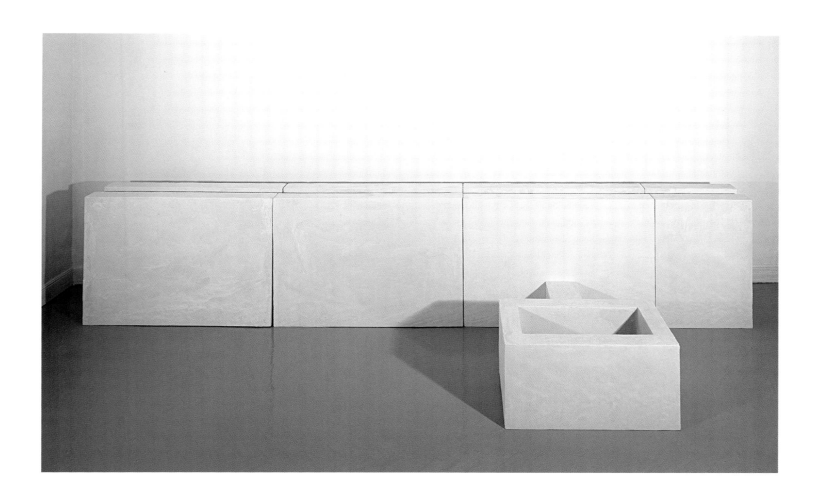

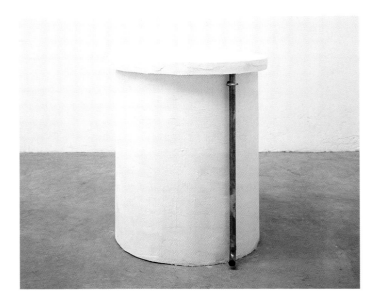

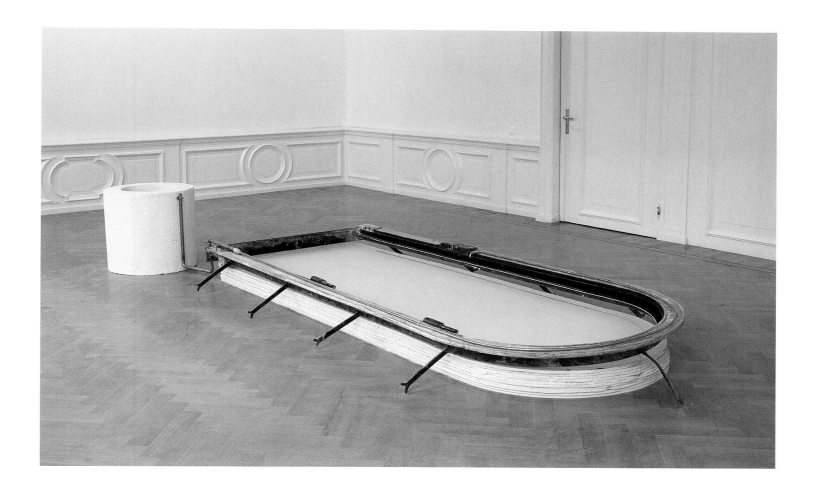

VII. COSA MENTALE | "Pereira declares he met him one summer's day. A fine fresh sunny summer's day and Lisbon was sparkling. It would seem that Pereira was in his office biting his pen, the editor-in-chief was away on holiday while he himself was saddled with getting together the culture page, because the *Lisboa* was now to have a culture page and he had been given the job. But he, Pereira, was meditating on death. On that beauteous summer day, with the sun beaming away and the sea breeze off the Atlantic kissing the treetops, and the city glittering, literally glittering beneath his window, and a sky of such a blue as never was seen, declares Pereira, and of a clarity almost painful to the eyes, he started to think about death. Why so? Pereira cannot presume to say." (5)

In this opening series of sentences from Antonio Tabucchi's *Declares Pereira*, we find a set of paradoxes based on the notion of repetition. "Pereira declares that" is already a repetition, repeating, writing, what has already been said. And then the comparison between the beautiful weather in Lisbon and the dark secret that seems to be behind this figure, "biting his pen", "meditating on death". And than the repetition of physical and psychic pain, a "clarity almost painful to the eyes" precludes more thoughts of death. Why, indeed? That, of course, will be the central question of the narrative, the enigma of Pereira, the light, idyllic life of Lisbon contrasted with the secrets of this character we will never completely understand.

30. ASCENSÃO, 1990

31. SOLEDAD! SEQUEDAD, 1990

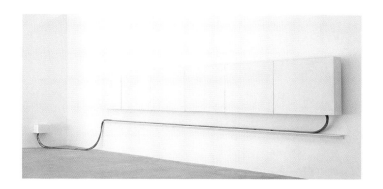

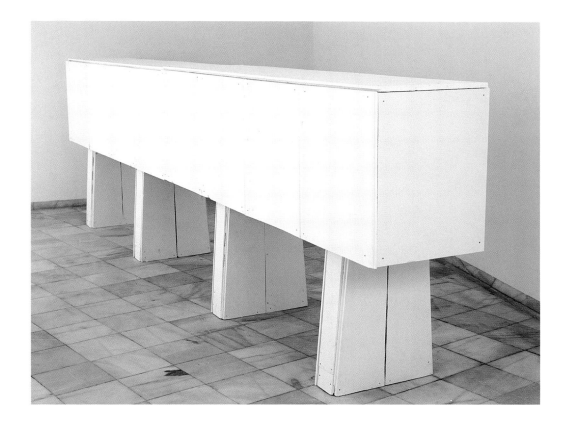

The phrase, "Pereira cannot presume to say" recalls Melville's Bartleby, the clerk who responds to every question, every provocation with the phrase, "I would prefer not to." Another enigma who is both the source and refutation of the narrative drive. Like "declares Pereira" or "Pereira cannot presume to say", these statements seem to take us into the mind of the character, seem to be simple subjective statements that we can translate into objective signs. The repetition (the obsessiveness of Bartleby's reply or the insistence on describing the Lisbon weather) seems to insure us that we are reading things properly. But narratives, and art, are based on disruption, on finding out what Pereira cannot presume to say, on exposing the space behind his declarations, on solving the enigma... even if the author creates other enigmas in its wake.

"He was not the perfect antagonist: but, as is known, perfection belongs to narrated events, not to those we live." (6)

"For what Leonardo said of painting can equally be said of love, that is *cosa mentale*, something in the mind." (7)

"There are moments that can be called crises, the only ones that count in a life. These are moments when abruptly the outside seems to respond to calls we send it from within, when the exterior world opens itself and a sudden communion forms between it and our heart. From my own experience, I have several memories like this, and they all relate to events that seem trifling, without symbolic value, and one might say *gratuitous...* poetry can emerge only from such 'crises,' and the only worthwhile works of art are those that provide their equivalents." (8) ■

NOTES

(1) Fernand Braudel, "The Structures of Everyday Life: Volume 1", Harper & Row Publishers, New York, 1981. Translated by Sian Reynolds. Page 228.

(2) Pedro Cabrita Reis, quoted in catalogue published by Fundação Calouste Gulbenkian, Centro de Arte Moderna, Lisbon, 1992. Page 74.

(3) Primo Levi, "The Periodic Table", Abacus Books, London, 1986. Translated by Raymond Rosenthal. Page 179.

(4) Mary Vidal, "Watteau's Painted Conversations", Yale University Press, New Haven & London, 1992. Pages 183 – 184.

(5) Antonio Tabucchi, "Declares Pereira", The Harvill Press, London, 1995. Translated by Patrick Creagh. Page 1.

(6) Levi, op. cit., p. 215.

(7) Marcel Proust, "In Search of Lost Time: Volume IV", Vintage Classics, London, 1996. Translated by C.K. Scott Moncrieff & Terence Kilmartin. Page 629.

(8) Michel Leiris, "Documents", Volume I, Number 4, 1929. Published by "October", Number 92, MIT Press, Cambridge, Massachusetts. Page 141.

32. **A CASA DO SILÊNCIO BRANCO**, 1990

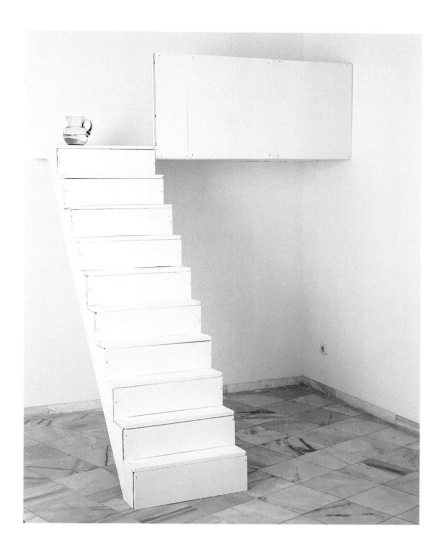

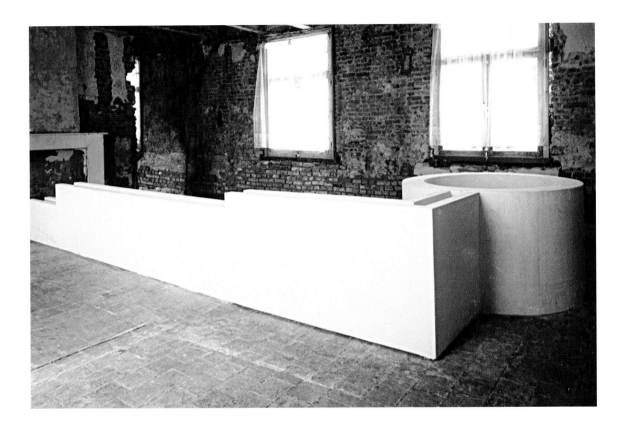

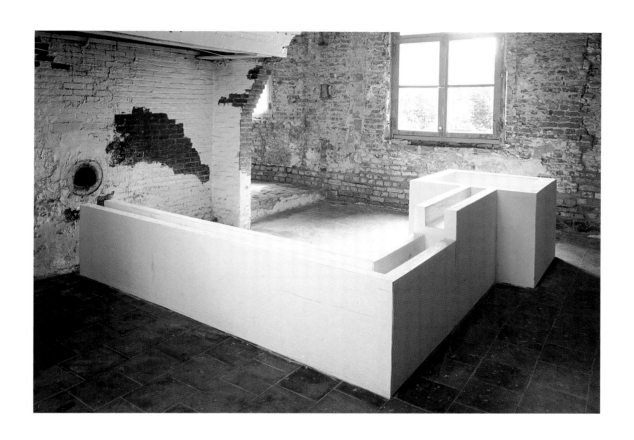

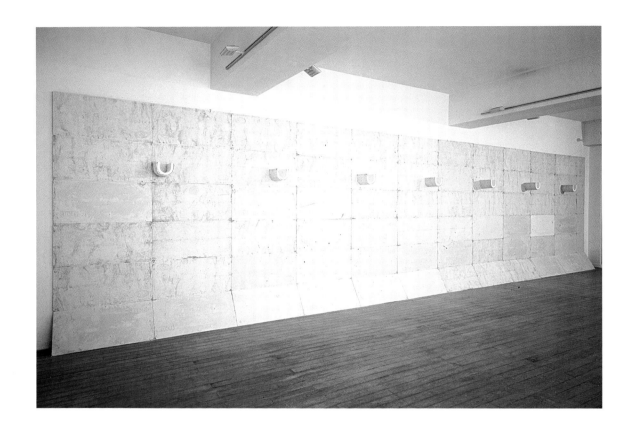

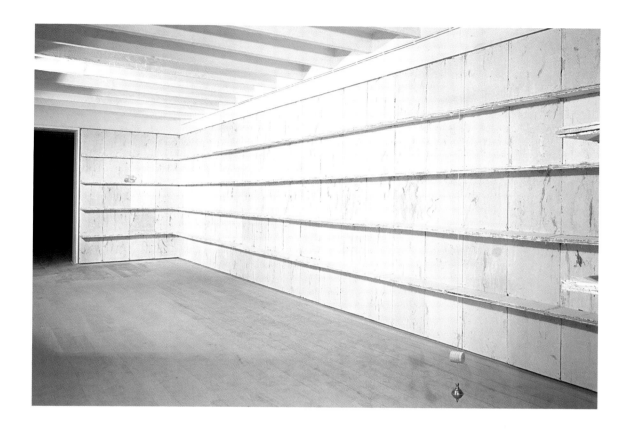

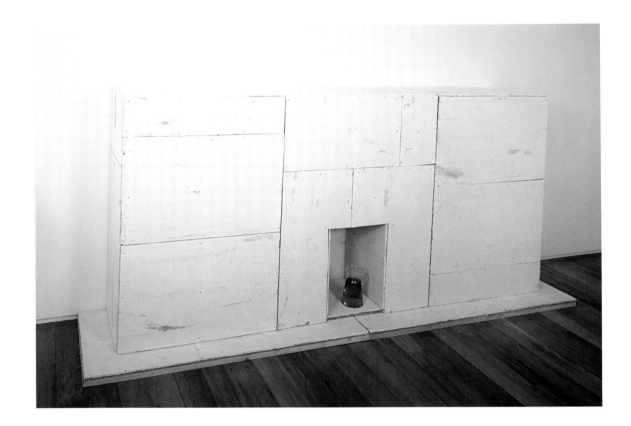

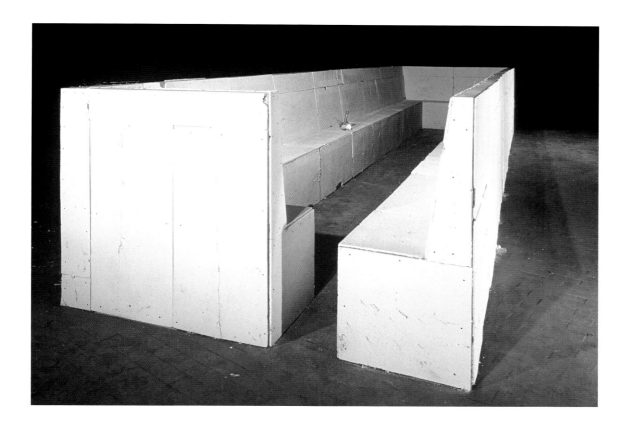

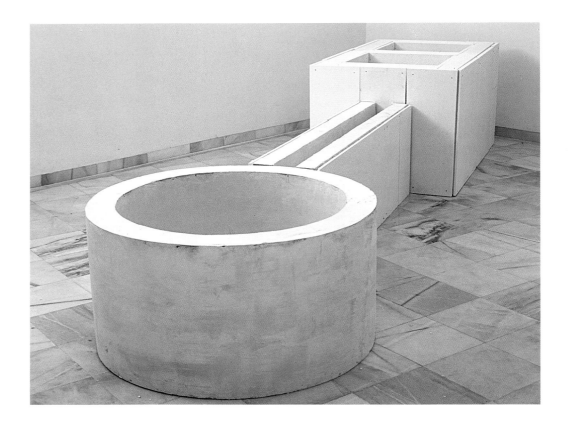

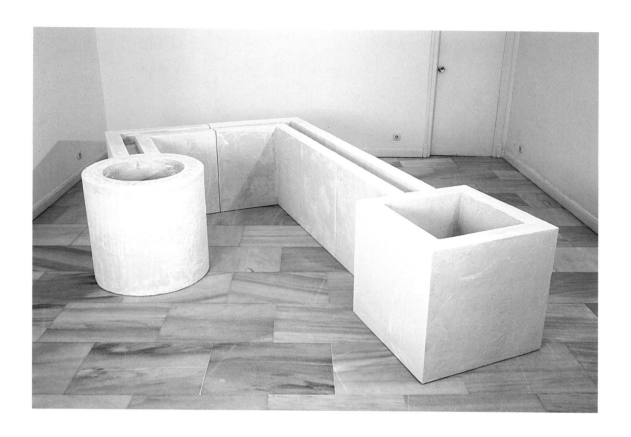

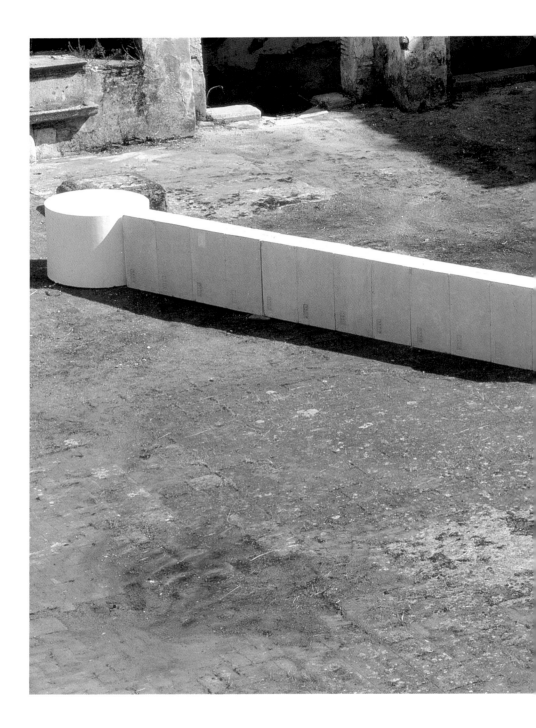

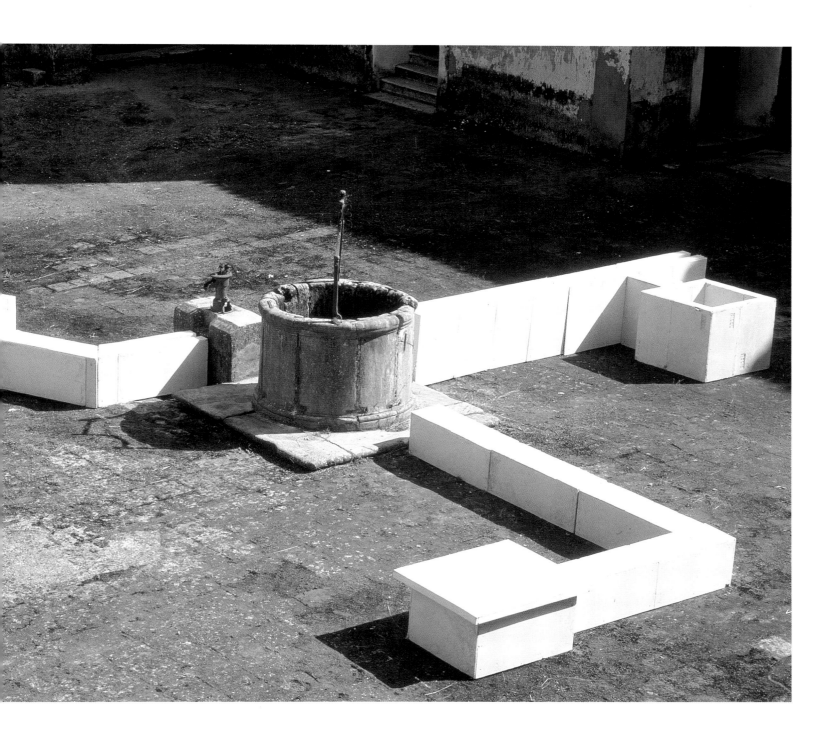

A CONVERSATION WITH PEDRO CABRITA REIS

ADRIAN SEARLE

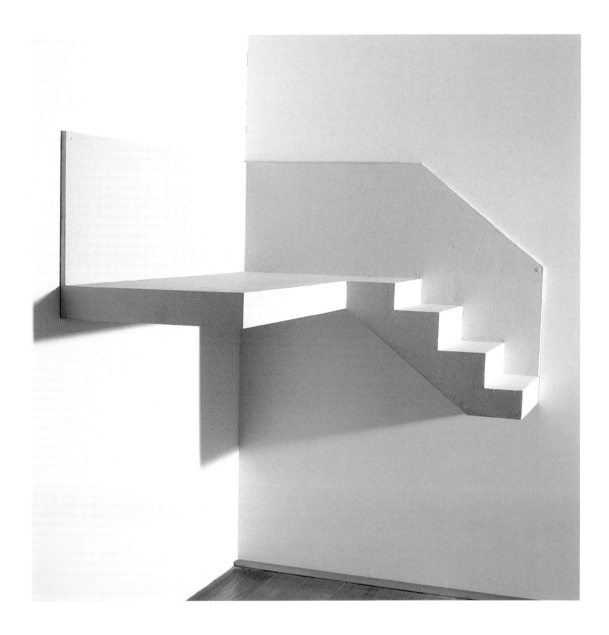

Pedro Cabrita Reis: Well, the thing is I never had any doubt about what I wanted to be. It was never a case of choices – vet, doctor, engineer, architect, liar. It just happens that I've always known it. I wanted to be an artist.

Adrian Searle: And your influences?

PCR: Many different ones. Art magazines were not around in Portugal in the 70s. Maybe a few old books with reproductions and no money to travel. After the revolution in '74, I met Bravo, who was one of the better-educated artists in the country. Most of the comprehension of art I've got back in those days came from the conversations we had. He died, but I still remember all the fun talking about Beuys, Nauman, Barnett Newman, and so on. At the same time, I was also looking at Greco, Tiziano, or Caravaggio but all that drinking together with Bravo usually ended up with Brancusi, Duchamp, Picabia and so on.

AS: But you still make self-portraits.

PCR: I do, even if I like to think about them as sculptures "strictu sensu". They can be divided into images of myself as blind, and all the others. Closed eyes usually don't make great self-portraits, do they? Maybe we should call it just "shadows".

AS: They look like death masks; as though you were depicting yourself as a dead man.

PCR: We die. Every moment, one moment after the other, one gets closer and closer. But when I look at a death mask there is always this almost perfect moment of suspension. Of complete revelation. I remember Beethoven in his tiny little home in Bonn. It is a moment when we are no longer able to be aware of ourselves, but at the same time it is like possessing the truth. Then, everything becomes absolutely serene. The serenity of those masks comes from that moment of suspension. You and the mask become one.

AS: Most of your work is without figures. But there are places and signs of life everywhere: habitations, windows, doorways, wells. Intimations of daily life and everyday ritual acts, including, of course, other people's art.

PCR: Well... I am a gatherer of memories, mostly.

AS: Yours or other people's?

PCR: Good question. Mine eventually, because everything I work with becomes my experience. It comes to me through memories, sounds, lost things, shadows. I am a gatherer of mysteries, signs of passage... It is like if you are in a hurricane, which is sucking up all the shit: houses, roofs, cars. And when the wind stops it deposits all this stuff and goes off somewhere else, leaving behind what looks like a chaotic archaeological site... which we will reconstruct and shape again and again. Why worry about who made this or that or whom does that belong to? My work has to do with things being unique to one person. It's about how to remain or what will remain. Survival? Order after chaos? Trying to make sense? A deep, profound desire to maintain one's self alive, perhaps.

AS: Looking back at your early work – early drawings, snapshots of paintings, all of which you have gathered as a sort of electronic memory on a CD-ROM – all the way through, right from the start, there are houses, plans, maps. Idyllic childhood homes. You are describing staircases, courtyards, little shadowy corners where a child might play. Presumably you only noticed this preoccupation in retrospect, you had no conscious project when you began?

PCR: It's very strange and almost dark when one goes back to gather his own work together, reanimating archives, opening all those folders and going back and forth, year after year, show after show, realising that after all, despite of the many fragmented and broken mirrors existing there, there's always underlying, one, just one simple consolidated idea, just as if the whole body of work is nothing but a certain and obsessive way of looking.

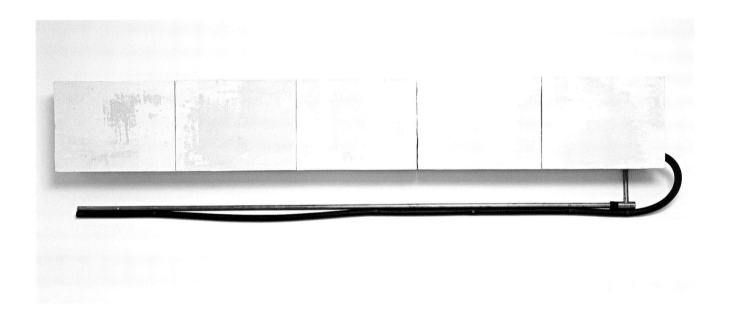

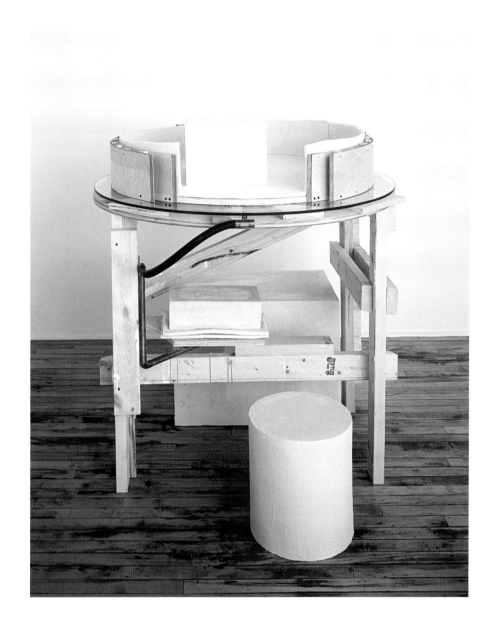

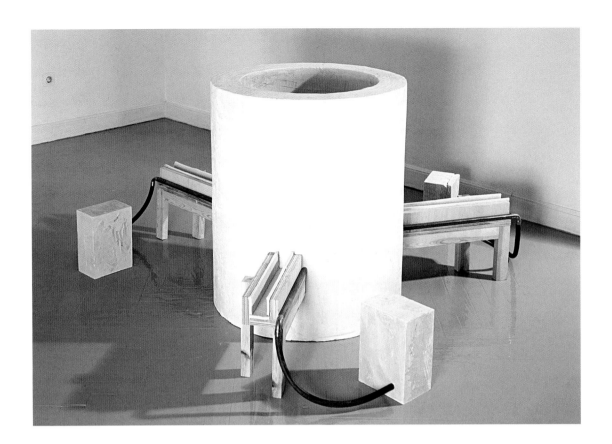

47. **ABSORTO**, 1991

AS: Whatever you did, whatever influences you had, everything you have done is about boundaries and human places, places of occupation.

PCR: That is something one only realize afterwards. In such fringes of memory, one might call it almost a no-one's land. Looking at some of the earliest paintings of mine, they might as well be understood like "aerial views" of some of the plaster sculptures I've made a few years later. Take the round and square wells, connected by a system of channels, for example. I guess you can say that everything I have done is about territory. It is all houses and how they define a geography of the territory. It is all about constructing, and how to perceive a place of it's own, thru the act of measuring. A palm of a hand or a look at the horizon, either both defines the same place or draws the same boundary.

AS: What kind of house did you grow up in?

PCR: In an old and rather sad residential part of town. The apartment was a corridor, with rooms to each side, like a system of cells clustered around a main vein.

AS: Why do you think this kind of subject matter has become such a preoccupation? One can trace this focus on architecture through so many artists' work of the past half century.

PCR: Because nature has disappeared as a reference. We have lost it within ourselves to such a point that we came to the moment where the exercise of architecture is the only form that makes the world comprehensible. After all, architecture is more about defining territories then actually building houses. Being an artist, what I do evolves around architecture as a mental discipline or an exercise of reality, since it's impossible even to look at a tree without considering it as a part of an elevation that includes my shadow, the line of the horizon, the space between both and the drawing of the steps or of the walk in between those points. And then again here we are talking about space, wich is again architecture, which leads us both to the loss of Nature and – why not? – to the fall of God. It has always been, as it were, against the trees. The world is meaningless unless you define it through a drawing. We have to shape the form of the world.

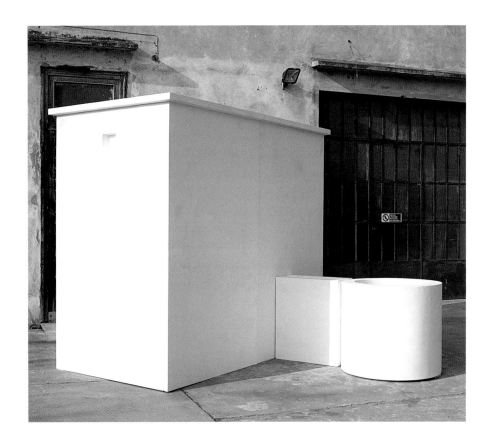

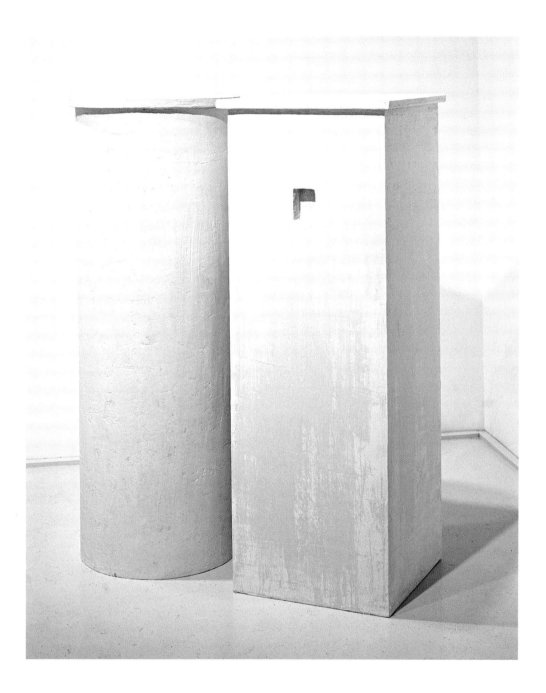

50. DESENHADO NO CÉU, 1991

51. GÉMEOS, 1991

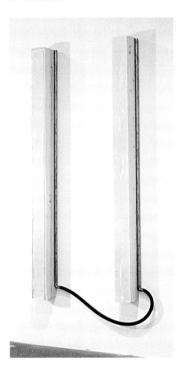

AS: It is difficult to think of this without feelings of loss and sadness, about nature and our place within it.

PCR: I would say that melancholia is the word we are missing here. Melancholia considered as the condition of being deprived of an external image of the self. Having lost the comfortable reassurance of being part of Nature, we are only left with the perception of the self. And this knowledge implies the drawing of a territory, shall I say an exercise of architecture, an assumption of a self that builds a sense of place. Shaping a form of a wall, opening doors and windows in it, is how one can deal with the landscape which is difficult to be perceived if not through the intersection of a line with another line. Those two create a space where the projection of our shadow is the measuring tool. Or, if you prefer, the reference of a finally regained unity.

AS: I understand your work as not about revolutionary gestures and schism, but about continuities.

PCR: The loss of nature is a wound, still, or forever, to be closed. To be healed. Only artists can do it; in a manner, I suppose, very desperate. I'm not interested in the ephemeral brilliance of those moments of rupture. Instead, I'm further more interested or implied in a gesture of re-building. I'm more interested in the act of doing. Putting things together, establishing a place of memory as an ability to construct. Memory as opposite to nostalgia. I would like my work to be referred to as an inner space of silence, introspection, serenity. Most of all it's about the inevitable quest for beauty, as a form of absolute inteligence.

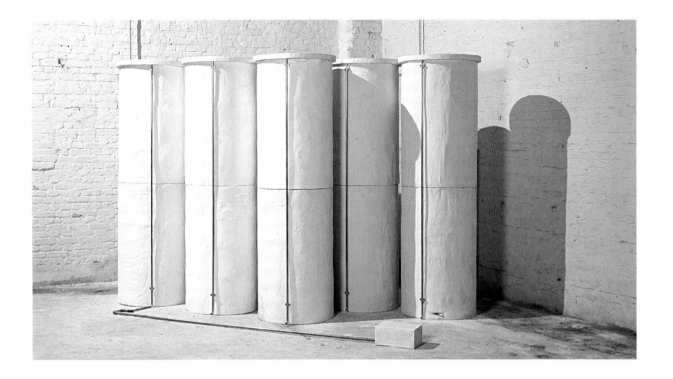

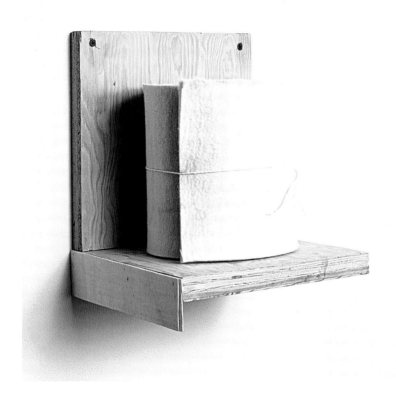

AS: Beauty?

PCR: Beauty is perhaps an old fashioned word or concept, but I still take it as a moment where self-awareness encounters the realization in one's mind of an image of the world. Understood in such a way, beauty is to be taken as an ultimate form of pure intelligence. In a more elliptical language, it could be the difference between desire and knowledge. What you want and what you have. Its achievement, the juxtaposition of these two levels, would eventually mean the absence of art, who knows?

AS: An art that does away with itself? Returning beauty to the everyday?

PCR: Why not? Everyday is one of the most complex forms of eternity, and Adrian, I'm completely convinced about eternity. Not such a contemporary issue these days, I agree, but that's another thing. Like waking up in the morning and realizing it's a day less in your life.

AS: How does this relate to your poverty of means as an artist, your use of commonplace materials and objects?

PCR: Maybe because that will be the way to celebrate this extreme imponderability of days which are slowly vanishing. Sometimes I feel an interdiction, like if I'm forbidden to use more than what is strictly necessary. Art is also about making, doing, building with the minimum gesture.

AS: Forbidden? You sound like a puritanical modernist.

PCR: There is neither much time nor much space left. We should be able to use the minimum, to concentrate energy and intelligence, to make a drawing without lifting the pencil from the paper. We have to be absolutely intense. To go back to beauty, I would say it's all a matter of putting one thing together with another thing in an accurate manner, where intelligence is embodied in the very act itself. Beginning with the simplest, smallest gesture, beginning with the things that are to hand, but carrying a vision.

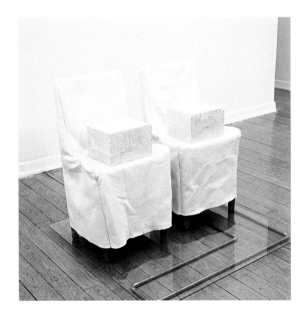

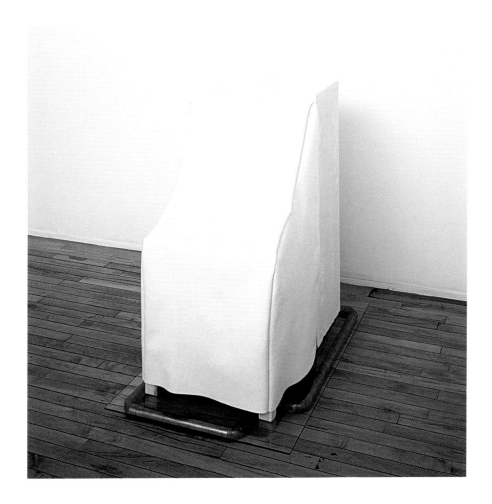

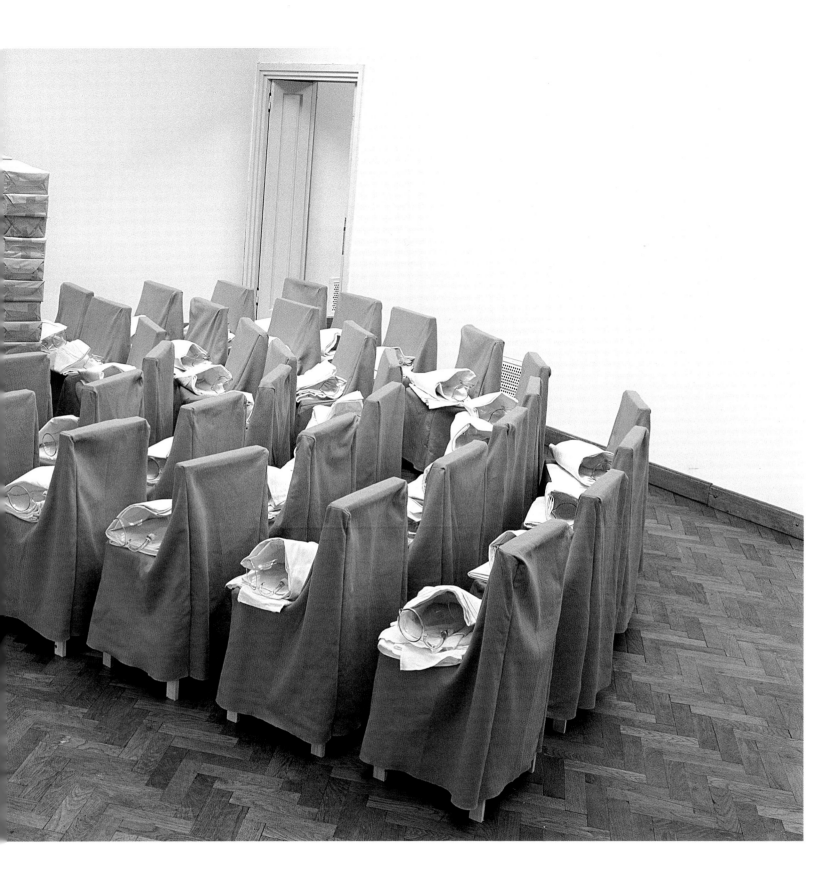

AS: You once said to me – I quote – 'My work is not about the materials, the plasterboard, breezeblocks and so on.'

PCR: It's about becoming a monk.

AS: You, Pedro, a monk?

PCR: It's an image. In the sense that you can imagine a monk building a garden in the desert. Knowing exactly where to put the trees. Or maybe not. No, perhaps not a monk after all. Better said, a visionary, someone who knows where the water comes from just by looking through the shadow of a stone in the sand. That's what an artist is. Someone who knows by looking through.

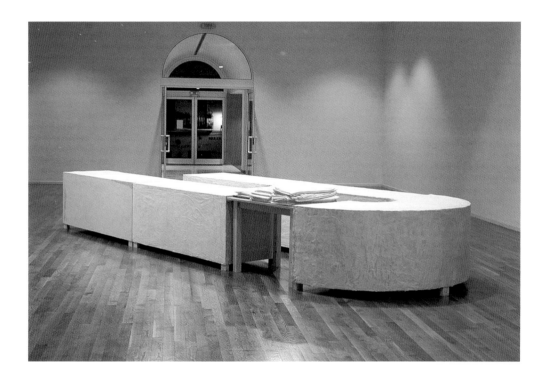

57. SCALA COELI, 1992

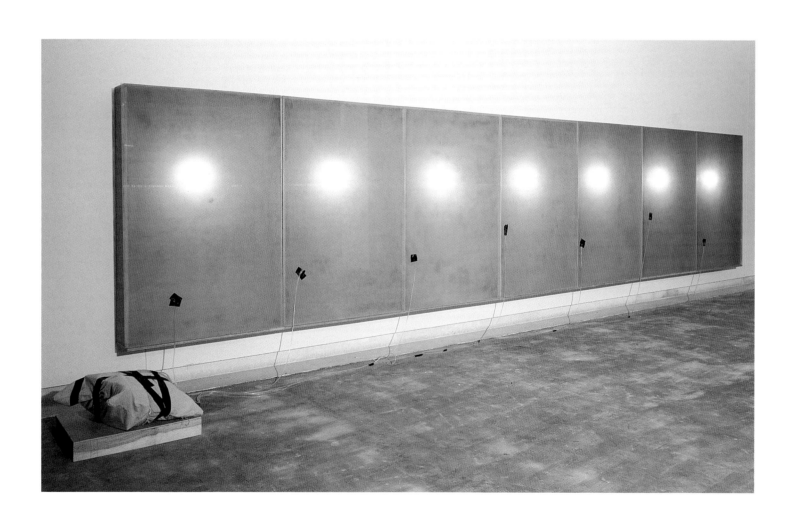

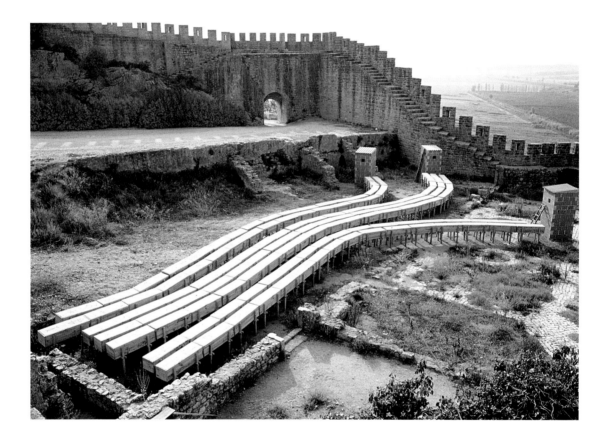

AS: I have seen you not knowing how to finish a show and inventing a piece right at the last moment, just before the opening – at Serralves in 1999 you went out and found an abandoned flagpole and dragged it into the gallery.

PCR: I'm never disturbed by having people around me when I work. I'm listening to myself saying "I don't know how to finish this…this table. What's missing?" And maybe someone says "A towel, a napkin". So, I ask, "Have you got one?" "No," they reply, "But I have a shirt." "Let's use the shirt then. Give me your shirt."

AS: The shirt off your back! There is a big difference between your approach to objects and things, and your approach to painting. A painter has lots of choices, an endless supply of colours and brand-names, but they already have associations with art. They are art materials. How does your approach migrate from one medium to another?

PCR: I just want pure colour, pure space. I want my paintings to be absolutely empty of meaning. This is not new anyway!

AS: It is impossible. We have all seen too many paintings.

PCR: When I am painting I can't possibly remember any other paintings. I am in a place of emptiness. Pure colour, one gesture, the two things together in one single act. A territory of complete radical absence. A pure self. Maybe this is just unachievable. The radical absence I told you about is like when I'm painting I know that that particular painting is the only one that ever existed or will exist. Everything is then forgotten, everything.

AS: That, surely, is the painter's tragedy. He cannot forget.

PCR: When I work as a sculptor. I say a stone and I mean it as a house, I say a glass of water, I name it as an oak tree, I say a beam of light, I name it as a body. That's metaphor… But as a painter I go on painting and saying at the same time: this is not a house, neither an oak tree, nor a body. Painting is. It just is.

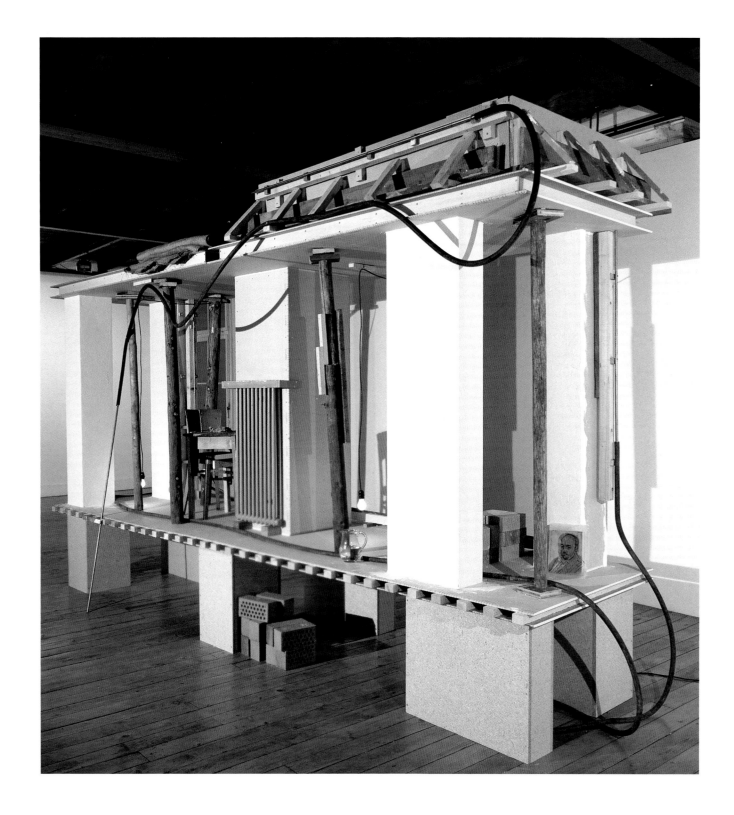

64. ECHO DER WELT I, 1993

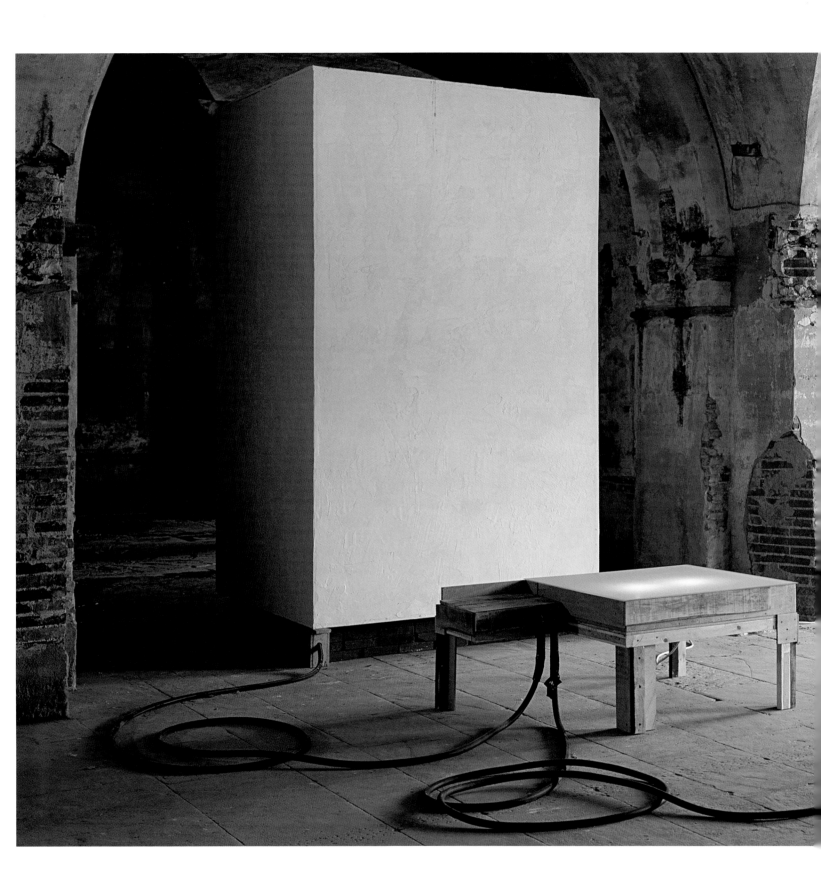

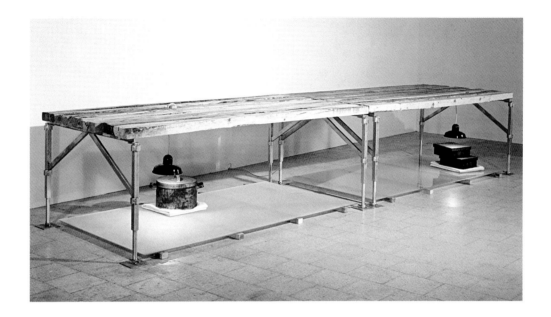

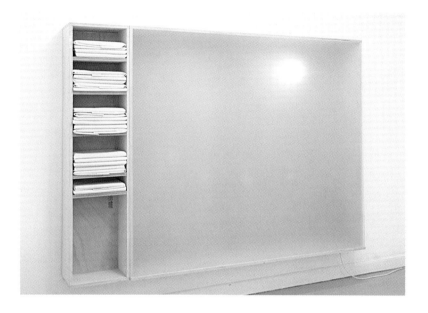

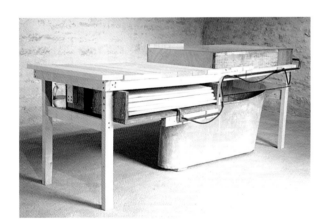

AS: But is it ever possible to pick up a tube of Cadmium Red and not think of Barnett Newman?

PCR: The actual question should be how to make a painting without him. Last summer it occurred to me doing some of my paintings and naming them after some of Newman's. You know, like 'Who's Afraid of Red, Yellow and Blue'... and so on. A very stupid thing to do, I must confess. The very simple assumption that painting is not about images, still seems very difficult to explain. A painter should be able to paint with his eyes closed, don't you think?

AS: You want each painting to be seen for itself, but it is always one amongst its fellows. You rarely show them singly. With the sculptures, there is often a sense of openness and change, of forms not being fixed. One of the most engaging aspects of your work is that it allows you to feel involved, that everything is in flux – without the relationships being arbitrary. There is a sense that one is inside the work, rather than looking at it.

PCR: No, I would like there to be no possibility of change whatsoever. When I work I am not aware of the audience. My work is not aware of the audience either.

AS: Does that include you yourself, as a member of your own audience?

PCR: Well, I think I'm the most privileged member of my audience because I'm the only one.

I se it happening before, during and after.

When it's finished, it's gone. Some others will take it somewhere else.

Now and then it happens that some of it passes by in my life once again.

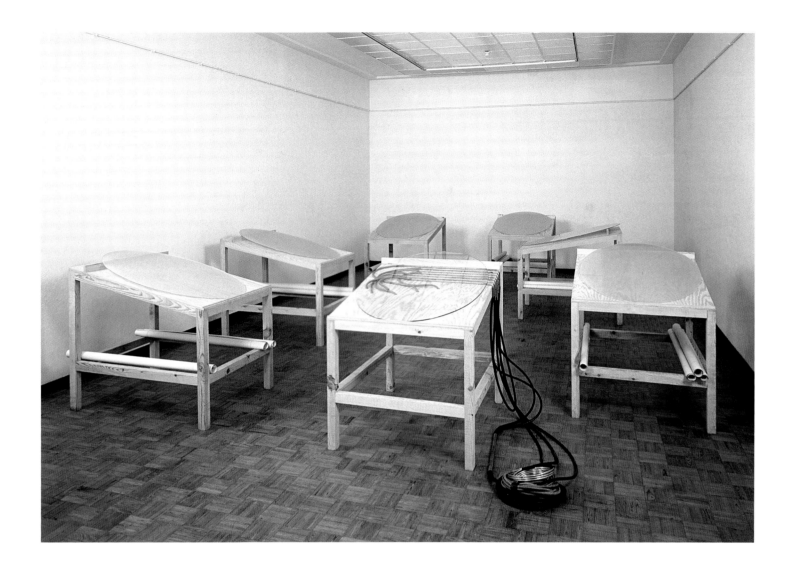

AS: In your sculptures from the mid-1980s there were sometimes forms like wrapped-up figures. There is a sense in which you are getting rid of people in your sculptures, while maintaining a sense of human presences and absences. In your recent sculptural installations there is an apparition of an absent worker, who has built, worked, destroyed and moved on. In an installation in Maastricht you left a nail stuck in the wall, just at the right height, somewhere for him to hang his coat. I found this little detail very poignant.

PCR: I'm always interested in poetry. And there's still the possibility that, after all, my works might be inhabited. You just have to think about the "absence" in them. Like if somebody passed by, like if somebody just left the lights on and went away. Like if somebody forgot to close the door. Or an unfinished glass of water on the table. And if we are speaking here about tables let me tell you that around mine, for wine and food, I rather prefer poets for company.

AS: Who's afraid of poetry?

PCR: Most of the artists I know are. For myself, this is a closed matter, a discussion for others. Poetry is far more important for me than art theory. I take it as a supreme form of language, the most condensed, the most conceptual, if you prefer, the one wich tends most to a desire of perfection. You see, language in a Velásquez is irrevelant, I don't see kings riding horses in canvas. I see brushstrokes, I see colour, I'm aware of the space, I see an artist's vision as opposite to all those big explanations like conrainers full of words unable to achieve the accurate clarity of poetry. It comes before literature, philosophy, criticism. Nothing to do with any mental hierarchy. It's just what it is. I like to read philosophical texts once in a while but I always take it as if it is a visionary writing, like a good religious text can be. It can also be beautiful sometimes but poetry goes beyond all that.

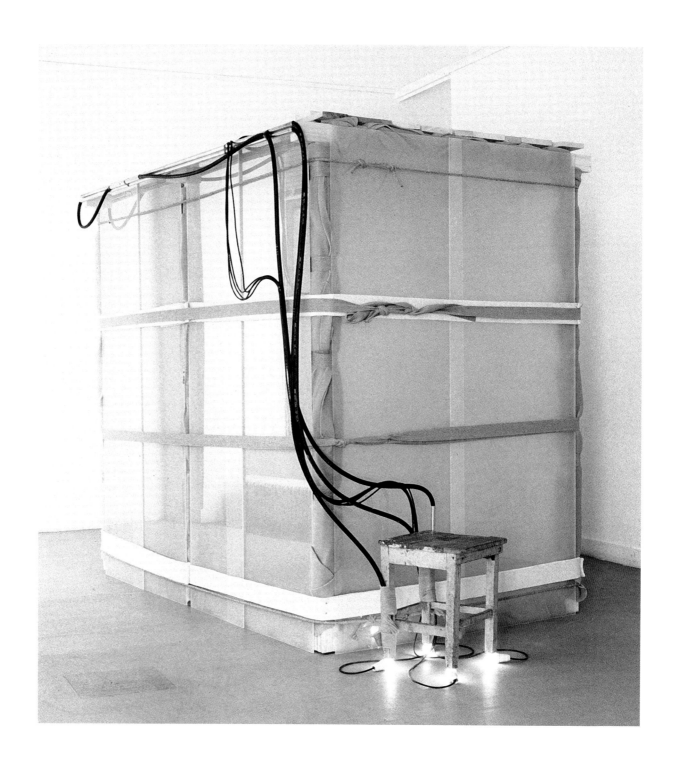

70. ECHO I, 1994

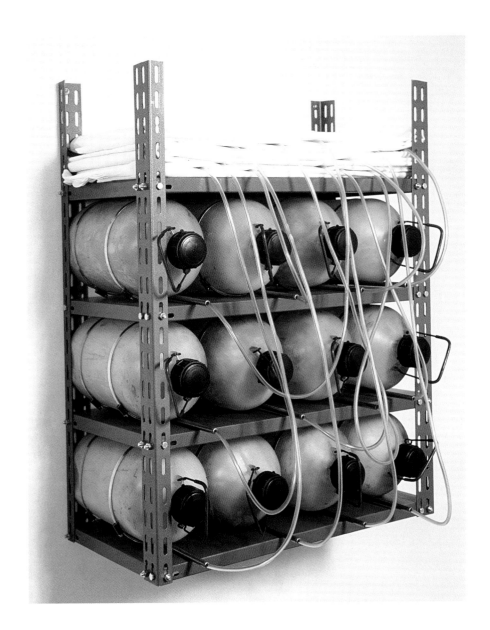

AS: Basic, profound things.

PCR: An artist is an intellectual who thinks with his eyes. A tree can be a figure but also a house.

AS: One of the overwhelming impressions you give, as a man, is as one who takes pleasure in life. In the poetry of simple things.

PCR: I prefer to live a very down-to-earth life. Enjoying ordinary things, not looking down on people. I like the 'Breughel' look of society, this humanly rough 'Breughelian' aspect behind the shiny McDonald's facade. Everywhere a sense of loneliness and there is no way to run away from it even beeing an artist. Somehow and using common words I have always been able to discuss art with the guy who works in the restaurant, even if more often it happens that I can't talk about art with a colleague of mine who I'm having dinner with.

AS: You have said the real enemy is fear and stupidity.

PCR: When I look at all those artworks shaping our existence since ages, it's also about moments of despair, woven together with belief, shaping our existence, giving us back testimony of ourselves but always playing high, one step ahead. How do you teach someone to play tennis? Do you indulge them by playing badly, to give confidence to your pupil? Or should you be absolutely ruthless and play to win, so that your opponent can learn the best from you?

There's a bit of cruelty in all this but that's part of the game. Art was never meant to be nice, it just has to be unique. To enlarge intelligence, and not indulge. I'm not interested in illustrating feelings, anxieties, or little moments of happiness. I bring silence with me into my work. I just want to give people a way for them to listen better to their "sounds" arising from their own "silence". Maybe I could do better. Maybe I could be more "socially engaged" as an artist like many others these days. But if you look seriously the difference between Cimabue and Reinhardt is not that big, is it? We are more or less the same as we were before, maybe just a little step ahead. And none of these two is waving a flag, is it? Small mindness ends in militantism.

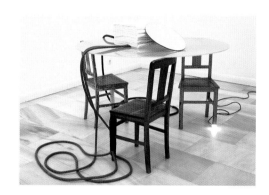

72. **ATLAS COELESTIS I**, 1994

AS: Is it still possible to be an idealist? You sound like one when you talk about your work.

PCR: We can't be anything else but idealists. The mere fact of writing tomorrow's schedule is still an ultimate, desperate, form of utopia. Then at night, when you try to fall asleep, all that darkness that fear of a no tomorrow comes back again. And to escape it either you go for another last drink, or you tune on your TV porno channel, could as well be National Geographic, or you just sit again at the kitchen table and think again about what you have to do tomorrow. Whatever you do, fear is always there.

AS: Does this anxiety feed the work?

PCR: It doesn't feed. It's there, all the time. Has been there before anything else. There's this strange thing I have to tell you about and that keeps coming to me again and again. It's a daydream, a recurrent image: I see myself in all those places I know from everyday life, they're still sunny, you can still feel a breeze but they are completely empty, like suspended in time, as if everyone has died a long, long time ago, and there I am, absolutely alone, feeling completely deaf in a world with no sound, standing still in the middle of the street. I have always thought an artwork could be something like this. Something completely silent, near to nothing, putting the viewer in a permanent gaze. A fragmented perception, where the viewer thinks he recognizes what he sees but he is unable to determine, with precision, the contours of what he recognizes. Leaving him with the feeling that "I think I know this...".

73. POSTO DE OBSERVAÇÃO | ATLAS COELESTIS V, 1994

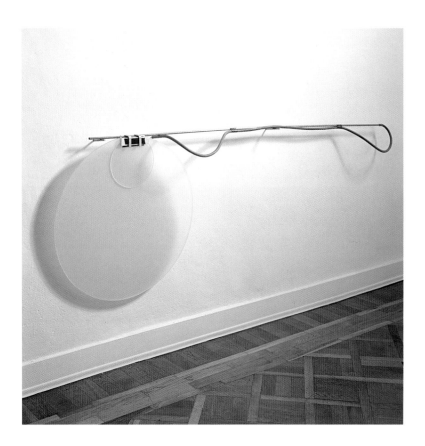

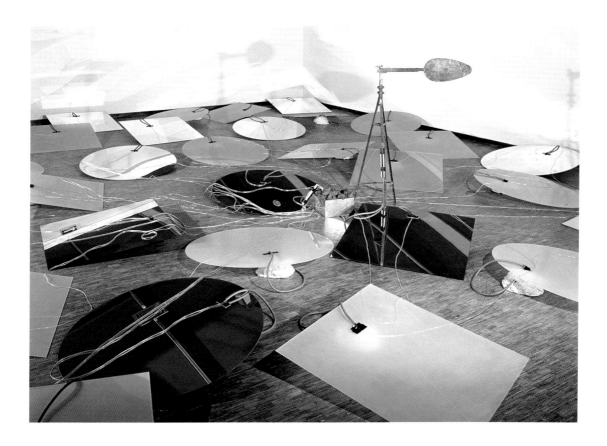

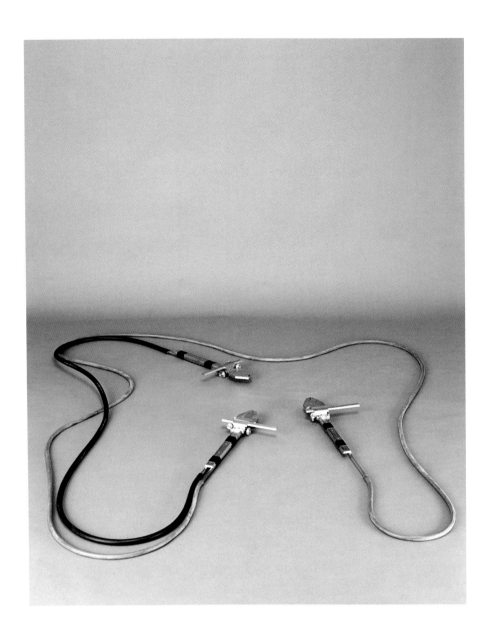

76. INSTRUMENTO PARA MEDIÇÕES NO CÉU, 1994

AS: There's a tendency in some quarters, even amongst artists, to view being an artist as a career like any other. And to make art as a kind of adjunct to the career. As entertainment. Or that making things and making money were the same.

PCR: It comes with the trendiness package. That's not a problem of mine. It's just about self-indulgence, and being tuned or monitored by the opinion makers in the market. In art history, shit like that has always been there. Comes together with the hype. The thing now is that the whole package comes wrapped with the global strategy of the neo liberal capitalism and its wet dream of a society of demented, never ending happiness. It's just the glossy fashion world plus some nasty greasy ketchup spots dropping from the burgers they all eat together.

There is always a thin line which makes the difference and has to be acknowledged. I want to put energy and mystery back into common everyday life normal things and give them back to people. Like it or not the actual word for that is aura. A rather inconvenient word I've been told. But, just look again at Fragonard's "The Swing". It's all about that magnificent, immense instant while the slipper flies through the air, and the time it takes us to imagine every single possible detail about the figure swinging. It's an experience of displacement between an image and a vision. It's a very devious painting. It's about aura.

AS: Well, that's Rococo for you. You could see Jeff Koons as a modern Rococo artist.

PCR: Rococo was mainly an attempt to teach Catholicism to children, and there, there's nothing hidding. There is nothing to discover, just like in pornography. Personally, I prefer to find hidden things, not having them à la carte. No mail orders or catering. In life or in art. I tend to go to restaurants, and engage with the chef talking about what I'd like to eat.

AS: What is the relationship between going to restaurants and pleasure, and, come to that, to pornography, and art?

PCR: It is like this: I wake up and say to myself 'today looks like a very good day to work'. I really want to go to the studio but I have to feed myself before I get there. So I walk the streets. I feel very receptive. Everything comes to me. I take all. I take sounds like I take words. I take clouds. I smell things and I take-in the gradations of light. I take the distractions of the pavement. I fill myself up with all this, I feed on it, then I go to the studio. I hardly ever eat when I am hungry. Eating is not about feeding. Eating is about pleasure. To do an artwork I have to be fed, but while I'm doing it I'm eating.

77. REPORTS #1, 1994

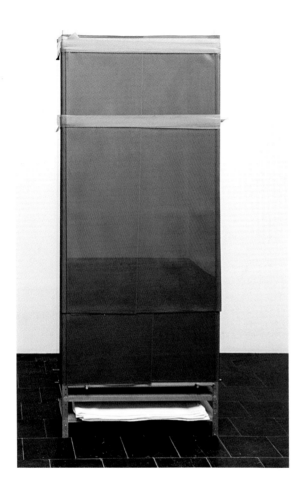

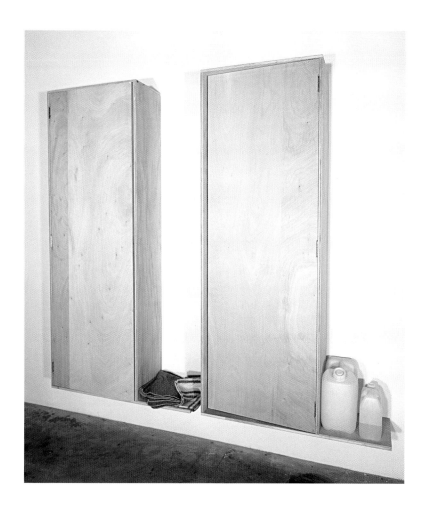

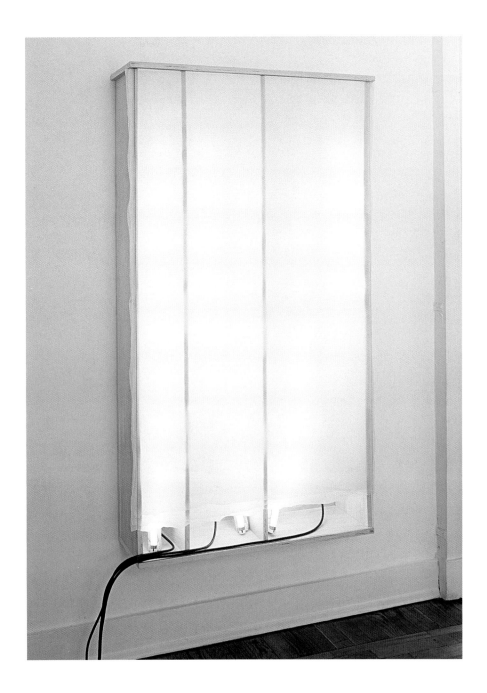

AS: I remember going to your studio once, and we were delayed on our way there. In fact, we were delayed for two days. But at this point, just as we passed a little cafe, the owner was just at that moment laying out a dish of cooked pig's feet in the cafe window. At this moment a silent question proposed itself – I saw it in your eye – Do we go to the studio or do we investigate this dish of pig's feet?

PCR: It was clear that we were not ready yet to go the studio. That was the question. I just take physical pleasure as a reference both in my life and in my work. I walk around town and I can translate a fragment of a phrase overheard between two girls on the sidewalk into a work of mine. I just grab at a snatch of conversation, but it achieves the grandeur of a declaration – the sound of the words, the context as they're walking by, the smell that they leave behind them, me looking ahead at the next thing – I take all this as a mental sketch book and use it to work with as well as I use all that disparate stuff laying in my studio floor. Gathering those images, those memories, those sounds, those things again, and again, and again…

AS: Having to perform again and again? For yourself and for the others – your audience, the curators, the critics, for people like me?

PCR: Absolutely. That is life, after all. That's the shadow of the others we keep looking through.

AS: Maybe artists are just better witnesses. A politician doesn't witness an age – he feels like he's enacting it.

PCR: Artists shape the world. Not as individuals, but in what we do. A politician with any political philosophy or anyone enacting an exercise of power is always lacking perspective. They just have an agenda. Artists just have time. ■

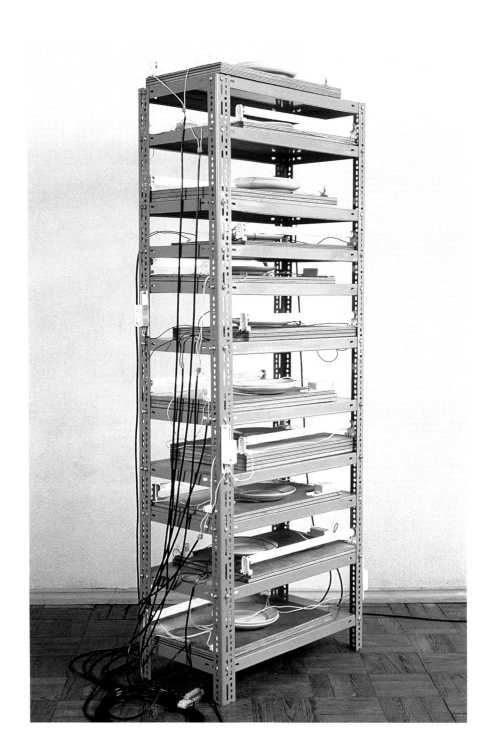

81. **ROOM**, 1995

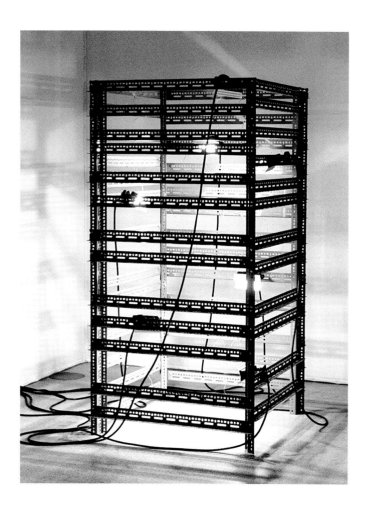

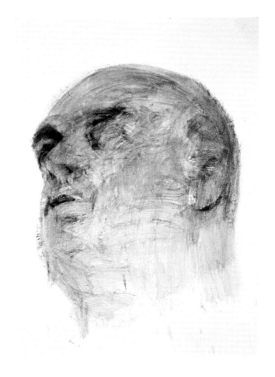

84. LOS CIEGOS, 1st series #1, #2, #3, #4, 1995

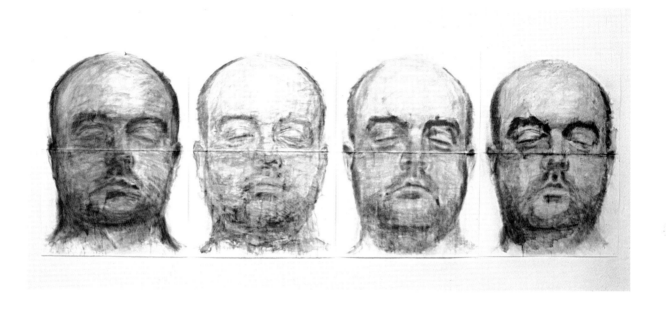

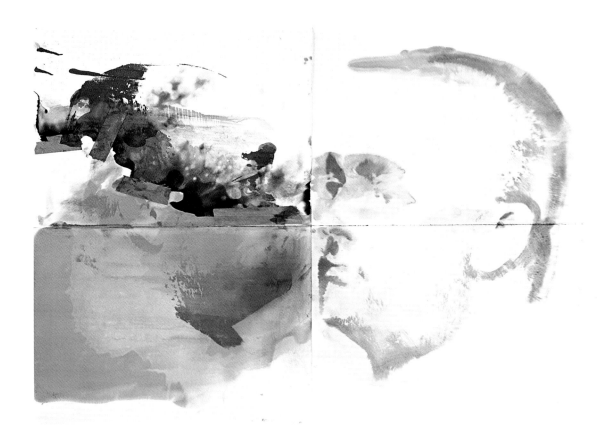

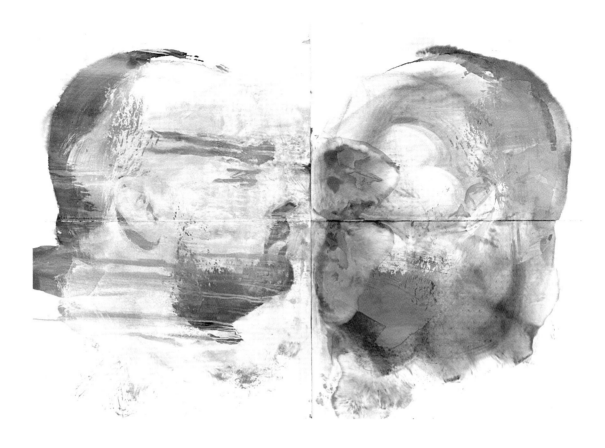

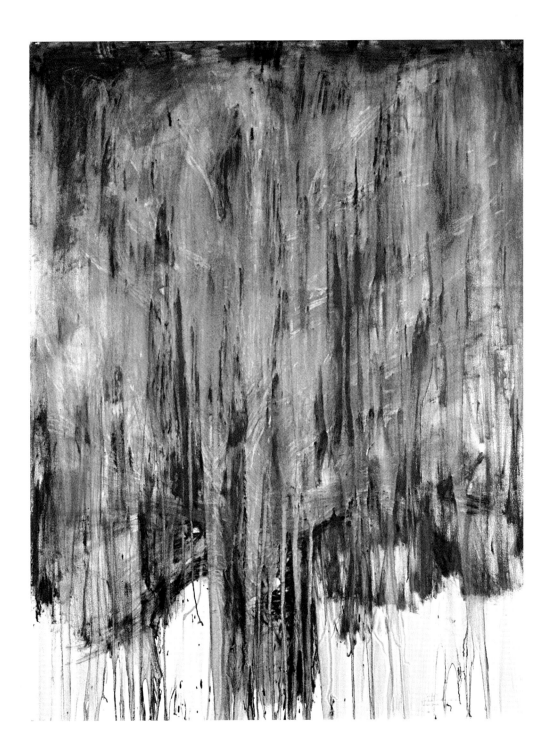

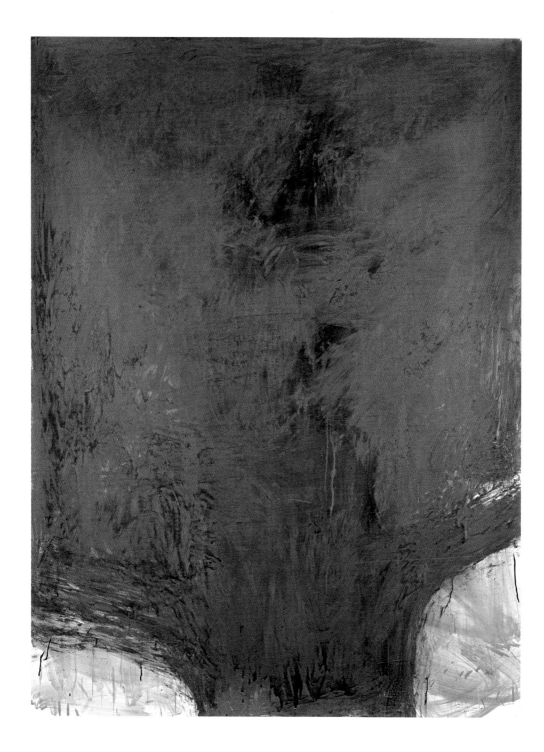

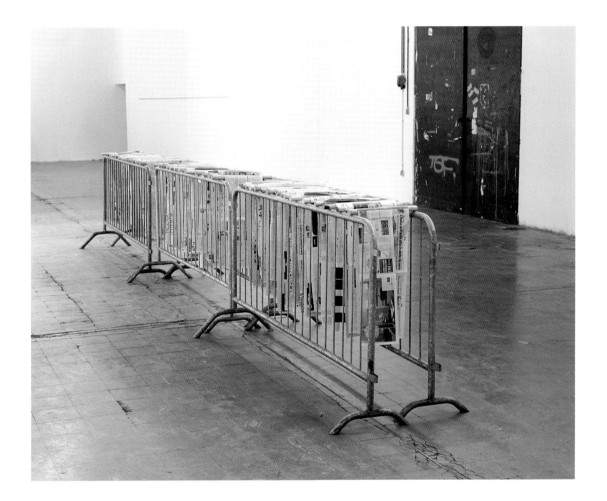

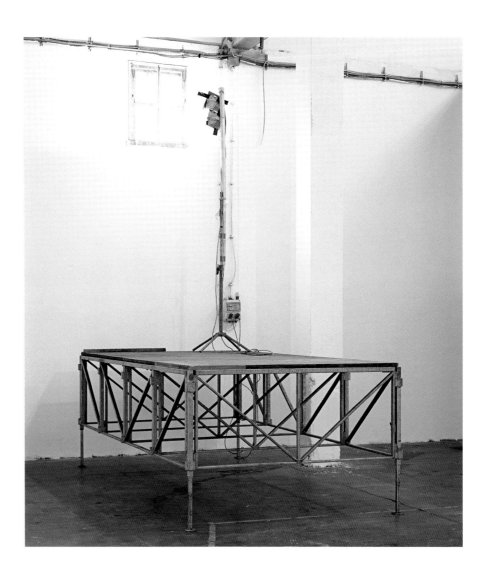

VOCABULARY EXERCISE FOR A DISCOURSE ON METHOD
JOSÉ M. MIRANDA JUSTO

MURMURING | In 1991, Pedro Cabrita Reis put on exhibition his work called *Conversation Piece*. Exactly ten years have gone by. Of course nobody has ever heard any of the words in that conversation. But it is still possible to *listen* to it, to listen to the endless murmuring. One could say it is "the Rustle of Language" in the absence of words.

SENSES | It is well known that PCR's work always deals with observation, i.e. with sight, hearing and touch. It involves capturing, apprehending, affection (as philosophers used to say centuries ago). Yet... Sight, far from being only a gaze, sight is a watchful eye in the middle of the night. Hearing is straining to listen in an overwhelming silence. As for touch, it is that of the blind, of clairvoyants; it could be said to be a Homeric groping. Therefore, without a doubt, what is involved are the senses. Nevertheless, it is not enough to say that the senses are involved because PCR, in fact, deals with problems to do with efficiency – building, understanding, orientation – which use the senses as a metaphor of the method (or of part of the method), although always by means of a hyperbole.

DISPLAY | The hyperbole of the senses involves at least three possibly superimposed layers: a sharpening of the senses, an intelligence of the senses and a display of the senses.
Let us see a little of what happens with what I call the display of the senses – for want of a better term.
Firstly, displaying the senses means neither harnessing the senses under a topic nor simply exciting them. For example, *Conversation Piece* displays the possibility of hearing what is, in fact, not heard so that we may hear what the noise at the surface of the words stops us from hearing. Thus, it is not our ear that hears. Rather, it is our intelligence that listens by means of displaying the auditory metaphor. Or, for instance, when PCR brings into play light, colour, reflection, or, in other words, looking, it is not precisely that the eye is excited but that the intelligence of looking is called upon by means of displaying the metaphor of looking. All this naturally demands a methodology of display, contrived in the strictest sense: bringing things into play, or rather placing tensions at opposite extremes, concentrating upon the essential, but also de-contextualising and duplicating the world diagrammatically. A diagram of emotions and a diagrammatic of the senses.

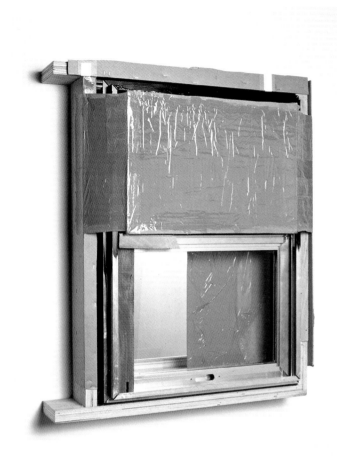

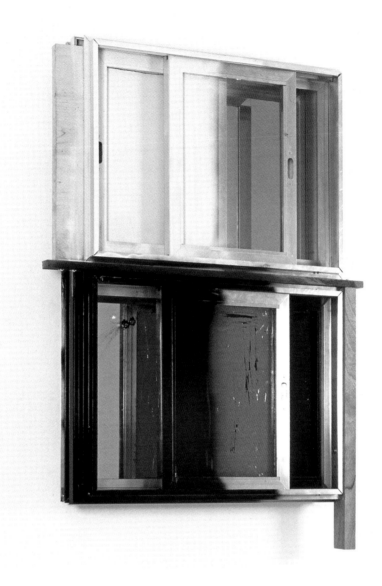

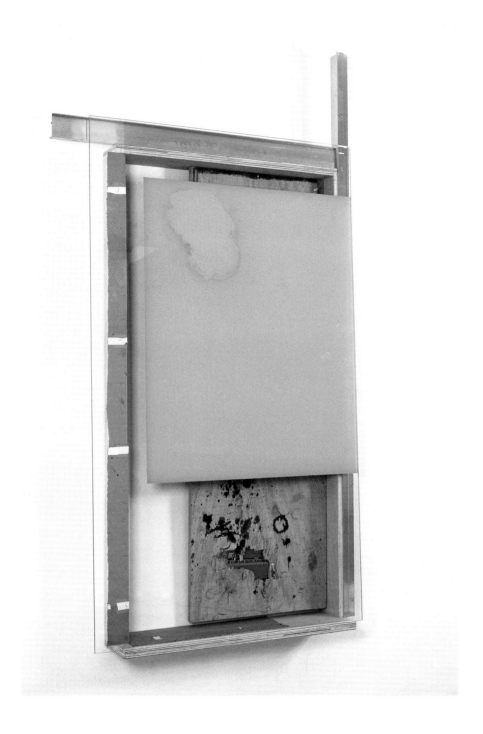

94. **A COR DA QUALIDADE**, 1997

DETOUR | Is the same black paint, on one or the other side of a glass pane, still the same black colour? Of course not. Our eyes know this. Our eyes tell us that the same is something else. That the same is a species of the other.

The intelligence of the senses works through this kind of knowledge that causes a detour.

SHARPENING | If a light shines from deep within the ground, from within open furrows in the floor, we say it is a sharp light. If a light shines from fluorescent tubing heaped in a corner of a doorless corridor, likewise, we say it is a sharp light. In both cases, though, what we say is arbitrary and unwarranted. Nonetheless, once the sharpness of light has been pronounced, it fits into these displays of light quite well.

Whereby we may conclude that it is not the light that is sharp, but the idea of sharpening which has made the light sharp. A certain light.

The same thing happens with the senses.

GARDENING | Flowers and gardens. We need to intersect two concepts here: amplification and striking. Once again, in both cases what they entail is duplicating and transfiguring.

Amplifying to the extent of making only the invisible of a "flower" visible. Or rather, an inner, fleeting darkness. If the departure point lies outside the process, then the process is one of inclusion. Striking of an angle. Projecting a vertical over a horizontal. Coloured glass striking a space specially prepared for the effect. If the departure point lies within the process, then the process has a multiplying effect.

The quest for totality is achieved by intersecting inclusion and multiplication. At least sometimes. Very often.

POET | House shade tree brick wall door window. Just like that: no commas, no hyphens. Exact juxtaposing in which previously established rules are limited to the barest minimum. The sparseness of rules is the method. The method – as poetic knowledge, or rather, as knowledge that makes, that carries out – is then bestowed with the maximum rigour: prescience and circumspection.

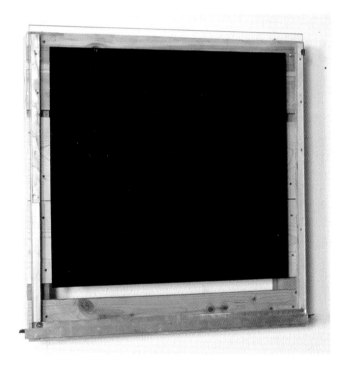

ALMOST | Parallelisms. There are many of them. But even so, it is always a quasi-parallelism of the parallelism that matters. It would be appropriate to deal with this *almost* as being a rigorous operation.

DUPLICATION | Duplication and parallelism. I am a little perplexed about how these two aspects of the method are articulated.

One could try to establish a sort of pendulum swing between the two things. However, this seems to show a very narrow understanding of things. There is so much of the obstinate, the intentional or the final in this work that the idea of any back-and-forth swinging would always be too precarious. If it is to help at all, then it would always be as passing concept, something provisional. Strictly speaking, a provisional concept is no concept at all.

Perhaps this forces me to think about parallelism as a kind of echo of the duplication itself. Or maybe the parallelism at the level of presenting/exhibiting as a counterpart to the duplication at the level of appropriating/building. But therein lies the risk of applying a grid of symmetries (or dichotomies), which I most certainly cannot do to this work. Assuredly:

(a) duplication is asymmetrical;

(b) parallelism is asymmetrical;

(c) in PCR's work, giving and receiving (giving to see by making the object, and receiving on the part of the one looking at it) coexist in radical asymmetry.

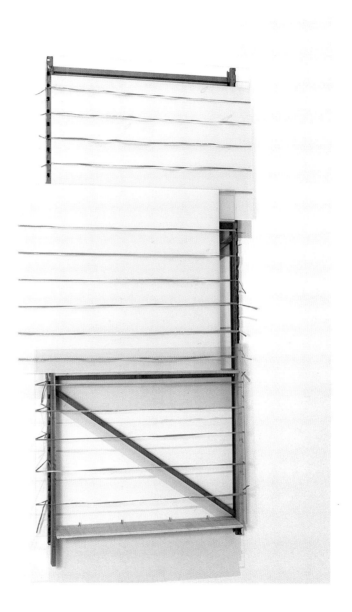

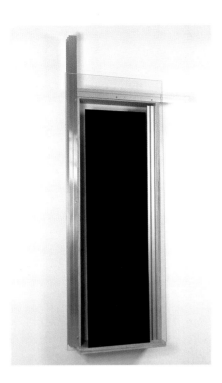

97. JARDINS #2 (PRETO), 1997

GIVING | I feel like calling this last asymmetry, the asymmetry of generosity. From a hermeneutic (romantic) perspective, the reader is always far better equipped than the author. (Only thus are we able to understand that later on the author is absent – or dies. Etc.) What happens here is completely different. The author, the subject of the conception, of the constitutive action, build-up and production of the piece of work is the *giving*… He is not even the giving person. It is giving itself that makes the object. This being the case, it is also the act of giving that makes the person – which is only relevant to the extent that it makes the person part and parcel of the work of art. Not the Duchampian life constructed as a work of art anymore, but – more radically – he person becoming part of the work of art. Better still, as we shall see: the person as a species of the gender, which is the work of art.

As for receiving, far from entering into any symmetry with giving, it would always be infinitely less than such giving. But only insofar as the one who receives is not completely transformed by means of yet another giving. His own.

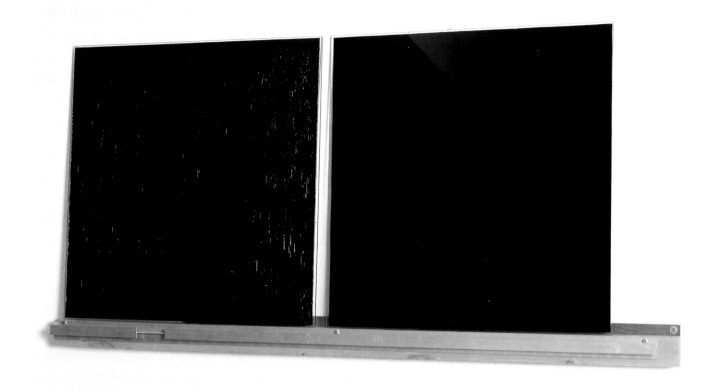

98. STUDY FOR "DOBLES PINTURAS NEGRAS", 1997

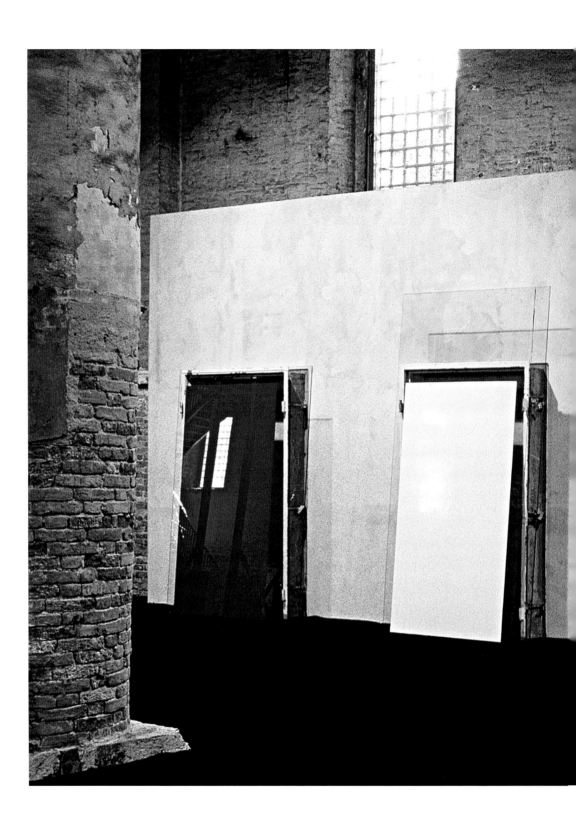

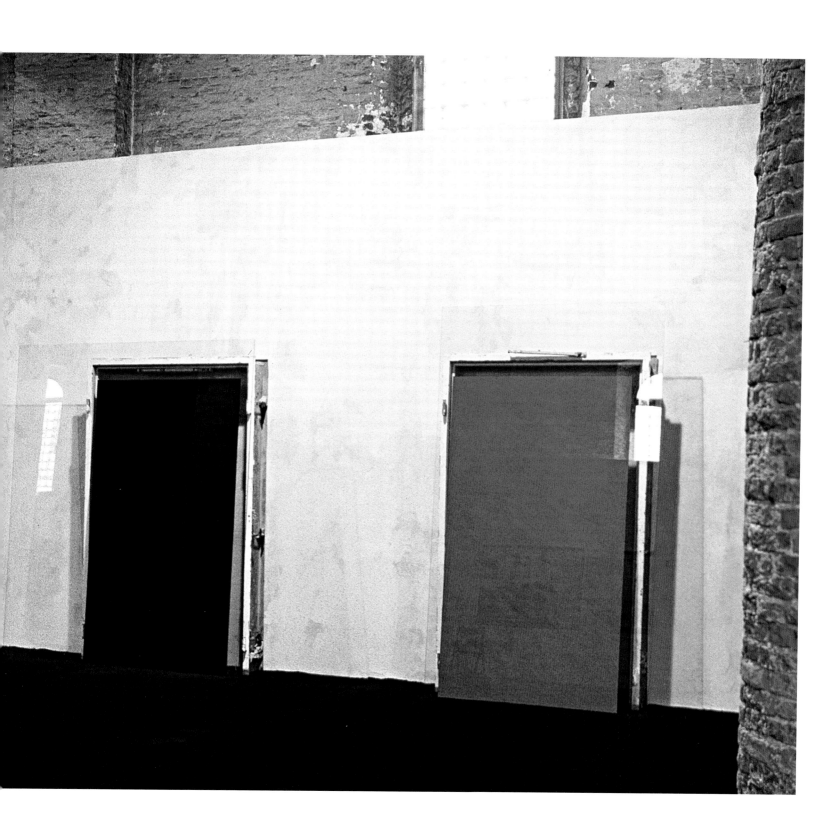

100. 101. LA CHAMBRE DE PÉTRARQUE, 1997

RECURRENCE | This being the case, obstinacy, intent and finality are, primarily, inherent to giving. They are not even characteristic features of giving. Strictly speaking, they are modalities in which the giving is manifested .
There is, therefore, a *teleology* recurring in the giving.

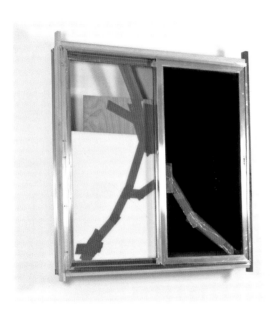

102. **ESTRADA DAS LÁGRIMAS**, 1997

DESTINY | I intend to come back to this question some day. But for the meantime, I can formulate it thus: when giving enunciates itself, it may only do so in prophetic language. As a result, giving is destining. There is, therefore, a *theology* inherent in the giving.

FRAGILITY | Two chairs. Side by side. Both covered. As if their occupants have been away for a very long time. Forever, most certainly.
On either one of the chairs, and placed on the cloth dust covers, we have two plaster-of-Paris parallelepipeds. Placid, inert, the two aligned blocks take on the shape of a long wait, an emptiness, a sort of pure place. A geometrical configuration, nevertheless fairly transitory, perhaps indifferent to what may eventually be inscribed on them; therefore available, like pieces of blank paper.
The two chairs stand, a little aback, on top of a sheet of glass. Unlikely, on this fragility. A copper tube circuit is partially visible through the glass, suggesting that some liquid or gas could flow between the two places. As far as we can make out, the circulation system is organised by means of a set of different sized parallels between the segments of the tube.
The amount of descriptive detail contained in the method is variable. Its exact measure in each case is given in the efficient working of the metaphor, which is achieved with the description.

103. NEW YORK RED AND BLACK WINDOW, 1997

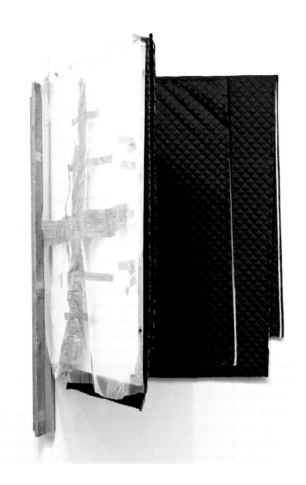

104. IL LIBRO, 1997

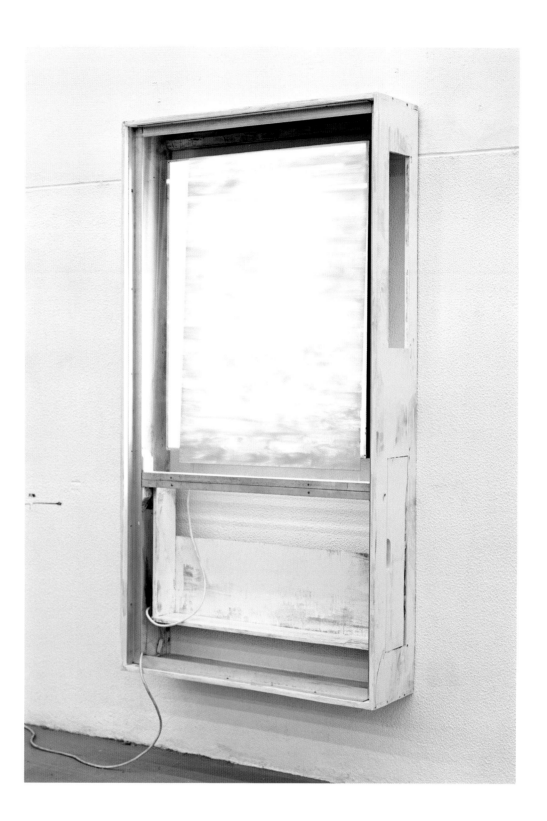

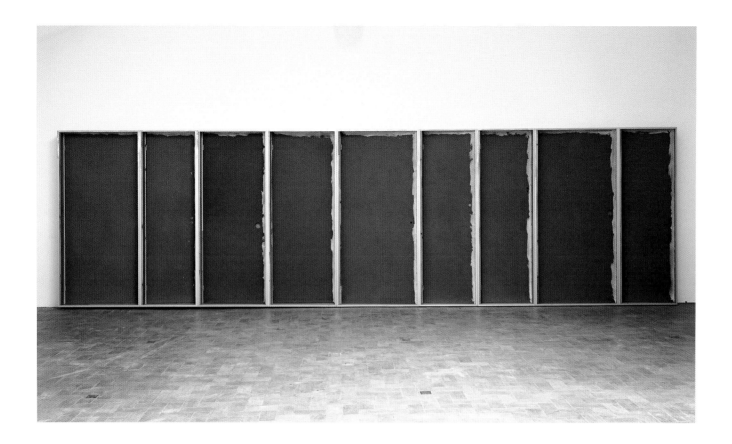

106. DANS LES VILLES #1, 1998

138

COUNTER-SENSE | When approaching these objects, the eye needs to follow a sequence in its viewing. For example, yet once again, in *Conversation Piece*. When we look at this composite object, when we turn our attention to it, we are unable to take everything in at one sweep of the eye. At one time. There is no place here for what in traditional philosophical terms was called the "immediacy" of an "intuition". It is inevitable to start with the chairs, move on to the plaster-of-Paris blocks and then right afterwards look at what is happening below. From then on, we are in a position to see the object as a whole. But not before. If there is any "intuition" – as I once wrote – then it is an indirect, discursive intuition, an intellectual intuition, which would act as counter-sense to the classical, enlightened theory of knowledge. PCR's work and thought deliberately deal with this kind of counter-sense. Or, better, they deal with what the identification or the diagnosis of such counter-senses are unable to capture, unable to see or understand, unable to show. For instance, a sudden, fleeting intuitive flash whose very existence, nonetheless, is the outcome of a process of multiple linkings in time.

UP-TO-A-CERTAIN-POINT | There are three layers. Up to a certain point they overlay each other. Up to a certain point they interact. But only up to a certain point. And afterwards, afterwards there is the parallelism. Cutting through all the layers. *Nota bene*: when you manage to understand the parallelism and the up-to-a-certain-point perception at one and the same time, you will have discovered the principle governing all the diagrams.

MACHINES | I like thinking about these objects – *Conversation Piece* and many others made during the same period or even ones coming much later on – as if they were machines. They are made up of parts, all scrupulously calculated, fitting in to each other, having circulation tubes and power sources. They have intermeshing sub-systems in a workable, rigorously efficient whole, irrespective of our knowing whether or not they produce anything more than what they are as machines. True, they are silent machines but it is precisely because they go against our immediate grasp of them, that they are discursive. They move. Obviously, they move because our intelligence refuses to allow them to stand still. But they are the ones demanding movement from our intelligence, they are the ones, in a manner of speaking, which begin working as soon as we walk into the room, when our gaze falls upon them and refuses any state of "contemplation".
If they work, it is because each part is a metaphor, each sub-system is a metaphorical field and the combined whole is a self-sufficient system enabling the transposition between metaphorical fields. Even when – as is the case with some of the most recent installations – everything seems to happen in a strictly sensory way. Mainly there.

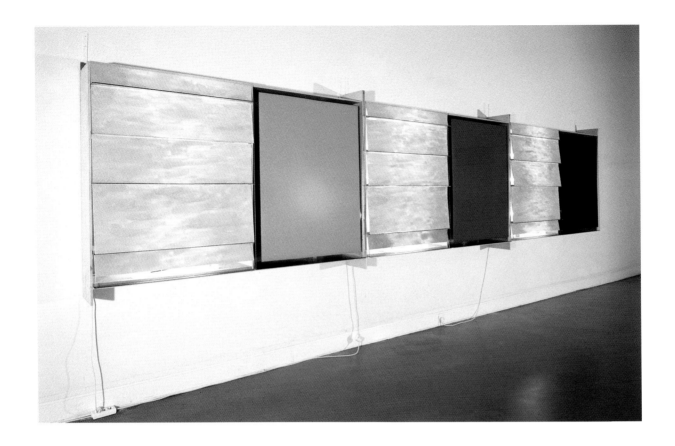

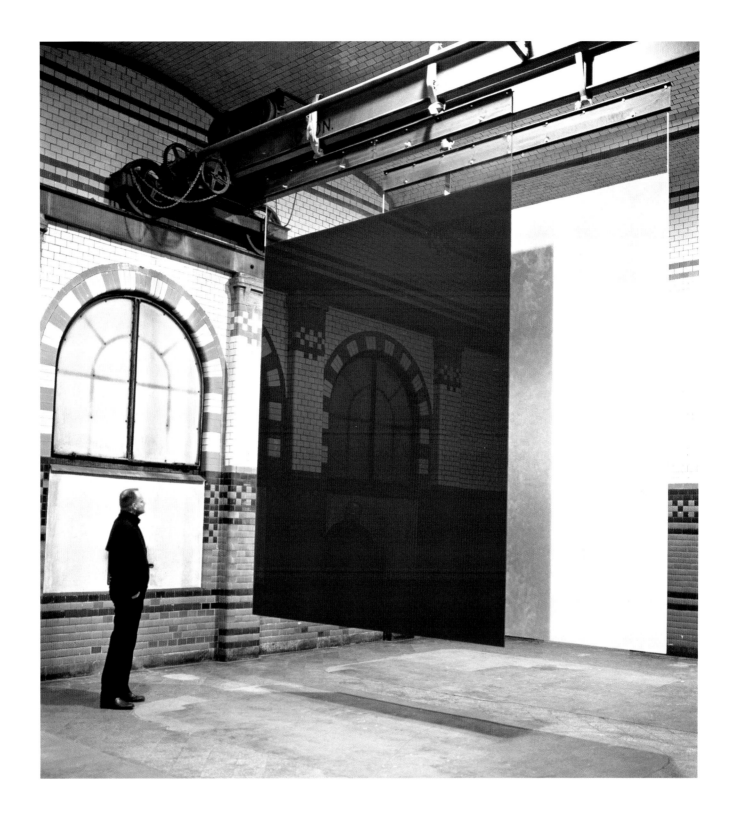

108. LARGE GLASS, WHITE AND RED (STOCKHOLM), 1998

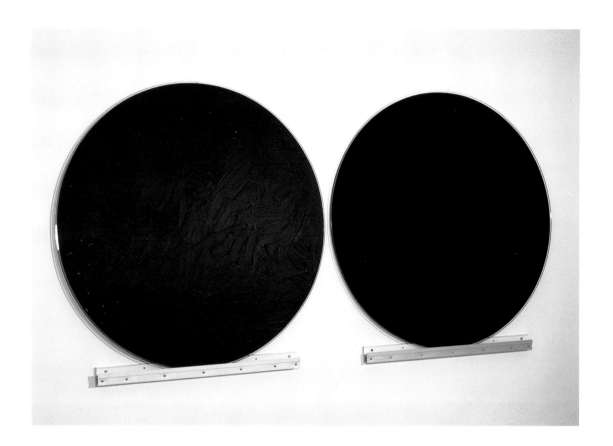

METAPHORS | PCR realised a long time ago – as any poet-poet would – that metaphors are not second-hand images, images of this or that, which could be said in another way, for example, telling a story or putting forward a theory. Metaphors are a way of getting us to come face to face with something unknown, with access to meaning, with the hunger and thirst we have for meaning overwhelming us and making us strive for what lies beyond all reasonably clear knowledge. (Everything begins with this "wound", as PCR has already said and written several times, quoting other specialists on wounds, gashes or fissures and on healing and suture.) Metaphors are transpositions, it is true, but not of the known to the known. Sometimes they are from the known to the unknown. At other times, they are from the unknown to the unknown. Whatever the case, what matters in the first place, is that they are effective in producing obscurity. As regards each of the three layers in an object such as *Conversation Piece*, therefore, the question does not fall into the category of: what are the chairs, the blocks and the tubes a metaphor of? The relevant questions to ask would rather be of the type: What discomfort is caused in me by the metaphor about absence? Or silence? What is this strangeness I feel, being struck by a metaphor about fluid communication that nevertheless runs silently, wordlessly underground? What unlikelihood do we have here that hangs two chairs in space? What kind of frailty or fragility is this, connecting them? What displacement of worlds is this where the

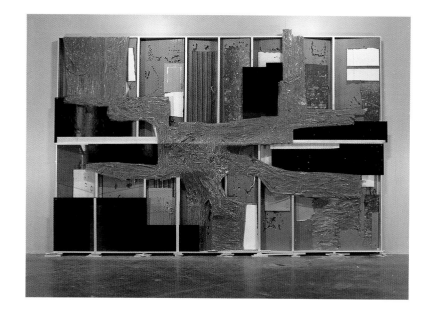

words I have at my disposal do not seem to make any effect? What sort of disparity do I perceive between the order I use to regulate my affairs and the order I am unable to read? What darkness has fallen upon me when only a moment ago it was daylight? And what steps will I be taking in the morning?

Diacritical note: It should not be forgotten that: the relevant questions are not nostalgic. It could be said then, as a corollary: there is a type of joy specific to melancholic questions.

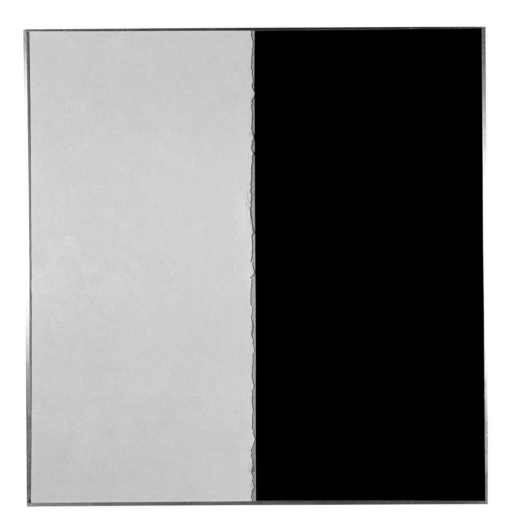

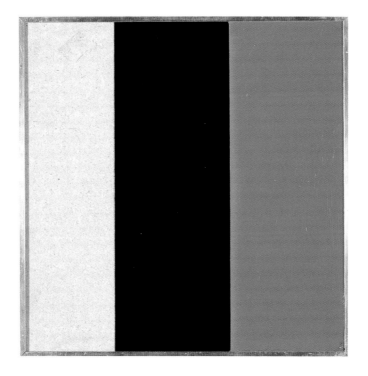

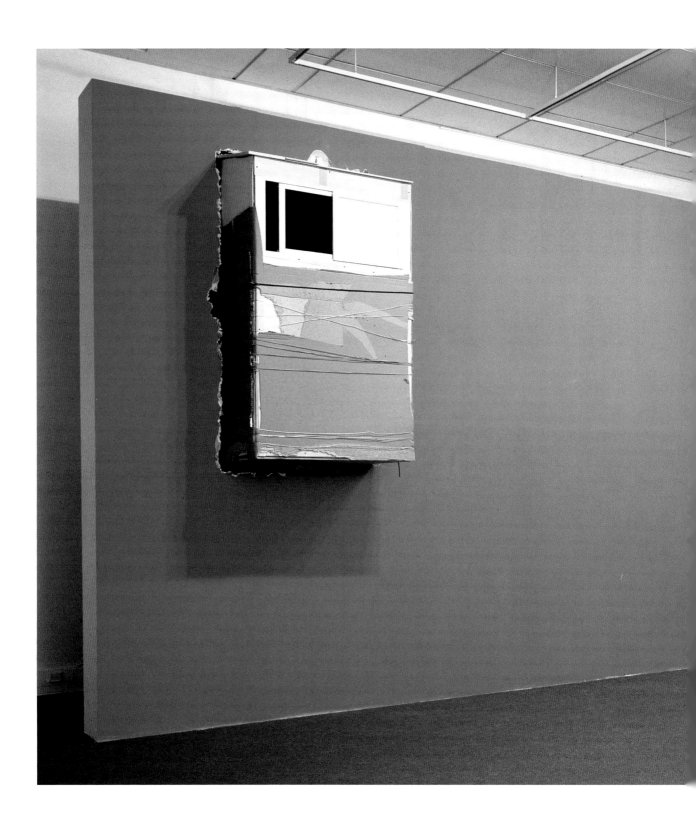

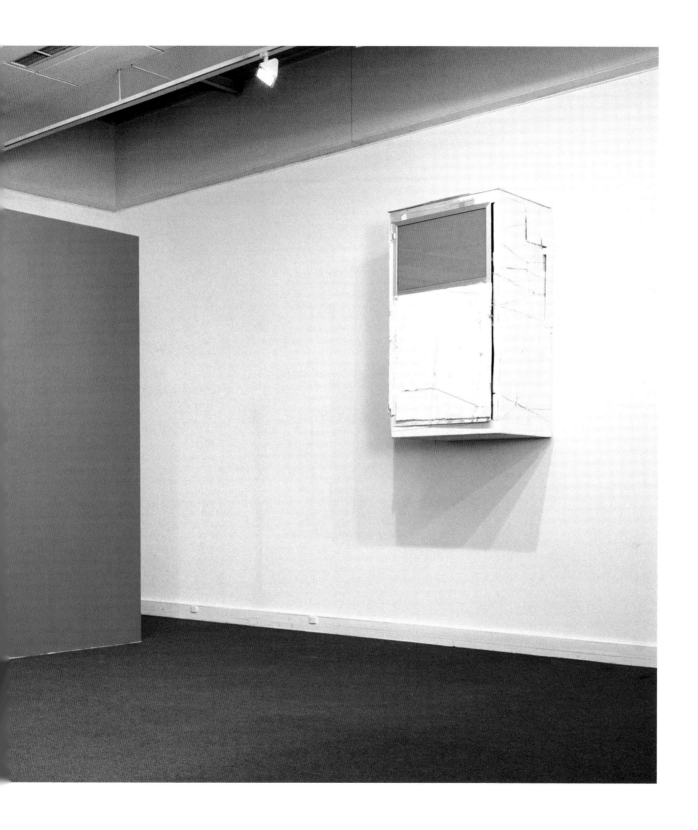

DUPLICATING | Everything is so near to be what it seems to be. Therefore, so close to being nothing. Tables, chairs, houses, rooms, staircases, wells, brick walls, sheets, tubes, lights, windows, doors. And the tables are tables, the chairs are chairs, the brick walls are really brick walls... and so it goes. There is no doubt that all this involves a duplication of the world, a repetition. The question is finding out whether the repetition in this case is fundamental. Or, on the contrary, merely a means. And if it is a means, to what purpose?

There is a more obvious side to it. Duplicating, repeating the world is precisely the opposite of representing the world. Representing something is creating a sign of the thing that is presented instead of the thing itself. When you decide to duplicate something instead of representing it, you are choosing a different paradigm. And in choosing this paradigm you displace the break-off point with the world. Representation – despite the way semiology usually sidesteps the issue – has always been basically iconic and possessed of a political nature: it cuts itself loose from the represented object so as to hide the representation behind a mask and allow the represented object to be used, thus becoming an exercise in manipulative power. It has been this private power of representative images that has always infuriated the iconoclasts. In opposition, when it comes to repetition, there is no break-off with the object itself but rather with its functionality. The object's primary use is stripped and the object is exposed to a kind of functional nudity: it keeps a functional significance (or the memory of what is signified) but loses its use. Upon losing its use, it becomes open to other uses. The metaphor may only really work as from this point. A diagram is then defined in the following way: duplicating an object according to some modality of functional nudity.

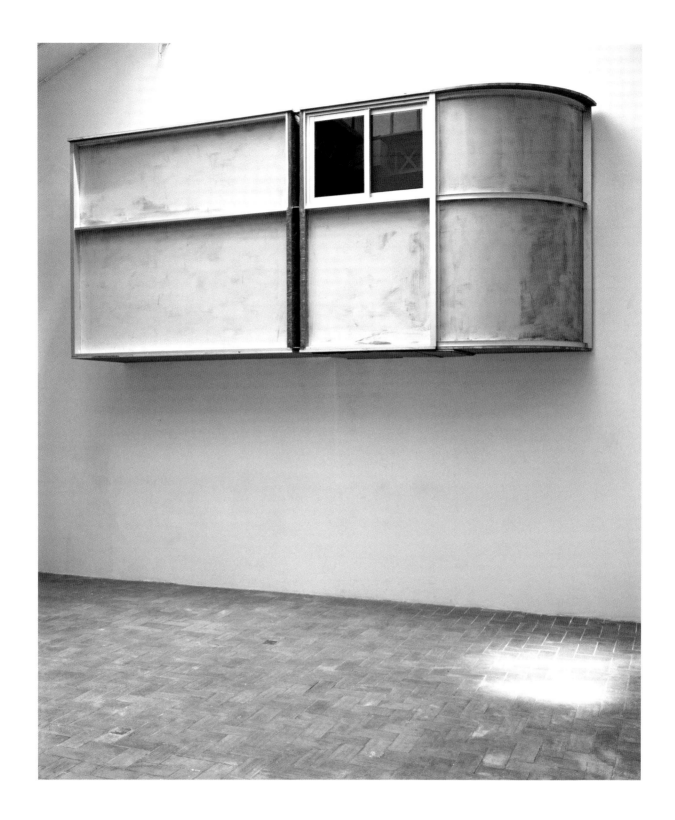

114. DANS LES VILLES II, 1998

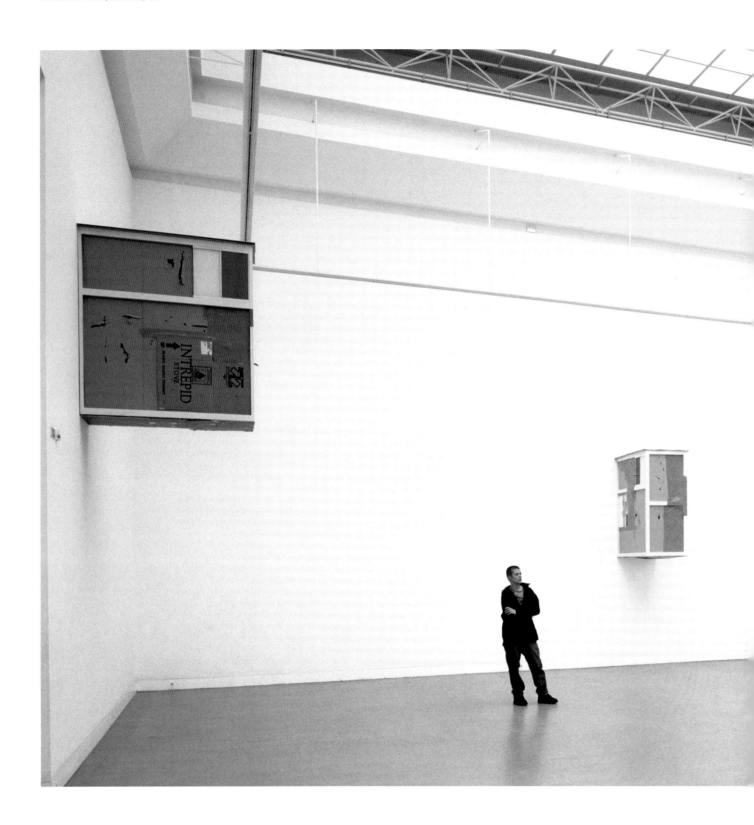

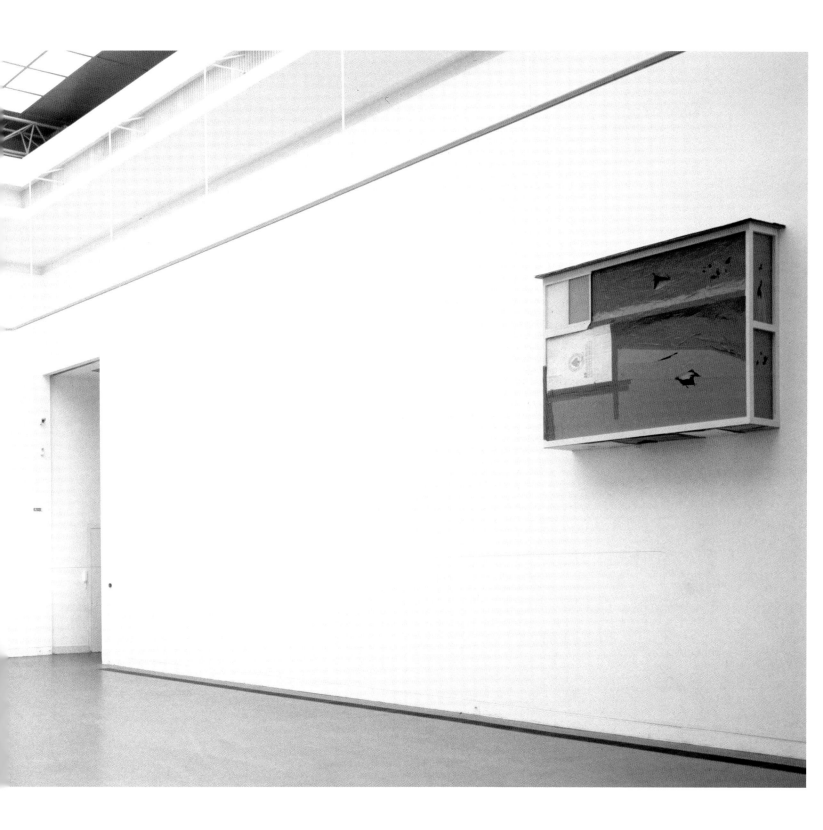

116. LINEA DI TERRA #2, 1999

117. LINEA DI TERRA #4, 1999

CELEBRATION | As for the iconoclasts, it is worth remembering that they are iconoclasts for two different reasons. On the one hand, they replace the representation by the exclusive nature of the celebration. On the other hand, it is because they hate everything large, whether it is applicable to size or time. We need to think about a celebration capable of loving what is large so that we may understand how an iconoclasm of giving may be possible.

ORDER | Because we are dealing with method, any kind of ordering is acceptable. Demonstration at the first level: if the method is a totality, any one of its components leads to this totality. Demonstration at the second level: if the method obtains a totality with the chaos it – supposedly – emerges from, any of its ingredients provides a sufficient enough picture of the totality of chaos and the method.
Demonstration at the third level: if the chaos is a retrospective construction of the method itself, any suggestion of disorder, of chaos, is merely a pale, far-off picture of the immeasurable productivity of the method. Corollary: The distance, the paleness, are qualities, not of the method or the method's discourse (the wordless discourse pronounced by the method itself, or as we have seen, pronounced by the *giving*) but of the discourse on method, i.e. of the words.

MULTIPLE SYNTAX | However, in losing function, another possibility is also offered. It involves articulating objects, which in their normal current uses, have no relation to one another. In other words, the duplication – or reiteration – of the object provides the chance to set up open-ended systems of syntax. The metaphorical machines are multiple syntax true to this type.

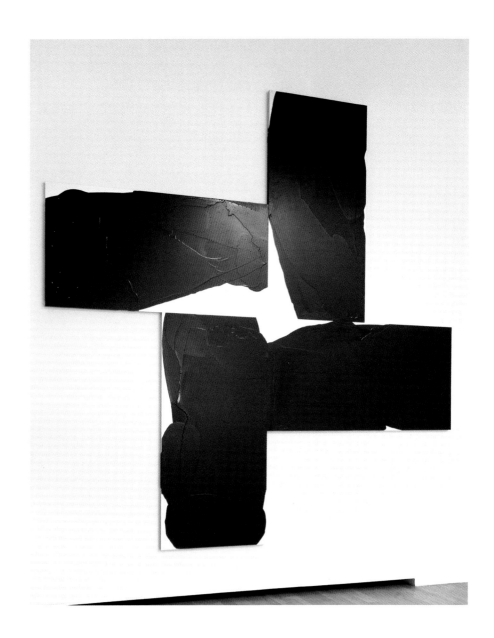

118. FLOR NEGRA, 1999

MULTIPLICATION | The most intriguing thing about this process, however, lies in another aspect. Because they are not symmetrical processes, the representation and duplication do not affect each other in the same way. If the representation makes its reappearance during the process, it is drastically affected by the duplication. Some say that representation is inevitable, that it always returns no matter how you wish to get completely rid of it, no matter how badly you want to clear the ground for pure pictorial (or musical, etc.) "abstraction". I have certain reservations about these assertions, about the essentialist (if not mentalist) vein in which the issue is addressed. I prefer handling concepts and ideas in a less ambitious fashion so as to be able to understand how a work of art – itself – may become radically ambitious. I therefore prefer thinking about whether the representation will reappear, not always (owing to some kind of psychological duty), although sometimes, perhaps quite often. And when it reappears, it may indeed do so because not enough attention has been paid or because atavistic forces are at work, but it may also reappear because of a need to include everything, or not to exclude anything. It is this desire for totality – from the perspective of the work of art itself – that theorising has no right to subsume under universal or anthropological categories.

I am thinking of PCR's "self-portraits", of some of his recent "landscapes", of a certain "bird" collection and also, perhaps, of his "flowers". I am mindful, above all, that such work going back to representation cannot be seen separately from what has been a prolific multiplication of the directions his work has taken – or from the "languages" he has used, as one would tend to write in a more pedagogical manner – mainly over the last ten years. I see various plausible angles of reflection in this multiplicity: not only the desire for totality, but also the game based on certainty, the question of the difference-indifference of means, the move towards de-compartmentalising things, the building of a centre-free centre.

SIMPLICITY | The desire for totality has various facets. From incorporating languages to reconverting history, from capturing daily objects to capturing the heart of personal signs.
The method goes like this: unfolding itself *ad infinitum* so that it becomes simple. Infinitely simple.

RUINS | Every time they appear in PCR's work, his ruins seem to be neither chance occurrences owing to an accident or damaging, nor are they the mere result of passing time; and neither are they the simple decayed vestiges of a splendid past which he would like to evoke or recall in some way. On the contrary, it becomes quite clear that his ruins are a conceptual instrument, a mental tool, and make an intricate part of his working methodology. Archaeological material, without a doubt, but something that may only be understood as some kind of archaeology of the future. Or even more succinctly put:

the archaeology of a timeless time. (In fact, the Greek concept of "arché" may only be interpreted out of a time context!) As a methodology, the ruins are the real departure point. Or rather, they are far from being the traces of another departure point, lost in time, rooted in the past, where they have to be rebuilt, re-interpreted, restored to what they once were or what they once meant. They are a diagram, a project, which provides a beginning. It is useful to develop this idea much further: ruins allow us to start from zero. But this zero is not nothingness. More than anything else, it is not a feeling of emptiness. It is a

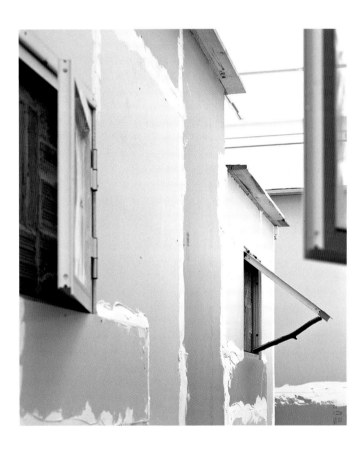

119. **BLIND CITIES #6 (BÜRO)**, 1999, detail

120. **BLIND CITIES #6 (BÜRO)**, 1999

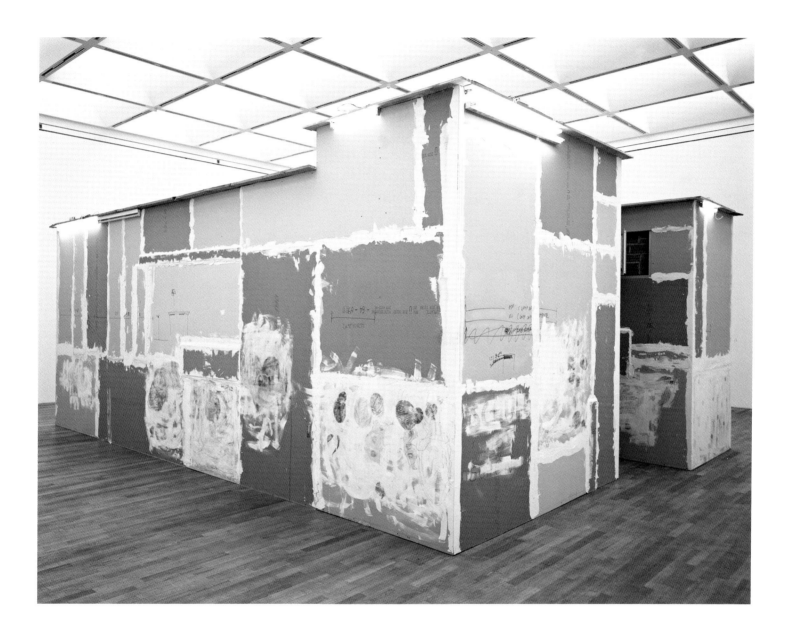

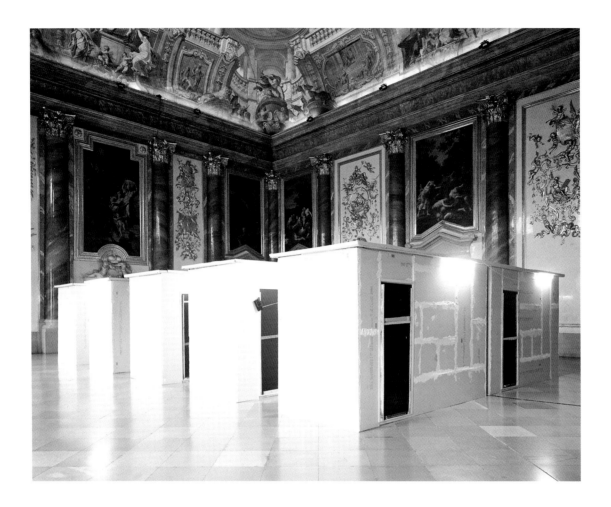

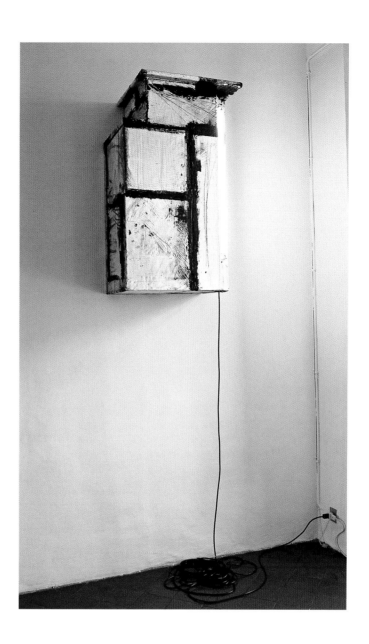

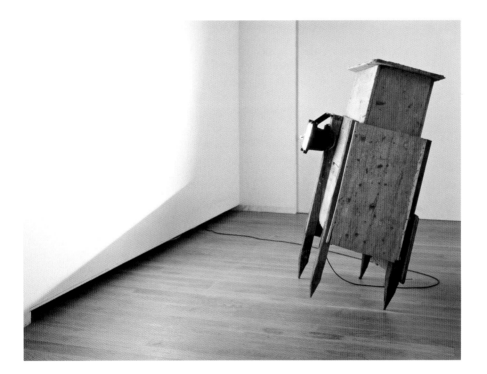

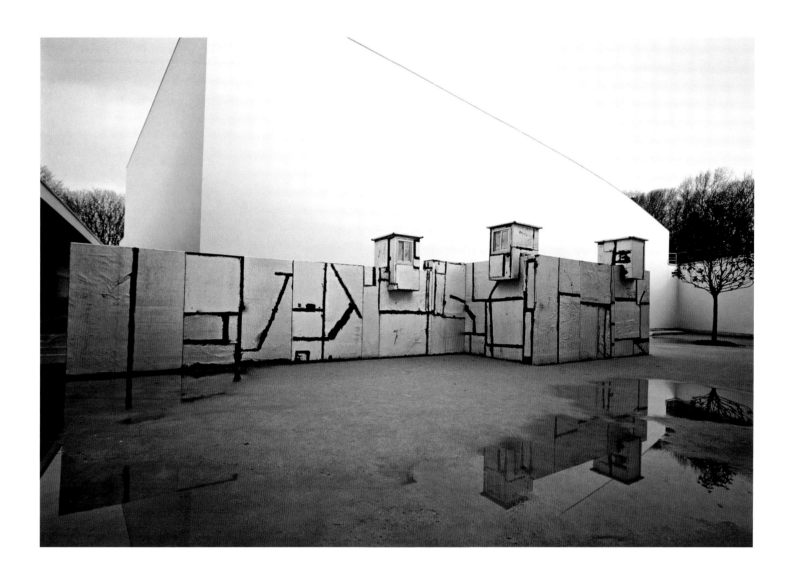

mathematical zero, it is the sort of zero that is called the origin in a co-ordinated system. And in a co-ordinated system, the origin does not exist without the coordinated system. It only makes sense when placed within the diagram. If it is a feeling, a zero of this kind would only be a feeling of plenitude. What this means to say is, that by resorting to his methodology of ruins, PCR has found an exacting way of dealing with the problem of *ex nihilo* creation. From an experiential, or rather, empirical and existential, point of view, nothingness does not exist: we are always a body weighed down by a multi-secular, multi-personal burden, by accumulated experiences, studied notions, ideological effects, small and great conditioning factors, contingencies and determining factors. However, from a conceptual point of view – that is, transcendental, to use Kant's terms – it is in fact possible to cut with contingency and seek a radical origin. The move is very simple, but only becomes understandable through an analogy with mathematics. It is enough to say: it does not matter what was there before the ruin, what its history is; the only thing that matters is what may be done with it, what may be built on the basis of its diagrammatic nature. Or according to the shadow it casts. And this implies that what is possible, in a mathematical sense, is everything.

ELEGANCE (RUINS II) | In a recent interview, PCR referred to this complexity by using an allegory. When he was asked whether his work was not an exercise in destruction, and whether the construction he produces would not be accomplished by means of de-constructing, he answered elegantly by telling a short story. He said he preferred seeing himself as someone working with "ruins" and added: "As an artist I am at the rear of a caravan collecting the remnants deposited by all those who have gone before me. It is with these remains that I construct an image, something akin to a shadow, an ephemeral image, but one of the highest circumspection". But he went on, introducing into the continuity depicted by the image of the caravan, the element causing the breach, one that radically revolutionises the sense of it. "Someone in the desert at night […] moves away from the caravan and loses his way […]. He simply isolates himself, leaves the caravan and his footsteps trace their own path soon to be erased by the wind. […] He has the capacity not only to put astronomical orientation to a different use, not only to see, but he can also record and establish his own geography. He knows what he has to do".

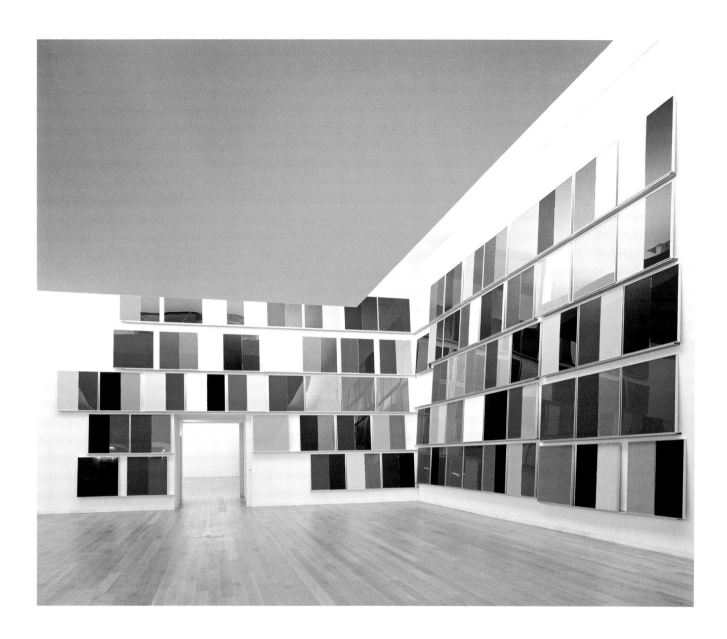

125. CABINET D'AMATEUR #1, 1999

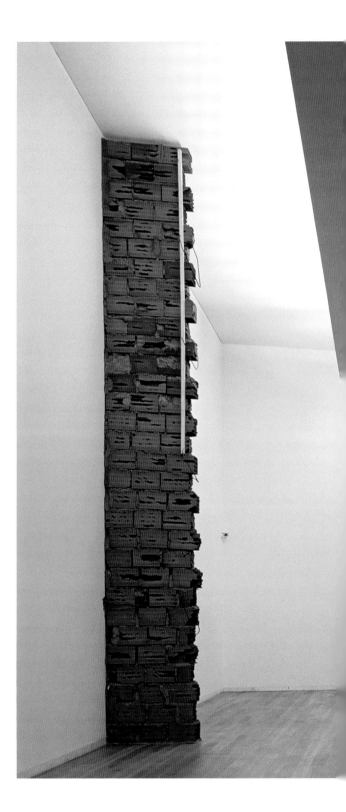

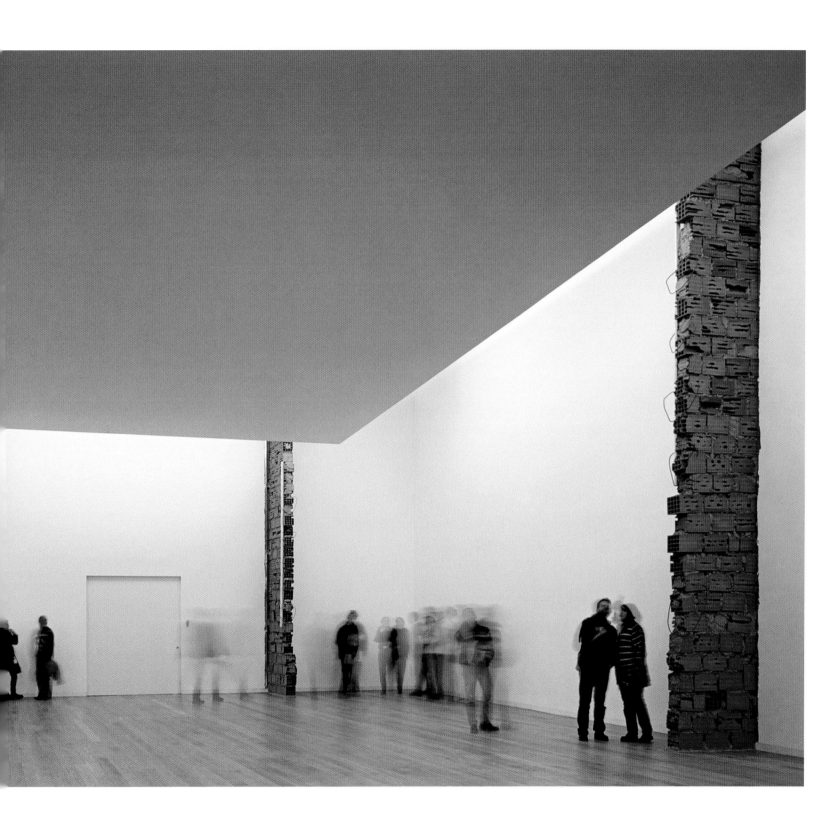

What in fact is important here, is the "circumspection" and the "moving away". It is the link between these two factors that tells us exactly what the role is of a methodology of "ruins" (or "remains"). But because it is the "moving away" that opens the way to "circumspection", it is necessary to start off by examining the former. Let us see how. History is a "caravan in the desert". What this picture tells us in its own clear way, is remarkable. We have a pre-defined sojourn from one point to another; we have a trail which is always the same over and over again; we have a guiding system in the stars, which allows the caravan to make its way in this repetition without getting lost; but above all, we have the immensity of the desert all around us, or rather, we have the inexhaustible indeterminacy of all the possibilities around the trajectory chosen by history. The remains left along the way by the caravan are, without doubt, the signs of its passing, of its trail and of those who have made it. But they are also something else: as they are the refuse, the wastes of history, as they do not matter, as no one wants them and they are of no use to anyone, the remains are exactly the

picture of what history did not wish to be. A kind reverse image of what history could have been but was not. They have no exchange value, they have lost the use they once had and therefore the whole value of their use has disappeared. As a result, they are suitable for everything else that history was not. They are, in fact, at zero-point.

The person drawing up the tail end of the caravan has, in his collection of remains, the possibility of glimpsing at innumerable variations of history, which never quite became part of history. In moving away, in taking another path, he does not only choose his own variation of history. In moving off, he chooses another history of mankind. (In choosing thus, would it mean something fleeting? Yes, because everything that is not eternal is ephemeral. And this line of thought is not founded in any nostalgia for eternity.)

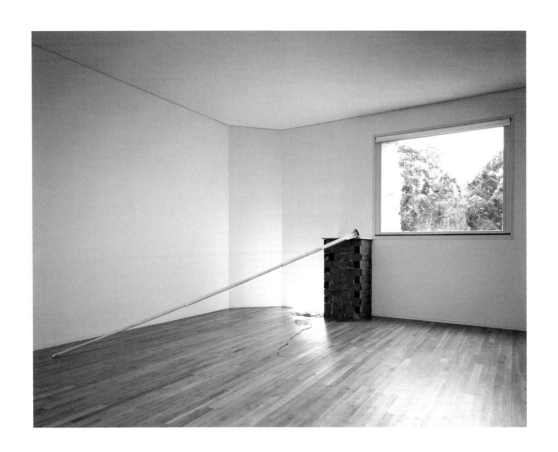

127. 128. ATÉ ONDE A MÃO CHEGAR, 1999

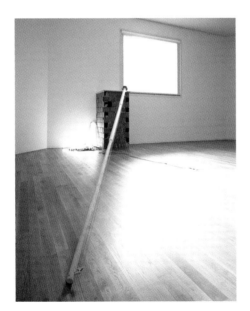

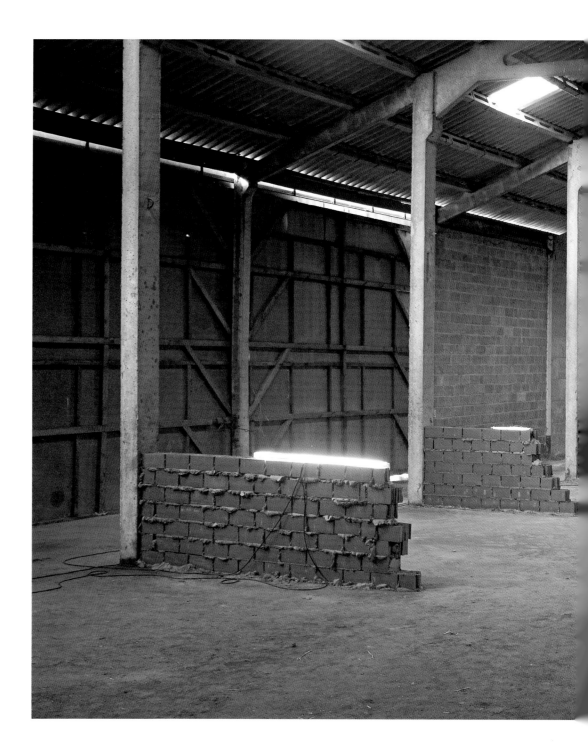

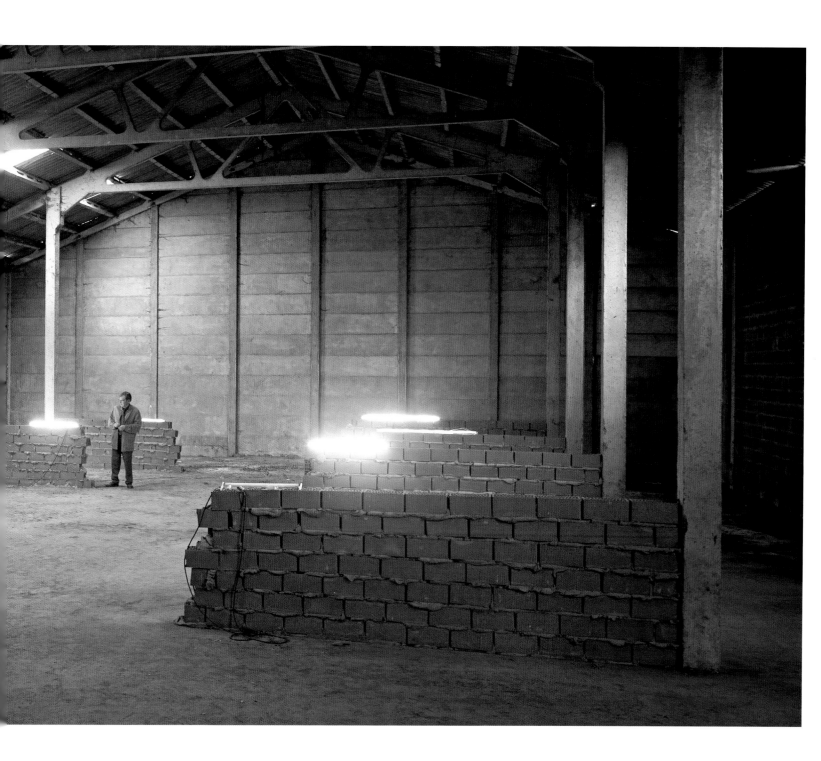

130. CATEDRAL #1 (BONN), 1999

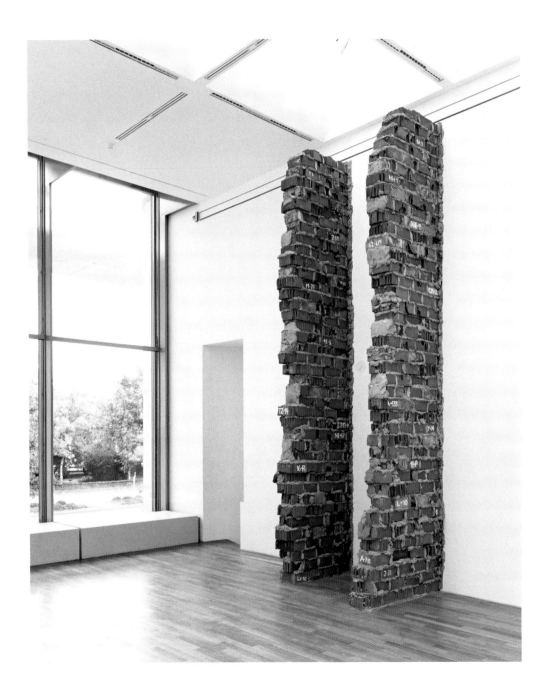

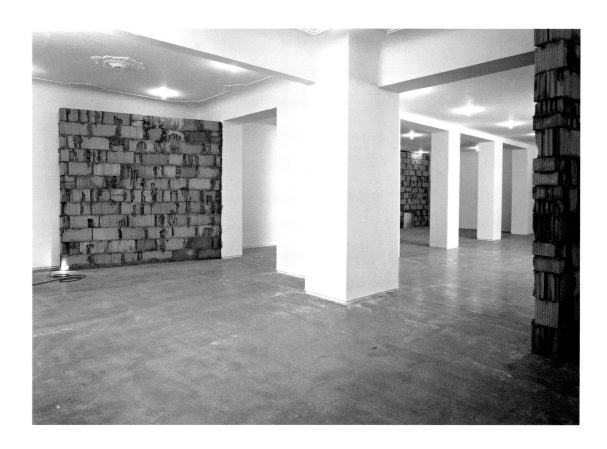

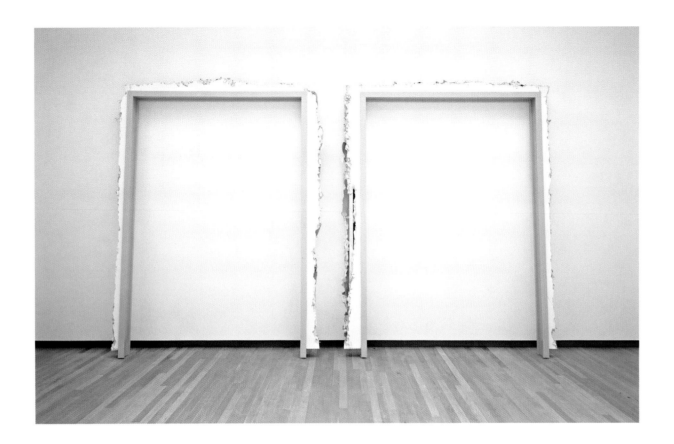

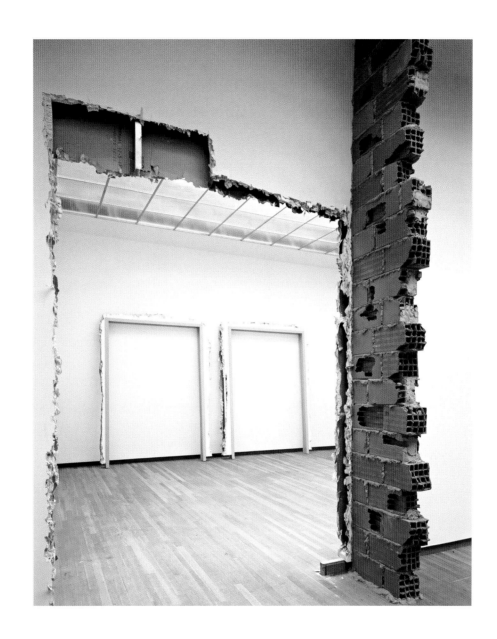

MUSICALITIES | Before we go onto what "circumspection might be, it still seems necessary to examine the *decision* to "move away": the one who moved away from the caravan, moved off precisely because "he knows what he has to do". The formula PCR uses when speaking about "moving away" does not exactly have the ring of decision-making about it, expressing an individual will. It is more in tune with the narrative musicality of the formulae about a destiny or a calling, which is characteristic of mythical language. I prefer to think that such words as destiny, calling – vocation – should be understood as signs at a second level. Not as if we could believe in the semantics of the words themselves, but as signs of what these terms fail to say directly but which they imply obliquely. They imply – and here is the first aspect – that they reject any kind of explanation based on cause, be it more sociological or more psychological, of what leads an artist to become an artist. And they therefore reject any sort of enlightened explanation of everything that happens from then on. They likewise imply – and here is the second aspect – a certain kind of finality: only from the horizon aimed at, or in other words, only with regard to a knowledge revealed, can certain acts, certain procedures, certain decisions obtain their sense. There is however, a third aspect: such signs imply a radical certainty that has no yardstick against which to be measured.

This certainty may perhaps seem the same as will, the sense that will imprints upon acts. However, as of late, I have begun to doubt my own somewhat vitalistic – certainly Nietzschean – understanding of PCR's aesthetic thinking. I have begun to see in this certainty the marks of an operation of analogy with theology. The will might provide personal certainty. But, what we are dealing with here, as we have seen, does not have to do primarily with the person.

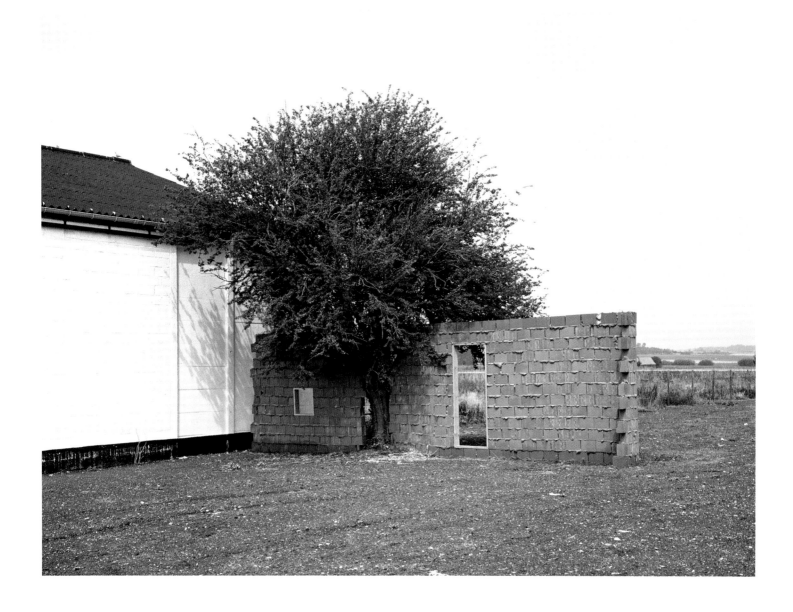

134. A ROOM FOR A POET, 2000

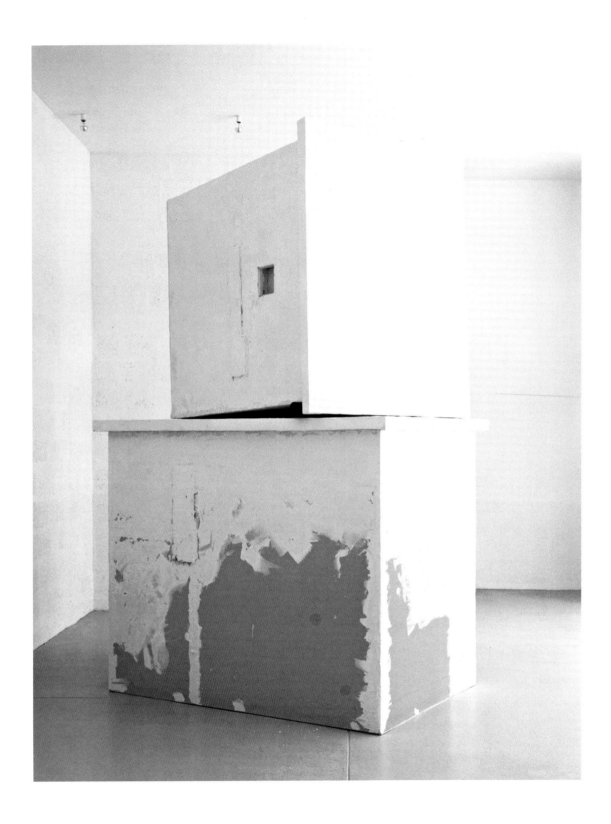

135. DES DIMANCHES TRISTES, 2000

THEOLOGY | "Seek and ye shall find!" It does not say how we should search or what we should search for. Which is the same as saying: "plunge deeply into the darkness of *chance* and the *certainty* is all yours". The certainty is certainly out there, somewhere in the darkness, perhaps even at the centre of chance. Perhaps, for sure.

What is a theology if not a theory of suturing, a (post-mythical) rationality, which is there for stitching up the wound of irrationality, the interminable unliveable gash of uncertainty. What is important for the workings of the analogy here is that theology is carried forward not by denying the denial (the will, Nietzsche's "yes to life" is a methodology of *pathos* against *pathos*, denying another denial which is the metaphor of death), but within the denial until, through a sudden detour impossible to demonstrate, at the darkest point of the denial, the certainty of affirmation is found.

This is what is implied by "moving away" from the caravan trail. Plunging into the haziest of chance occasions of all that history could have been but was not, and finding there, in the darkest of the darkness, the certainty of another history – or of another "geography" as PCR also says – which, once it has been found, allows for a total view of everything around. But we should not forget: the one looking around, the one undertaking this "circumspection", is not the person but the giving.

DOORS | Upon a door frame, leaning against it, is a sheet of painted glass. Thus placed, the glass tells me of (a) non-transposition; (b) a rigorous surface; (c) fragility; (d) a reflected image of me to myself.

When Narcissus sees himself mirrored in the water, he does not only see himself. He also sees the sky, the clouds, the branch of a tree, the entire universe. He sees what cannot be seen if not through this instrument of observation: I, myself in the universe as a whole. In the end, Narcissus turns his gaze away from his own reflection so as to use the mirrored surface of the water as an instrument. As an instrument giving him, as the "I", to the entire universe.

This being the case, the reflected image entails a turning away of one's gaze. Or the turning away of one's body. Relocating one's body so that this motion is the means by which to see the entire transfigured universe.

Narcissus knows about non-transposition, interdiction. There is another side to the door. However, the interdiction does not reside in not being allowed to go through it. It lies in the impossibility of coming back. But Narcissus also knows that the mirror in the water is fragile. This is why his gaze is sometimes frozen, resting only on the surface, seeking to retain it. Attracted by the water's pure reflexive quality, the gaze loses its focus on the reflected images in order that it might hang onto another image: a crystal surface. This is the wound-free surface.

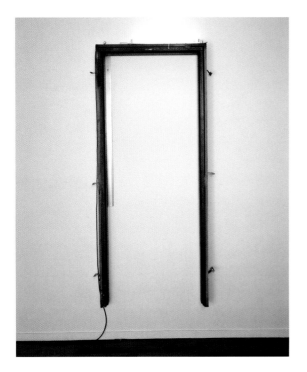

QUOTATION | One day, a long time ago, a man who had dedicated the greater part of his labour to the most complicated philosophical questions about language, told me: "Words don't really matter."
Even today, I am still discovering plausible meanings of this statement.
(I would love to have been able to write this essay in just this way. On the far side of the superficiality of words. Something to be heard without bothering about the words.)

DENIAL | A psychoanalyst may be tempted to interpret some statements in PCR's interviews as a form of denial. For example, what he says about "suicide", "death", "rivers", "quaysides", "departures". And maybe also about "staging". But psychoanalysis, which has a lot of theory about mirrors, has very little theory about mirror-doors. It would have to acknowledge the non-return.

ENERGIES | If we wish to look for energies that set a great piece of art into motion, we would always have to do two things: the first is to look sideways, transversally, obliquely; the second would be to join together the extremes.

DISTURBANCE | Looking sideways is a necessity that becomes more obvious materially when we are standing in front of a plate glass that reflects our own image. Our presence, in front of the object, disturbs it.
However, it is useless to want to do away with our reflection. What we should do is start seeing through the eyes of our reflection.

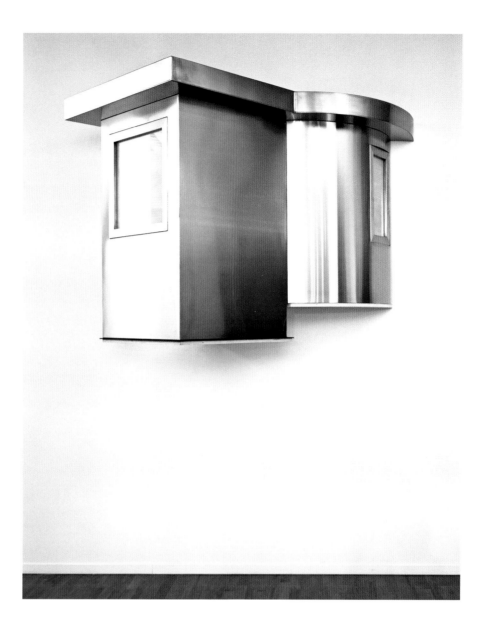

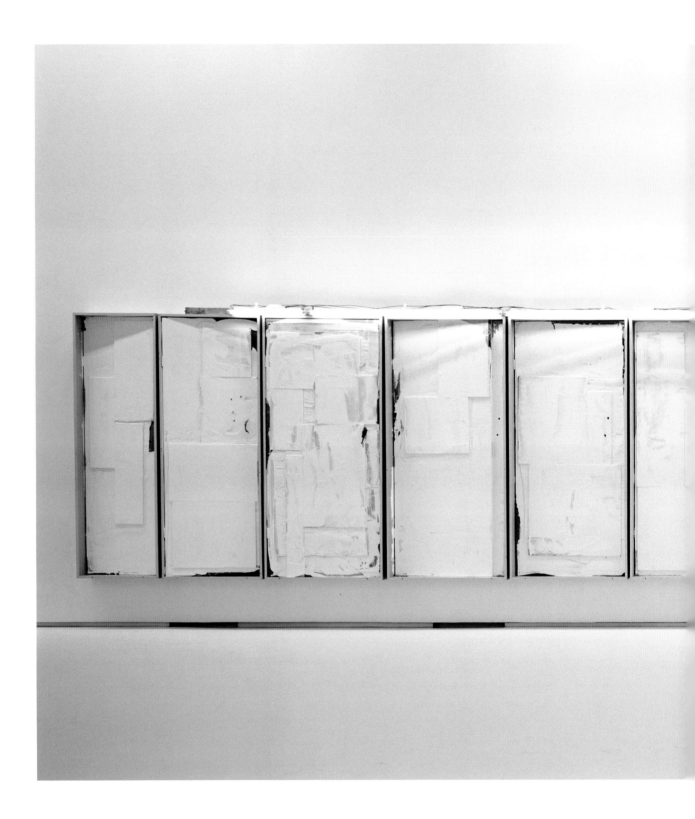

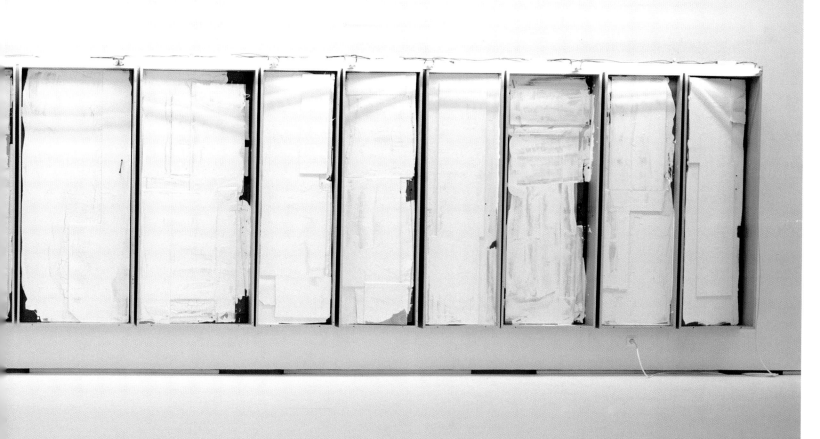

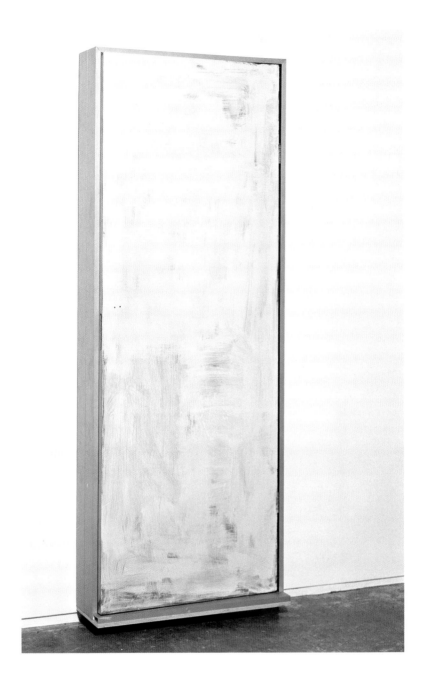

140. UNA CASA, 2000

141. ALTRA CASA, 2000

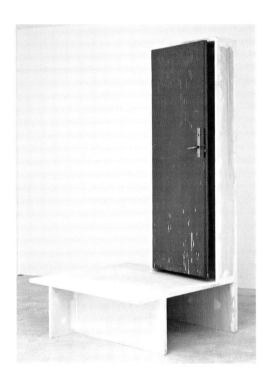 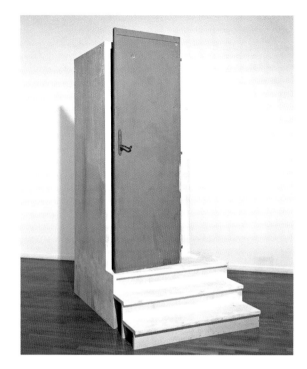

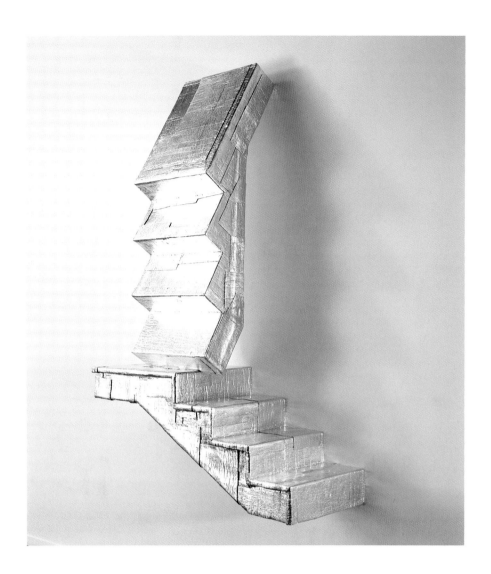

EXTREMES | Joining together the extremes does not mean adding them together. And it certainly does not mean making them symmetrical. Movement and rest are not symmetrical. The same may be said of extremes that are only dichotomies in appearance, such as life/death, war/peace, light/dark, subject/object, and many others. (Join the extremes thus: the sky and the bottom under the water.)

RULE | A useful rule for thinking as thinking-that-seeks: where you find a dichotomy, test the gender-species relationship. Examples. Try to understand light as a species of darkness. Try to see peace as a species of a gender, which is war. Try to understand the beautiful as a species of a gender that would be ugliness, or harmony as a species of conflict. Affirmation as a species of denial. Likewise, though, try to understand negation and denial as a species of affirmation. If you do so, you will always see more than you did before.

ENDS | Health would be a species of sickness, or could it be that sickness is a species of health? How to decide which of the extremes of a dichotomy is the gender and which the species? What is interesting in determining the gender-species relationship is that it implies a direction of one's thoughts. Direction is orientation leading somewhere, to something. This being the case, before I decide on the relationship, I first have to know where I want to get to. What I want to do. The end I have in mind has to tell me whether A is the gender where species B may be found, or if B is the gender where species A may be found. If there are two ends in sight instead of only one, the case may arise where the relationship is valid from A to B and at the same time, from B to A. If the two ends I have in mind are not contradictory, the contradiction between the A-B and B-A relationships is illusive.
Furthermore: the relationship's inverted duplication expresses the unity of the ends.

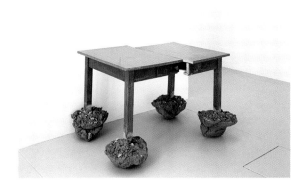

143. PAPA EST PARTI..., 2000

ABILITY | What PCR has been constructing for a long time is a method able to deal with all things. Nothing has the privilege of being left outside, untouched. Outside is a species of the gender that he has called "the place-of-the-inside".

HISTORY | To tell the truth, I started off here: history is a species of the gender that is the history of art.

PROCESSES | Some speak of an artist's work by using architectural metaphors, such as a building, foundations, platforms, cupolas, etc. I prefer other metaphors, more organic ones, or more chemical, or more mechanical, or more economic, or more warlike, or more political, or... This is why I speak of energies. It matters very little what the actual results are, the *ergon*. The result does not speak, it imposes itself. If it speaks, it does so afterwards. As an interpretation, as an explanation. It is demagogic. What matters are the processes. Processes and procedures. It is there that the *energeia* is legible. Not the processes which may lie behind the work of art. Not the making of it, not the technique, not the fingers at work. Above all, not the psychology. The processes matter, yes, but the processes in the work of art... Whatever it means. "Giving" is the word that I found for this processing feature in the work of art.

PASSIONS | For a long time, the subject was excluded from art. It has returned today. The subject is coming back everywhere. Not only in art, but also in philosophy, science, history. In philosophy, it is fairly clear that the subject has returned not so much as the topic of the subject, but above all, as philosophy-as-subject. For this to have happened, it is, in fact, necessary to study the passions, the passive face of activity. The subject is not the one that does, that says, organises, creates, perceives, etc. The subject has become that which, being the subject to something, for this very reason, confers otherwise lacking legitimacy to that which it is subject to. Giving is passion *par excellence*. Giving, therefore, is the subject which confers us legitimacy.

HOUSES | At times it dawns upon me that they, the houses, mainly when they are impenetrable, when they climb up walls or when doors and windows become opaque, when they are wrapped in waterproof sheeting and tar, are the most perfect image of a centre without a centre.

WORDS | Not all the terms in a vocabulary without a centre, therefore, suffer from the same lack of centrality. ∎

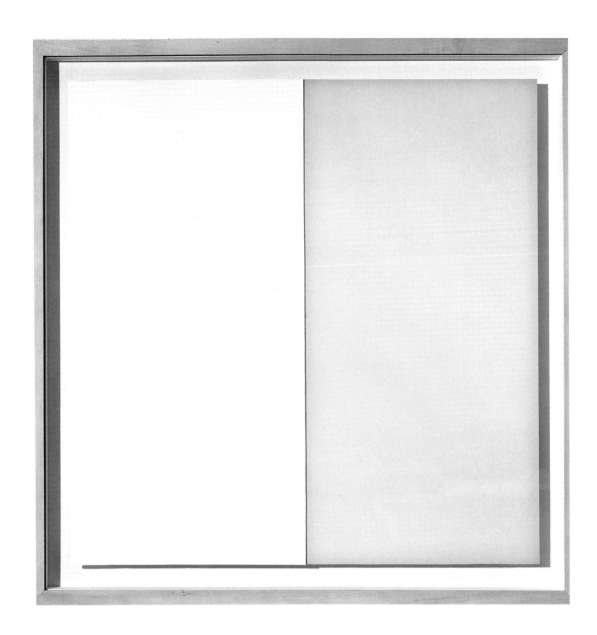

144. GLASS PAINTINGS # 23, 2000

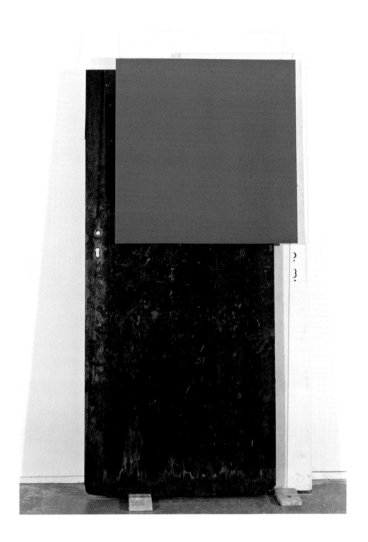

146. **POLYCHROME #2**, 2000

147. **POLYCHROME #3**, 2000

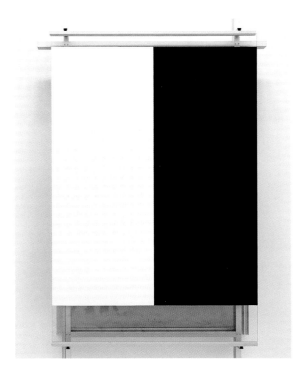 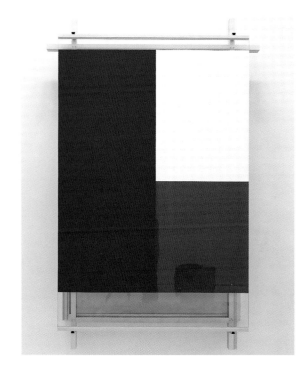

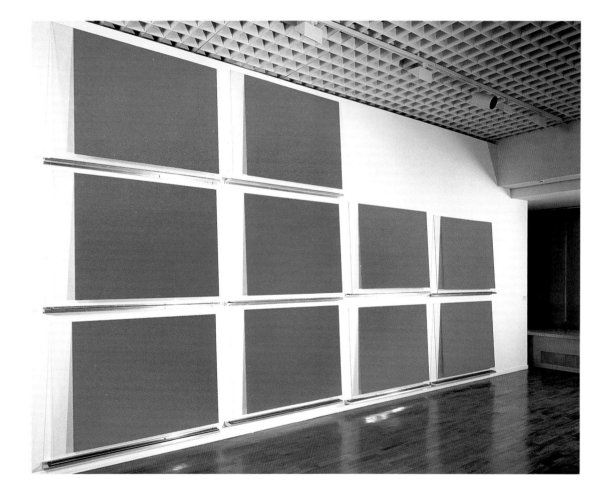

149. DOUBLE MONOCHROME BLACK (PB9), 2000

150. DOUBLE MONOCHROME WHITE (PW6), 2000

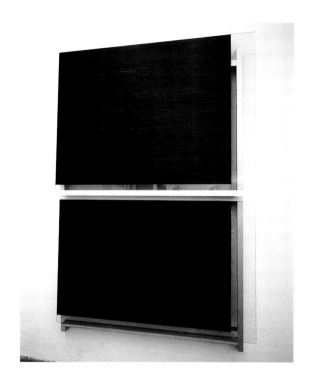

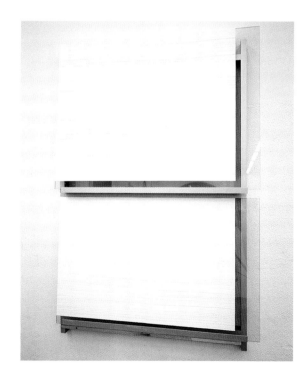

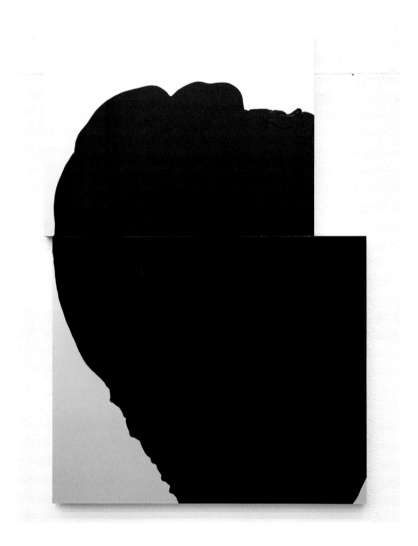

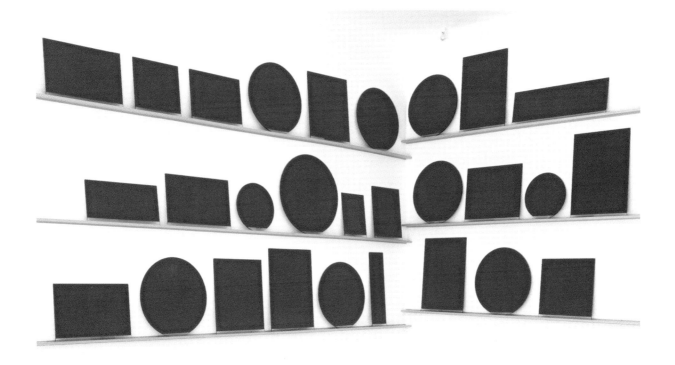

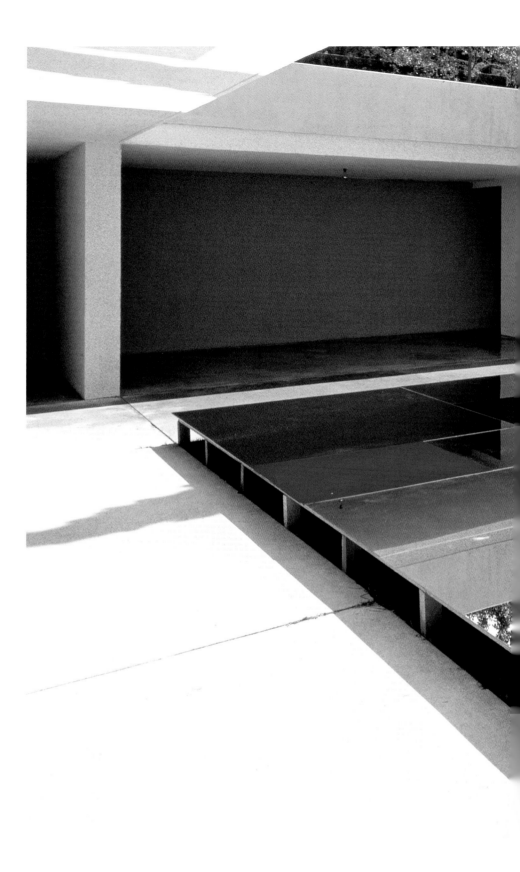

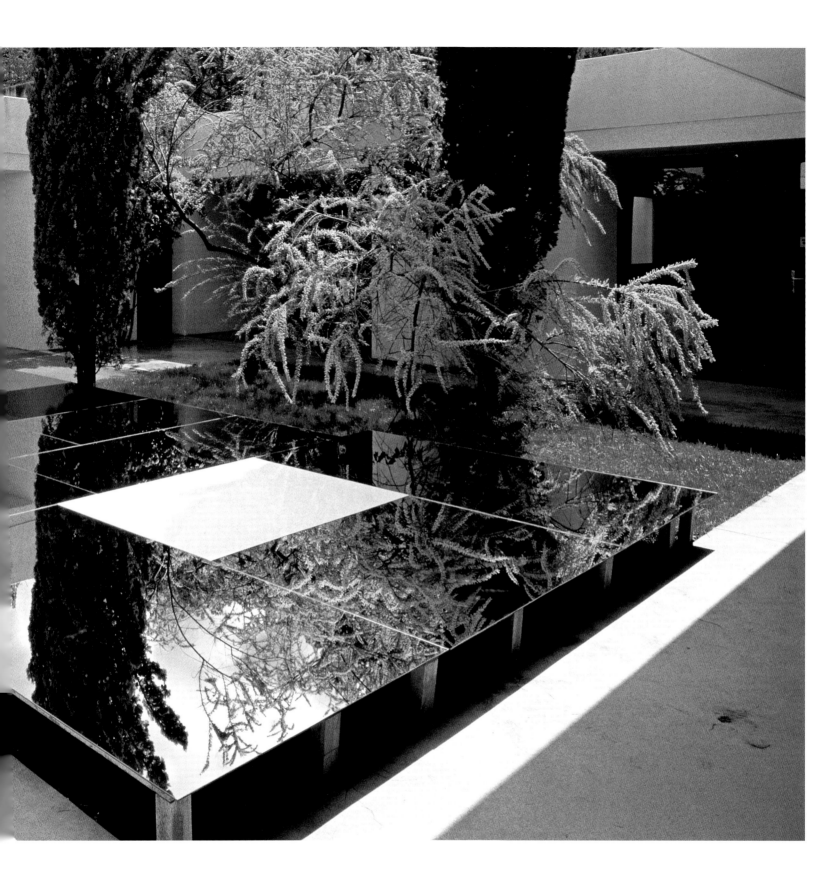

154. 155. 156. 157. 158. 159. THE SLEEP OF REASON #1, #2, #3, #4, #5, #6, 2000

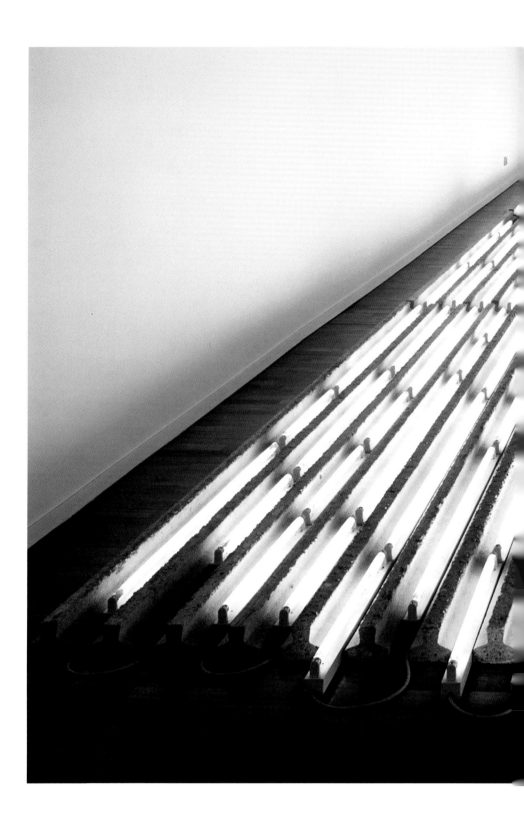

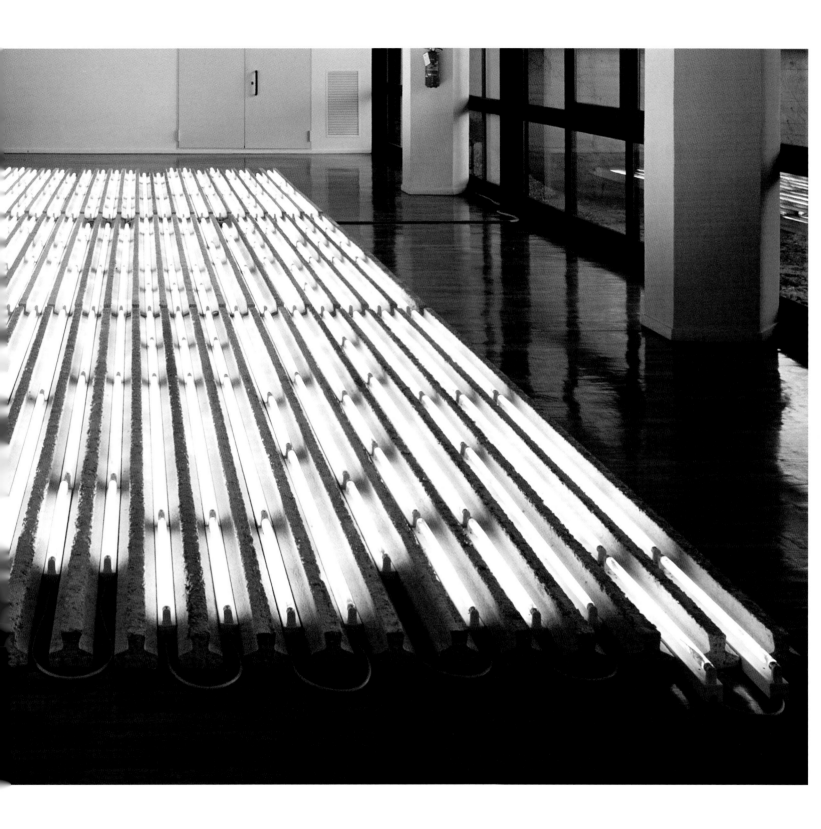

THE CONSTRUCTOR OF PLACES
JOÃO FERNANDES

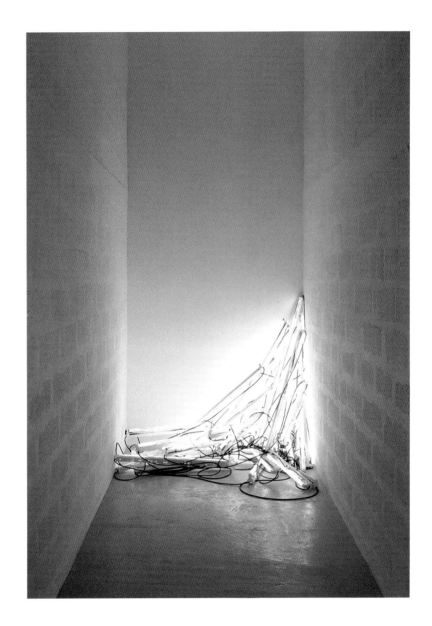

The work of Pedro Cabrita Reis emerges in the context of the renewing of contemporary sculpture witnessed since the mid-eighties until today, finding its place in a period with no paradigm, in which subjects, concepts and forms arise more from unique and idiosyncratic formulations and resolutions than from ideological programmes as to the status of art and of the art object relative to whatever life, society or the world may be. This is a period in which it is common to make a reassessment of great historical, social, political and aesthetic narratives in order to give rise to new paths in which the freedom inherent to artistic reflection and creation is increasingly an original and solitary programme.

Independently of the accumulative revisionism post-modern discussion has become during this period, Pedro Cabrita Reis's work re-centres upon problems that then appeared to have become extinct, such as the issue of the author and that of structure. The author is reconfigured as a constructor who appropriates what he finds in the world, in order to confront it with the enigmas and share them through the vestiges, perennial or perishable, that make up his life and his work; they can be unified through the unique energy that reveals him. The structure originates a combining grammar of the materials and of the processes, which does not fear a rhetoric that becomes a confrontation of senses and of memory in the experience of the spaces and places.

As an author, Pedro Cabrita Reis sees himself as a producer of ambiguity, of double, multiple meanings. His work clearly fits into the field of strangeness, mystery and subjectivity: it is presented to our understanding through a precise objective and conceptual dimension that suggests a possibility of order, comprehension and rigour to us. As structure, Pedro Cabrita Reis's work revisits some of the classic themes of traditional sculpture, such as light and space, which take on new meaning in his works and are redefined as the proposal for a new relationship between architecture and the work of art.

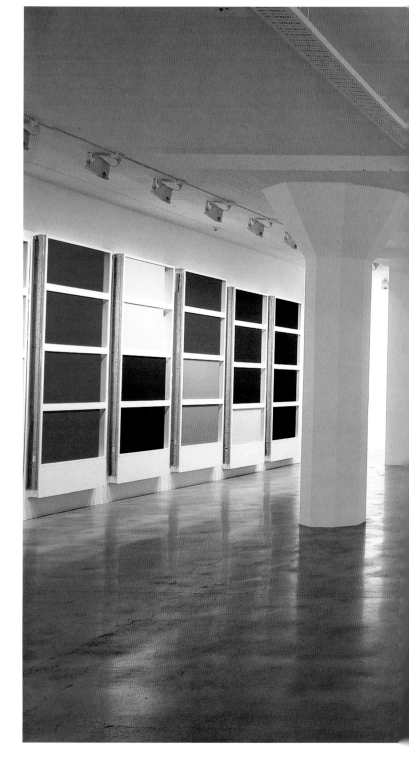

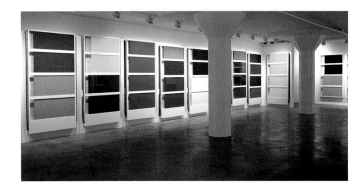

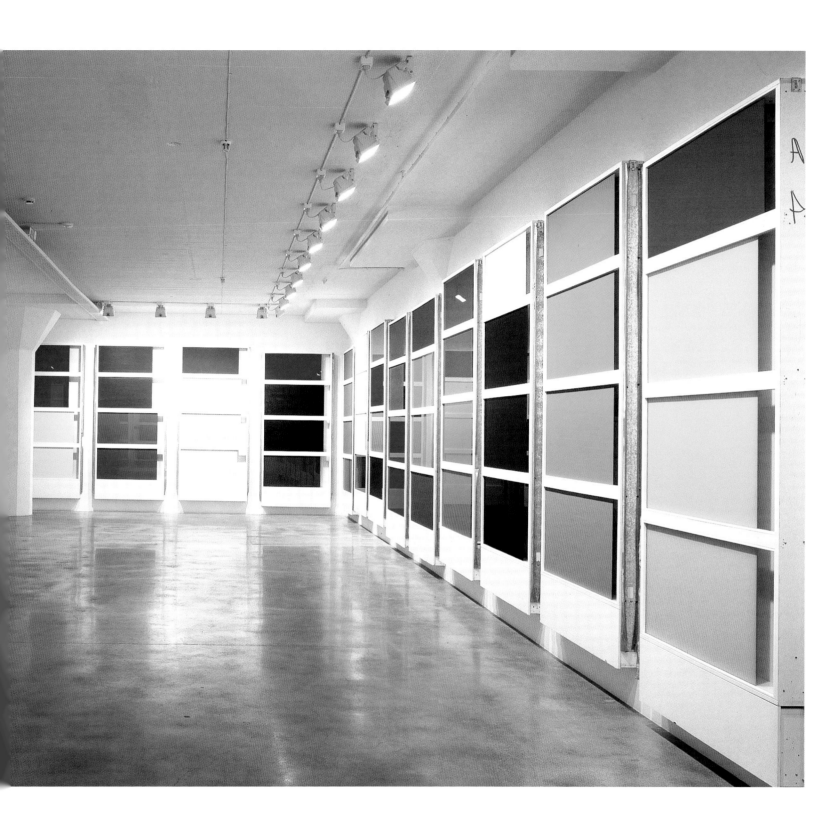

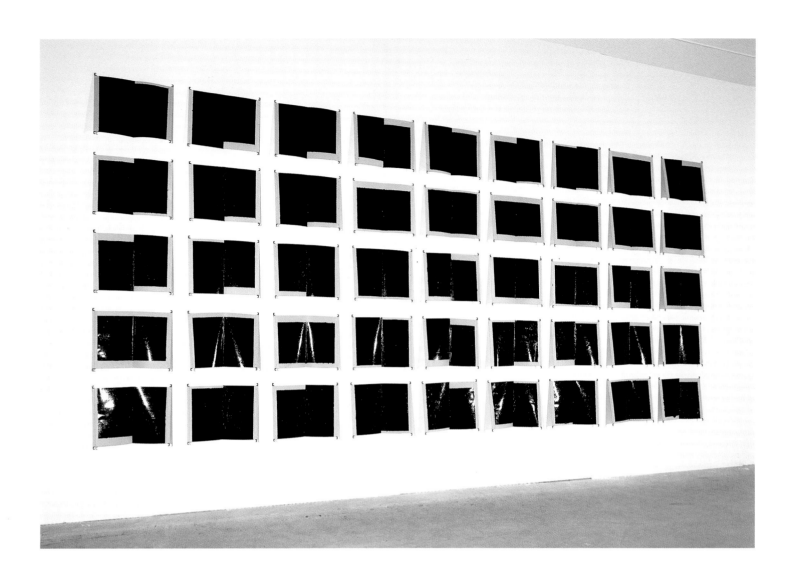

164. ARCHIVES SERIES #1 (BLACK), 2001

Pedro Cabrita Reis's sculpture is characterised by the use of simple materials, recycled from existing materials and reminiscent of the experience and knowledge of daily life. A large part of these materials are construction materials: wood, bricks, plaster, glass, electric cables, copper and rubber tubing and fluorescent strip-lights. However, the artist transfers the issue of the assembly of materials to the process of construction and to a discourse in which melancholy is proposed as an unstable and creative balance between the absence of referents and the omnipresence of signs that find some of their main references in an intimate, personal history, as well as within the affective context of their Portuguese cultural origins.

The House and the City emerge as evidences of this process of transference, of the work of the construction of places in which Art provides the possibility for a permanent celebration of life and of human presence in the world. The House starts out appearing as an echo of that World, the protective and matric shelter that condenses the energy of the celestial atlas of which it reconfigures the cosmogony. A well of cool water, doors, windows, walls and corridors are turned into interior labyrinths of memory, like the memories of a summer or the details of the childhood home that each person may carry with them. The City results from the inevitability of the cartographic proliferation of the House, of the evidence of its generating and constructive potential. The City belongs to the dislocated territory of the energy of the suburb, of human persistence in survival, in the use of the remains of constructions that always produce other constructions, in the modest and hidden epopee of the builders. Pedro Cabrita Reis's cities are blind. As blind as are anonymous the hands of the builders, of whose results the artist makes concealed monumentality stand out.

In Pedro Cabrita Reis's sculpture, confrontation with the space forms its re-ordering originating in the transforming energy that subverts its pre-existing conditions, independently of temporality or of the architectural characteristics that might define it. In his work, architecture always becomes the choice territory for the intromission of sculpture that alters its coordinates and redefines its possibilities. For this reason, Pedro Cabrita Reis's sculpture does not fear the monument. Quite the reverse; it exploits the monumental effect, inscribing the place on the territory, rediscovering centralities where they would be least expected and suspected. In his work, the monument devours the cathedral, architecture grants its dominance to the arts and crafts.

In a piece that began the paths that Cabrita Reis's work has taken since the beginning of the nineties, in *Alexandria* (1990), a well in the cloisters of an old monastery is recentred by the sculpture that rediscovers it in the blocks of plaster that flow out from it and make other well-memories flow into it, as the metaphorical evidence of the former well in the new place that the artist raises up from it. The sculptor's constructed drawing becomes the unexpected cartography of that new place. A new topology is inscribed on the sculptural transformation of the world, mysterious and blind in its perfect blocks of white plaster that confront the spectator

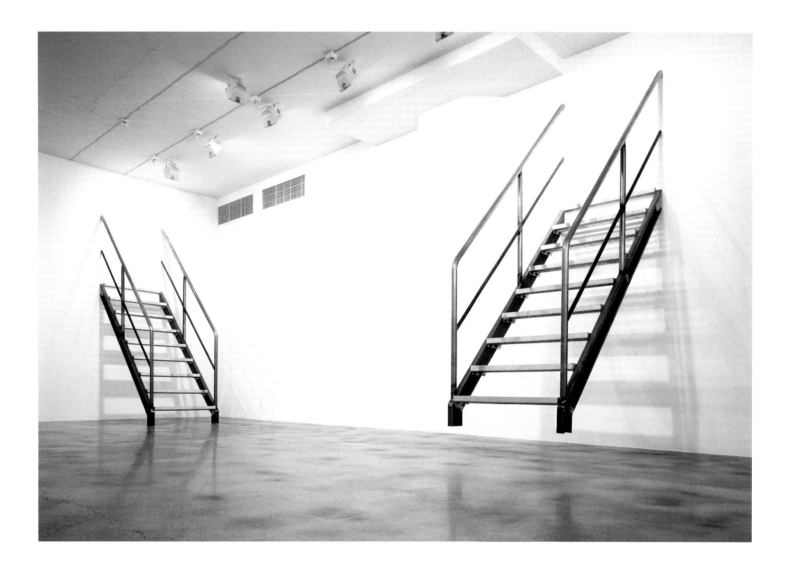

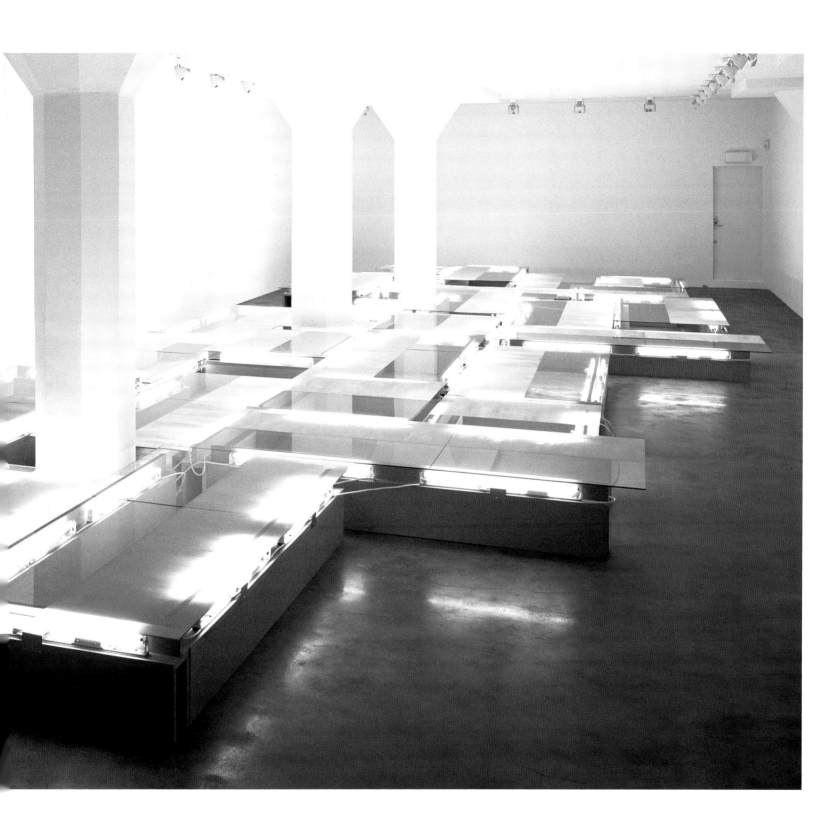

with the necessary overcoming of any expectation of function or justification. From this project on, up to projects like *River* (1992) and *Of the Hands of the Builders I* (1993), Pedro Cabrita Reis's work inscribes its unique maps that re-appropriate pre-existing spaces. Any work by Cabrita Reis is radically taken as an *in situ* construction, because it makes the place where it is installed, independently of its possible site-specific circumstances. If, in *River*, the spectator was challenged to a path that, however, hid the space outside that path from him, through the limestone walls that isolated him from the Kassel garden opposite the Fridericianum, in *Of the Hands of the Builders I* the spectator is irredeemably condemned to a physical exteriority that deepens the mystery of the sinuous drawing of the cement blocks supported by fragile wooden structures "flowing into" three small hermetic brick and zinc towers, against which rough wooden steps stress the impossibility of any access. The sculpture can never be integrated within the space: it appropriates the latter in an implacable transforming logic that rhetorically underlines its necessary condition.

The increasing "deafness" of Pedro Cabrita Reis's projects will progress from a symphonic dimension that can be detected in the above-quoted works to a series of "chamber" pieces like those we find in the series *H Suite* (1992–1994) or in sculptures like *Battery* (1994) or *Machina per verificare / Identità e Luogo* (1994), where the artist shows the autonomy of the object in the space through the structural and compositional relations that unexpectedly associate the materials that make it up. The syntax of the materials is associated to an intimate and idiosyncratic semantics of each piece, polarising a set of metaphors of creative energy. The sculptor wisely explores formal oppositions that he transforms into conceptual dichotomies. Rigidity and malleability, weight and lightness, transparency and opaqueness, light and shade establish unusual relations between hiding and revealing, discovery and construction, potency and the act, made and found. Each sculpture stands as a device of a utopia announced in each *topos* it constructs. The myth of creation is reconstructed from an archaeology of daily life that leads to a tension of conflicts between an alchemic process of emotions and the materiality of the asserting of life in the registers of its residues and questionings.

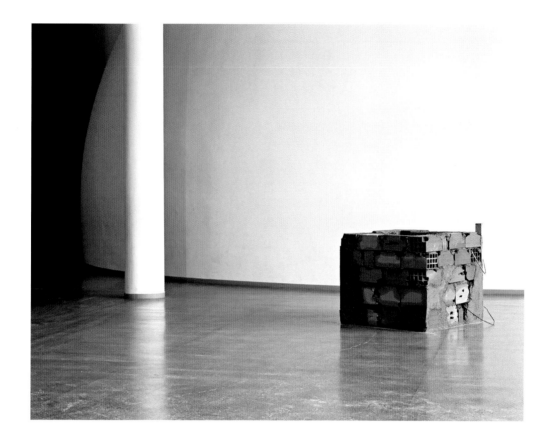

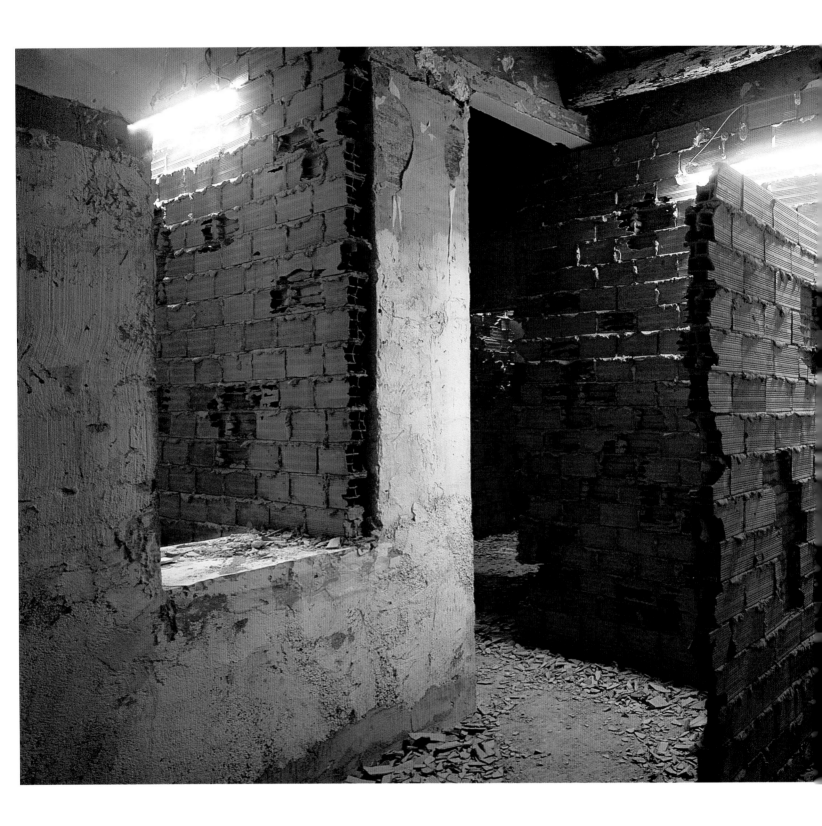

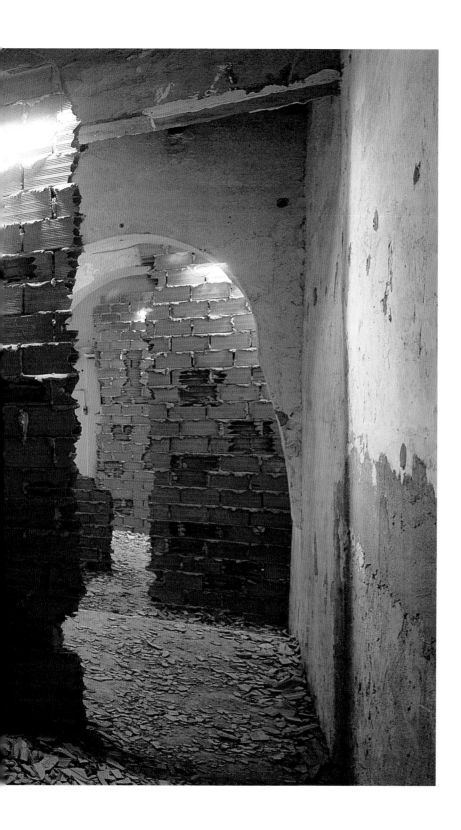

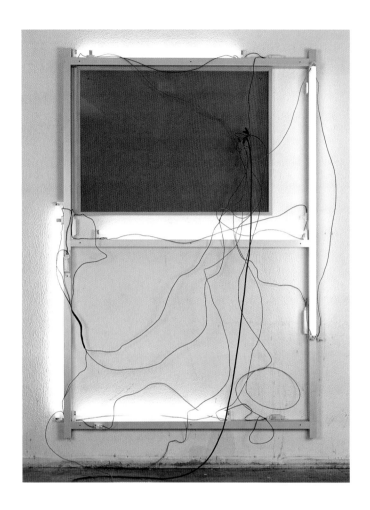

This intimate and secret laboratory will give off a new cosmogony, detectable in series like *Atlas Coelestis* and *Echo der Welt*, both from between 1993 and 1994. Large spatial constructions emerge from the places they transform into map rooms, observation posts, altars with no worship and radars with a concentration of energy that drives away any metaphysics, apart from the material nature of their creative propositions. Each of these constructions is the place of an alchemy of the gaze and of the thought that challenges the spectator to a confrontation with his own ignorance of its motifs and meanings. Large round panes suggest glasses through which one can see nothing but their transparency in *Map Room / Atlas Coelestis III*; a stairway to an imaginary tower is shown to be inaccessible through the large glass panes that cover its steps in *Observation Post / Atlas Coelestis IV*; a strange device generating unknown energy is discovered in *Echo der Welt I*. From the combination of simple and unexpected elements there arises the lost monumentality of a sense of construction, which converts it into a device for the asserting of the place of art in the world, a filter of the absence suspected in the lack of coincidence between the artist and the spectator. Later, from this auscultation of the firmament, the bright lights of the cities will emerge in the iridescence of their suburbia, taken as laboratories for constructive materials and processes.

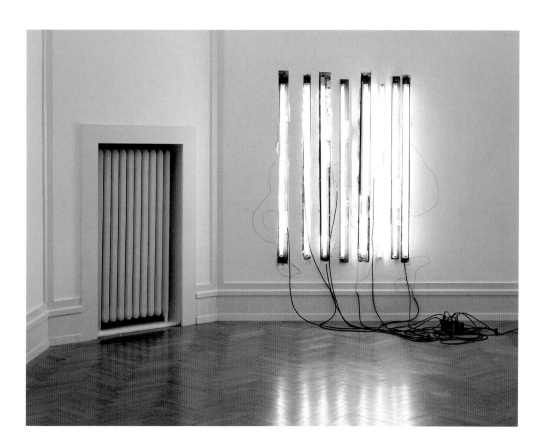

Indeed, from 1997 on, we may see in Pedro Cabrita Reis's work a progressive transference of the metaphor of the House to the metaphor of the City, the two great isotopies of the whole of his work. The way that Pedro Cabrita Reis uses metaphor is removed from any possible understanding of it as a mere symbolic or semantic result. The artist is aware that the process of transformation is precisely what is most radical in the metaphor. Metaphor has its origin in an anthropological reflection that transforms the confronting emotions, the memories, the silences and the questions, as opposed to the lyrical exaltation of allegory and simile, or to the reductionism of sociological discourse. If the House covers a period of work in which sculpture confronts its object nature, where the syntax of its materials originates the definition of a semantic paradigm of the intimacy of absence and remembering, the City will extend, as the metaphor of a set of works and of a sculpture project, the formal and conceptual possibilities of confrontation with space. The latter is used to show a work programme in which the intimate register becomes less and less dissociable from a social memory, which will be transferred to the exploration of the transforming possibilities of sculpture in relation to an anthropology of the present. Architecture emerges as an inevitable consequence of sculpture, although it never asserts itself as its target or aim.

In this transition from the House to the City, Pedro Cabrita Reis presents a set of sculptures, among which one may highlight the series *Lisbon Gates*, as well as the site-specific installation *New York Red and Black Window*, which deal precisely with the frontier territories between the two, in the evidence of the limits that might define the passing from the public to the private, from the street to intimacy. In *New York Red and Black Window* (1997), the artist installs a window in a museum building. Its panes are painted red and black. In *Lisbon Gates* (1997), we find gates made from frames found from other gates, against which glass panes with smooth coloured rectangles painted on them are leaning, as if supremacist echoes were allied to the constructive nature of each sculpture. This is not the first time he has used a door as a "found object". One should recall *D(oor)/D(am)* (1990), in which a door-frame set off a group of plasterboard structures on which it was placed horizontally parallel to the ground. It is, however, one of the first times that he reintroduces colour into his work, in a return to the painting that he had been working on in his work on canvas from the previous decade.

176. **SEDE**, 2002

177. **SEDE**, 2002

The irruption of colour in Pedro Cabrita Reis's work goes along with a reconsideration of the role of painting in the compositional structure of his works. Painting occurs as a constructive perception of the gaze. The memories of a place are constructed through a particular association of the interior and exterior communication that becomes the space of the painting, setting contrasts of form and colour in opposition. Cabrita Reis usually uses enamel on glass or wood, industrial paints that contribute to structural games of opaqueness and transparency. Colour becomes a constructive material, a covering that hides and reveals, allowing dynamic oppositions according to its specificity, its smooth or textured application and the

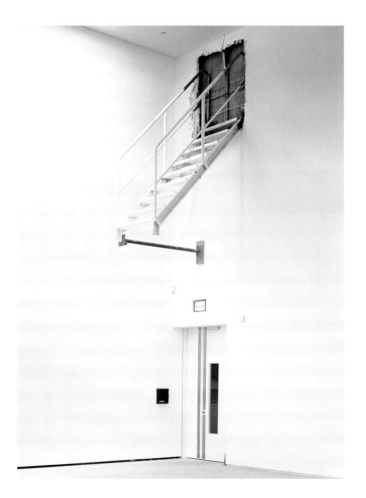

178. NORTHERN STAIRS #2, 2002

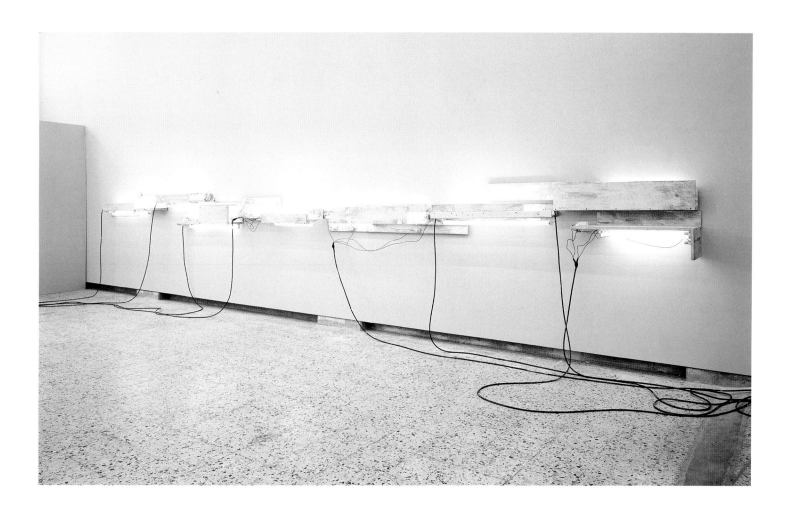

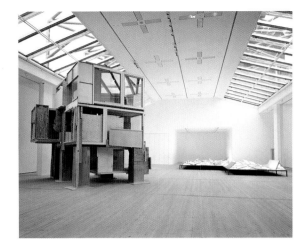

180. **THE PROJECT** (exhibition view), 2002

181. **THE PROJECT**, 2002

interior or exterior of the surface painted. In *Cabinet d'Amateur #1* (1999), the transformation of matter, glass or wood, by colour takes on the dimension of an industrial catalogue transposed into an exhibition room. The chromatic problems of pictorial representation gain unexpected relief in the spatial proliferation of these numerous diptychs painted on glass, supported by parallel lines of aluminium profiles that structure the space in which they are presented.

The formal and conceptual use of construction materials and processes takes on progressive autonomy in series such as *Dans les villes* and *Blind Cities*, carried out from 1998 on. The compositional principles of collage are applied on walls, houses and towers, constructions in which stand out combinations of materials like plywood, cardboard, brick, plasterboard, asphalted canvas, aluminium and adhesive tape. The works from these series transform the spaces in which they are installed into territories marked by the possibilities of observation they represent. Many of these constructions are blind and mysterious, impenetrable. The spectator is confronted with constructed places that hide from him like bunkers, or that spy on him, like watchtowers. The windows are there, but they are closed by the painting, which has made them opaque, or they have been made inaccessible due to being walled over. Gaps or boundary lines are omnipresent. Besides the territory drawn out by these volumes, there is also the territory charted on each flat surface by the joins in the adhesive tape or in the lumps of plaster that unite the walls. The construction shows off its processes, its

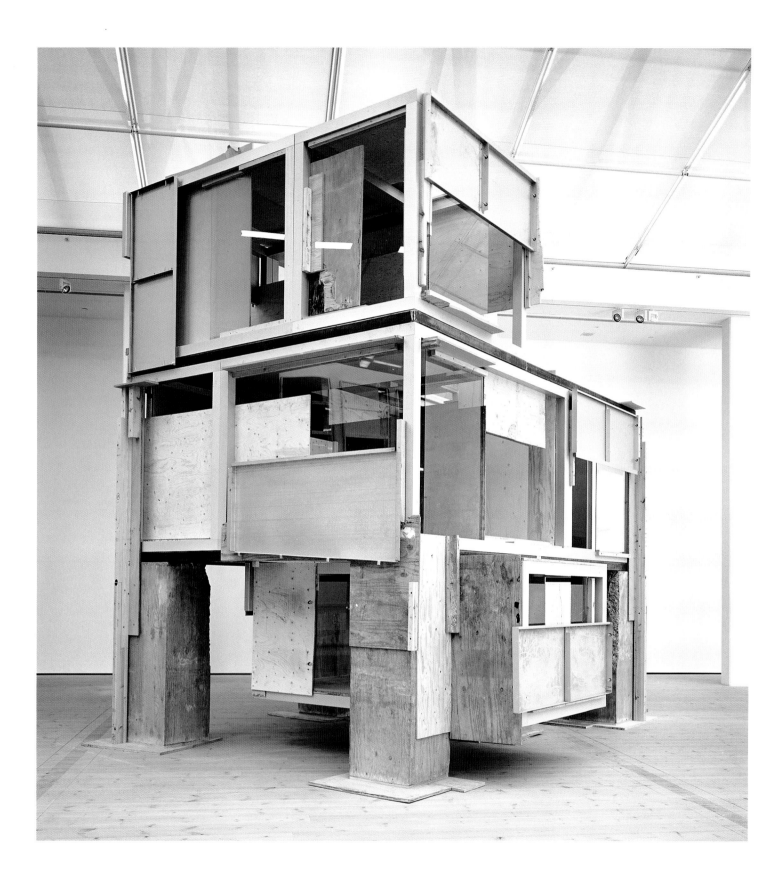

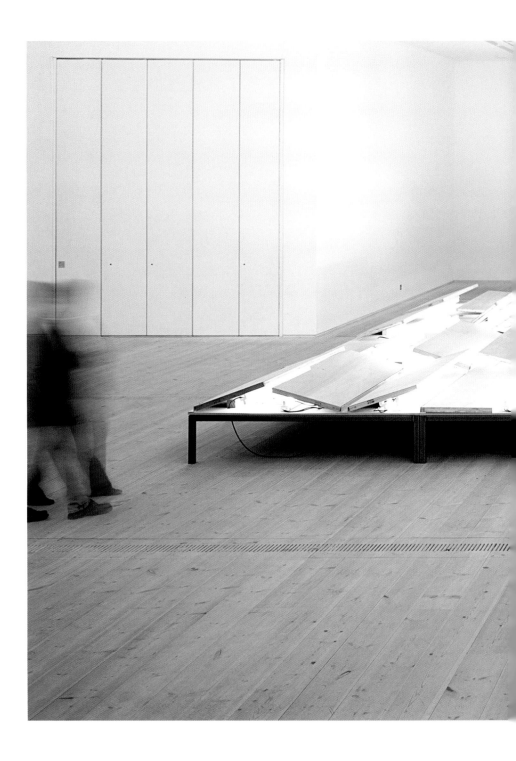

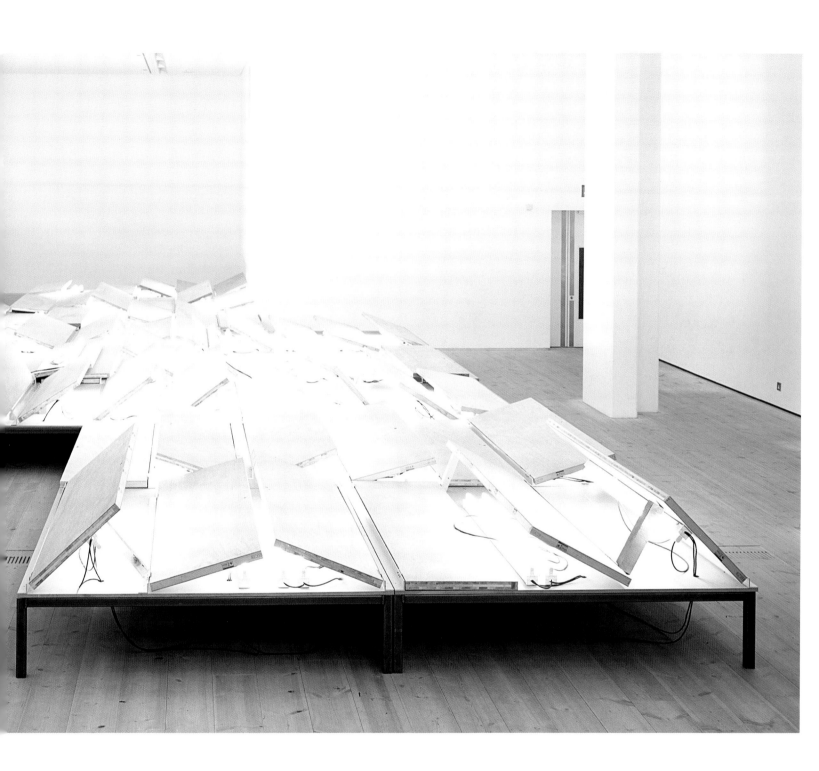

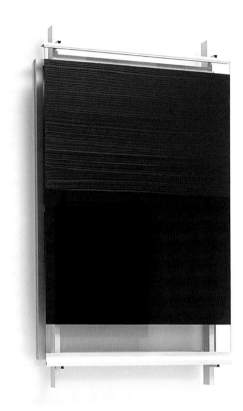

scars, beyond all and any functionality of its marks. The adhesive tape not only joins, but also blocks out, it "paints" and covers, taking on the autonomy of drawing or of monochrome painting. The installation produces a permanent re-invention of the space in the coming together of colour and object, as takes place in *Blind Cities #1*. The volumes arouse the movement of the gaze on the walls; the height stresses their impenetrability, their self-absorption, as can be discovered in *Blind Cities #2* and *#4*. The walls take on a mysterious monumentality, as can be seen in *Blind Cities #5 / The Echo and #6 / Büro*. The sculpture constructs the place without the intention of architecture. Light breaks out in a precise and non-functional pattern: fluorescent lights appear in *Büro* as a way of marking out territory. Indeed, the whole space becomes a strategy of territorialisation, throughout the series, as the result of the hidden rules of the growth of cities, in the use of its built remains.

An elegiac dimension accompanies this progression of Pedro Cabrita Reis's work. Each construction results in a suspected absence, in the dull echo of the unknown addresses, in the attraction of the monument as the expression of solitude and of melancholy. The sculpture asserts itself as a permanent recycling of the ruin,

184. BLACK MONOCHROME / TRIPTYCH LANDSCAPE, 2002

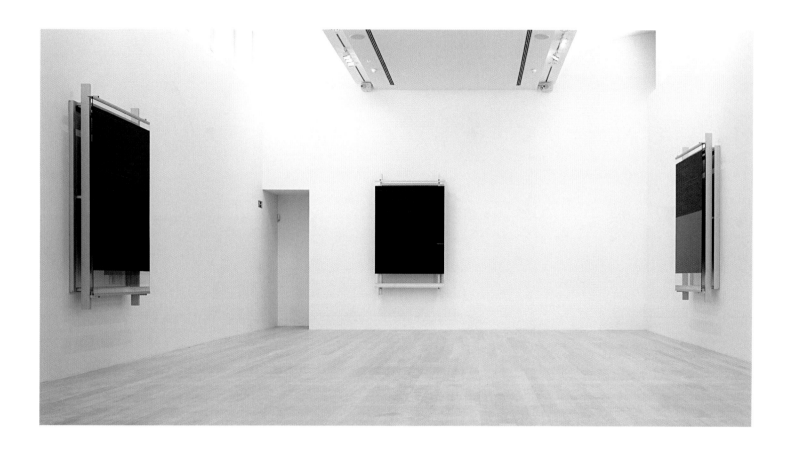

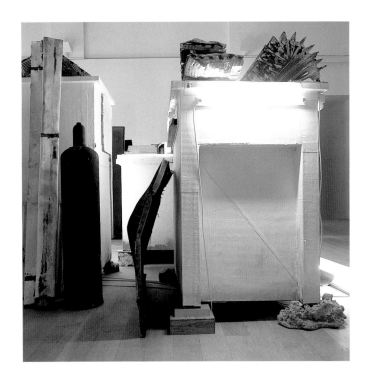
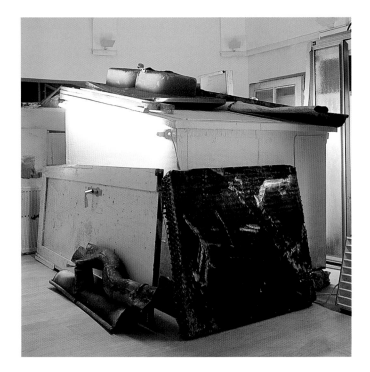

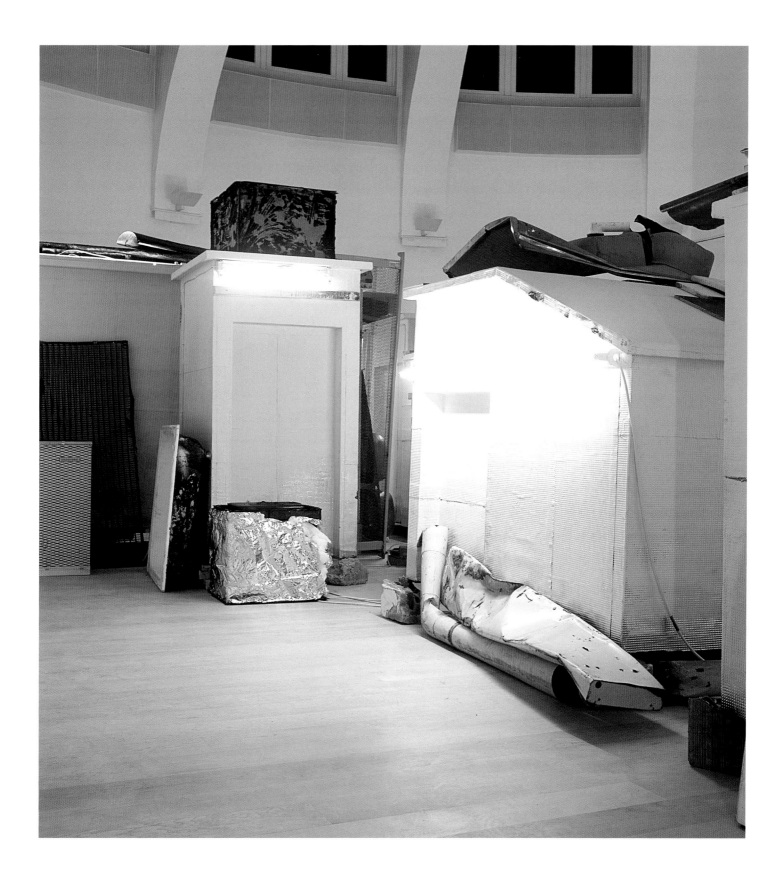

as clearly becomes visible in the series *Cathedral* (1999): brick walls rise up from the floor, between the perfect and the imperfect, between the finished and the unfinished, between the ruin and its permanent reconstruction. Pedro Cabrita Reis's cathedrals prove how "everything that is solid dissolves in the air". The bulwarks of memory give rise to the nostalgia of foresight, in the cyclical and implacable certainty of their nostalgia. *Silence and Vertigo* loom in these constructions, as in the forewarning title of a previous work by the artist.

In some projects carried out between 2000 and 2001, the exploration of the interior/exterior dichotomy is deepened, as well as the use of lighting as a structuring element of the place. This is the case of *Semina* (2000), in which cement beams are installed on the ground, literally covered by uneven-sized parallel lines of fluorescent strip lights that are roughly painted with white acrylic. In turn, in *True Gardens #1* (2000), the natural light allows the convergence of transparency and reflection on the horizontal plane, in an outer patio, with the ground taking on the dimension of a screen for the surrounding sky and garden; while in *True Gardens #2* (2001), it is once again electric light that structures the spatial reality of this interior garden, with the space from the ground to the ceiling being illuminated through the composition defined by several MDF panels, the perimeter of which is bordered by rows of fluorescent lights.

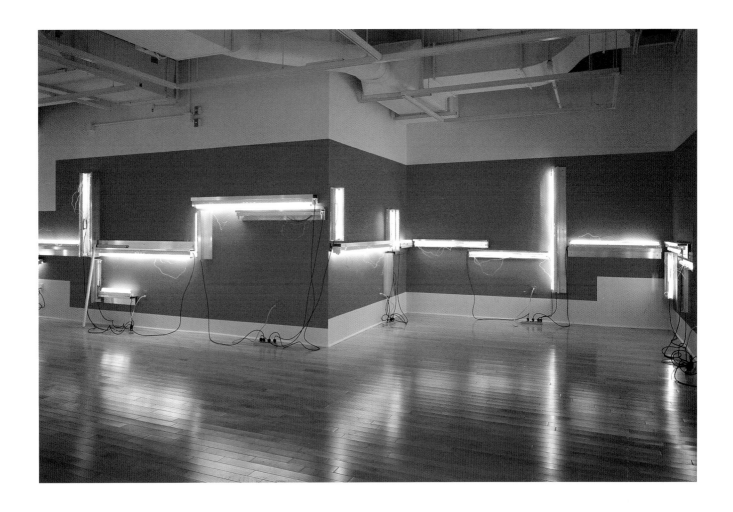

189. I DREAMT YOUR HOUSE WAS A LINE (partial view), 2003

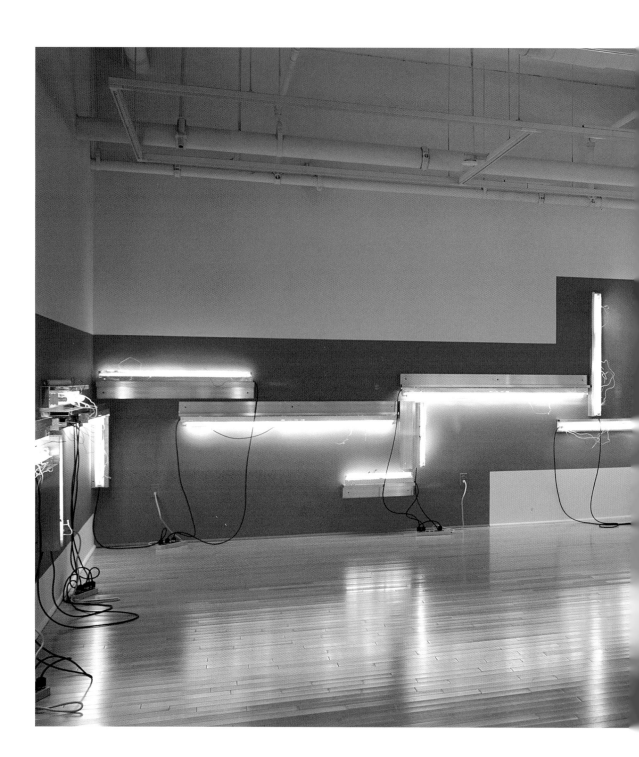

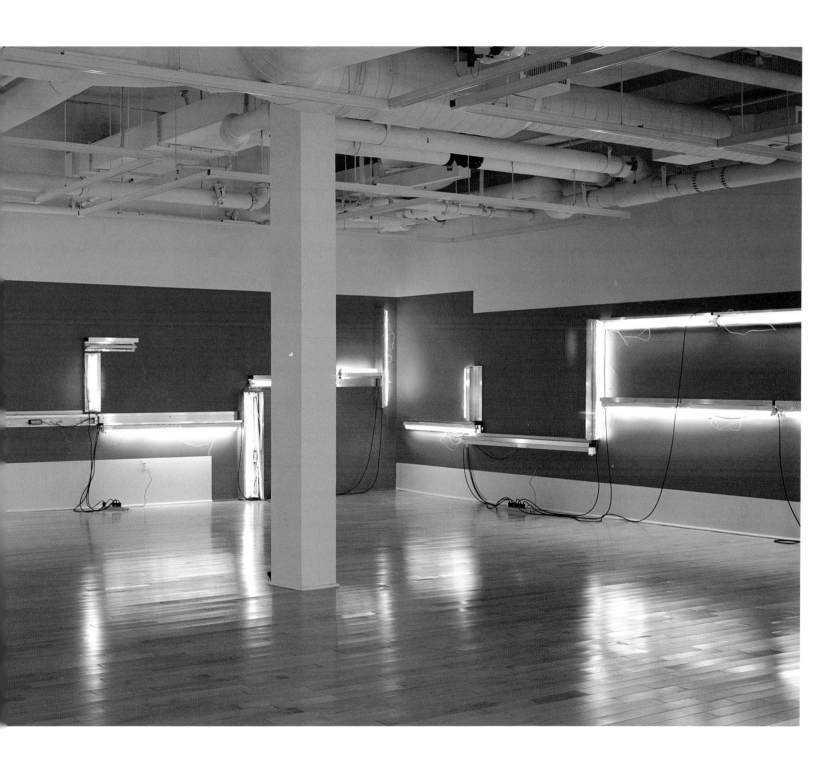

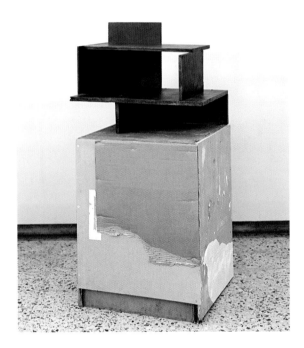

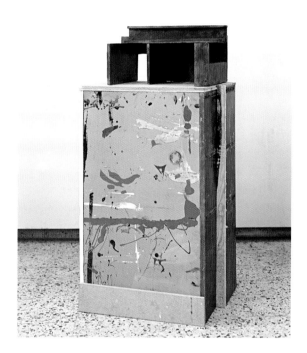

In his projects for the 50th Venice Biennial, in the Giardini and the Giudecca, Pedro Cabrita Reis extends and intensifies some of the fundamental principles of his recent work, with special note for his original reconstruction of the concepts of the interiority and exteriority of a space. Invited both by the curator of the Biennial and by the Portuguese representation, he adds an ephemeral "artist's pavilion" to the Giardini, a place for his uniqueness, independent from the geopolitical map that charts them; at the same time, he simultaneously transforms another place, the space of some old industrial warehouses in the Giudecca, the Antichi Granai.

In the Giardini, a rectangular pavilion rises up, blind, mysterious, windowless, with only one door. Everything foreshadows darkness: the almost military architecture of the building, the absence of openings to the outside, the cubic volumes that stand out on each wall, its setting up in the site. Inside, the visitor is surprised by hundreds of fluorescent strip-lights, supported by a structure that draws out a strange grating, an oneiric reticule in the chaotic undoing of its original rigour and geometrical precision. A dull rumbling becomes perceptible and insistent throughout the whole space: the noise of enormous air conditioning convectors that lower the heat from the strip-lights down to an unexpected and human coolness. The revisiting of some modernist paradigms seems possible in this massive and industrial proliferation of strip-lights. One enters an inferno cool and blind from so much light, as if that final "more light" of Goethe's found a cruel response here, as if all the utopias of an industrial society

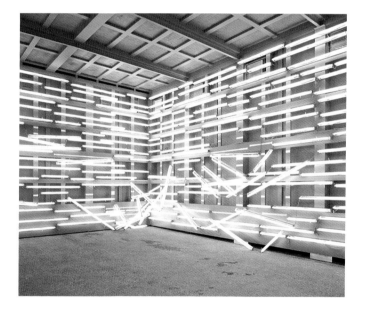

197. **ABSENT NAMES** (partial inside view), 2003

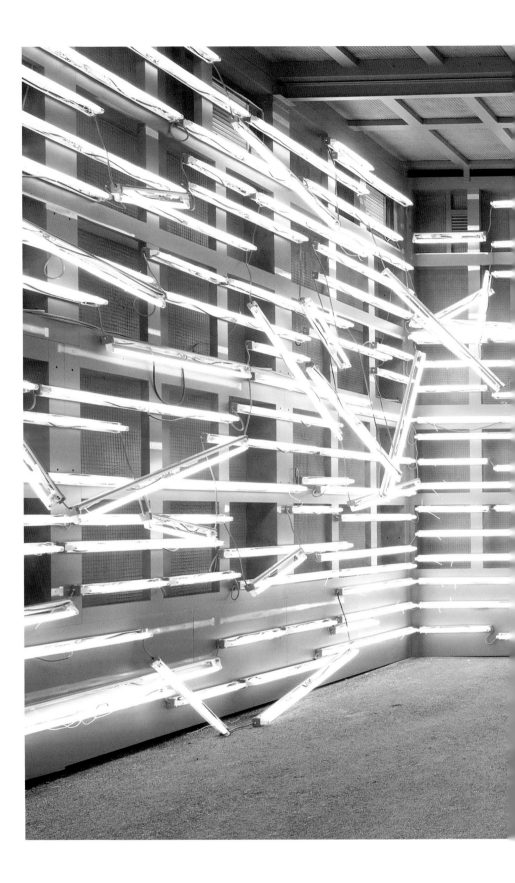

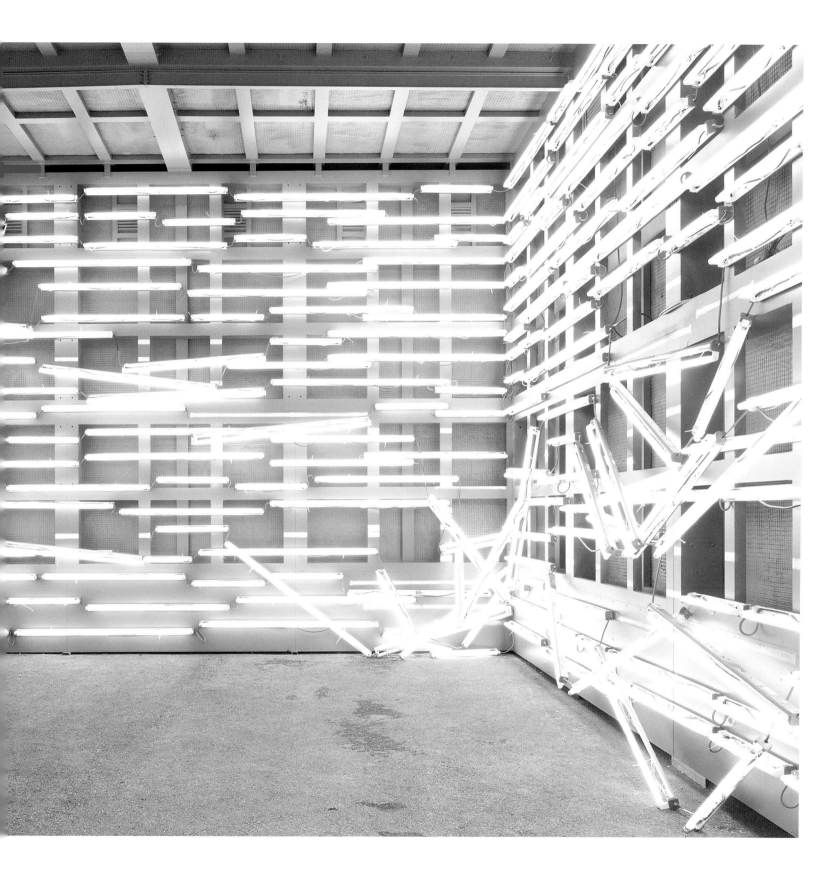

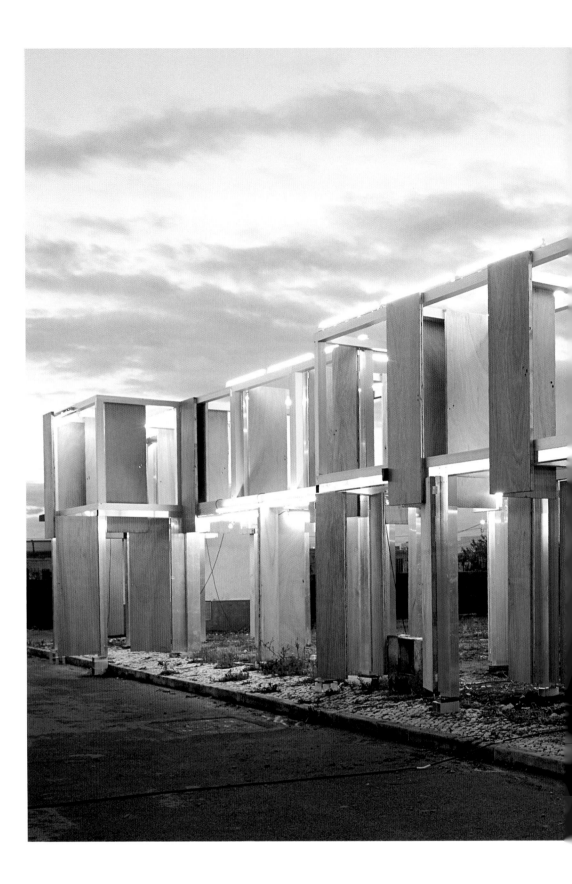

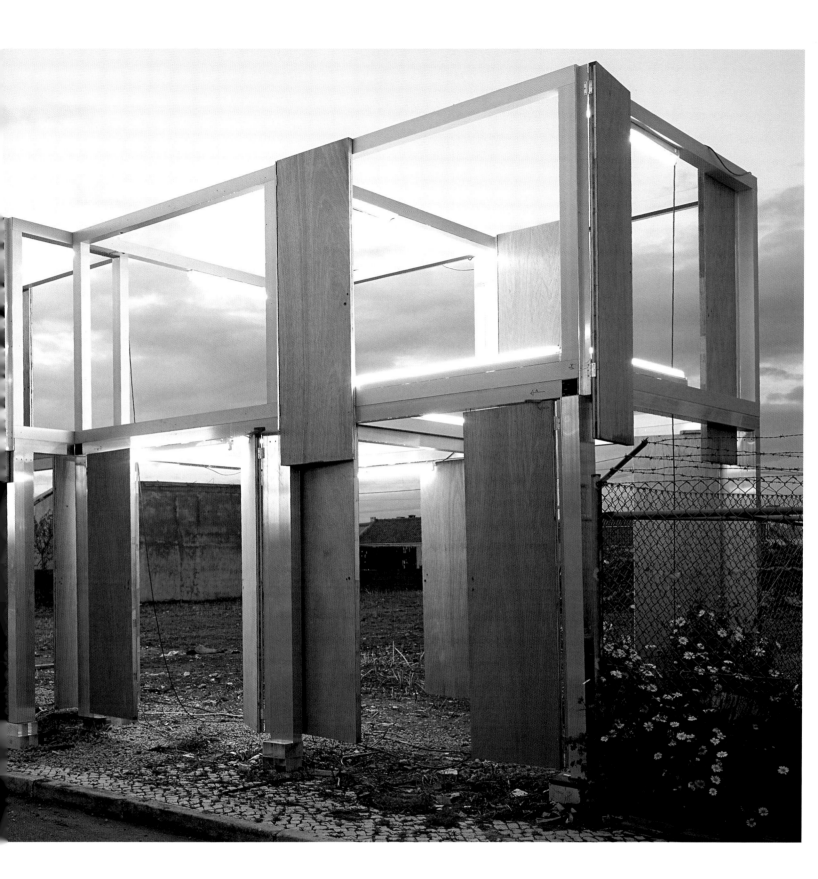

were shown to be obsolete beneath that shadowless, all-dissolving light. The construction seems to assimilate everything and everyone, under an implacable principle of inclusion. Pedro Cabrita Reis's sculpture here irredeemably moves away from the minimal projection of form on space. Light, sound, space and spectator are fused within this coincidence of sensations, in which the reinvention of the space results from its fluidity, the irreducible antithesis of the rigidity of its architecture.

In the Antichi Granai, in the Giudecca, it is, contrarily, semi-darkness that reigns. The spectator discovers, above his head, a house supported by a beam structure that he may glimpse from down upwards. The plane of the projection of the architectural plan is thus subverted by the spectator's being shifted, literally transferred into the bases of the construction that rises up above him. In a city built on stakes in the laguna, now a new building rises up, also resting on a support structure. Inside and above, a labyrinth of varying shapes arouses the curiosity of the visitor, who is always in a cordoned-off area outside and beneath the structure taking shape above his head. The whole trajectory becomes a challenge to the spectator's limits of visibility and perceptibility. Monumental, at times; intimate at others. Projected onto a vertical axis, the spectator is placed at the base of the recognition of what the artist considers to be a primordial human action: the art of construction. Here he can seek his roots, certainties and ambiguities, through this exemplary work of the way Pedro Cabrita Reis reconciles individual subjective awareness and daily life, thus establishing a reconstruction of individual and collective memory, creating an expansion of meaning and proposing a reconstruction of the world. ■

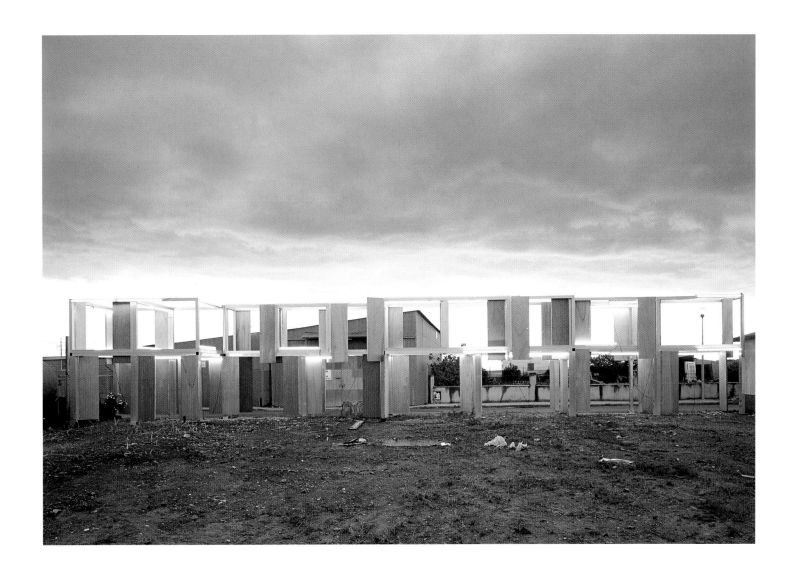

200. **LONGER JOURNEYS**, 2003

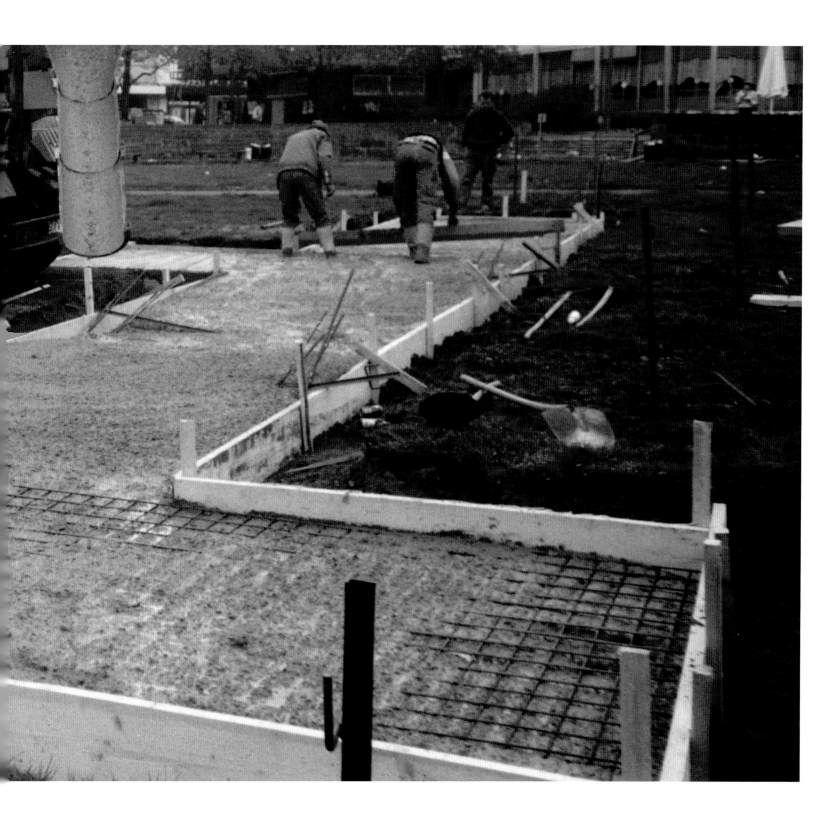

		1	2				7	8

ANTWERP STAIRS | | | **RETRATO DE HOMEM** | | **UNTITLED** | | | **UNTITLED**

1987	**date**	1986		1987	**date**	1987		
160 x 200 x 10 cm	**dimensions**	184 x 12,5 x 3 cm		240 x 240 cm (4 elements,	**dimensions**	60 x 60 cm (4 elements,		
enamel on aluminum	**technique**	enamel on wood		120 x 120 cm each)		20 x 30 cm each)		
the Artist	**collection**	Fundação Luso-Americana, Lisbon		mixed media on wood	**technique**	asphalt and enamel on linen		
Daniel Malhão / Rosário Sousa	**photo**	Paulo Cintra and Laura Castro Caldas		Fundação Luso-Americana, Lisbon	**collection**	Rosa Carvalho, Lisbon		
				Paulo Cintra and Laura Castro Caldas	**photo**	Fabien de Cugnac		

		3	4				9	10

UNTITLED | | | **UNTITLED** | | **A SOMBRA NA ÁGUA #5** | | | **UNTITLED**

1988	**date**	1988		1988	**date**	1986		
30 x 21 cm	**dimensions**	30 x 21 cm		150 X 150 cm	**dimensions**	94 x 75 cm		
ink on paper	**technique**	ink on paper		asphalt on masonite	**technique**	mixed media on wood		
Margarida Cabrita Reis	**collection**	Margarida Cabrita Reis		Luís Valadas Fernandes, Lisbon	**collection**	António Pinto Marques, Lisbon		
Paulo Cintra and Laura Castro Caldas	**photo**	Paulo Cintra and Laura Castro Caldas		Paulo Cintra and Laura Castro Caldas	**photo**	Mário Soares		

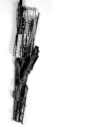
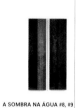

		5	6				11	12

UNTITLED | | | **UNTITLED** | | **A SOMBRA NA ÁGUA #8, #9** | | | **MELANCOLIA**

1985	**date**	1985		1988	**date**	1989		
200 x 265 cm	**dimensions**	203 x 40 x 39 cm		dyptich (205 x 52 cm each)	**dimensions**	230 x 100 x 80 cm		
mixed media on	**technique**	mixed media		asphalt on masonite	**technique**	enamel on fiberglass and oil lamp		
masonite standard doors				Carlos Sousa, Porto, on loan to	**collection**	Fundação Paço d'Arcos, Lisbon		
Manuel Reis, Lisbon	**collection**	Fundação Luso-Americana, Lisbon		Serralves, Museu de Arte				
Pedro Calapez	**photo**	Paulo Cintra and Laura Castro Caldas		Contemporânea, Porto				
				José Fabião	**photo**	Paulo Cintra and Laura Castro Caldas		

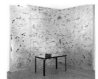

13

CELEBRATIO

	date	1989
	dimensions	300 x 328 x 224 cm
	technique	painted wood, iron and glass table
		and bronze cast of bread
	collection	Carlos Sousa, Porto, on loan to
		Serralves, Museu de Arte
		Contemporânea, Porto
	photo	José Fabião

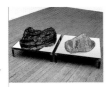

14

AS APARÊNCIAS

1988
205 x 100 x 73 cm
iron, mirror, papier-mâché
and tree trunk
Paulo Pimenta, Famalicão

José Fabião

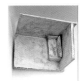

19

A CASA DO CÉU

	date	1989
	dimensions	200 x 164 x 80 cm
	technique	painted wood
	collection	Peter Meeker, Lisbon,
		on loan to Serralves, Museu de Arte
		Contemporânea, Porto
	photo	Paulo Cintra and Laura Castro Caldas

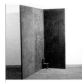

20

UM QUARTO DENTRO DA PAREDE

1989
200 x 164 x 80 cm
synthetic resins and painted wood
Peter Meeker, Lisbon,
on loan to Serralves, Museu de Arte
Contemporânea, Porto
Paulo Cintra and Laura Castro Caldas

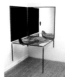

15

MAGNIFICAT

	date	1988
	dimensions	178 x 100,5 x 100,5 cm
	technique	iron and glass table, iron framed
		painted glass, iron framed
		painted mirror and leadplate
	collection	Colecção Serpa, Lisbon
	photo	José Fabião

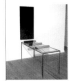

16

COCTEAU

1988
215 x 61 x 182 cm
iron and glass table,
iron tubes, glass and velvet

the Artist
José Fabião

21

MOINHOS DE VENTO

	date	1989
	dimensions	15 x 160 x 160 cm
	technique	iron, fiberglass and glass
	collection	the Artist
	photo	Paulo Cintra and Laura Castro Caldas

22

MORITURI

1989
30 x 100 x 200 cm
iron, asphalt on fiberglass,
gold leaf and paint on glass
Fundação Paço d'Arcos
Paulo Cintra and Laura Castro Caldas

17

HORAS DE CALOR

	date	1989
	dimensions	74 x 200 x 100 cm
	technique	painted wood and concrete
	collection	Francisco Capelo, Lisbon
	photo	Luisa Ferreira

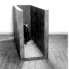

18

INFERNO

1989
107 x 65,5 x 201 cm
painted wood, ceramic dog
and synthetic resins
Fundação Luso-Americana, Lisbon
Paulo Cintra and Laura Castro Caldas

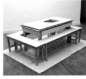

23

A CASA DA POBREZA

	date	1989
	dimensions	62 x 200 x 140 cm
	technique	wood and plaster
	collection	European Parliament, Strasbourg
	photo	Luisa Ferreira

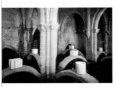

24

SILÊNCIO E VERTIGEM

1990
site specific / variable dimensions
wood, plaster and copper tubes
the Artist (project)
Paulo Cintra and Laura Castro Caldas
exhibited Silêncio e Vertigem, Igreja de Santa
Clara-a-Velha, Coimbra, 17.11.90

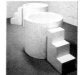 25 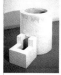 26

B.A.A.D.M.

1990	**date**	1990
two elements	**dimensions**	80 x 110 x 69 cm
(73 x135,5 x 90,5 cm each)		
wood and plaster	**technique**	wood and plaster
Museum of Contemporary Art, San Diego	**collection**	Fernando Meana, Madrid
Hughes Colson	**photo**	Fanny Fotografos

FONTE

 31 32

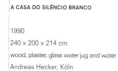

SOLEDAD, SEQUEDAD

1990	**date**	1990
57 x 493 x 143 cm	**dimensions**	240 x 200 x 214 cm
wood and plaster	**technique**	wood, plaster, glass water jug and water
private collection, Berlin	**collection**	Andreas Hecker, Köln
Claudio del Campo	**photo**	Claudio del Campo

A CASA DO SILÊNCIO BRANCO

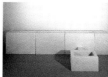 27 28

UMA LINHA AFLUENTE

1990	**date**	1990
70 x 350 x 110 cm	**dimensions**	94 x 78 x 78 cm
wood and plaster	**technique**	wood, plaster and copper tube
Peter Meeker, Lisbon, on loan to MNCA Reina Sofia, Madrid	**collection**	Rina Lowie, Knokke
Fanny Fotografos	**photo**	Dirk Geysels

UT COGNOSCANT TE

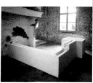 33 34 35

A CASA DE FONTEINSTRAAT

1990	**date**	1990
80 x 670 x 340 cm	**dimensions**	300 x 1200 x 30 cm
wood and plaster	**technique**	wood and plaster
Museum Van Hedendaagse Kunst, Ghent	**collection**	the Artist (project)
Dirk Pauwels	**photo**	Paulo Cintra and Laura Castro Caldas

A CASA DOS SUAVES ODORES

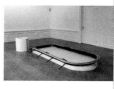 29 30

D(OOR) D(AM)

1990	**date**	1990
70 x 380 x 173 cm	**dimensions**	185 x 780 x 92 cm
wood, plaster, cooper tubes and found door frame	**technique**	wood, plaster and rubber tubes
Centro de Arte Moderna da Fundação Calouste Gulbenkian, Lisbon	**collection**	Raf Declerq, Knokke
Victor Arnolds	**photo**	Dirk Geysels

ASCENSÃO

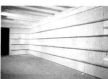 36 37

A CASA DA SERENIDADE

1990	**date**	1990
site specific / variable dimensions	**dimensions**	165 x 220 x 60 cm
wood, plaster, glass water jug, water and plumb	**technique**	wood, plaster and glass jug with olive oil
the Artist (project)	**collection**	Centro de Arte Moderna da Fundação Calouste Gulbenkian, Lisbon
Manuel Aguiar	**photo**	Manuel Aguiar
Galeria Roma e Pavia / Pedro Oliveira, Porto, 19.01.90	**exhibited**	

A CASA DO ESQUECIMENTO

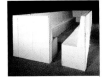

38 39

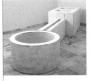

A CASA DA FAMÍLIA		**A CASA DOS MURMÚRIOS**
1990	date	1990
147 x 1000 x 250 cm	dimensions	73 x 400 x 100 cm
wood, plaster and glass "pórron" with water	technique	wood and plaster
the Artist (project)	collection	Serralves Museu de Arte Contemporânea, Porto
Martin Garcia Perez	photo	Claudio del Campo

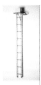

44 45

MY HEAD		**UNTITLED**
1991	date	1991
262 x 43 x 39,5 cm	dimensions	51 x 190,5 x 20,5 cm
plaster, glass, copper and rubber tubes and iron ladder	technique	wood, plaster, copper and rubber tubes
Ms and Mr Robert Mollers, Houston	collection	Rhona Hoffman, Chicago
Tony Cunha	photo	Michael Tropea

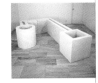

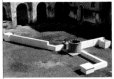

40 41

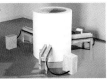

46 47

A CASA DA PAIXÃO E DO PENSAMENTO		**ALEXANDRIA**
1990	date	1990
70 x 281 x 206 cm	dimensions	site specific / variable dimensions
wood and plaster	technique	wood and plaster
Peter Meeker, Lisbon, on loan to M.N.C.A. Reina Sofia, Madrid	collection	the Artist (project)
Fanny Fotografos	photo	Paulo Cintra and Laura Castro Caldas
	exhibited	Alexandria, Convento de S. Francisco, Beja, 28.07.90

GENITRIX		**ABSORTO**
1991	date	1991
122 x 102 x 123 cm	dimensions	80 x 200 x 235 cm
wood, plaster, felt, glass, copper and rubber tubes	technique	wood, plaster, felt, copper and rubber tubes
the Artist	collection	Instituto Valenciano de Arte Moderno, Valencia
Michael Tropea	photo	Fanny Fotografos

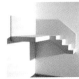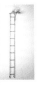

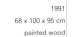

42 43

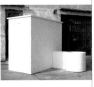

48 49

ESCADAS DE CANTO		**WATERFALL**
1991	date	1991
68 x 100 x 95 cm	dimensions	265 x 39,5 x 30,5 cm
painted wood	technique	glass, iron ladder, glass water jug and water
Pinto da Fonseca, Lisbon	collection	Art Gallery of Ontario, Ontario
Manuel Aguiar	photo	Tony Cunha

VITE PARALELE		**O MESMO E OUTRO**
1991	date	1991
221 x 282 x 261 cm	dimensions	152 x 125 x 59 cm
wood and plaster	technique	wood and plaster
the Artist (project)	collection	Camille and Paul Oliver Hoffman, Chicago
Giuseppe Bozzola	photo	Michael Tropea

 50 51 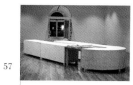 56 57

DESENHADO NO CÉU		GÉMEOS
1991	date	1991
75 x 59 x 40 cm	dimensions	197 x 89 x 16,5 cm
wood, plaster and felt	technique	wood, plaster, felt, copper and rubber tubes
private collection, Chicago	collection	Jorge Molder, Lisbon
Michael Tropea	photo	Tony Cunha

JARDIM DE IRMÃOS		SCALA COELI
1992	date	1992
site specific / variable dimensions	dimensions	80 x 600 x 250 cm
wood chairs, wood library stairs, felt, paper, glass water jugs and sheets	technique	wood table, plaster and linen sheets
Moderna Galerija, Museum of Modern Art, Ljubljana	collection	the Artist (project)
Matija Pavlovec	photo	Claudio del Campo
Silence – Contradictory Shapes of Truth, Moderna Galerija, Museum of Modern Art, Ljubljana, 19.05.92	exhibited	

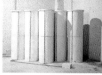 52 53 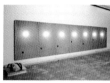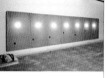 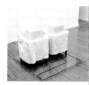 ... 58 59

BERLIN PIECE		O MEU CORPO
1991	date	1991
240 x 360 x 190 cm	dimensions	30,5 x 25,4 x 25,4 cm
wood, plaster and copper tubes	technique	wood and felt (graphite drawing inside)
Dr. Georg Ludwig, Krefeld	collection	Jocelyn and Andre Gordt-Vanthournouts, Kortrijk
Werner Zelien	photo	Tony Cunha

H. SUITE VI		ANJOS CAÍDOS / (UMA LUZ INTERDITA II)
1992	date	1992
133 x 861 x 100 cm	dimensions	site specific / variable dimensions
wood, plywood, sandblasted glass, electric cables, lightbulbs, burlap, plastic hoses and wrapping tape	technique	plywood, plaster, felt and graphite wall drawings
Banco Privado, Lisbon, on loan to Serralves, Museu de Arte Contemporânea, Porto	collection	the Artist
Mário de Oliveira	photo	Joseph Loderer
	exhibited	Uma Luz Interdita, Kunstraum München, Munich, 26.11.92

 54 55 60 61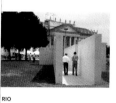

CONVERSATION PIECE		TESTEMUNHA
1991	date	1991
83 x 100 x 100 cm	dimensions	94 x 61 x 99 cm
wood, felt, plaster, glass, and copper tubes	technique	wood, plaster, felt, glass and copper tubes
M. Margoulis, Miami	collection	Elayne and Marvin Mordes, Baltimore
Luisa Ferreira	photo	Michael Tropea

H. SUITE (the first one)		RIO
1992	date	1992
100 x 253 x 157 cm	dimensions	255 x 630 x 2530 cm
wood, glass, lamp, pillow and plaster	technique	lime stone
the Artist	collection	the Artist (project)
Fanny Fotografos	photo	Dirk Pauwels

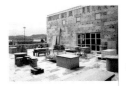 62 63

DAS MÃOS DOS CONSTRUTORES II

date 1994

dimensions site specific / variable dimensions

technique fibrociment draining structures, bricks, found wood table, stolen bicycle, geranium in flower pots and iron-mash containers

collection Ministério da Cultura, Portugal, on loan to Centro Cultural de Belém, Fundação das Descobertas, Lisbon

photo Paulo Cintra and Laura Castro Caldas

exhibited Centro Cultural de Belém, Fundação das Descobertas, Lisbon, 20.09.94

DAS MÃOS DOS CONSTRUTORES I

date 1993

dimensions site specific / variable dimensions

technique wood, cement, bricks, fibrocement and wood ladder

collection the Artist (project)

photo José Fabião

exhibited Cerco, Bienal Internacional de Óbidos, Óbidos, 09.10.93

H. SUITE X

date 1993

dimensions 90 x 256 x 100 cm

technique wood, glass, glass water jug half filled with water, found zink bathtub, copper tubes, rubber hoses and linen sheets

collection Fond Nacional d'Art Contemporain / Centre d'Art Domaine de Kerguehennec, Locminé

photo Laurent Sillian

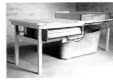 68 69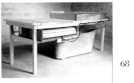

A SALA DOS MAPAS / ATLAS COELESTIS III

date 1994

dimensions site specific / variable dimensions, 7 elements (each: 140 x 125 x 160 cm)

technique wood, plywood, sandblasted and transparent glass, copper tubes, rubber hoses, graphite drawing on plywood and paper

collection the Artist

photo Paulo Cintra and Laura Castro Caldas

exhibited A Sala dos Mapas, Museu José Malhoa, Caldas da Rainha, 30.04.94

 64 65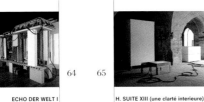

ECHO DER WELT I

date 1993

dimensions 304 x 500 x 133 cm

technique wood, plasterboard, plaster, bricks, burlap, found wood chair and table, found radiator, glass water jug half filled with water, oil colour on cardboard, drawing on tracing paper, book, copper tubes, rubber hoses, electric cables and light bulbs

collection Serralves, Museu de Arte Contemporânea, Porto

photo Eliane Laubscher

H. SUITE XIII (une clarté interieure)

date 1993

dimensions site specific / variable dimensions (3 elements)

technique wood, plywood, plaster, copper and rubber tubes, sandblasted glass, electric cables and lamps

collection the Artist

photo Francisco Artigas

exhibited Nos Rêves Façonnent le Monde, Moulins Albigeois, Albi, 22.06.93

ECHO DER WELT III

date 1994

dimensions 233 x 326 x 152 cm

technique wood, foam, sandblasted glass, copper tubes, rubber hoses, juta and felt strips, rope, electric cables, light bulbs and found wood stool

collection the Artist

photo Lado Mlekuz

 70 71

PROFONDO E PERMANENTE

date 1994

dimensions 104 x 80 x 58 cm

technique iron, plastic recipients, bed sheets, plastic tubes and copper tubes

collection Oliva Arauna, Madrid

photo Paolo Pellion

 66 67

MEUS PAIS DERAM-ME AQUILO QUE PODIAM, ALMA DA SUA DIVERSA

date 1993

dimensions 92,5 x 540 x 135 cm

technique wood, sandblasted glass, iron, nettle, two found wood boxes, two found warehouse lamps, found tin pan, electric cables and light bulbs

collection Centro de Arte Contemporânea da Fundação Calouste Gulbenkian, Lisbon

photo Mário de Oliveira

H. SUITE IX

date 1993

dimensions 170 x 240 x 30 cm

technique plywood, sandblasted glass, nettle and light bulb

collection M.N.C.A. Reina Sofia, Madrid

photo Fanny Fotografos

ATLAS COELESTIS I

date 1994

dimensions 110 x 160 x 160 cm

technique sandblasted glass, mirror, three found wood chairs, wool fabric, rubber hoses, electric cables and light bulb

collection the Artist

photo Fanny Fotografos

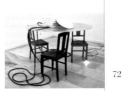 72 73

POSTO DE OBSERVAÇÃO / ATLAS COELESTIS V

date 1994

dimensions 400 x 570 x 270 cm

technique wood, glass, workers' safety helmets and rain coats

collection Serralves, Museu de Arte Contemporânea, Porto

photo Mário de Oliveira

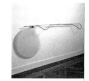

74 75

MACCHINA PER VERIFICARE / IDENTITÁ
E LUOGO, TORINO

1994	date	1994
90 x 260 x 15 cm	dimensions	site specific / variable dimensions
sandblasted glass, wood, iron,	technique	sandblasted glass, mirrors,
copper tube, rubber hose,		terracota, rubber hoses, plastic
adhesive tape and clamps		tubes, steel basin with clay, wood
		and found object
Collezione Massobrio, Turin	collection	the Artist
Paolo Pellion	photo	José Pessoa
	exhibited	Depois de Amanhã, Centro Cultural
		de Belém, Lisbon, 20.09.94

OS OBSERVADORES / ATLAS COELESTIS VI

80 81

ORFANATO

1995	date	1995
208 x 80 x 44 cm	dimensions	200 x 100 x 100 cm
iron structure, plywood, enamel on	technique	iron structure, electric cables
fluorescent lamps,		and halogen spots
electric cables and dishes		
Museum of Contemporary Art,	collection	private collection, Madrid
Sarajevo		
Paulo Cintra and Laura Castro Caldas	photo	Concha Aizpuru

ROOM

76 77

INSTRUMENTO PARA MEDIÇÕES NO
CÉU / ATLAS COELESTIS II

1994	date	1994
site specific / variable dimensions	dimensions	218 x 82 x 32 cm
steel, rubber hoses and wrapping tape	technique	iron, rubber strip, glass,
		mdf and bed sheets
Patricia Garrido, Lisbon	collection	the Artist
Paulo Cintra and Laura Castro Caldas	photo	Victor Dahmen

REPORT #1, KÖLN

82 83

FURTIVO FRA LE TENEBRE VI

1994	date	1994
160 x 130 cm	dimensions	160 x 130 cm
graphite, pastel and	technique	graphite and pastel on paper
varnish on paper		
Patricia Garrido, Lisbon	collection	Margarida Cabrita Reis, Lisbon
Vitor Branco / Campiso Rocha	photo	Vitor Branco / Campiso Rocha

FURTIVO FRA LE TENEBRE IX

78 79

MODELO PARA TERRITÓRIO MÍNIMO

1994	date	1994
215 x 214 x 35 cm	dimensions	174 x 98 x 30 cm
plywood, wool blanket and plastic	technique	plywood, glass, tracing paper,
recipients with water		fluorescent lights and electric cables
the Artist	collection	private collection, Valencia
Eduardo Ortega	photo	Paolo Pellion

TRE FIUMI

84 85

LOS CIEGOS, 1st series #1, #2, #3, #4

1995	date	1995
140 x 400 cm, 4 elements,	dimensions	140 x 200 cm
two sheets each (70 x 100 cm each)		4 sheets (70 x 100 cm each)
graphite, pastel and varnish on paper	technique	asphalt and white spirit
		silkscreened on paper
Juana de Aizpuru, Madrid	collection	the Artist
Paulo Cintra and Laura Castro Caldas	photo	Paulo Cintra and Laura Castro Caldas

CONVERSATION PIECE, 1st series, #7

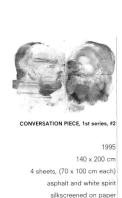

86 87

CONVERSATION PIECE, 1st series, #2

1995	date	1995
140 x 200 cm	dimensions	160 x 120 cm
4 sheets, (70 x 100 cm each)	technique	
asphalt and white spirit		graphite and varnish on paper
silkscreened on paper		
Museo Alejandro Otero, Caracas	collection	Caja de Astúrias, Gijon
Paulo Cintra and Laura Castro Caldas	photo	Paulo Cintra and Laura Castro Caldas

O QUE OS OLHOS VÊEM #7

92 93

S. VITO #2

1997	date	1997
87 x 75 x 19 cm	dimensions	118 X 95 X 18 cm
aluminium window frame, wood,	technique	aluminium window frame, wood
glass, mirror and wrapping tape		and enamel on glass
Paul and Stacy Polidor, Des Moines	collection	Bruno Mussatti, S. Paulo
Vicente de Mello	photo	Vicente de Mello

S. VITO #1

88 89

O QUE OS OLHOS VÊEM #6

1995	date	1995
160 x 120 cm	dimensions	110 x 700 x 40 cm
graphite and varnish on paper	technique	galvanized iron fences, wood and
		Italian newspapers
Patricia Garrido	collection	the Artist
Paulo Cintra and Laura Castro Caldas	photo	Paolo Rosseti

BANDIERE ROSSE E CAPITALE

94 95

A COR DA QUALIDADE

1997	date	1997
227 x 111 x 19,5 cm	dimensions	78,5 x 81 x 15 cm
wood, enamel on glass,	technique	found palette, aluminium and
aluminium and rubber strip		enamel on glass
Frederick Bohen Foundation, New York	collection	Patricia Garrido, Lisbon
Vicente de Mello	photo	Paulo Cintra and Laura Castro Caldas

WINDOW #1

90 91

TOWARDS THE OUTSIDE LIGHT

1995	date	1997
441 x 204 x 404 cm	dimensions	90 x 90 cm
galvanized iron platform, tripod with	technique	polyester filler paste
halogen spots and window		and oil on canvas
the Artist	collection	António Marieiro, Aveiro
Paolo Rosseti	photo	José Manuel Costa Alves

S. PAINTINGS #31

96 97

COPAN

1997	date	1997
298 x 140 x 20 cm	dimensions	218 x 76 x 20 cm
enamel on glass, wood, iron,	technique	aluminium, wood, enamel on glass
plastic and rubber strip		and rubber strip
Art Gallery of Ontario, Ontario	collection	Frederick Bohen Foundation, New York
Vicente de Mello	photo	Vicente de Mello

JARDINS #2 (PRETO)

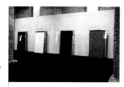

98 99

STUDY FOR DOBLES PINTURAS NEGRAS

1997	date
77 x 160 x 7,5 cm	dimensions
wood, aluminium and oil on glass	technique
Carlos de Sousa, on loan to Serralves, Museu de Arte Contemporânea, Porto	collection
Paulo Cintra and Laura Castro Caldas	photo

LISBON GATES

1997
4 elements (Red: 238 x 180 x 38 cm;
Alabaster: 298 x 165 x 38 cm;
Black: 250 x 212 x 38 cm;
Blue: 270 x 156 x 38 cm)
found steel door frames
and enamel on glass
Museum Moderner Kunst–Stiftung
Ludwig Wien, Wien

Attilio Maranzano

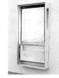

105 106

ONE OF MY CHILDREN

1998	date
23,5 x 12,5 x 8 cm	dimensions
enamel on wood bed, enamel on glass, aluminium electric cables and fluorescent light	technique
the Artist	collection
PCR Studio / Tânia Simões	photo

DANS LES VILLES #1

1998
204 x 738 x 20 cm
aluminium door frames, plywood,
standard masonite doors and silicone

the Artist

Marc Domage

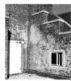

100
101 102

LA CHAMBRE DE PÉTRARQUE

1997	date
site specific / variable dimensions	dimensions
wood table, acrylic paint on mirrors and found stone	technique
the Artist (project)	collection
Claude Gaspari	photo
L'arrière-pays, Chateau des Adhémar, Montelimar, 27.06.97	exhibited

ESTRADA DAS LÁGRIMAS

1997
130 x 122 x 18 cm
enamel on glass, wood, aluminium
window frame, wrapping tape and
rubber strip
Fernando Meana, Madrid
Vicente de Mello

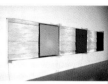
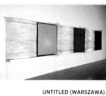
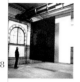

107 108

UNTITLED (WARSZAWA)

1998	date
170 x 690 x 30 cm	dimensions
aluminium, alkyd and enamel on glass, electric cables and fluorescent lights	technique
the Artist (on temporary loan to Zacheta Gallery, Contemporary Art, Warsaw)	collection
José Manuel Costa Alves	photo

LARGE GLASS, WHITE AND RED

1998
site specific (two glasses,
each: 430 x 300 x 1,5 cm)
oil colour on laminated glass
and iron beams

Statens Konstrad (The National
Public Art Council), Stockholm

Mathias Givell
Arkipelag, Ferdinand Boberg's
Powerstation, Skansen, Stockholm,
16.01.98

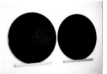

103 104

NEW YORK RED AND BLACK WINDOW

1997	date
site specific (75 x 90 x 30 cm)	dimensions
aluminium window frame, enamel on glass and mirror	technique
the Artist (on permanent loan to PS1, New York)	collection
Bill Orcutt	photo
PS1 Reopening/Artists Projects, PS1, New York, 26.10.97	exhibited

IL LIBRO

1998
280 x 200 x 22 cm
aluminium, wood, plywood, found
plastic with wrapping tape and fabric
the Artist (on temporary loan to
Museo Pecci, Prato)
Carlo Fei

109 110

DOBLES PINTURAS NEGRAS #4

1998	date
153 x 303 x 5 cm	dimensions
aluminium shelves and alkyd on laminated glass	technique
Pedro Almeida Freitas, Guimarães	collection
P. F. Lorenzo	photo

BLIND CITIES #1

1998
435 x 600 x 30 cm
aluminium door frames, standard
masonite doors, enamel on
plexiglas, wood and wrapping tape
the Artist
Vicente de Mello

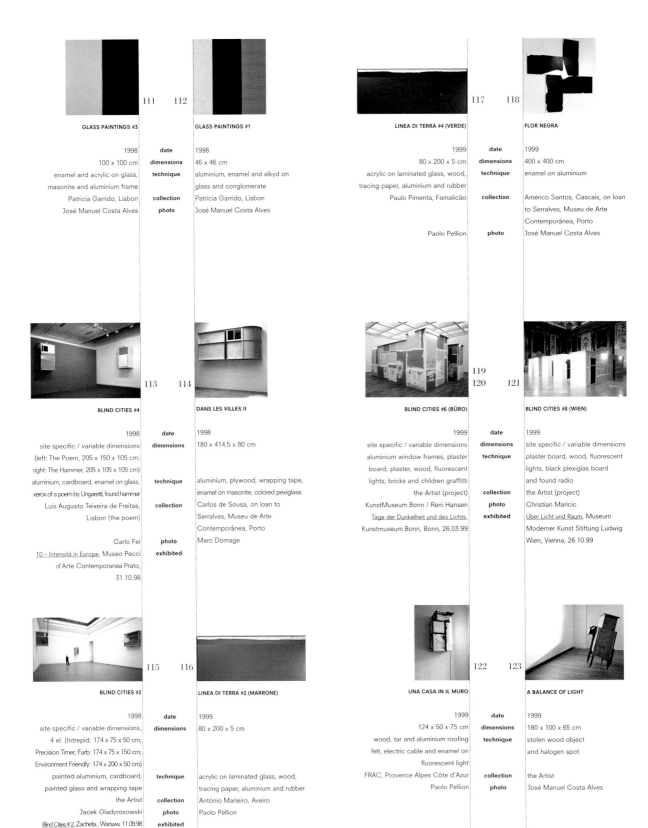

111 112

GLASS PAINTINGS #3

1998	date	1998
100 x 100 cm	dimensions	46 x 46 cm
enamel and acrylic on glass, masonite and aluminium frame	technique	aluminium, enamel and alkyd on glass and conglomerate
Patricia Garrido, Lisbon	collection	Patricia Garrido, Lisbon
José Manuel Costa Alves	photo	José Manuel Costa Alves

GLASS PAINTINGS #1

117 118

LINEA DI TERRA #4 (VERDE)

1999	date	1999
80 x 200 x 5 cm	dimensions	400 x 400 cm
acrylic on laminated glass, wood, tracing paper, aluminium and rubber	technique	enamel on aluminium
Paulo Pimenta, Famalicão	collection	Américo Santos, Cascais, on loan to Serralves, Museu de Arte Contemporânea, Porto
Paolo Pellion	photo	José Manuel Costa Alves

FLOR NEGRA

113 114

BLIND CITIES #4

1998	date	1998
site specific / variable dimensions (left: The Poem, 205 x 150 x 105 cm; right: The Hammer, 205 x 105 x 105 cm)	dimensions	180 x 414,5 x 80 cm
aluminium, cardboard, enamel on glass, xerox of a poem by Ungaretti, found hammer	technique	aluminium, plywood, wrapping tape, enamel on masonite, colored pexiglass
Luís Augusto Teixeira de Freitas, Lisbon (the poem)	collection	Carlos de Sousa, on loan to Serralves, Museu de Arte Contemporânea, Porto
Carlo Fei	photo	Marc Domage
10 – Intensità in Europe, Museo Pecci d'Arte Contemporanea Prato, 31.10.98	exhibited	

DANS LES VILLES II

119
120 121

BLIND CITIES #6 (BÜRO)

1999	date	1999
site specific / variable dimensions	dimensions	site specific / variable dimensions
aluminium window frames, plaster board, plaster, wood, fluorescent lights, bricks and children graffitti	technique	plaster board, wood, fluorescent lights, black plexiglas board and found radio
the Artist (project)	collection	the Artist (project)
KunstMuseum Bonn / Reni Hansen	photo	Christian Maricic
Tage der Dunkelheit und des Lichts, Kunstmuseum Bonn, Bonn, 26.03.99	exhibited	Über Licht und Raum, Museum Moderner Kunst Stiftung Ludwig Wien, Vienna, 26.10.99

BLIND CITIES #8 (WIEN)

115 116

BLIND CITIES #2

1998	date	1999
site specific / variable dimensions, 4 el. (Intrepid: 174 x 75 x 50 cm; Precision Timer, Farb: 174 x 75 x 150 cm; Environment Friendly: 174 x 200 x 50 cm)	dimensions	80 x 200 x 5 cm
painted aluminium, cardboard, painted glass and wrapping tape	technique	acrylic on laminated glass, wood, tracing paper, aluminium and rubber
the Artist	collection	António Marieiro, Aveiro
Jacek Gladyrosowski	photo	Paolo Pellion
Blind Cities # 2, Zacheta , Warsaw, 11.09.98	exhibited	

LINEA DI TERRA #2 (MARRONE)

122 123

UNA CASA IN IL MURO

1999	date	1999
124 x 50 x 75 cm	dimensions	180 x 100 x 65 cm
wood, tar and aluminium roofing felt, electric cable and enamel on fluorescent light	technique	stolen wood object and halogen spot
FRAC, Provence Alpes Côte d'Azur	collection	the Artist
Paolo Pellion	photo	José Manuel Costa Alves

A BALANCE OF LIGHT

BLIND CITIES #5 (THE ECHO)

1999	**date**
site specific / variable dimensions	**dimensions**
plywood, tar and aluminium roofing felt, aluminium window frames and acrylic on glass	**technique**
the Artist	**collection**
José Manuel Costa Alves	**photo**
Blind Cities #5, Galleria Giorgio Persano, Turin, 10.03.99	**exhibited**

124 125

CABINET D'AMATEUR #1

1999

site specific / variable dimensions, 77 paintings (each 100 x 100 cm)

acrylic on plexiglas, aluminium frame and plywood

Pedro Almeida Freitas, on loan to Serralves, Museu de Arte Contemporânea, Porto

José Manuel Costa Alves

Da Luz e do Espaço, Serralves, Museu de Arte Contemporânea, Porto, 20.11.99

131

EIN GETEILTES HAUS

2000	**date**
site specific / variable dimensions	**dimensions**
bricks, concrete, light bulb, electric cable, aluminium, masonite door and German dictionaries	**technique**
the Artist (project) Sebastian Schobbert	**collection** / **photo**
Ein Geteiltes Haus, Galerie Markus Richter, Berlin, 05.02.00	**exhibited**

132 133

TO ASCERTAIN SOMETHING

2000

site specific / variable dimensions

bricks, concrete, wood door frames and nail

the Artist (project)

Peter Cox

The Vincent Award, Bonnefanten Museum, Maastricht, 09.06.00

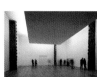

127 126

CATEDRAL #3, (PORTO)

1999	**date**
site specific / variable dimensions	**dimensions**
bricks, concrete, wood and iron wire	**technique**
the Artist (project)	**collection**
José Manuel Costa Alves	**photo**
Da Luz e do Espaço, Serralves, Museu de Arte Contemporânea, Porto, 20.11.99	**exhibited**

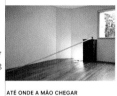

127 128

ATÉ ONDE A MÃO CHEGAR

1999

site specific / variable dimensions

acrylic on window, bricks, concrete, enamel on fluorescent lights, flag pole

the Artist (project)

José Manuel Costa Alves

Da Luz e do Espaço, Serralves, Museu de Arte Contemporânea, Porto, 20.11.99

134

A ROOM FOR A POET

2000	**date**
site specific / variable dimensions	**dimensions**
bricks, concrete and wood	**technique**
the Artist (project)	**collection**
Dirk Pauwels	**photo**
Storm Centers, Watou, 01.06.00	**exhibited**

135

DES DIMANCHES TRISTES

2000

2 elements (bottom element: 150 x 180 x 120 cm; top element: 150 x 130 x 100 cm)

wood, plasterboard, plaster and empty wine bottle

the Artist

Hervé Abadie

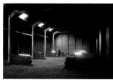

129 130

CATEDRAL #2, (WATOU)

1999	**date**
site specific / variable dimensions	**dimensions**
bricks, concrete and enamel on fluorescent lights	**technique**
the Artist (project)	**collection**
Dirk Pauwels	**photo**
Serendipiteit, Watou, 25.06.99	**exhibited**

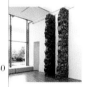

129 130

CATEDRAL #1, (BONN)

1999

site specific / variable dimensions

bricks, concrete and enamel

the Artist (project)

Reni Hansen / Kunstmuseum Bonn

Zeitwenden, Kunstmuseum Bonn, Bonn, 04.12.99

136 137

LUCE E MISURE

2000	**date**
225 x 108 x 10 cm	**dimensions**
found wood door frame, enamel on fluorescent light and aluminium ruler	**technique**
the Artist	**collection**
Paolo Pellion	**photo**

136 137

OLHAR, OLHAR SEMPRE

2000

220 x 140 x 132 cm

stainless steel, acrylic on glass, rubber, plywood and collage (porno magazine photo on back window)

the Artist

Paolo Pellion

138 139

ALA NORTE

		BERLIN WHITE DOOR
2000	date	2000
205 x 1160 x 27 cm	dimensions	206 x 74 x 30 cm
aluminium, acrylic on masonite	technique	enamel on standard masonite door,
doors, electric cables and		wood and aluminium door frame
fluorescent lights		
António Cachola, Campo Maior	collection	Herrmann Collection, Berlin
PCR Studio / Tânia Simões	photo	Sebastian Schobbert

144 145

GLASS PAINTINGS # 23

		TWO DOORS AND AN ORANGE SQUARE
2000	date	2000
100 x 100 cm	dimensions	205 x 105 x 35 cm
acrylic on laminated glass	technique	two found wood doors
		and enamel on glass
Patricia Garrido, Lisbon	collection	the Artist
PCR Studio / Rodrigo Peixoto	photo	Sebastian Schobbert

140 141

ALTRA CASA

		UNA CASA
2000	date	2000
252 x 175 x 120 cm	dimensions	252 x 180 x 120 cm
plywood, found wood door	technique	plywood, found wood door
and plaster		and plaster
the Artist	collection	the Artist
Paolo Pellion	photo	Paolo Pellion

146 147

POLYCHROME #2

		POLYCHROME #3
2000	date	2000
255 x 170 x 30 cm	dimensions	255 x 170 x 30 cm
aluminium, acrylic and glass	technique	aluminium, acrylic and glass
European Investment Bank,	collection	José Carlos Santana Pinto, Lisbon
Luxemburg		
PCR Studio / Rodrigo Peixoto	photo	PCR Studio / Rodrigo Peixoto

142 143

UNA SCALA NEL MURO

		PAPA EST PARTI...
2000	date	2000
220 x 145 x 55 cm	dimensions	120 x 180 x 72 cm
(2 elements)		
plywood and thermic isolation	technique	wood table and concrete
(styrofoam and aluminium)		
Collezione Levi, Turin	collection	the Artist
Paolo Pellion	photo	Hervé Abbadie

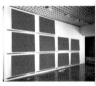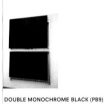

148 149

CATALOGUE #2, ORANGE (TORINO)

		DOUBLE MONOCHROME BLACK (PB9)
2000	date	2000
ten elements	dimensions	220 x 182 x 13 cm
(112 x 154 x 6 cm each)		
acrylic on laminated glass	technique	aluminium and acrylic
and aluminium shelves		on laminated glass
Galleria Civica d'Arte Moderna e	collection	António Monteiro, Lisbon
Contemporanea, Turin		
Paolo Pellion	photo	PCR Studio / Tânia Simões

150 151

DOUBLE MONOCHROME WHITE (PW6) ALUMINUM BLACK FLOWER #1

2000	date	2001
220 x 182 x 13 cm	dimensions	160 x 113.5 x 5 cm
aluminium, plywood and acrylic	technique	enamel on aluminium
on laminated glass		
the Artist	collection	Colecção Gomes de Pinho, Lisbon
PCR Studio / Tânia Simões	photo	PCR Studio / Tânia Simões

156 157

THE SLEEP OF REASON #3 THE SLEEP OF REASON #4

2000	date	2000
50 x 75 cm (edition of two)	dimensions	50 x 75 cm (edition of two)
acrylic on photo mounted	technique	acrylic on photo mounted
on aluminium		on aluminium
Patricia Garrido, Lisbon (ed. 1 of 2)	collection	Patrícia Garrido, Lisbon (ed. 1 of 2)
Paolo Pellion	photo	Paolo Pellion

152 153

CATALOGUE #1 (CRESTET) TRUE GARDENS #1 (CRESTET)

2000	date	2000
site specific / variable dimensions	dimensions	694 x 570 x 30 cm (9 elements)
acrylic on laminated glass	technique	enamel on mirrors
and aluminium shelves		on a wood structure
the Artist	collection	the Artist (project)
Hervé Abbadie	photo	Hervé Abbadie
Une sculpture qui rassemble	exhibited	
l'architecture et des objects qui veulent		
devenir peinture, Crestet Centre		
d'Art, Le Crestet, 29.04.00		

158 159

THE SLEEP OF REASON #6 THE SLEEP OF REASON #6

2000	date	2000
50 x 75 cm (edition of two)	dimensions	50 x 75 cm (edition of two)
acrylic on photo mounted	technique	acrylic on photo mounted
on aluminium		on aluminium
Patricia Garrido, Lisbon (ed. 1 of 2)	collection	Patrícia Garrido, Lisbon (ed. 1 of 2)
Paolo Pellion	photo	Paolo Pellion

154 155

THE SLEEP OF REASON #1 THE SLEEP OF REASON #2

2000	date	2000
50 x 75 cm (edition of two)	dimensions	50 x 75 cm (edition of two)
acrylic on photo mounted	technique	acrylic on photo mounted
on aluminium		on aluminium
Patricia Garrido, Lisbon (ed. 1 of 2)	collection	Patrícia Garrido, Lisbon (ed. 1 of 2)
Paolo Pellion	photo	Paolo Pellion

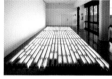

160 161

SEMINA FOUNTAIN

2000	date	2000
1130 x 362 x 10 cm	dimensions	site specific / variable dimensions
concrete beams and	technique	enamel on fluorescent lights and
acrylic on fluorescent lights		electric cables
Galleria Civica d'Arte Moderna e	collection	the Artist
Contemporanea, Turin		
Paolo Pellion	photo	Hervé Abbadie
	exhibited	Une sculpture qui rassemble l'architecture
		et des objects qui veulent devenir peinture,
		Crestet Centre d'Art, Le Crestet, 29.04.00

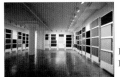

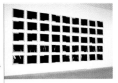

162
163 164

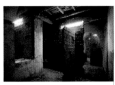

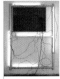

170 171

CABINET D'AMATEUR #2 (STOCKHOLM)

ARCHIVES SERIES #1 (BLACK)

D'APRÈS PIRANESI

UNFRAMED

	date				date	
2001		2001	2001			2001
33 standard doors,	dimensions	45 elements (40,5 x 49,5 cm each)	site specific / variable dimensions	dimensions		215 x 151 x 13,5 cm
6 x (116 x 229 x 12 cm) +			brick walls and fluorescent lights	technique		aluminium, fluorescent lights,
27 x (125 x 248 x 12 cm)						electric cable, wood frame,
mdf, iron and acrylic on glass	technique	enamel on hanging				glass and mdf
		cardboard file folders	the Artist (project)	collection		Maria de Belém Sampaio, Porto
the Artist	collection	the Artist	Claudio Abate	photo		PCR Studio / Tânia Simões
Anna Kleberg	photo	PCR Studio / Tânia Simões	D'après Piranesi, Volume, Roma,	exhibited		
			11.04.01			

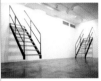

165 166

172 173

UNA SCALA ED ANCHE UN ALBERO

NORTHERN STAIRS #1

UMA LUZ NA JANELA

EVERYWHERE, ANYWHERE, ELSEWHERE

	date				date	
2001		2001	2002			2002
105 x 170 x 145 cm	dimensions	site specific,	186 x 81 x 20 cm	dimensions		220 x 113 x 30 cm
		2 elements (165 x 275 x 89 cm each)	wood, enamel, fluorescent light	technique		wood, enamel, aluminium,
painted steel	technique	galvanized iron staircases	and electric cable			fluorescent light and electric cable
Sergio Longo, Cassino	collection	the Artist	the Artist	collection		the Artist
Brunella Longo	photo	Anna Kleberg	PCR Studio / Tânia Simões	photo		PCR Studio / Tânia Simões
	exhibited	The silence within, Magasin 3				
		Stockholm Konsthall, Stockholm,				
		17.02.01				

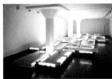

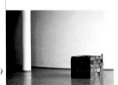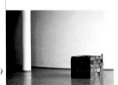

167
168 169

175
176
174 177

TRUE GARDENS #2 (STOCKHOLM)

O POÇO

LA SOURCE

SEDE

	date				date	
2001		2001	2002			2002
site specific / variable dimensions	dimensions	85 x 100 x 100 cm	site specific / variable dimensions	dimensions		edition of 50 posters,
mdf, fluorescent lights	technique	concrete, bricks, wood,				(150 x 120 cm each)
and acrylic on laminated glass		iron and burnt oil	wood, aluminium, electric cables,	technique		silkscreen on paper
Magasin 3 Stockholm Konsthall,	collection	the Artist (project)	fluorescent lights and acrylic paint			
Stockholm			the Artist	collection		
Neil Goldstein	photo	PCR Studio / Tânia Simões	Dominique Uldry	photo		PCR Studio / Tânia Simões
The silence within, Magasin 3	exhibited		Basics,	exhibited		
Stockholm Konsthall, Stockholm,			Kunsthalle Bern, Bern, 23.03.02			
17.02.01						

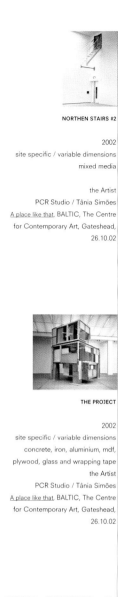

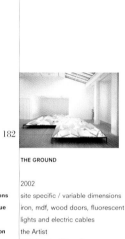

178 179

NORTHEN STAIRS #2

2002	date
site specific / variable dimensions	dimensions
mixed media	technique
the Artist	collection
PCR Studio / Tânia Simões	photo
A place like that, BALTIC, The Centre	exhibited
for Contemporary Art, Gateshead,	
26.10.02	

L.T.

2002
41 x 775 x 31 cm
wood, enamel, fluorescent lights
and electric cable
the Artist
PCR Studio / Tânia Simões

THE PROJECT

180
181 182

2002	date
site specific / variable dimensions	dimensions
concrete, iron, aluminium, mdf,	technique
plywood, glass and wrapping tape	
the Artist	collection
PCR Studio / Tânia Simões	photo
A place like that, BALTIC, The Centre	exhibited
for Contemporary Art, Gateshead,	
26.10.02	

THE GROUND

2002
site specific / variable dimensions
iron, mdf, wood doors, fluorescent
lights and electric cables
the Artist
PCR Studio / Tânia Simões
A place like that, BALTIC, The Centre
for Contemporary Art, Gateshead,
26.10.02

**BLACK MONOCHROMES / TRIPTYCH
LANDSCAPE**

185
186
183 187
184 188

2000	date
site specific,	dimensions
3 elements (255 x 170 x 30 cm each)	technique
aluminium and acrylic on laminated glass	
the Artist	collection
Gunter Lepkowski	photo
Serene Disturbance	exhibited
Kestner Gesellschaft, Hanover,	
29.11.02	

SERENE DISTURBANCE

2002
site specific / variable dimensions
mixed media

the Artist (project)
Gunter Lepkowski
Serene Disturbance
Kestner Gesellschaft, Hanover,
29.11.02

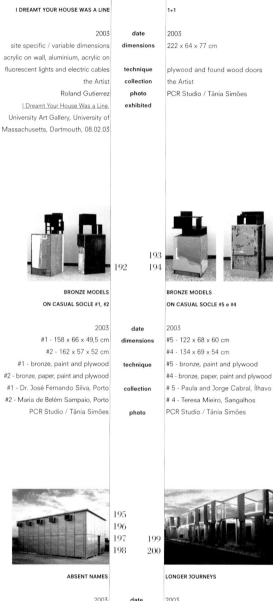

189
190 191

I DREAMT YOUR HOUSE WAS A LINE

2003	date
site specific / variable dimensions	dimensions
acrylic on wall, aluminium, acrylic on	
fluorescent lights and electric cables	technique
the Artist	collection
Roland Gutierrez	photo
I Dreamt Your House Was a Line,	exhibited
University Art Gallery, University of	
Massachusetts, Dartmouth, 08.02.03	

1+1

2003
222 x 64 x 77 cm

plywood and found wood doors
the Artist
PCR Studio / Tânia Simões

**BRONZE MODELS
ON CASUAL SOCLE #1, #2**

193
192 194

2003	date
#1 - 158 x 66 x 49,5 cm	dimensions
#2 - 162 x 57 x 52 cm	
#1 - bronze, paint and plywood	technique
#2 - bronze, paper, paint and plywood	
#1 - Dr. José Fernando Silva, Porto	collection
#2 - Maria de Belém Sampaio, Porto	
PCR Studio / Tânia Simões	photo

**BRONZE MODELS
ON CASUAL SOCLE #5 e #4**

2003
#5 - 122 x 68 x 60 cm
#4 - 134 x 69 x 54 cm
#5 - bronze, paint and plywood
#4 - bronze, paper, paint and plywood
5 - Paula and Jorge Cabral, Ílhavo
4 - Teresa Mieiro, Sangalhos
PCR Studio / Tânia Simões

ABSENT NAMES

195
196
197 199
198 200

2003	date
site specific (400 x 1000 x 600 cm)	dimensions
painted aluminium, asphalt roofing felt,	technique
standard air conditioners, fluorescent lights	
the Artist	collection
Daniel Malhão / Rosário Sousa	photo
50. Biennale di Venezia,	exhibited
Dreams and Conflicts,	
The Viewer's Dictatorship,	
Giardini della Biennale, Venice, 15.06.03	

LONGER JOURNEYS

2003
site specific (400 x 2300 x 440 cm)
aluminium, standard plywood
doors, and fluorescent lights
the Artist
Daniel Malhão / Rosário Sousa
50. Biennale di Venezia,
Longer Journeys
Portuguese Pavilion, Antichi Granai,
Giudecca, Venice, 13.06.03

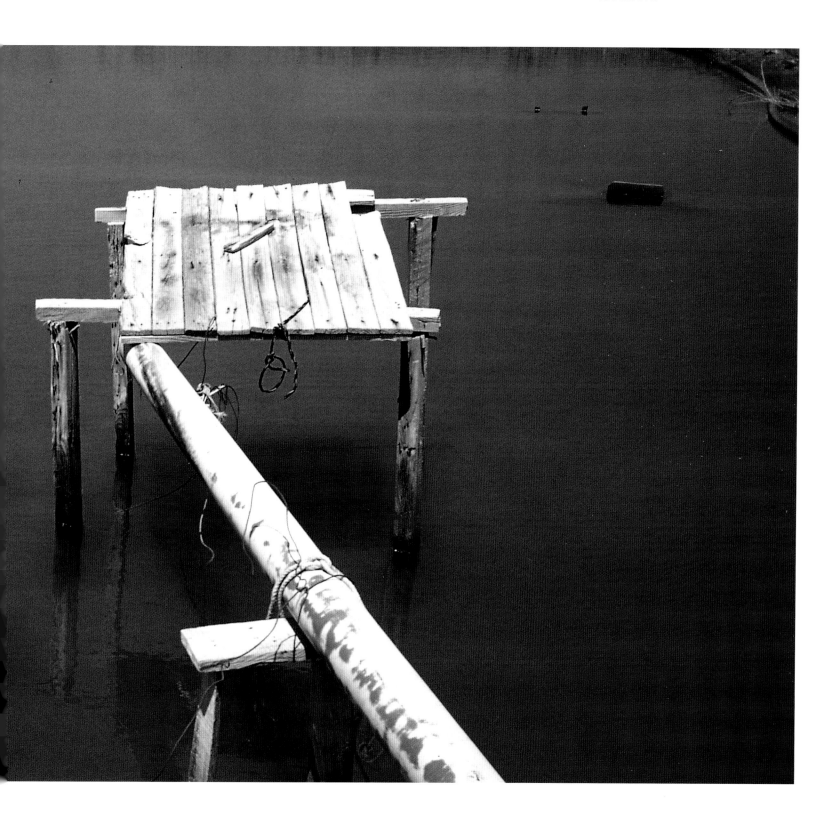

SOLO EXHIBITIONS

PEDRO CABRITA REIS

Lisbon, 1956

Lives and works in Lisbon

1981

(16.02.81)
25 Desenhos, Galeria de Arte Moderna da SNBA, Lisbon.

(08.10.81)
Até ao Regresso, Galeria Diferença, Lisbon.

1983

(18.03.83)
Pedro Cabrita Reis - Pintura, SNBA, Lisbon (cat.).

(08.11.83)
Cenas da Caça e da Guerra, Galeria Diferença, Lisbon (cat.).

1984

(10.10.84)
Os Discretos Mensageiros, Galeria Cómicos, Lisbon.

1985

(14.06.85)
De um Santuário e Certos Lugares, Galeria Jornal de Notícias, Porto (cat.).

1986

(03.04.86)
Da Ordem e do Caos, Galeria Cómicos, Lisbon (cat.).

GROUP EXHIBITIONS

1979

(28.08.79)
Exposição de pintura dos alunos da ESBAL, Centro de Cultura Popular de Vila Viçosa (cat.).

(Sept. 79)
Exposição de artes plásticas, Câmara Municipal de Coruche (cat.).

(Dec. 79)
Exposição de gravura dos alunos da ESBAL, ESBAL, Lisbon.

1980

(Jan. 80)
Arte portuguesa hoje, SNBA, Lisbon (cat.).

(31.01.80)
Prémio Alves Redol de Artes Plásticas, SNBA, Lisbon (cat.).

(Feb. 80)
Desenho e gravura, SNBA, Lisbon (cat.).

(Apr. 80)
Desastres de Guerra, Festa da Paz e da Cultura, Antiga Fábrica da Ribeira, Lagos (cat.).

(Apr. 80)
Exposição de Gravura Portuguesa - Alunos e Professores da ESBAL – Comemorações do Dia de Portugal, República do Cazaquistão.

(June 80)
Exposição de Artes Plásticas: 43º aniversário da Biblioteca Museu, Torres Novas.

(03.07.80)
Exposição sobre Lisboa, Grupo de Amigos de Lisboa, Palácio Foz (cat.).

(Aug. 80)
II Bienal de Vila Nova de Cerveira, V. N. de Cerveira (cat.)

1981

(16.10.81)
XVI Bienal de S. Paulo – Nucleus I – Arte Postal, São Paulo (cat.).

(30.10.81)
LIS 81, Exposição Internacional de Desenho, Galeria Nacional de Arte Moderna de Belém, Lisbon (cat.).

(Dec. 81)
1º Salão de Arte Moderna de Faro, Galeria 21, Faro (cat.).

1982

(May 82)
3ª Exposição de Arte Moderna, SNBA, Lisbon (cat.).

(08.05.82)
Pedro Cabrita Reis, Ana Léon, J. P. Croft, P. Calapez, CAPC, Coimbra (cat.).

1983

(07.05.83)
Pedro Cabrita Reis, Ana Léon, J. P. Croft, P. Calapez, Rosa Carvalho, Galeria Metrópole, Lisbon (cat.).

(June 83)
O papel como suporte, SNBA, Lisbon.

(July 83)
1ª Exposição Nacional de Desenho da Cooperativa Árvore, Cooperativa Árvore, Porto (cat.).

(06.12.83)
O Livro de Artista, Cooperativa Diferença, Lisbon (cat.).

1987
(04.06.87)
Anima et Macula, Cintrik Gallery, Antwerp.

1988
(29.04.88)
A Sombra na Água, Galeria Cómicos, Lisbon.

(14.10.88)
Cabeças, Árvores e Casas, Galeria Roma e Pavia, Porto (cat.).

1989
(18.03.89)
Melancolia, Bess Cutler Gallery, New York (cat.).

1990
(20.04.90)
Cabrita Reis, Rui Sanches, fundación Luis Cernuda, Seville (cat.).

(03.05.90)
A Casa dos Suaves Odores, Galeria Cómicos, Lisbon.

(28.07.90)
Alexandria, Convento de S. Francisco, Beja (cat.).

(26.09.90)
A Casa da Paixão e do Pensamento, Galeria Juana de Aizpuru, Madrid.

(13.10.90)
A Casa da Ordem Interior, Galerie Joost Declerq, Ghent.

(15.12.83)
Artistas da SNBA, SNBA, Lisbon.

1984
(Feb. 84)
Atitudes Litorais, 1ª Exposição de Artes Plásticas na Faculdade de Letras de Lisboa, Lisbon (cat.).

(22.02.84)
1ª Exposição Nacional de Desenho da Cooperativa Árvore, SNBA, Lisbon (cat.).

(24.02.84)
Exposição de pintura de finalistas de 83 da ESBAL, ESBAL, Lisbon (cat.).

(10.03.84)
Pedro Cabrita Reis, Ana Léon, J. P. Croft, P. Calapez, Rosa Carvalho, CAPC, Coimbra.

(Sept. 84)
Novos Novos, SNBA, Lisbon (cat).

1985
(Apr. 85)
Diferença / Diálogos, Livros de Artista, Galeria Diferença, Lisbon (cat.).

(July 85)
Situações, travelling exhibition organized by D.G.A.C. da SEC, Lisbon (cat.).

(11.07.85)
2ª Exposição Nacional de Desenho da Cooperativa Árvore, Cooperativa Árvore, Palácio de Cristal, Porto (cat.).

(28.11.85)
Arquipélago, (with Ana Léon, J. P. Croft, P. Calapez, Rosa Carvalho and Rui Sanches), SNBA, Lisbon (cat.).

(13.12.85)
Finisterra, Sala Atlântica, Galeria Nasoni, Porto (cat.).

(14.12.85)
Gaetan, Calapez, Cabrita, Galeria Alfarroba, Cascais.

1986
(28.04.86)
Le XXème au Portugal, Centre Albert Borschette, Brussels (cat.).

(Aug. 86)
VII Bienal Internacional de Pontevedra, Pontevedra (cat.).

(Aug. 86)
Bienal de Vila Nova de Cerveira – Anos 80, V. N. Cerveira.

(01.09.86)
AICA Philae, SNBA, Lisbon (cat.).

(02.09.86)
Cumplicidades, Galeria EMI - Valentim de Carvalho, Lisbon.

(04.09.86)
L'Attitude, Galeria Cómicos, Lisbon.

(09.09.86)
Pinturas sobre papel, Galeria Cómicos, Lisbon.

(20.09.86)
Escultura Ibérica Contemporânea, 8ª Bienal Internacional de Zamora, Zamora (cat.).

(24.10.86)
Esculturas sobre la pared, Galeria Juana Aizpuru, Madrid.

(05.11.86)
Nine Portuguese Painters, John Hansard Gallery, Southampton (cat.).

(27.11.86)
Fora da corrente, Atelier 2, Lisbon (cat.).

1987
(10.07.87)
Lusitanies: Aspects de l'Art Contemporain Portugais, Centre Culturel de L'Albigeois, Albi (cat.).

(Dec. 87)
Últimas décadas, Leal Senado, Macau (cat.).

1988
(16.04.88)
Tendências dos anos 80, Centro de Arte de S. João da Madeira, S. João da Madeira (cat.).

(17.11.90)
Silêncio e Vertigem, Igreja
de Santa Clara-a-Velha,
Coimbra (cat.).

(01.12.90)
Cabrita Reis, Sculptures,
Barbara Farber Gallery,
Amsterdam (cat.).

1991
(12.03.91)
Vite Paralelle, Sala
Umberto Boccioni, Milan.

(27.04.91)
Os Lugares Cegos, Galerie
Jennifer Flay, Paris.

(31.05.91)
Pedro Cabrita Reis,
Rhona Hoffman Gallery,
Chicago.

(12.10.91)
Pedro Cabrita Reis,
Burnett Miller Gallery,
Los Angeles.

(20.11.91)
A Cidade Levantada,
Galeria Juana de Aizpuru,
Seville.

(27.02.91)
Pedro Cabrita Reis,
Ferrán Garcia Sevilla
Espacio Santiago Corbal,
Pontevedra (cat.).

1992
(01.07.92)
Casa do silêncio,
Galerie Andreas Binder,
Munich.

(26.11.92)
Uma Luz Interdita,
Kunstraum München,
Munich (cat.).

(June 88)
Artistas da Galeria,
Galeria Cómicos, Lisbon.

(Aug. 88)
*Um olhar sobre a arte
contemporânea
portuguesa*, Casa de
Serralves, Porto (cat.).

(19.12.88)
(03.03.89)
(31.03.89)
*200 anos: Bicentenário do
Ministério das Finanças:
Exposição de pintura e
escultura do património
da Caixa Geral de
Depósitos*, Ministério das
Finanças, Lisbon (cat.).

1989
(02.02.89)
*Cabrita Reis, Jan Van Oost,
Lili Dujourie, Ulrich
Horndash*, Galeria
Cómicos, Lisbon.

(Apr. / May 89)
Complex objects,
Galeria Marga Paz, Madrid.

(19.10.89)
Crise de L'objet,
Galeria Cómicos / Luís
Serpa, Lisbon.

1990
(19.01.90)
*Cabrita Reis, Gerardo
Burmester, Nancy Dwyer,
Stephan Huber*, Galeria
Roma e Pavia / Pedro
Oliveira, Porto (cat.).

(Feb. 90)
Tapetes, Loja Domo,
Lisbon (cat).

(14.03.90)
*Ultima Frontera, 7
artistes portuguesos*,
Centre d'Art Santa Monica,
Barcelona (cat.).

(23.06.90)
Ponton – Temse, Temse (cat.).

(07.10.90)
Carnets de Voyage 1,
Fondation Cartier pour
l'Art Contemporain,
Jouy-en-Josas (cat.).

1991
(18.01.91)
Sculpture (with M. Balka,
J. Muñoz, S. Seager),
Burnett Miller Gallery,
Los Angeles.

(19.04.91)
Metropolis,
Martin Gropius Bau,
Berlin (cat.).

(03.05.91)
*Parlamento Europeu:
Semana da Europa, Artes
Plásticas Portuguesas*,
SNBA, Lisbon.

(07.06.91)
Escultura Internacional,
Museu Pablo Gargallo,
Zaragoza (cat.).

(28.09.91)
Triptico, Museum Van
Hedendaagse Kunst,
Ghent (cat.).

(24.10.91)
*Manufacturas: création
portugais contemporain*,
IEFP / Europalia 91,
Brussels (cat.).

(Dec. 91)
Arte com Timor, Palácio
Galveias, Lisbon (cat.).

(Dec. 91)
A secreta vida das imagens,
Galeria Atlântica, Lisbon
(cat.).

(12.12.91)
*Há um minuto do mundo
que passa: obras na
colecção de Serralves*,
Fundação de Serralves,
Porto (cat.).

1992
(18.01.92)
*New Year/New Work, 12
Gallery Artists*, Barbara
Farber Gallery, Amsterdam.

(03.04.92)
*Joaquim Bravo –
Reencontros*, Galeria Alda
Cortez, Lisbon (cat.).

(19.04.92)
Los Últimos Dias, Salas
del Arenal, Seville (cat.).

(20.04.92)
*Serralves, um museu
português – Expo 92*,
Seville (cat.).

(08.05.92)
*15th anniversary
exhibition*, Rhona
Hoffman Gallery, Chicago.

(17.05.92)
Skulptur Konzept, Galerie
Ludwig, Krefeld (cat.).

1993

(13.02.93)
H. Suite – piezas de Madrid, Galeria Juana de Aizpuru, Madrid (cat.).

(03.04.93)
Über Malerei,
Galerie Ludwig, Krefeld (cat.).

(26.06.93)
Pedro Cabrita Reis – Escultura,
Galeria Municipal,
TREM, Faro (cat.).

1994

(28.01.94)
Echo der Welt III,
Moderna Galerija Ljubljana/Museum of Modern Art, Ljubljana (cat.).

(30.04.94)
A Sala dos Mapas, Museu José Malhoa, Caldas da Rainha (cat.).

(24.05.94)
Contra a Claridade,
C.A.M. – Fundação Calouste Gulbenkian, Lisbon (cat.).

(20.09.94)
Das mãos dos Construtores II,
Centro Cultural de Belém,
Fundação das Descobertas, Lisbon (cat.).

(12.10.94)
XXII Bienal Internacional de São Paulo, Pavilhão de Portugal, São Paulo (cat.).

(26.10.94)
Macchine per Verificare,
Galleria Giorgio Persano, Turin (cat.).

(19.05.92)
Silence, Contradictory Shapes of Truth, Museum of Modern Art, Ljubljana (cat.).

(04.06.92)
Arte Contemporânea Portuguesa na Colecção FLAD, C.A.M. – Fundação Calouste Gulbenkian (cat.).

(13.06.92)
Documenta IX, Kassel (cat.).

(23.10.92)
10 Contemporâneos,
Fundação de Serralves, Porto (cat.).

(18.12.92)
Silence to Light, Watari Museum of Contemporary Art, Tokyo (cat.).

1993

(10.04.93)
Douze Oeuvres dans L'Espace, Centre d'Art Contemporain, Le Domaine de Kerguehennec (cat.).

(01.05.93)
De la main à la tête: L'Object Theórique, Centre d'Art Contemporain, Le Domaine de Kerguehennec (cat.).

(22.06.93)
Nos Rêves Façonnent le Monde, Cimaise & Portique, Moulins Albigeois, Albi (cat.).

(01.07.93)
Jimmie Durham, David Hammons, Pedro Cabrita Reis, Fri-Art, Centre d'Art Contemporain, Fribourg (cat.).

(10.07.93)
Tradición, Vangarda e Modernidade do Séc. XX Portugués, Auditorio de Galicia, Santiago de Compostela (cat.).

(29.07.93)
Imagens para os anos 90, Fundação Serralves, Porto (cat.).

(14.08.93)
Bienal de Escultura e Desenho das Caldas da Rainha, Pavilhão de Exposições, Caldas da Rainha (cat.).

(11.09.93)
Western Lines, Contemporary Art from Portugal, Hara Museum ARC, Gun Ma (cat.).

(09.10.93)
Cerco, Bienal Internacional de Óbidos, Óbidos (cat.).

(12.10.93)
Arte Moderna em Portugal, Colecção de Arte da Caixa Geral de Depósitos, C.G.D., Lisbon (cat.).

(14.10.93)
Ilegítimos, Artefacto 3, Lisbon (cat.).

(19.10.93)
Imagens para os anos 90, Centro de Exposições e Conferências do Alto Tâmega, Chaves (cat.).

(28.10.93)
Set Sentits, Palau Robert, Barcelona (cat.).

(26.11.93)
Cámaras de Fricción,
Galeria Luis Adelantado, Valencia (cat.).

(06.12.93)
Imagens para os anos 90, Culturgest, Lisbon (cat.).

1994

(24.03.94)
Quando o mundo nos cai em cima, Centro Cultural de Belém, Lisbon (cat.).

(13.05.94)
Art Union Europe,
Zappeion Hall, Atenas (cat.).

(07.06.94)
O Rosto da Máscara,
Centro Cultural de Belém, Lisbon (cat.).

(22.08.94)
August, Centre d'Art Contemporain, Le Domaine de Kerguehennec (cat.).

(20.09.94)
Depois de Amanhã,
Centro Cultural de Belém, Lisbon (cat.).

(11.11.94)
Reports, Galerie Tanit,
Cologne (cat.).

(05.12.94)
Sistemas de Preservação,
Galeria Camargo-Vilaça,
São Paulo (cat.).

1995
(08.06.95)
XLVI Biennale di Venezia,
Portuguese Pavilion (with
Chafes and Croft), Venice
(cat.).

(20.07.95)
O que os Olhos Vêem,
Palacio Revillagigedo /
Centro Internacional de
Arte, Gijón (cat.).

(23.11.95)
O Quarto de Gutemberg,
Livraria Assírio & Alvim,
Lisbon (cat.).

1996
(02.02.96)
Naturalia / Parte 1,
Galeria Porta 33, Funchal
(cat.).

(18.06.96)
Al-Mutamide, Galeria dos
Escudeiros, Beja.

(30.06.96)
Pedro Cabrita Reis,
Museum Folkwang, Essen
(cat.).

(30.08.96)
Pedro Cabrita Reis,
Stichting De Appel,
Amsterdam (cat.).

(31.10.96)
Pedro Cabrita Reis,
IVAM, Valencia (cat.).

1997
(02.10.97)
Pedro Cabrita Reis,
Galeria Camargo-Vilaça,
São Paulo (cat.).

(10.11.94)
Objectos, Loja da Atalaia,
Lisbon (cat.).

(12.12.94)
Cocido y Crudo, Museo
Nacional Centro de Arte
Reina Sofia, Madrid (cat.).

1995
(08.03.95)
*Extremo Ocidente: Col.
CAM/FCG*, Sala Rekalde,
Bilbao (cat.).

(05.05.95)
*Tributo às Gravuras do
Vale do Rio Côa*, Assírio
& Alvim, Lisbon.

(09.05.95)
Exposição Inaugural,
Museo Extremeño e
Iberoamericano de Arte
Contemporáneo, Badajoz.

(24.06.95)
*Formas Únicas de
Continuidade no Espaço*,
Galeria Cómicos / Luís
Serpa, Lisbon.

(06.07.95)
Sota la carpa, Montesquiu
94, Capella de l'Antic
Hospital de la Santa
Creu, Barcelona (cat.).

(08.07.95)
Insomnie,
Centre d'Art Contemporain,
Le Domaine de
Kerguehennec (cat.).

(08.07.95)
La Figure et le Lieu,
Centre d'Art Contemporain,
Le Domaine de
Kerguehennec (cat.).

(02.09.95)
Ripple Across the Water,
The Watari Museum of
Contemporary Art, Tokyo
(cat.).

(20.09.95)
Beyond the Borders, 95
Kwangju Biennale,
Kwangju, Korea (cat.).

(04.10.95)
*Salon d'Art Contemporain
d'Montrouge*, Centre
Culturel et Artistique de
Montrouge, Paris.

(08.10.95)
*Occhio: Concetti del
disegno*,
Galleria Marco Noir,
Turin.

(13.10.95)
*6. Triennale der Kleinplastik
1995*, Stuttgart.

(02.12.95)
O Desejo do Desenho,
Casa da Cerca-Centro de
Arte Contemporânea,
Câmara Municipal de
Almada, Almada.

(05.12.95)
Prints, Brooke Alexander
Gallery, New York.

1996
(02.02.96)
*Colección Permanente –
Novas Incorporacións*,
Colección Fundación
Arco, Centro Galego de
Arte Contemporánea,
Santiago de Compostela.

(08.05.96)
*Leonkart / Città Del
Desidèrio*, Centro Sociale
Leoncavallo, Milan (cat.).

(18.06.96)
Al-Mutamide,
Galeria dos Escudeiros, Beja.

(12.09.96)
Un Certain Sourire,
Galerie Windows, Brussels.

(Oct. 96)
Lo construido es el paisage,
Taller LÍNEA, Lanzarote.

(07.11.96)
Colección Caja de Asturias,
Caja de Asturias, Asturias
(cat.).

(22.11.96)
Abstrakt / Real, Museum
Moderner Kunst Stiftung
Ludwig Wien, Vienna (cat.).

(07.12.96)
Hors Catalogue,
Maison de la Culture,
Amiens (cat.).

(14.12.96)
Ecos de la materia,
MEIAC, Badajoz (cat.).

1997
(Jan. 97)
La casa, su idea,
Sala Plaza de España,
Comunidad de Madrid,
Madrid (cat.).

1998

(29.01.98)
Pedro Cabrita Reis,
Paço Imperial, Rio de
Janeiro.

(03.02.98)
Dobles Pinturas Negras,
Galeria Juana de Aizpuru,
Madrid.

(11.09.98)
Blind Cities # 2, Zacheta
Gallery of Contemporary
Art, Warsaw.

(17.09.98)
Portraits, Gandy Gallery,
Prague (cat.).

1999

(10.03.99)
Blind Cities #5,
Galleria Giorgio Persano,
Turin.

(26.10.99)
Über Licht und Raum,
Museum Moderner Kunst
Stiftung Ludwig Wien,
Vienna (cat.).

(20.11.99)
Da Luz e do Espaço,
Serralves, Museu de Arte
Contemporânea, Porto
(cat.).

(09.01.97)
Low Budget,
Centro Cultural de Belém,
Lisbon (cat.).

(23.01.97)
For Heiner Muller,
Centro Cultural de Belém,
Lisbon (cat.).

(23.03.97)
Pode a arte ser afirmativa?,
Culturgeste, Lisbon.

(11.04.97)
Margens, Auditório
Municipal, Vila do Conde (cat.).

(19.04.97)
Portfólio I, Galeria Alda
Cortez, Lisbon.

(14.05.97)
En la piel de toro, Museo
Nacional Centro de Arte
Reina Sofia, Madrid (cat.).

(11.06.97)
*Passato, Presente, Futuro
– XLVII Biennale di
Venezia*, Venice (cat.).

(27.06.97)
L'arrière-pays, Chateau
des Adhémar, Montelimar
(cat.).

(Oct. 97)
Nove artistas, Cesar
Galeria, Lisbon (cat.).

(15.10.97)
Hors-texte,
49th Frankfurt Book Fair,
Portugal representation,
Frankfurt.

(26.10.97)
*PS1 Reopening/Artists
Projects*, PS1, New York.

(13.11.97)
*Anatomias Contemporâneas:
o corpo na arte portuguesa
dos anos 90*, Fundição de
Oeiras, Câmara Municipal
de Oeiras, Oeiras (cat.).

1998

(16.01.98)
Arkipelag, Ferdinand
Boberg's Powerstation,
Skansen, Stockholm (cat.).

(18.01.98)
*A Figura Humana na
Escultura Portuguesa do
Século XX*, Universidade
do Porto, Porto (cat).

(07.03.98)
Livro de Artista, Galerias
Municipais de Arte
TREM e ARCO, Faro.

(23.04.98)
Recent Aquisitions,
Museum Moderner Kunst
Stiftung Ludwig Wien,
Vienna.

(25.04.98)
*Longe e perto: arte
contemporânea em
colecções institucionais*,
Galeria de Exposições da
União de Pintores da
Ucrânia, Kiev (cat.).

(12.05.98)
Art of the Eighties,
Culturgest, Lisbon (cat.).

(June 98)
*Arte português desde
1960, en la Colección del
Centro de Arte Moderna
José Azeredo Perdigão de
la Fundação Calouste
Gulbenkian*, Fundacíon
Pedro Barrié de la Maza,
Spain (cat.).

(06.06.98)
*As Dimensões da Arte
Contemporânea: Colecção
João Carlos de Figueiredo
Ferraz*,
Museu de Arte de Ribeirão
Preto, Brazil (cat.).

(01.08.98)
Fisuras na Percepción,
25ª Bienal de Arte de
Pontevedra (cat.).

(03.10.98)
Roteiros, Roteiros, ...,
XXIV Bienal Internacional
de São Paulo (cat.).

(03.10.98)
*Arte Portuguesa dos Anos
Oitenta na Colecção da
Fundação de Serralves*,
Sociedade Martins Sarmento,
Guimarães (cat.).

(14.10.98)
Europa Edition, Portfolio
Kunst AG, Neue Ausstel-
lungshalle, Vienna.

(27.10.98)
Sarajevo 2000, Museum
Moderner Kunst Stiftung
Ludwig Wien, Vienna (cat.).

(31.10.98)
10 – Intensità in Europe,
Museo Pecci d'Arte
Contemporanea Prato (cat.).

1999

(29.01.99)
Linha de Sombra, C.A.M.
Fundação Calouste
Gulbenkian, Lisbon (cat.).

2000

(05.02.00)
Ein Geteiltes Haus,
Galerie Markus Richter,
Berlin.

(25.03.00)
Pedro Cabrita Reis,
Galeria 30 Dias, Caldas
da Rainha (cat.).

(04.05.00)
Peinture comme Peinture,
Galerie Arlogos, Paris.

(29.04.00)
*Une sculpture qui
rassemble l'architecture et
des objects qui veulent
devenir peinture*, Crestet
Centre d'Art, Le Crestet.

(27.05.00)
Passage, Chelouche
Gallery for Contemporary
Art, Tel-Aviv (with Gal
Weinstein).

(08.07.00)
*Naturalia II - Estranhas
aves de várias cores*,
Centro Cultural Emmerico
Nunes, Sines (cat.).

(23.09.00)
*Pedro Cabrita Reis –
Recent Works*, Galeria
Mário Sequeira, Braga.

(09.10.00)
Polaroids, Café Valentim,
Chiado, Lisbon.

(24.11.00)
Il silenzio in ascolto,
Galleria Civica d'Arte
Moderna e Contemporanea,
Turin (cat.).

2001

(17.02.01)
The silence within,
Magasin 3 Stockholm
Konsthall, Stockholm
(cat.).

(11.04.01)
D'après Piranesi, Volume,
Rome.

(11.02.99)
Autoretratos na Colecção,
C.A.M. – F. Calouste
Gulbenkian, Lisbon (cat.).

(26.03.99)
*Tage der Dunkelheit und
des Lichts*, Kunstmuseum
Bonn, Bonn (cat.).

(17.04.99)
*Rui Reininho convida e diz
porquê*, Galeria Canvas, Porto.

(13.05.99)
*Dobles Vides, Museu
d' Història de la Ciutat*,
Barcelona (cat.).

(21.05.99)
*Spore-Arti nel transito
epocale*, Università degli
Studi di Cassino, Cassino.

(15.06.99)
*Obras da Colecção de Arte
da F.L.A.D.*, Palácio dos
Capitães Generais, Angra
do Heroísmo, Açores (cat.).

(24.06.99)
La casa, il corpo, il cuore,
Museum Moderner Kunst
Stiftung Ludwig Wien,
Vienna (cat.).

(25.06.99)
Serendipiteit,
Poeziesommer Watou
1999, Watou (cat.).

(04.12.99)
Zeitwenden,
Kunstmuseum Bonn,
Bonn (cat.).

2000

(20.04.00)
Durchreise, Künstlerhaus
Bethanien, Berlin.

(02.05.00)
*Um Oceano Inteiro para
Nadar*, Culturgest, Lisbon.

(24.05.00)
*Colección MMKSLW, Viena
– De Warhol a Cabrita Reis*,
Centro Galego de Arte
Contemporánea de Santiago
de Compostela, Santiago
de Compostela (cat.).

(01.06.00)
Storm Centers,
Poeziesommer Watou
2000, Watou (cat.).

(09.06.00)
The Vincent Award, (with
M. Balka, L. Tuymans,
E. A. Athila and O. B.

Ogiboyé), Bonnefanten
Museum, Maastricht.

(17.06.00)
Opening exhibition,
Galeria Mário Sequeira,
Braga.

(24.06.00)
2000+Arteast Collection,
Moderna Galerija
Ljubljana/Museum of
Modern Art, Ljubljana
(cat.).

(04.07.00)
Zeitwenden, Museum
Moderner Kunst Stiftung
Ludwig Wien, Vienna
(cat.).

(21.10.00)
about: blanck,
Galerie Markus Richter,
Berlin.

(17.11.00)
*Colecção Banco Privado
para Serralves*, Serralves,
Museu de Arte
Contemporânea, Porto (cat.).

(01.12.00)
La Santé des Restes,
FRAC, Martigues (cat.)

2001

(09.02.01)
*Pedro Cabrita Reis,
Carlos Vidal, Avelino Sá*,
MK Expositieruimte,
Rotterdam.

(10.03.01)
A experiência do lugar,
Porto 2001, Centro
Astrofisíco – Fac. Ciências
do Porto, Porto (cat.).

(03.05.01)
*Espelho Cego – Seleções
de uma Colecção
Contemporânea*, Paço
Imperial, Rio de Janeiro.

(15.05.01)
Autoretratos sobre papel,
Fundação Calouste
Gulbenkian, Paris.

(18.05.01)
*Modos Afirmativos e
Declinações – Alguns
aspectos do desenho da
década de oitenta*, Museu
de Évora, Évora (cat.).

(20.05.01)
Milão Europa 2000,
Palácio da Trienal e
Pavilhão de Arte
Contemporânea, Milan.

(14.05.01)
Pedro Cabrita Reis,
Galleria Giorgio Persano
invited by Galerie Michel
Rein, Paris.

2002
(01.02.02)
Pedro Cabrita Reis,
Instituto Açoriano de
Cultura, Angra do
Heroísmo, Açores.

(07.09.02)
A Balance of Light,
Galerie Markus Richter,
Berlin.

(26.10.02)
A Place like That,
BALTIC, The Centre for
Contemporary Art,
Gateshead.

(29.11.02)
Serene Disturbance,
Kestner Gesellschaft,
Hanover.

2003
(08.02.03)
*I Dreamt Your
House Was a Line*,
University Art Gallery of
Massachusetts, Dartmouth
(cat.).

(08.03.03)
*Bronze Models on
Casual Socles*,
Galeria Presença, Porto.

(13.06.03)
Longer Journeys,
Portuguese Pavilion,
Antichi Granai, Giudecca
50. Biennale di Venezia,
Venice.

(25.05.01)
*Inonia: quali città d'arte a
venire?*, Università degli
Studi di Cassino, Cassino
(cat.).

(22.06.01)
*Wir sind die Ander(en) /
(We are the Others)*,
Public Project by S.M.A.K.,
Gent, in Herford.

(21.07.01)
Al Quimias,
Centro Cultural Emmérico
Nunes, Sines (cat.).

(11.08.01)
*Modos Afirmativos e
Declinações – Alguns
aspectos do desenho da
década de oitenta*, Museu
Arqueológico e Lapidar /
Galeria Trem, Faro (cat.).

(13.09.01)
*Encrucijada – Reflexiones
en torno a la pintura actual*,
Sala de Exposiciones de Plaza
de España, Madrid (cat.).

(15.10.01)
*Argumentos de futuro – arte
português contemporâneo*,
Colección MEIAC, Caja
San Fernando, Seville (cat.).

(15.11.01)
*La GAM costruisce il suo
futuro*, Galleria
d'Arte Moderna e
Contemporanea, Turin.

(17.11.01)
*Modos Afirmativos e
Declinações – Alguns
aspectos do desenho da
década de oitenta*, Museu
Sousa Cardoso, Amarante
(cat.).

2002
(25.02.02)
100 Anos – 100 Artistas,
Sociedade Nacional de
Belas Artes, Lisbon (cat.).

(13.03.02)
Arte-Público,
Serralves, Museu de Arte
Contemporânea, Porto.

(14.03.02)
Conceptes de L'Espai,
Fundació Joan Miró,
Barcelona (cat.).

(23.03.02)
Basics,
Kunsthalle Bern, Bern (cat.).

(16.04.02)
*Colecção C.G.D. Arte
Contemporânea – novas
aquisições*,
Culturgest, Lisbon (cat.).

(19.04.02)
Close Reading #2,
objectif, Antwerp.

(20.04.02)
Self/In material conscience,
Fondation Sandretto,
Guarene (cat.).

(09.06.02)
*The shock of September
11th 2001/The Mystery of
the Other*,
Lettre International,
Berlin (cat.).

(31.10.02)
Points de vue,
frac paca, Château des
Villeneuve-Tourrettes-sur
Loup (cat.).

(01.09.02)
Os dias de Tavira,
Tavira (cat.).

(25.10.02)
Zoom – 1986-2002,
*Col. de Arte Contemporânea
Portuguesa da FLAD:
uma selecção*,
Serralves, Museu de Arte
Contemporânea, Porto.

(26.10.02)
*Territórios Singulares na
Colecção Berardo*,
Sintra Museu de Arte
Moderna, Colecção
Berardo, Sintra (cat.).

(30.10.02)
Trabalhos sobre papel,
Galeria Arte Moderna e
Contemporânea João
Esteves de Oliveira,
Lisbon (cat.).

2003
(15.06.03)
Dreams and Conflicts,
The Viewer's Dictatorship,
Giardini della Biennale,
50. Biennale di Venezia,
Venice (cat.).

BIBLIOGRAPHY

Compiled by Maria de Aires Carmo

1. ARTIST'S WRITINGS

1984 "Do meu posicionamento perante a actividade plástica". In: *Atitudes Litorais: I Exposição de Artes Plásticas na Faculdade de Letras de Lisboa*. Lisbon: FLL, 1984, p. 36. (Portuguese).

1986 "A inevitável clareza". In: *Bravo*. Lisbon: EMI – Valentim de Carvalho, 1986, pp. [4–5]. (Portuguese).

"A inevitável clareza". In: *Bravo: obras sobre papel: (1965/82)*. Lisbon: EMI – Valentim de Carvalho, 1986, pp. [5–6]. (Portuguese).

1987 "Começar pelo impróprio…" In: *José Paulo Ferro: exposição de desenho*. Lisbon: Galeria Atlântica, 1987, pp. [4–5]. (Portuguese).

1988 "Aforismos". In: *Cabrita Reis: da luz como na noite*. Lisbon: INCM, 1988, pp. 25–30. (Portuguese-English).

"Gostaria de poder ainda fazer declarações…" In: *Pedro Cabrita Reis: cabeças, árvores e casas*. Porto: Galeria Roma e Pavia, 1988, p. [2]. (Portuguese).

"Um texto de Cabrita Reis = Un testo di Cabrita Reis". In: *Spazio Umano / Human Space*. Bregnano: Enrico R. Comi, no. 4 (1988), col. 118–120. (Portuguese).

1990 "Alexandria". In: *Alexandria*. Beja: Convento de S. Francisco, 1990, pp. [4–5]. (Portuguese-English).

"A arte tem uma inteligência própria…" In: *Carnet de voyages: I*. Jouy-en-Josas: Fondation Cartier, 1990, p. 40. (French).

"Notas de construcción". In: *Cabrita Reis/Rui Sanches: arte portugués contemporâneo: I*. Seville: Fundación Luis Cernuda, 1990, pp. 23–24. (Spanish-English).

"Gostaria de poder ainda fazer declarações…" In: *Ultima frontera: 7 artistes portugueses*. Barcelona: Centro d'Art Santa Mónica, 1990. (Catalan).

1991 "Hors concours". In: *Hipólito Clemente: pintura*. Lisbon: Clube de Jornalistas, 1991, pp. [1–2]. (Portuguese).

"Museu". In: *Tríptico*. Ghent: Museum Van Hedendaagse Kunst, 1991, p. 58. (English-Dutch).

"Silêncio e vertigem". In: *Via Latina*. Coimbra, no. 3 (May 1991), pp. 112–116. (Portuguese).

1992 "[Sessenta e oito textos por Pedro Cabrita Reis]". In: *Pedro Cabrita Reis*. Lisbon: Centro de Arte Moderna da Fundação Calouste Gulbenkian, 1992, pp. 6–153. (Portuguese-English).

"Este livro…." In: *Pedro Cabrita Reis*. Lisbon: Centro de Arte Moderna da Fundação Calouste Gulbenkian, 1992, pp. 6–8. (Portuguese-English).

1993 "Echo der Welt/A First Text". In: *Cámaras de fricción*. Valencia: Galeria Luis Adelantado, 1993, pp. 22–23. (Portuguese-English).

1994 "Echo der Welt/A First Text". In: *Pedro Cabrita Reis: Echo der Welt III*. Ljubljana: Moderna Galerija, 1994. Ljubljana, Museum of Modern Art, January 1994, pp. 1–3. (Slovenian-English).

"A Sala dos Mapas". In: *A Sala dos Mapas*. Caldas da Rainha: Museu de José Malhoa, 1994. pp. 6–7. (Portuguese-English).

"A Sala dos Mapas". In: *22ª Bienal Internacional de São Paulo*. São Paulo: Fundação Bienal de São Paulo, 1994, pp. 350–351. (Portuguese-English, translated by Margareth Kelting).

"Consideremos uma árvore". In: *O rosto da máscara: a auto-representação na arte portuguesa: II – rostos em fuga*. Lisbon: Fundação das Descobertas. Centro Cultural de Belém (May 1994), pp. 196–198. (Portuguese).

1995 "En Japón". In: *Pedro Cabrita Reis: o que os olhos vêem*. Oviedo: Caja de Asturias, 1995, pp. 12–14. (Spanish).

"Consideremos un árbol". In: *Pedro Cabrita Reis: o que os olhos vêem*. Oviedo: Caja de Asturias, 1995, pp. 15–16. (Spanish).

1997 "Escrevo-te com bastante atraso…" In: *Puro prazer: histórias de charutos em Portugal*. Lisbon: Bulhosa Livreiros, 1997, p. 22. (Portuguese).

1998 "Ao olhá-la atentamente…" In: *Portraits: os cegos de Praga*. Prague: [imp. Cicero FPs, Kaliba] (Sept. 1998), pp. 3–5. (Hungarian-English, translated by Barbara Drahozalová and Anton Pastenka).

2000 "5' Pedro Cabrita Reis". In: DUARTE, José – *Cinco minutos de Jazz: cinco homenagens*. Lisbon: Oficina do Livro, 2000, p. 149. (Portuguese).

2002 "Mes jours, l'un après l'autre…" In: *Lettre International*. Europa Kulturzeitung. Frankfurt: vol. 56, 2002. (German).

"Semânticas do lugar" = "Semantics of Place". In: *Prototypo. Cidade em Performance* = Performing City. Lisbon, no. 7 (Aug. 2002), pp. 54–57. (Portuguese-English).

2. INTERVIEWS

1983 "Nós somos a coisa aonde vamos chegar". Conducted by Alexandre Melo and João Pinharanda. In: *Jornal de Letras, Artes e Ideias* (Lisbon), 28.11.1983, p. 18. (Portuguese).

"Novíssimos portugueses: 'nós somos os melhores'". Conducted by Alexandre Melo, João Pinharanda and José Navarro de Andrade. In: *Expresso* (Lisbon), 3.12.1983, pp. 30–33. With Pedro Calapez, José Pedro Croft, Rosa Carvalho, Ana Léon. (Portuguese).

1984 "Entre o destino e a pintura a diferença é o homem". Conducted by Alexandre Melo. In: *Expresso* (Lisbon), 13.10.1984, pp. 36–37. (Portuguese).

1985 "Reponer una nueva nocion de vanguardia". Conducted by Alexandre Melo. In: *Figura*. [S.l.], spring/summer 1985, pp. 47–48. (Spanish).

"Pedro Cabrita Reis: 'Desejo criar o irrepetível'". Conducted by Eduardo Paz Barroso. In: *Jornal de Notícias* (Porto), 15.6.1985. (Portuguese).

"Frágil, sob camadas de tinta".
Conducted by Manuel
Graça Dias.
In: *Arquitectura Portuguesa*
(Lisbon), year 1, series 5,
no. 4, Nov./Dec. 1985.
(Portuguese).

1986 "Um artista violento".
Conducted by Eurico
Gonçalves.
In: *O Jornal* (Lisbon), Apr.
1986, pp. 12–14.
(Portuguese).

"Os vértices do lugar".
Conducted by Alexandre Melo.
In: *Expresso* (Lisbon),
27.9.1986.
With Pedro Calapez, Rui
Sanches and José Pedro Croft.
(Portuguese).

1987 "Cabrita Reis: pintor".
Conducted by Lurdes Féria.
In: *Diário de Lisboa*
(Lisbon), 11.4.1987, p. 24.
(Portuguese).

"Pedro Cabrita Reis: um
pintor no Chiado".
Conducted by Maria José
Mauperrin.
In: *Expresso* (Lisbon),
11.4.1987, pp. 60–61.
(Portuguese).

1988 "Os cinco que acontecem".
Conducted by Horácio Nunes.
In: *Mais. Semanário* (Lisbon),
31.3.1988, pp. 24–26.
With Pedro Proença, Pedro
Portugal, Julião Sarmento
and José Pedro Croft.
(Portuguese).

1989 "A infinita voracidade da
década".
Conducted by Lurdes Féria.
In: *Diário de Lisboa* (Lisbon),
27.12.1989, pp. 18–21.
Alexandre Melo, Clara Ferreira
Alves, Manuel Graça Dias,
João Romão, Margarida
Grácio Nunes, Nunes Viegas,
Tomás d'Eça Leal.
(Portuguese).

1990 "Galeria dos Escudeiros:
local de encontro entre
artistas".
Conducted by Rafael
Rodrigues.
In: *Diário do Alentejo* (Beja),
27.7.1990, pp. 12–13.
(Portuguese).

"Só faço coisas que as
pessoas reconheçam".
Conducted by João
Pinharanda.
In: *Público* (Lisbon),
28.7.1990, p. 17.
(Portuguese).

1991 "Pedro Cabrita Reis".
Conducted by António
Cerveira Pinto.
In: *Kapa* (Lisbon), Apr. 1991.
(Portuguese).

"O lugar de um artista é o
mundo inteiro".
Conducted by Tereza
Coelho and João
Pinharanda.
In: *Público* (Lisbon),
12.6.1991.
(Portuguese).

"Cabrita Reis, formas de
interrogación".
Conducted by José António
Chacon.
In: *Diário 16* (Seville), Dec.
1991.
(Portuguese).

1992 "Pedro Cabrita Reis".
Conducted by Zdenka
Badovinac.
In: *Tisina: protislovne oblike
resnice = Silence: contradictory
shapes of truth*. Ljubljana:
Moderna Galerija, 1992.
pp. 25–26.
(Slovenian-English).

"Druga dusa cloveka…"
Conducted by Mojca
Kumerdej.
In: *Delo* (Ljubljana),
25.4.1992, p. 26.
(Slovenian).

1993 "Buscando lo esencial".
Conducted by Santiago Olmo.
In: *Lapiz* (Madrid), year XI,
no. 92, Mar./Apr. 1993, pp.
46–52.
(Spanish).

"[Part of enterview]"
In: *Pedro Cabrita Reis:
escultura*. Faro: Galeria
Municipal de Arte,
26.06–27.08.93, p. [1]

Part of an enterview –
"Pedro Cabrita Reis".
Conducted by Zdenka
Badovinac. In: *Tisina:
protislovne oblike resnice =*

*Silence: Contradictory
Shapes of Truth*. Ljubljana:
Moderna Galerija, 1992,
pp. 25–26.
(Portuguese).

1994 "Gerar a dúvida".
Conducted by Alexandre
Pomar.
In: *Expresso. Cartaz* (Lisbon),
28.5.1994, pp. 20–21.
(Portuguese).

"Reis absoluto".
Conducted by Catarina Portas.
In: *Diário de Notícias*
(Lisbon) 26.6.1994, pp. 2–3.
(Portuguese).

"A nova proposta lusitana:
Pedro Cabrita Reis brilha
no mercado de arte
internacional".
Conducted by Paulo Brasil.
In: *Jornal do Brasil* (São
Paulo), 31.12.1994, p. 6.
(Portuguese).

1995 "Tudo claramente".
Conducted by Fernanda
Câncio.
In: *Grande Reportagem*
(Lisbon), year 6, series 2,
no. 48, Feb. 1995, pp. 19–26.
(Portuguese).

"Uma conversa em Maio de
1995".
Conducted by Alexandre
Melo.
In: *Pedro Cabrita Reis:
Portugal XLVI Bienal de
Veneza 1995*. Lisbon:
Secretaria de Estado da
Cultura, 1995, pp. 15–17.
(Portuguese-Italian-English).

"Pedro Cabrita Reis".
In: *Kwang-Ju Biennale:
beyond the borders*. Seoul:
Kwang-Ju, 20 September to
20 November 1995, p. 344.
Parts of interview conducted
by Alexandre Melo.
In: *Pedro Cabrita Reis:
Portugal XLVI Biennale di
Venezia 1995*. Lisbon:
Secretaria de Estado da
Cultura, 1995, pp. 7–9.
(English).

1996 "…de alguna frase que he
oído…: una entrevista con
Pedro Cabrita Reis por
Alexandre Melo" (Lisbon,
Mar. 1996).

In: *Pedro Cabrita Reis*.
Essen: Museum Folkwang;
Amsterdam: De Appel
Foundation; Valencia: IVAM,
1996, pp. 31–36 .
(Spanish-English /
German-English).

1997 "Pedro Cabrita Reis: el asceta
de la ciudad blanca".
Conducted by Michel Hubert
Lépicouché.
In: *Spacio / Espaço Escrito*.
Badajoz: Ángel Campos
Pámpano, no. 13–14 (spring
1997), pp. 169–179.
(Spanish, translated to French
by Marga Calvo Romero).

1999 "Cabrita Reis: artista
primordial".
Conducted by Luísa Soares
de Oliveira.
In: *City* (Lisbon), year 2, no.
14 (Nov. 1999), pp. 76–77.
(Portuguese).

"Pedro Cabrita Reis".
Conducted by Teresa Maia
and Carmo.
In: *Diário de Notícias*. DNA
(Lisbon), no. 156,
20.11.1999, pp. 16–21
(Portuguese).

"Retrato de artista: o desejo
de ser diferente".
Conducted by Susana Neves.
In: *Elle Deco* (Lisbon), no. 18,
Dec. 1999, pp. 16–18.
(Portuguese).

"Conversa com vista para…
Pedro Cabrita Reis".
Conducted by Maria João
Seixas.
In: *Público. Pública*
(Lisbon), no. 184, 5.12.1999,
pp. 18–28.
(Portuguese).

2000 "Realidades utópicas".
Conducted by José Sousa
Machado.
In: *Arte Ibérica* (Lisbon), year
4, no. 32, Feb. 2000, pp. 68–74.
(Portuguese).

"Pedro Cabrita Reis no CCEN
em homenagem a Al Berto:
um permanente balancear
entre o rigoroso e o caos".
Conducted by Rita Elias.
In: *Notícias de Sines* (Sines),
15.7.2000, p. 8.
(Portuguese).

"[Entrevista com Pedro
Cabrita Reis]".
Conducted by Alexandre
Melo. (Audio cassette).
In: *RDP 2*, 16.10.2000,
45 min.
(Portuguese).

"[Entrevista com Pedro
Cabrita Reis]".
Conducted by Claudia
Galhoz. (Audio cassette).
In: Ultravox. Artes. *Radio Vox*,
28.12.2000, 40 min.
47 sec.
(Portuguese).

"Pedro Cabrita Reis: Blind
sein, kann ein sehr reiches
Sehen bedeuten".
Conducted by Doris von
Drathen.
In: *Kunstforum. International*
(Cologne), vol. 157, Nov./Dec.
2001, pp. 200–211.
(German).

"Pedro Caritas Reis".
Conducted by Mark Gisbourne.
In: *Contemporary* (London),
Dec. 2002, pp. 66–71.

**3. GROUP EXHIBITION
CATALOGUES
(selected)**

1990 MELO, Alexandre
"Nos últimos anos a
escultura…"
In: *Cabrita Reis, Gerardo
Burmester, Nancy Dwyer,
Sephan Huber*. Porto: Galeria
Pedro Oliveira/Rome and
Pavia, 1990, pp. 5–6.
(Portuguese-English).

POWER, Kevin
"Cabrita Reis o la
construccion de nuestro
modo de sentir".
In: *Cabrita Reis/Rui Sanches:
arte portugues contemporáneo: I*.
Seville: Fundação Luis
Cernuda, 1990, pp. 7–13.
(Spanish-English, translated
by Africa Vidal).

1991 ALMEIDA, Bernardo Pinto de
"Não sabemos nada do que
seja (ou possa ser) a arte
contemporânea…"
In: *Há um minuto do mundo
que passa*. Porto: Fundação
de Serralves, 1991,
pp. 11–19.
(Portuguese).

POWER, Kevin
"Pedro Cabrita Reis".
In: *Metropolis: International
Art Exhibition Berlin: 1991*.
New York: Rizzoli, 1991,
p. 277.
(Portuguese)

1992 BREA, José Luis
"Los últimos dias".
In: *Los últimos dias*. Seville:
Salas del Arsenal, 1992,
pp. 13–31. (Spanish).

BREA, José Luis
"The Last Days".
In: *The Last Days*. Seville:
Salas del Arsenal, 1992,
pp. 13–31.
(English).

CALDAS, Manuel Castro
"A Place in the East".
In: *Silence to Light:
Portuguese Contemporary
Art*. Tokyo: Watari-Um, The
Watari Museum of
Contemporary Art (Dec.
1992), pp. 16–19.
(English-Japanese).

HOPPE-SAILER, Richard
"Skulptur-Konzept:
Anmerkungen zu einigen
Positionen zeitgenössischer
Skulptur".
In: *Skulptur-Konzept*.
Krefeld: Galerie Ludwig
(May 1992), p. [10].
(German).

PINHARANDA, João
"Proposta de entendimento
de algumas linhas da
produção escultórica, em
Portugal, na segunda
metade do século XX".
In: *Fundação de Serralves:
um museu português =
Fundação de Serralves: un
museo portogués*. [S.l.:
Fundação de Serralves,
1992], pp. 32–33.
(Portuguese-English).

"Pedro Cabrita Reis".
In: *10 contemporâneos*.
Porto: Fundação de
Serralves, 1992. pp. 20–28.
(Portuguese).

1993 ALMEIDA, Bernardo Pinto de
"No caminho de Santiago =
En el camino de Santiago".
In: *Tradición, vanguarda e
modernidade do século XX

portugués*. Santiago de
Compostela: Consorcio da
cidade de Santiago. (Aug.
1993), pp. 45–46.
(Spanish-Galician).

BAERE, Bart de
"Finalement, le chat était là".
In: [Fondation Fri-Art:
Catalogue du Centre d'Art
Contemporain de Fribourg].
Fribourg: Centre d'Art
Contemporain de Fribourg,
1993, pp. 22, 28, 31.
(French-German).

BLANCH, Teresa
"Palidece la memoria= As
Memory Fades".
In: *Cámaras de friccion*.
Valencia: Galeria Luis
Adelantado, Dec. 1993,
pp. 7–12, 75–82.
(Spanish-English).

JUSTO, José Miranda
"Illuminer l'obscurité=To
Shed Light on Darkness".
In: *Nos rêves façonnent le
monde*. Albi: Cimaise &
Portique, May 1993,
pp. 28–30.
(French-English).

MELO, Alexandre
"Protocolos de legitimidade
= conventions of form".
In: *Ilegútimos: jóias portuguesas
contemporâneas*. Lisbon:
Artefacto 3, Oct. 1993, p. 14.
(Portuguese-English).

MELO, Alexandre
"Notas de uma história
paralela = Notas para una
historia paralela".
In: *Tradición, vanguarda e
modernidade do século XX
portugués*. Santiago de
Compostela: Consorcio da
cidade de Santiago, Aug.
1993, pp. 54–55.
(Spanish-Galician).

MEYER, Jackie-Ruth
"Nos rêves façonnet le
monde = Our Dreams
Shape the World".
In: *Nos rêves façonnent le
monde*. Albi: Cimaise &
Portique, Mai. 1993,
pp. 7–10.
(French-English).

MOLDER, Jorge
"Drawings".
In: *Contemporary Art from
Portugal: Western Lines*.
Tokyo: Hara Museum of
Contemporary Art, 1993,
p. 9.
(English-Chinese).

PINHARANDA, João
"Construir um objeto:
alguns exemplos nas artes
do espaço, em Portugal, no
final do século XX =
Construir un objeto: algunos
ejemplos en las artes del
espacio, en Portugal, a
finales del siglo XX".
In: *Tradición, vanguarda e
modernidade do século XX
portugués*. Santiago de
Compostela: Consorcio da
cidade de Santiago, Aug.
1993, p. 69.
(Spanish-Galician).

PINHARANDA, João
"Uma jóia é uma jóia, não é
uma jóia".
In: *Ilegútimos: jóias
portuguesas
contemporâneas*. Lisbon:
Artefacto 3, Oct. 1993,
p. 16.
(Portuguese-English).

"Pedro Cabrita Reis va
começar la seva
carrera….= Pedro Cabrita
Reis iniciou a sua
carreira…"
In: *Set sentits = Sete
sentidos*. [Barcelona]:
Generalitat de Catalunya.
Departamento de Cultura,
28 October to 14 November
1993, pp. 15–16.
(Catalan-Portuguese).

1994 CAMERON, Dan
"Cocido y crudo".
In: *Cocido y crudo*. Madrid:
Museu Nacional Centro de
Arte Reina Sofia, Dec.
1994, pp. 44–61.
(Spanish-English).

CARLOS, Isabel
"Da necessidade do ver".
In: *Depois do amanhã*.
Lisbon: Centro Cultural de
Belém, Sept. 1994.
Lisbon 94, p. 3.
(Portuguese).

CARLOS, Isabel
"Of the Need to See".
In: *The Day after Tomorrow.*
Lisbon: Centro Cultural de
Belém, Sept. 1994.
Lisbon 94, p. 3.
(English).

MELO, Alexandre
Pedro Cabrita Reis.
In: *Art Union Europe.* Athens,
Thessaloniki, Kerkyra: The
Art Magazine, 1994, p. 39.
(Greek-English).

1995 SAN MARTIN, Javier
"Mendabalde urruna".
In: *Extremo Occidente: arte
portugués contemporáneo.*
Biscaya: Sala de Exposiciones
Rekalde, [1995], pp. 23–24.
(Basque-Spanish, translated
by ERCISA).

TEIXEIRA, José Monterroso
"Nel Portogallo degli anni
ottanta".
In: *46 esposizione
internazionale d'arte.*
Venice: Marsilio Editore
S.P.A., 1995, p. 148.
(Italian).

1996 FERNANDES, João
"Artistes de la collection:
Pedro Cabrita Reis".
In: *Hors catalogue: Un
project Gulbenkian à propos
de sa collection.* Amiens:
Maison de la Culture
d'Amiens, 1996, p. 30.
(French-Portuguese).

HEGYI, Lóránd
"Europa – Ostasien:
Bemerkungen zur
Konzeption der Ausstellung
und zur Positionierung der
zeitgenössischen
Kleinplastik".
In: *6. Triennale der
Kleinplastik 1995: Europa –
Ostasien.* Stuttgart:
Trägerverein der Triennale
der Kleinplastik e. V.,
1995. 14 October 1995 to
14 January 1996, pp. 33–34.
(German).

HEGYI, Lóránd
"Pedro Cabrita Reis".
In: *Abstrakt/Real.* Vienna:
Museum moderner Kunst
Stiftung Ludwig Wien,
1996, pp. 154–156.
(German-English).

TRIPODI, Pino
"Pedro Cabrita Reis".
In: *Leonkart: Città del
desiderio.* Milan: CSL,
1996, pp. 8–9.
(Italian).

1997 CELANT, Germano
"A–Z".
In: *La Biennale di Venezia:
XLVII esposizione internazionale
d'arte: future, present, past.*
Venice: Electa, 1997,
pp. XXII–XXIII.
From the text "Universes of
Shadow". In: *Pedro Cabrita
Reis.* Essen: Museum
Folkwang; Amsterdam: De
Appel Foundation;
Valencia: IVAM, 1996, pp.
11–29. (English, translated
from Italian by Stephen
Sartarelli).

CHAMBON, Cati
"Descendre pour s'elever".
In: *L árrière-pays.* Paris:
ADAGP, 1997, p. 13.
(French-Spanish).

DANVILLA, José Ramón
"Pedro Cabrita Reis: el
paisaje aprehendido".
In: *Ecos de la materia.*
Valencia: Generalitat
Valenciana, 1997, pp. 52–55.
(Spanish).

MELO, Alexandre
"Ecos de Portugal".
In: *Ecos de la materia.*
Valencia: Generalitat
Valenciana, 1997, p. 188.
(translated to Spanish by
Maria Elvira Cosme).

MELO, Alexandre
"Nove artistas, 1987/1997".
In: *Nove artistas,
1987/1997.* [Lisbon]: Cesar
Galeria, D.L. 1997, p. [4].
(Portuguese).

NEVES, Susana
"Paper and Rosemary: Two
Conversations: Manuel de
Brito and Hermínio
Monteiro".
In: *Hors texte: Hall 3 (art):
49th Frankfurt Book Fair.*
[Lisbon: Ministério da
Cultura], 1997, p. 10.
(English).

REYES, Juan Antonio
Álvarez
"La casa, su idea".
In: *La casa, su idea: en
ejemplos de la escultura
reciente.* Madrid: Dirección
General de Patrimonio
Cultural de la Consejería de
Educación y Cultura de la
Comunidad de Madrid, 1997,
p. 52.
(Spanish).

STORCH, Wolfgang
"O trabalho dos artistas
plásticos".
In: *For Heiner Müller.*
Lisbon: Centro Cultural de
Belém, 1997, pp. 15–17.
(Portuguese-English).

1998 ALMEIDA-MATOS, Lúcia
"Escultura humana=Human
sculpture".
In: *A figura humana na
escultura portuguesa do séc.
XX = The Human Figure in
20th-Century Portuguese
Sculpture.* Porto: Universidade do
Porto; Fundação Gomes
Teixeira; Faculdade de Belas
Artes, D.L. 1998, p. 18.
(Portuguese-English).

CAMERON, Dan
"Unidos pela diferença:
América, Europa & os anos
80 = United through
Difference: America, Europe,
and the Eighties".
In: *Anos 80 = The Eighties.*
Lisbon: Culturgest (May
1998), p. 43.
(Portuguese-English).

CORÁ, Bruno
"10 intensità in Europa".
In: *10 intensità in Europa.*
Florence and Siena:
Marchietto & Musolino,
1998, p. 15
(Italian-English)

CORRAL, Maria de
"Anos 80 = The Eighties".
In: *Anos 80 = The Eighties.*
Lisbon: Culturgest, May
1998, p. 20.
(Portuguese-English).

GONZÁLEZ-ALEGRE,
Alberto
"Pasar, quen sabe se
tranquilamente, por un muro
de pronomes, por un barullo
de bandeiras".

In: *25 Bienal de arte de
Pontevedra: Fisuras na
percepción.* Pontevedra:
Depuntación Provincial de
Pontevedra, D.L., 1998,
p. 19.
(Spanish).

JUSTO, José Miranda
"Pedro Cabrita Reis: a
hipérbole do imperfeito =
The Hyperbole of the
Imperfect".
In: *Arte Urbana = Urban Art.*
Lisbon: Parque Expo 98,
S.A. (Aug. 1998), pp. 29–31.
(Portuguese-English).

PINHARANDA, João
"Arte portugués actual:
possobilidad de la
heteronimia".
In: *Arte portugués desde
1960: en la colección del
Centro de Arte Moderna
José de Azeredo Perdigão da
la Fundación Calouste
Gulbenkian.* [S.l.],
Fundación Pedro Barrié de
La Maza, D.L. 1998,
pp. 18–20.
(Portuguese-Spanish).

SARDO, Delfim
"Longe e perto".
In: *Longe e perto: arte
contemporânea portuguesa
em colecções institucionais.*
[Lisbon: Instituto de Arte
Contemporânea, 1998], p. 10.
Exhibition in Kiev
(Apr./May 1998), Galeria
de Exposições da União de
Pintores da Ucrânia.
(Portuguese).

TARANTINO, Michael
"I Love the Sound of
Breaking Glass".
In: *Arkipelag.* [S.l.: s.n.],
1998.
(A project organised and
fully supported by
Stockholm – Cultural
Capital of Europe, 1998),
pp. [19–20].
(English).

TARANTINO, Michael
"Mi piace il rumore del
vetro che si rompe".
In: *10 intensità in Europa.*
Florence and Siena:
Marchietto & Musolino,
1998, pp. 68–69.
(Same text in English –

"I Love the Sound of Breaking Glass". In: Arkipelag. [S.l.: s.n.], 1998. pp. [19–20]). (Italian-English).

1999 HEGYI, Lóránd
"Pedro Cabrita Reis".
In: *La casa, il corpo, il cuore: Konstruktion der Identitäten*. Vienna: Museum moderner Kunst Stiftung Ludwig Wien, [1999], pp. 212–214. (German).

MELO, Alexandre
"Portugal: eine Gesellschaft und ihre Künstler: weder Zentrum noch Peripherie". In: *Tage der Dunkelheit und des Lichts: zeitgenössische Kunst aus Portugal*. Bonn: Kunstmuseum (Feb. 1999), pp. 26–28. (German).

PEDROSA, Adriano
"Pedro Cabrita Reis: Museu d'História de la Ciudad".
In: *Dobles vidas = Duble Lives = Dobles vidas*. Barcelona: Electa, 1999, pp. 50–51. (Catalan-English-Spanish).

SEARLE, Adrian
"Von unserem Auslandskorrespondenten (Pedro Cabrita Reis)".
In: *Tage der Dunkelheit und des Lichts: zeitgenössische Kunst aus Portugal*. Bonn: Kunstmuseum. (Feb. 1999). pp. 38–44. (German).

"Pedro Cabrita Reis".
In: *Europa-edition*. Vienna: [s.n.], 1999, p. 56. (German-English).

JUSTO, José Miranda
"Das Dreieck der Nächte, die vergehen".
In: *Zeitewenden*. Bonn: Dumont, 1999, pp. 63–65. (German).

ALMEIDA, Marta Moreira de
"Arte portuguesa na colecção da Fundação Serralves".
In: *Arte portuguesa na colecção da Fundação Serralves*. Porto: Fundação Serralves, 1999, p. 17. (Portuguese).

2000 HEGYI, Lóránd;
"Conscientes de nuevas orientaciones = Conscientes de novas orientacións".
In: FABEIRO, Elena; FERNÀNDEZ-CID, Miguel; SCHRAGE, Dieter – *Colección MMKSLW, Viena: de Warhol a Cabrita Reis*. [S.l.]: CGAC; Xunta de Galicia, 2000. pp. 24–33. (Spanish; English version, pp. 97–100).

HEGYI, Lóránd;
"De Andy Warhol a Pedro Cabrita Reis: sobre la selección de obra = De Andy Warhol a Pedro Cabrita Reis: sobre a selección de obra".
In: FABEIRO, Elena; FERNÀNDEZ-CID, Miguel; SCHRAGE, Dieter – *Colección MMKSLW, Viena: de Warhol a Cabrita Reis*. [S.l.]:CGAC; Xunta de Galicia, 2000. p. 34–37. (Spanish-English version, pp. 101–102).

"Pedro Cabrita Reis"
In: FABEIRO, Elena; FERNÀNDEZ-CID,Miguel; SCHRAGE, Dieter – *Colección MMKSLW, Viena: de Warhol a Cabrita Reis*. [S.l.]: CGAC; Xunta de Galicia, 2000, pp. 84–85, 91. (Spanish-English version, p. 110).

VANDERLINDEN, Barbara;
TODOLI, Vicente
"Pedro Cabrita Reis".
In: *The Vincent: The Shortlisted Artists*. Maastricht: Bonnefanten, 2000, pp. 22–25. (English).

HEGYI, Lóránd
"Two Artists in the Passage".
In: CHELOUCHE GALLERY; HEGYI, Lóránd; ITZHAKI, Nira – *"Passage" internacional art encontres: Pedro Cabrita Reis, Gal Weinstein*. Tel Aviv: Chelouche Gallery, 2000, p. 5. (English-Hebrew version, p. 13–3).

HEGYI, Lóránd
"Pedro Cabrita Reis: Sightless Cities – Periphery Experiences in the Labyrinth of Deserted Rooms".
In: CHELOUCHE GALLERY; HEGYI, Lóránd; ITZHAKI, Nira – *"Passage" internacional art encontres: Pedro Cabrita Reis, Gal Weinstein*. Tel Aviv: Chelouche Gallery, 2000, pp. 7–9. (English-Hebrew version p. 13–3).

ITZHAKI, Nira
"'Passage': internacional art encontres".
In: CHELOUCHE GALLERY; HEGYI, Lóránd; ITZHAKI, Nira – *"Passage" internacional art encontres: Pedro Cabrita Reis, Gal Weinstein*. Tel Aviv: Chelouche Gallery, 2000, pp. 3–4. (English-Hebrew version p. 13–3).

"Pedro Cabrita Reis Biography"
In: CHELOUCHE GALLERY; HEGYI, Lóránd; ITZHAKI, Nira – *"Passage" internacional art encontres: Pedro Cabrita Reis, Gal Weinstein*. Tel Aviv: Chelouche Gallery, 2000. pp. 18–19. (English-Hebrew version p. 13–3).

2001 ALMEIDA, Bernardo Pinto de
"Uma colecção".
In: ALMEIDA, Bernardo Pinto; PINHARANDA, João [et.al.] – *Fundação António Prates: um projecto para Ponte de Sor*. Junta de Extremadura; Fundação António Prates, 2001, pp. 53–58. (Catalan translation, pp. 232–234), p. 57. (Portuguese-Spanish)

CUNHA E SILVA, Paulo
"A cidade da experiência = The City of Experience".
In: SAMEIRO, Susana [coord], [et.al.] – *A experiência do lugar: arte & ciência = The Experience of the Place: Art and Science*. Porto: Porto 2001, pp. 24–29, 27. (Portuguese-English).

HAFFE PÉREZ, Miguel von
"10+10=10"
In: SAMEIRO, Susana [coord], [et.al.]
A experiência do lugar: arte & ciência = The Experience of the Place: Art and Science. Porto: Porto 2001, 2001, pp. 12–23. (Portuguese-English).

IANNI, Paolo; COIA, Daniela
"Pedro Cabrita Reis".
In: CORÁ, Bruno [ed.lit.]. – *Spore: arti contemporanee nel transito epocale*. Cassino: Università degli Studi di Cassino, 2001. Atti della Mostra-Convegno Internazionale Cassino, 21–22 May 1999, p. 143. (Italian).

PINHARANDA, João
"Modos afirmativos e declinações".
In: FERNANDES, José Manuel; PINHARANDA, João. *Modos afirmativos e declinações: alguns aspectos do desenho na década de oitenta*. [S.l.]: Ministério da Cultura, Instituto de Arte Contemporânea, 2001, pp. 15, 21, 60–71. (Portuguese).

PINHARANDA, João
"Antes, durante e depois = Antes, durante y después".
In: PINHARANDA, João; ALMEIDA, Bernardo Pinto de; PINTO, António Cerveira [et al.]
Arte português contemporâneo: argumentos de futuro: colección MEIAC. [S.l.]: Caja San Fernando; MEIAC, 2001. (col. Itinerários de arte contemporâneo/Portugal), pp. 98–153. (Portuguese-Spanish).

"Biografias".
In: ALMEIDA, Bernardo Pinto; PINHARANDA, João [et.al.]. *Fundação António Prates: um projecto para Ponte de Sor*. Junta de Extremadura; Fundação António Prates, 2001, pp. 169–215, 205, 234. (Portuguese-Spanish).

"Biografias = Biographies: Pedro Cabrita Reis".
In: SAMEIRO, Susana [coord], [et.al.]. *A experiência do lugar: arte & ciência = The Experience of the Place: Art and Science*. Porto: Porto 2001, pp. 157–159. (Portuguese-English).

"[Pedro Cabrita Reis]".
In: HOET, Jan; DEMEESTER, Ann. *Zeitweise: wir sind die anderen*. Herford: MKK GMBH, 2001, p. 56. (German).

"[Pedro Cabrita Reis]".
In: FORTES, Márcia; CAMERON, Dan [et.al]. *Espelho cego: selecções para uma colecção contemporânea: Blind mirror: selections from a contemporary collection*. São Paulo: MAM, 2001, pp. 78, 181. (Portuguese-English).

"Pedro Cabrita Reis: Planetário do Porto".
In: SAMEIRO, Susana [coord], [et.al.]. *A experiência do lugar: arte & ciência = The Experience of the Place: Art and Science*. Porto: Porto 2001, pp. 128–133. (Portuguese-English).

2002 JORGE, João Miguel Fernandes
"Territórios singulares na colecção de Berardo"
In: BERARDO, José Manuel; JORGE, João Miguel Fernandes *Territórios singulares na colecção de Berardo*. [S.l.] : Sintra Museu de Arte Moderna, Colecção Berardo, [2002], pp. 83–84. (Portuguese).

"Pedro Cabrita Reis".
In: FARIA, Nuno; FALCÃO, Pedro [ed.] – *Os dias de Tavira*. [S.l.:s.n.], 2002. Catalogue of the project "Os dias de Tavira", pp. 93–100. (Portuguese).

"[Pedro Cabrita Reis]".
In: CENTRO PER L'ARTE CONTEMPORANEA LUIGI PECCI-PRATO; CORÁ, Bruno. *Collezione permanente: nuove*

acquisizioni. Prato: Centro per l'Arte Contemporanea Luigi Pecci-Prato; Glii Ori, 2002, pp. 25, 70. (Italian-English).

"[Pedro Cabrita Reis]".
In: KUNSTHALLE BERN; FIBICHER, Bernard [ed.]. *Basics: in der Kunsthalle Bern*. Bern: Kunsthalle Bern, 2002, pp. 17, 58–61, 99. (German-English).

"[Pedro Cabrita Reis]".
In: POTT, Karin [et.al] – *Der Schock des 11. September und das geheimnis des anderen: eine dokumentation = The Shock of September 11 and the Mystery of the Other: A Documentation*. Berlin: Haus am Lützowplatz; Lettre International, 2002, pp. 167, 342. (German-English).

"[Pedro Cabrita Reis]".
In: OLIVEIRA, João Esteves de – *Galeria de Arte Moderna e Contemporânea: trabalhos sobre papel*. [Lisbon: s.n., 2002, pp. [36–37]. (Portuguese).

4. SOLO EXHIBITION CATALOGUES

1985 BARROSO, Eduardo Paz
"Viagem, mito e destino na pintura de Pedro Cabrita Reis".
In: *Pedro Cabrita Reis: "De um santuário e certos lugares…"*. [S.l. : Empresa do Jornal de Notícias, SARL, 1985]. (Portuguese).

1988 MELO, Alexandre
"O quadrado de ouro".
In: *Cabrita Reis: da luz como na noite*. Lisbon: INCM, 1988, pp. 17–20. (Portuguese-English).

PINHARANDA, João
"A criação da realidade".
In: *Cabrita Reis: da luz como na noite*. Lisbon: INCM, 1988, pp. 21–24. (Portuguese-English).

POWER, Kevin
"Cabrita Reis: geada tardia em feridas nocturnas".
In: *Cabrita Reis: da luz como na noite*. Lisbon: INCM, 1988, pp. 11–15. (Portuguese-English).

1989 MELO, Alexandre
"Cabrita Reis: A Stranger in Xanadu".
In: *Melancolia*. New York: Bess Cutler Gallery (May 1989), pp. 5–8. (English).

1992 APPEL, Arnulf
"A Forbidden Light".
In: *A Forbidden Light = Ein verbotenes Licht*. Munich: Kunstraum München (Dec. 1992), pp. [6–8]. (English-German).

1993 CAMERON, Dan
"Deslizamiento a la medida =Costumized Slippage".
In: *Pedro Cabrita Reis: H. Suite: (piezas de Madrid = Madrid works)*. Madrid: Galeria Juana de Aizpuru, (Feb. 1993), pp. [4–5, 33]. (Spanish-English).

1994 JUSTO, José M. Miranda
"Construcção e totalidade: processos e materiais do pensamento estético de Pedro Cabrita Reis = Construction and Totality: Processes and Materials in the Aesthetic Thinking of Pedro Cabrita Reis".
In: *Contra a claridade*. Lisbon: Fundação Calouste Gulbenkian. Centro de Arte Moderna José Azeredo Perdigão (May 1994), pp. 23–40. (Portuguese-English).

MELO, Alexandre
"Pedro Cabrita Reis, anos 90 = Pedro Cabrita Reis, The Nineties".
In: *Contra a claridade*. Lisbon: Fundação Calouste Gulbenkian. Centro de Arte Moderna José Azeredo Perdigão (May 1994), pp. 9–22. (Portuguese-English)

MELO, Alexandre
"A escala humana = The Human Scale".
In: *Pedro Cabrita Reis: Portugal*. São Paulo: XXII Bienal de São Paulo (Sept. 1994), pp. [7–13]. (Portuguese-English).

SARDO, Delfim
"A peça 'Das mãos dos construtores II' …= 'Das mãos dos construtores II', currently on display…"
In: *Das mãos dos construtores II*. Lisbon: Centro Cultural de Belém (Sept. 1994), pp. 8–13. (Portuguese-English).

1995 CAMERON, Dan
"Deslizamiento a la medida".
In: *Pedro Cabrita Reis: o que os olhos vêem*. Oviedo: Caja de Asturias, 1995, pp. 17–20. (Spanish).

CASORATI, Cecília
"A exasperada multiplicidade da produção artística contemporânea…"
In: *Pedro Cabrita Reis: Portugal XLVI Bienal de Veneza 1995*. Lisbon: Secretaria de Estado da Cultura, 1995, pp. 11–13. (Portuguese-Italian-English, translated by Jennipher Franchina).

MAIER, Anne
"Allegories of Life and Death".
In: *Pedro Cabrita Reis*. Lisbon: Instituto de Arte Contemporânea, 1995, pp. 6–8. (German-English, translated by L. Lyon and T. Efthymiou).

MESQUITA, Ivo
"An Introduction to Pedro Cabrita Reis".
In: *Pedro Cabrita Reis*. Lisbon: Instituto de Arte Contemporânea, 1995, pp. 9–11. (Portuguese-English, translated by Stephen Berg).

MELO, Alexandre
"Pedro Cabrita Reis –
Gijón: dibujos, proyjectos,
autorretratos y árboles".
In: *Pedro Cabrita Reis: o
que os olhos vêem*. Oviedo:
Caja de Asturias, 1995,
pp. 21–26.
(Spanish).

TEIXEIRA, José Monterroso
"O eco que em Portugal
operou, nos anos 80, a
redefinição medium da
escultura".
In: *Pedro Cabrita Reis:
Portugal XLVI Bienal de
Veneza 1995. Lisbon*:
Secretaria de Estado da
Cultura, 1995, pp. 7–9.
(Portuguese-English).

1996 CELANT, Germano
"Universos de sombra".
In: *Pedro Cabrita Reis*.
Essen: Museum Folkwang;
Amsterdam: De Appel
Foundation; Valencia:
IVAM, 1996, pp. 11–29.
(Spanish-English/German-
English, p. 5).

FINCKH, Gerhard;
BOS, Saskia; TODOLI, Vicent
"Introdución".
In: *Pedro Cabrita Reis*.
Essen: Museum Folkwang;
Amsterdam: De Appel
Foundation; Valencia:
IVAM, 1996, pp. 8–10.
(Spanish-English/German-
English, p. 5).

1999 CORÀ, Bruno
"Pedro Cabrita Reis:
ensembles of places in
which to find him".
In: *CHARTA* [ed.] – Pedro
Cabrita Reis. Milan:
Charta, 1999, pp. 26–30,
32–37, 39–42.
(English-German-
Portuguese).

HEGYI, Lóránd
"Pedro Cabrita Reis:
Sightless Cities – Periphery
Experiences in the
Labyrinth of Deserted
Rooms".
In: *CHARTA* [ed.] – Pedro
Cabrita Reis. Milan:
Charta, 1999, pp. 13–15,
17–19, 21–25.
(English-German-
Portuguese).

MELO, Alexandre
"The Cities Have no
Entrances nor Exits, no
Order nor Landscape".
In: *CHARTA* [ed.] – Pedro
Cabrita Reis. Milan:
Charta, 1999, pp. 44–46,
48–51, 55–59.
(English-German-
Portuguese).

ZACHAROPOULOS, Denys
"To Dwell Poetically in the
World".
In: *CHARTA* [ed.] – Pedro
Cabrita Reis. Milan:
Charta, 1999, pp. 55–59,
60–64, 65–69.
(English-German-
Portuguese).

2001 PACE, Alessandra
"Introduzione =
Introduction".
In: *Il silenzio in ascolto*.
Turin: Hopefulmonster,
2001, pp. 7–8, 9–10.
Galeria Civica d'Arte
Moderna e Contemporanea
di Torino.
(Italian-English).

VON DRATHEN, Doris
"Ascoltare il silenzio =
Giving Heed to Silence".
In: *Il silenzio in ascolto*.
Turin: Hopefulmonster,
2001, pp. 35–42, 61–68.
Galeria Civica d'Arte
Moderna e Contemporanea
di Torino.
(Italian-English).

YEHUDA, E. Safran
"Pedro Cabrita Reis'
Paradigm Is the Displaced
Ruin…"
In: *Il silenzio in ascolto*.
Turin: Hopefulmonster,
2001, pp. 81–84, 101–104
Galeria Civica d'Arte Moderna
e Contemporanea di Torino.
(Italian-English).

2002 ALMEIDA, Marta Moreira
de Almeida
"Um lugar no mundo: Pedro
Cabrita Reis".
In: *Um lugar no mundo:
Pedro Cabrita Reis*. Angra do
Heroísmo: Instituto Açoreano
de Cultura, [2002], pp. 4–5.
(Portuguese).

NORDGREN, Sune
"Pedro Cabrita Reis".
In: NORDGREN, Sune;
MARTIN , Sara [ed.lit.] –
*Pedro Cabrita Reis: A Place
like That*. Exhibition Guide
no. 2. Gateshead, [2002], p. [2].
(English).

5. PERIODICALS

5.1. NEWSPAPER ARTICLES (selected)

1995 MELO, Alexandre
"Todos igualmente diferentes".
In: *Expresso. Revista*
(Lisbon), 4.2.1995.
(Portuguese).

PINHARANDA, João
"Era uma vez uma feira".
In: *Público. Cultura*
(Lisbon), 10.2.1995.
(Portuguese).

PINHARANDA, João
"Imagens do fim do século".
In: *Público. Cultura*
(Lisbon), 11.2.1995.
(Portuguese).

PINHARANDA, João
"Portugal no seu melhor".
In: *Público. Cultura*
(Lisbon), 12.2.1995.
(Portuguese).

PINHARANDA, João
"Os caminhos nunca acabam".
In: *Público. Zoom* (Lisbon),
17.2.1995.
(Portuguese).

POMAR, Alexandre
"Verde e vermelho".
In: *Expresso. Revista*
(Lisbon), 18.2.1995.
(Portuguese).

PINHARANDA, João
"Prova de artista".
In: *Público. Leituras*
(Lisbon), 4.3.1995.
(Portuguese).

COUTINHO, Wilson
"Um conto sobre a
irracionalidade".
In: *O Globo* (São Paulo),
24.6.1995, p. 4.
(Portuguese).

1996 "O desejo do desenho a ver
na Casa da Cerca".
In: *Correio da Manhã*
(Lisbon), 7.1.1996.
(Portuguese).

"Ícones de Mihajlovic na
Galeria Escada 4".
In: *Correio da Manhã*
(Lisbon), 15.1.1996.
(Portuguese).

"Cabrita Reis expõe no Funchal"
In: *Diário de Notícias*
(Lisbon), 30.1.1996.
(Portuguese).

PINHARANDA, João
"As flores e os frutos".
In: *Público. Zap* (Lisbon),
9.2.1996, p. 18.
(Portuguese).

POMAR, Alexandre
"Ilusões perdidas".
In: *Expresso* (Lisbon),
12.2.1996.
(Portuguese).

POMAR, Alexandre
"A flecha portuguesa".
In: *Expresso. Revista*
(Lisbon), 17.2.1996, pp.
74–76.
(Portuguese).

"António Dantas expõe em
breve, Cabrita Reis já tem
catálogo".
In: *Diário de Notícias da
Madeira* (Funchal),
24.3.1996.
(Portuguese).

"Arte portuguesa rumo a
Estrasburgo".
In: *Diário de Notícias*
(Lisbon), 4.5.1996).
(Portuguese).

"Anos 60–80 no Funchal".
In: *Expresso* (Lisbon),
6.7.1996.
(Portuguese).

"Memória do poeta árabe".
In: *Comércio do Porto*
(Porto), 7.7.1996.
(Portuguese).

"Catálogos exposição na
Assírio & Alvim".
In: *Diário de Notícias*
(Lisbon), 11.9.1996.
(Portuguese).

"Artists Seek Recognition Abroad".
In: *The Washington Times. Portugal '96* (Washington), 12.9.1996, p. 12.
(English).

PINHARANDA, João
"Dar arte ao Sul".
In: *Público* (Lisbon), 14.10.1996.
(Portuguese).

PROENÇA, João Tiago
"'Ateliers' de São Paulo a funcionar".
In: *Público* (Lisbon), 24.10.1996.
(Portuguese).

"Los objetos de Pedro Cabrita".
In: *El Mercantil Valenciano* (Valencia), 1.11.1996, p. 55.
(Portuguese).

POMAR, Alexandre
"Cabrita Reis: monumento a Azeredo Perdigão".
In: *Expresso* (Lisbon), 4.11.1996, p. 5.
(Portuguese).

"El IVAM muestra la corporeidad del silencio a través de las instalaciones de Cabrita Reis".
In: *El Pais. Comunidad Valenciana* (Valencia), 1.11.1996, p. 9.
(Spanish).

MELO, Alexandre
"O gesto inexorável: uma série inédita numa obra multifacetada".
In: *Expresso* (Lisbon), 10.11.1996.
(Portuguese).

PORTO, Carlos
"Portugueses em Cádis".
In: *Jornal de Letras, Artes e Ideias* (Lisbon), 20.11.1996.
(Portuguese).

MELO, Alexandre
"Cabrita Reis europeu".
In: *Expresso* (Lisbon), 23.11.1996, p. 5.
(Portuguese).

"Azeredo Perdigão: monumento".
In: *Público. Cultura* (Lisbon), 28.11.1996, p. 27.
(Portuguese).

"Pedro Cabrita Reis…"
In: *Jornal de Letras, Artes e Ideias* (Lisbon), 4.12.1996.
(Portuguese).

TOMÁS, Carla
"Geração de 90".
In: *Expresso* (Lisbon), 14.12.1996.
(Portuguese).

1997 NUNES, Maria Leonor
"Retrato de um artista enquanto homem vivo".
In: *Jornal de Letras, Artes e Ideias* (Lisbon), 15.1.1997, pp. 13–15.
(Portuguese).

CRUZ, Ana Bela Martins da
"Fotografia, pintura e objectos".
In: *Diário de Notícias* (Lisbon), 23.1.1997.
(Portuguese).

"Arte portuguesa exposta em Amiens".
In: *Correio da Manhã* (Lisbon), 28.1.1997.
(Portuguese).

PINHARANDA, João
"For Heiner Müller".
In: *Público. Zap* (Lisbon), 31.1.1997, p. 17.
(Portuguese).

"Veneza marca Bienal".
In: *Expresso* (Lisbon), 1.2.1997.
(Portuguese).

GASPAR, Miguel
"Todos os artistas vão dar a Madrid".
In: *Diário de Notícias* (Lisbon), 12.2.1997.
(Portuguese).

"Fotografia e pintura na Galeria Maria Lebre".
In: *Correio da Manhã* (Lisbon), 18.2.1997.
(Portuguese).

VAZ, Rodrigues
"Arte latino-americana ajuda recuperação".
In: *Correio da Manhã* (Lisbon), 18.2.1997.
(Portuguese).

"For Heiner Müller".
In: *Diário Económico* (Lisbon), 6.3.1997.
(Portuguese).

SOUSA, Rocha de
"Homenagem a Heiner Müller".
In: *Jornal de Letras, Artes e Ideias* (Lisbon), 12.3.1997, p. 33.
(Portuguese).

PINHARANDA, João
«"A minha bandeira…": interrogação das fronteiras na Culturgest».
In: *Público. Zap* (Lisbon), 28.3.1997, p. 17.
(Portuguese).

NUNES, Maria Leonor
"O vício do olhar".
In: *Jornal de Letras, Artes e Ideias* (Lisbon), 9.4.1997.
(Portuguese).

"Arte contemporânea em Vila do Conde".
In: *Diário de Notícias* (Lisbon), 11.4.1997.
(Portuguese).

F.R.
"Arte pública na Marechal Gomes da Costa: Pedro Cabrita Reis completa intervenção".
In: *Público* (Lisbon), 29.4.1997, p. 42.
(Portuguese).
"Cabrita Reis em Veneza".
In: *Público* (Lisbon), 12.5.1997, p. 25.
(Portuguese).

"Diálogo artístico peninsular".
In: *Público* (Lisbon), 19.5.1997.
(Portuguese).

«Portugueses e espanhóis "Na pele do touro"».
In: *Diário de Notícias* (Lisbon), 19.5.1997.
(Portuguese).

"Leões de Veneza".
In: *Expresso* (Lisbon), 21.6.1997.
(Portuguese).

SOUSA, Rui Ferreira de
«Uma metáfora sobre a liberdade: "cenas de uma execução" no D. Maria II».

In: *Público* (Lisbon), 1.7.1997, p. 28.
(Portuguese).

GOMES, Manuel João
"A pintura de encomenda".
In: *Público* (Lisbon.), 3.7.1997, p. 31.
(Portuguese).

POMAR, Alexandre
"Veneza: Bienal 97".
In: *Expresso* (Lisbon), 7.7.1997.
(Portuguese).

AMARAL, Rosa
"Azedo Perdigão".
In: *O Independente* (Lisbon), 25.7.1997, p. 31.
(Portuguese).

CASTANHEIRA, José Pedro
"Filhos de Perdigão criticam monumento".
In: *Expresso* (Lisbon), 26.7.1997, p. 12.
(Portuguese).

BÉNARD DA COSTA, João
"O dependente".
In: *O Independente* (Lisbon), 29.8.1997.
(Portuguese).

HENRIQUES, António
"Mamarrachos, dizem eles…"
In: *Expresso. Revista* (Lisbon), 30.8.1997, pp. 16–23.
(Portuguese).

CHICÓ, Sílvia
"Da presença portuguesa às instalações vídeo".
In: *Jornal de Letras, Artes e Ideias* (Lisbon), 10.9.1997.
(Portuguese).

BRAGANÇA, Pedro
«Entrevistas imaginárias: Pedro Cabrita Reis: "a ilusão é o primeiro de todos os prazeres"».
In: *Expresso*. Revista (Lisbon), 13.9.1997, p. 8.
(Portuguese).

C.F.
"Cabrita Reis trabalha a energia da cidade".
In: *Folha de S. Paulo. Ilustrada* (São Paulo), 2.10.1997, p. 5.
(Portuguese).

"Visuais".
In: *O Estado de S. Paulo. Caderno 2*, 2.10.1997, p. D11.
(Portuguese).

MORAES, Angêlica de
"Esculturas contemporâneas são destaque".
In: *O Estado de S. Paulo. Caderno 2*, 3.10.1997, pp. D4, D21.
(Portuguese).

FERNANDES, José Manuel
"Monumentos & estátuas (2)".
In: *Expresso. Revista* (Lisbon), 4.10.1997, pp. 118–119.
(Portuguese).

M.H.
"As possibilidades da escultura".
In: *Jornal da Tarde (São Paulo)*, 4.10.1997, p. 2C.
(Portuguese).

"Portugueses internacionais".
In: *Público* (Lisbon), 3.11.1997.
(Portuguese).

"Pensar o corpo".
In: *Expresso* (Lisbon), 15.11.1997.
(Portuguese).

RODRIGUES, António
"A caminho dos circuitos internacionais".
In: *Capital* (Lisbon), 23.11.1997.
(Portuguese).

"Agenda".
In: *Notícias Magazine* (Lisbon), 16.12.1997.
(Portuguese).

1998 "Desenhos para Al-Mu'tamid".
In: *Público* (Lisbon), 9.1.1998.
(Portuguese).

CARVALHO, Paulo de
"A cultura em Estocolmo".
In: *Expresso* (Lisbon), 17.1.1998.
(Portuguese).

"Não há nada como fumar um charuto".
Conducted by Rute Manuel.
In: *Capital* (Lisbon), 17.1.1998.
(Portuguese).

"Razões para algum optimismo".
In: *Comércio do Porto* (Porto), 20.1.1998.
(Portuguese).

KUIN, Simon
"Cultura em Estocolmo".
In: *Expresso* (Lisbon), 31.1.1998.
(Portuguese).

MELO, Alexandre
"Breve panorámica del arte portugues".
In: *El Periodico del Arte. Suplemento ARCO* (Madrid), no. 8, Feb. 1998, p. 14.
(Spanish).

MENDES, Pedro Rosa
"Emoções à solta em Calecute".
In: *Público* (Lisbon), 7.2.1998.
(Portuguese).

FARIA, Óscar
"Imagens de Portugal".
In: *Público* (Lisbon), 12.2.1998.
(Portuguese).

POMAR, Alexandre
"Arte portuguesa causa decepção em Madrid".
In: *Expresso* (Lisbon), 14.2.1998.
(Portuguese).

OLIVEIRA, Luísa Soares de
– Pelas galerias de Madrid.
In: *Público* (Lisbon), 14.2.1998.
(Portuguese).

OLIVEIRA, Luísa Soares de
"Diz-me o que lês".
In: *Público* (Lisbon), 22.3.1998.
(Portuguese).

"São Paulo abre "atelier" esta noite".
In: *Jornal de Notícias* (Porto), 8.5.1998.
(Portuguese).

"Ateliers de São Paulo".
In: *Correio da Manhã* (Lisbon), 8.5.1998.
(Portuguese).

"Começa hoje".
In: *Capital* (Lisbon), 13.5.1998.
(Portuguese).

INFANTE, Isabel
"Ateliers de São Paulo abertos ao público".
In: *Diário Económico* (Lisbon), 14.5.1998.
(Portuguese).

"Artes plásticas portuguesas na Bienal de São Paulo".
In: *Diário de Notícias* (Lisbon), 19.5.1998.
(Portuguese).

"Arte no meio da rua".
In: *Diário de Notícias* (Lisbon), 21.5.1998.
(Portuguese).

"O panorama da arte portuguesa não é nada mau".
In: *Primeiro de Janeiro* (Porto), 5.6.1998.
(Portuguese).

"Modelos de inovação e de continuidade".
In: *Jornal de Notícias* (Porto), 22.6.1998.
(Portuguese).

"Quatro exposições em Lisboa".
In: *Diário de Notícias* (Lisbon), 16.7.1998.
(Portuguese).

"Pavilhão de Portugal promove pintura nacional".
In: *Correio da Manhã* (Lisbon), 31.7.1998.
(Portuguese).

PINHARANDA, João
"Verão desvairadas gentes…"
In: *Público* (Lisbon), 21.8.1998.
(Portuguese).

PINTO, Maria João
"Chamar a atenção dos fluxos culturais".
In: *Diário de Notícias* (Lisbon), 24.8.1998.
(Portuguese).

"Uma colectiva de artes plásticas em Lisboa".
In: *Diário de Notícias* (Lisbon), 26.9.1998.
(Portuguese).

"Colecção de Serralves em Guimarães".
In: *Jornal de Notícias* (Porto), 30.9.1998.
(Portuguese).

PINHARANDA, João
"Antropofagia e contaminação…"
In: *Público* (Lisbon), 7.10.1998.
(Portuguese).

"Exposição de obras de Serralves na Sociedade Martins Sarmento".
In: *Primeiro de Janeiro* (Porto), 8.10.1998.
(Portuguese).

"Anos 80".
In: *Primeiro de Janeiro* (Porto), 1.11.1998.
(Portuguese).

"Arte portuguesa: os anos 80".
In: *O Dia* (Lisbon), 9.11.1998.
(Portuguese).

SIMÕES, João Manuel
"Um centro cultural no coração do Porto".
In: *Jornal de Notícias* (Porto), 12.11.1998.
(Portuguese).

"Exposições".
In: *O Diabo* (Lisbon), 10.12.1998.
(Portuguese).

"Surrealismos".
In: *Público* (Lisbon), 22.12.1998.
(Portuguese).

1999 MAGALHÃES, Fernando
"O artista frente ao espelho".
In: *Público* (Lisbon), 13.2.1999.
(Portuguese).

"Galeria de notáveis na Gulbenkian".
In: *Correio da Manhã* (Lisbon), 13.2.1999.
(Portuguese).

ASSUNÇÃO, Francisco
"Cultura portuguesa
'invade' Bona".
In: *Diário de Notícias*
(Lisbon), 20.3.1999.
(Portuguese).

"Relíquias portuguesas são
tema principal da exposição
'Grandes…'"
In: *Primeiro de Janeiro*
(Porto), 20.3.1999.
(Portuguese).

"Museu de Arte Antiga vai
a Bona".
In: *Diário Económico*
(Lisbon), 22.3.1999.
(Portuguese).

"Portugal invade Bona".
In: *Diário Económico*
(Lisbon), 25.3.1999.
(Portuguese).

"Cultura portuguesa exibe-se
em Bona".
In: *Correio da Manhã*
(Lisbon), 26.3.1999.
(Portuguese).

"Cultura portuguesa chega
a Alemanha".
In: *Semanário* (Lisbon),
26.3.1999.
(Portuguese).

RATO, Vanessa
"Arte antiga foi a Bona".
In: *Público* (Lisbon),
26.3.1999.
(Portuguese).

RATO, Vanessa
"Arte de Portugal".
In: *Público* (Lisbon),
27.3.1999.
(Portuguese).

PINTO, António Cerveira
"Uma sensibilidade
humana".
In: *O Independente*
(Lisbon), 23.4.1999.
(Portuguese).

PINHARANDA, João
"Descoberto um artista
encoberto".
In: *Público* (Lisbon),
23.4.1999.
(Portuguese).

PINHARANDA, João
"Antológica de Pedro Cabrita
Reis em Serralves: 'As minhas
peças são monólogos'".
In: *Público*. Artes (Lisbon),
19.11.1999, pp. 28–29.
(Portuguese).

PINHARANDA, João
"O artista no centro do
mundo".
In: *Público*. Artes (Lisbon),
19.11.1999, p. 29.
(Portuguese).

COELHO, Eduardo Prado
"Tempo de paz".
In: *Público* (Lisbon),
23.11.1999.
(Portuguese).

SEARLE, Adrian
"Raising the Roof".
In: *The Guardian* (London),
23.11.1999, pp. 10–11.
(English).

POMAR, Alexandre
"Três artistas no Porto".
In: *Expresso. Cartaz* (Lisbon),
no. 1413, 27.11.1999,
pp. 26–27.
(Portuguese).

PINTO, Ana
"Passado presente".
In: *O Independente*. 3
(Lisbon), 3–9.12.1999, p. 88.
(Portuguese).

PORFÍRIO, José Luís
"O excesso e a diferença:
Cabrita Reis construiu um
percurso cego em Serralves,
que tem de ser visto como
tal, peça a peça, espaço a
espaço, corpo a corpo".
In: *Expresso. Cartaz*.
(Lisbon), no. 1414, 4.12.1999,
pp. 24–25.
(Portuguese).

MARTINS, Celso
"Exposições: Pedro Cabrita
Reis".
In: *Expresso* (Lisbon),
24.12.1999, p. 16.
(Portuguese).

2000 BRAGANÇA, Pedro
"Um tropeção na
imortalidade".
In: *Expresso. Revista*
(Lisbon), no. 1419,
8.1.2000, p. 16.
(Portuguese).

FALCÃO, Fernando
"'Sem título': o convite".
In: *Jornal de Notícias*
(Porto), 12.1.2000, p. 44.
(Portuguese).

ALMEIDA, Bernardo Pinto de
"A Terra vista da Lua: um
puro golpe de magia".
In: *Jornal de Notícias*
(Porto), 17.1.2000, p. 37.
(Portuguese).

PEREIRA, Ana Cristina
"Albuquerque Mendes
mostra arte a jovens
carenciados de Matosinhos:
'A casa de banho dos
trolhas'".
In: *Público* (Lisbon),
18.1.2000, p. 45.
(Portuguese).

HENZE, Nikola
«Bemalte Eingangstüren,
'Das geteilte Haus': die
Galerie Markus Richter
stellt eine Rauminstallation
von Pedro Cabrita Reis vor».
In: *Berliner Morgenpost*
(Berlin), 15.2.2000.
(German).

STELZER, Tanja
"Künstler verstehen, wie
eine Neuberlinerin diese
Stadt erleben kann".
In: *Der Tagesspiegel*
(Berlin), 2.3.2000.
(German).

VOGT, Tobias
"Sentiment zwischen Stein
und Mörtel, Pedro Cabrita
Reis in der Berliner Galerie
Markus Richter."
In: *Berliner Zeitung.
Feuilleton* (Berlin),
4–5.3.2000.
(German).

HERBSTREUTH, Peter
"'Das geteilte Haus': die
Galerie Markus Richter
zeigt in ihren neuen
Berliner Räumen
Skulpturen von Pedro
Cabrita Reis".
In: *Der Tagesspiegel*
(Berlin), 11.3.2000.
(German).

LEHNART, Ilona
"In der Leere irritiert die
Fremdheit der Dinge:
Räume und Zeichen des
documenta-Künstlers Pedro
Cabrita Reis in der Galerie
Markus Richter".
In: *Frankfurter Allegemeine
Zeitung*, Berliner Seiten,
21.3.2000.
(German).

"Artes plásticas: Graça
Dias/José Vieira e Cabrita
Reis vencem AICA".
In: *Público* (Lisbon), year
11, no. 3665, 30.3.2000, p.
31.
(Portuguese).

GOMES, Kathleen
"A geração de 80 chegou à
idade dos prémios".
In: *Público* (Lisbon), year
11, no. 3666, 31.3.2000, p.
26.
(Portuguese).

FARIA, Óscar
"O mistério e a revelação".
In: *Público* (Lisbon), year
11, no. 3666, 31.3.2000, p.
27.
(Portuguese).

OLIVEIRA, Luísa Soares de
"Arte efémera".
In: *Público. Artes* (Lisbon),
year 11, no. 3666,
31.3.2000.
(Portuguese).

DANIELS, Corina
"Neue internationale
Kunstgewächse, Konkurrenz
belebt das Geschäft: Jenseits
der Torstrasse entwickelt
sich eine neue Szene".
In: *Die Welt. Berliner
Feuilleton* (Berlin), 5.4.2000.
(German).

JIMENEZ, Jose
"Pedro Cabrita Reis: sólo los
ciegos ven".
In: *El Mundo. Cultura*
(Madrid), year XII, no. 3834,
17.5.2000, p. 58.
(Spanish).

"Neiuwe prijs europese
kunstenaars ingesteld:
Maastricht".
In: *De Volkskrant*,
19.05.2000.
(Dutch).

"Twee belgeen genomineerd vorr eerste Vincent".
In: *De Morgen*, 20.5.2000.
(Dutch).

"Zes nominaties voor Europeses Kunstprijs".
In: *Dablad de Limburger*, 20.5.2000.
(Dutch).

"Zes Kandidaten voor eerste Vena Gogh Award".
In: *NRC*, 23.5.2000.
(Dutch).

SEARLE, Adrian
"For a Few Euros More: Who Needs the Turner When You've Got the Vincent?"
In: *The Guardian* (London), 20.6.2000, pp. 10–11.
(English).

BORG, Lucette ter
"De toekomst is aan de bejaarden".
In: *Kunst & Cultuur* (Maastricht), 29.6.2000, p. 19.
(Dutch).

"Exposição na UNESCO".
In: *Expresso. Cartaz* (Lisbon), 10.6.2000.
(Portuguese).

LEVINE, Angela
"Elevating the Banal".
In: *The Jerusalem Post*. Friday Art (Jerusalem), 23.6.2000, p. B14.

CRUZ, Valdemar
"Saberes cruzados".
In: *Expresso. Cartaz* (Lisbon), 3.7.2000.
(Portuguese).

PINHARANDA, João
"Enciclopédia: continua: desenhos de Pedro Cabrita Reis em Sines".
In: *Público* (Lisbon), 8.7.2000, p. 64.
(Portuguese).

L-ÖBE, João
"Pedro Cabrita Reis em Sines: Naturalia II no Centro Cultural Emmérico Nunes".
In: *Sudoeste*. Cultural, (Sines), 11.7.2000, p. 24.
(Portuguese).

"Sines: Cabrita Reis expôe estranhas aves".
In: *Diário do Alentejo* (Sines), 13.7.2000, p. 34.
(Portuguese).

"Sines: Naturália"
In: *Diário do Alentejo* (Sines), 13.7.2000, p. 15.
(Portuguese).

OLIVEIRA, Luísa Soares de
"A vida das imagens anónimas".
In: *Público. Artes* (Lisbon), 14.7.2000, pp. 14, 19.
(Portuguese).

"Sines: aves de várias cores".
In: *Diário do Alentejo* (Sines), 20.7.2000, p. 34.
(Portuguese).

L-ÖBE, João
"Romantismo mutante: Naturalia II estranhas aves de várias cores".
In: *Sudoeste*. Cultural (Sines), 25.7.2000, p. 24.
(Portuguese).

ANKERMAN, Karel
"Somber gelanden toekomstbeeld: video een wandeting langs van The Vincent 2000".
In: *The Dutch Financial Times*. Kunst & Financien, 16.9.2000.
(Dutch).

Van de VELDE, Paola
"Finse Athila wint eerst Vincentprijs".
In: *De Telegraaf*, 14.9.2000, col. 2.
(Dutch).

ALMEIDA, Bernardo Pinto de
"Cabrita Reis".
In: *Jornal de Notícias* (Lisbon), 18.12.2000),
(Portuguese).

PINHARANDA, João
"O prémio de arte mais antigo rejuvenesce".
In: *Público*. Cultura (Lisbon), 21.12.2000, p. 26.
(Portuguese).

2001 "Kunstpionier Teixeira wacht nog steeds op Portugals inhaalslag".
In: *Rotterdamns Dagblad* (Rotterdam), 16.2.2001, col. 1.
(Dutch).

"Portuguese Kunst staat buiten de mode".
In: *NRC Handelsblad*, 26.2.2001, col. 1.
(Dutch).

FARIA, Óscar; GARRIDO, Nelson [fot.]
"Cruzar saberes".
In: *Público*. Cultura (Lisbon), 10.3.2001, pp. 42–43.
(Portuguese).

RATO, Vanessa
"Experimentadesign 2001: como é que fazes o que fazes?"
In: *Público*. Cultura (Lisbon), 22.3.2001, p. 8.
(Portuguese).

MARQUES, Lúcia
"Arte em laboratórios".
In: *Expresso. Cartaz* (Lisbon), no. 1487, 28.4.2001, pp. 40–41.
(Portuguese).

PINHARANDA, João
"Com remontagem".
In: *Público*. Artes Plásticas (Lisbon), 28.4.2001, pp. 19–22, 21.
(Portuguese).

MACRI, Teresa
"Il cielo sopra Regina Coeli: 'D'après Piranesi', in mostra a Roma le opere dell'artista portoghese Pedro Cabrita Reis".
In: *Il Manisfesto*. Cultura (Rome), 16.5.2001, p. 13.
(Italian).

POMAR, Alexandre
"Desenhos dos anos 80: Museu de Évora".
In: *Expresso. Cartaz* (Lisbon), 19.5.2001, p. 36.
(Portuguese).

RATO, Vanessa
"A Europa das artes em Milão, antes de Veneza: exposição reúne 20 países".
In: *Público*. Cultura (Lisbon), 22.5.2001.
(Portuguese).

RATO, Vanessa
"Sete Portugueses em exposição".
In: *Público*. Cultura (Lisbon), 22.5.2001.
(Portuguese).

NEVES, Joana
"Afirmar e declinar, desenho dos anos oitenta".
In: *Público. Mil Folhas* (Lisbon), 26.5.2001, pp. 18–19.
(Portuguese).

BARRETO, Pedro
"Arquitectos de todo o mundo debatem a cidade contemporânea".
In: *Público* (Lisbon), 31.05.2001, p. 43.
(Portuguese).

"Arquitectos em 'performance'".
In: *Público* (Lisbon), 2.6.2001, p. 45.
(Portuguese).

POMAR, Alexandre
"Um palácio em Veneza".
In: *Expresso. Cartaz* (Lisbon), 16.6.2001, pp. 4–5.
On Pedro Cabrita Reis, p. 5.
(Portuguese).

CELSO, Martins
"Traços geracionais".
In: *Expresso. Cartaz* (Lisbon), 16.6.2001, pp. 42–43.
(Portuguese).

CARVALHO, Ricardo
"Pensar, construir, habitar".
In: *Público. Cartaz* (Lisbon), 21.7.2001, pp. 30–31.
(Portuguese).

OLIVEIRA, Luísa Soares de
"Al Químias em Sines".
In: *Público. Cartaz* (Lisbon), 28.7.2001, pp. 24–25.
(Portuguese).

SOUSA, Margarida Bon de
"BPP aposta nos anos 90: colecção do banco de João Rendeiro está à guarda do Museu de Serralves. Acervo é seleccionado por Vicente Todoli".
In: *Diário de Notícias. Negócios* (Lisbon), 10.9.2001, p. 18.
(Portuguese).

CRUZ, Valdemar
"Albuquerque Mendes:
(auto)-retrato de um artista".
In: *Expresso. Revista*
(Lisbon), 10.10.2001.
(Portuguese).

Molina, Margot
"Portugal se acerca a
Sevilla con un ciclo en
torno al arte contemporanea
y al cine".
In: *El Pais* (Madrid),
12.10.2001.
(Spanish).

ROCHA, Luís
"Porta 33 participa na
'ARCO 2002' com Pedro
Cabrita Reis".
In: *Diário de Notícias*
(Madeira), Funchal,
28.11.2001, p. 22.
(Portuguese).

FARIA, Óscar
"100 autores da nova
visualidade portuguesa
reunidos em livro: 'Tráfego'
lançado hoje no Porto:
publicação organizada por
Alexandre Melo em
colaboração com Paulo
Cunha e Silva integra 100
nomes de Abi Feijó a Wize".
In: *Público* (Lisbon),
9.12.2001, p. 49, col. 5.
(Portuguese).

FARIA, Óscar
"Arte-público no Mil Folhas".
In: Público. Mil Folhas
(Lisbon), 22.12.2001, pp. 2,
12–13, col. 1.
(Portuguese).

2002 POMAR, Alexandre
"De volta à ARCO"
In: *Expresso. Cartaz*
(Lisbon), 12.1.2002, p. 6,
col. 1.
(Portuguese).

POMAR, Alexandre
"Os artistas do momento".
In: *Expresso. Cartaz* (Lisbon),
12.1.2002, pp. 12–13.
(Portuguese).

FARIA, Óscar
"Serralves poderá ser
parceiro na Bienal de
Veneza".
In: *Público* (Lisbon),
18.1.2002, p. 41, col. 2.
(Portuguese).

"Pintor Pedro Cabrita Reis
expõe nos Capitães
Generais".
In: *Diário Insular* (Angra do
Heroísmo), 30.1.2002.
(Portuguese).

"Exposição nos Capitães
Generais".
In: *Diário Insular* (Angra do
Heorismo), 31.1.2002.
(Portuguese).

CABRAL, Tibério
"A arte de Cabrita Reis na
galeria do Palácio".
In: *A União*, 31.1.2002,
p. 4.
(Portuguese).

ROCHA, Luís
"Porta 33 na ARCO em
Madrid entre 257 galerias".
In: *Diário de Notícias*
(Madeira), Funchal.
2.2.2002, p. 26, col. 2.
(Portuguese).

OLIVEIRA, Luísa Soares de
"Os rituais da ARCO
começaram em Madrid".
In: *Público* (Lisbon),
14.2.2002, p. 36, col. 2.
(Portuguese).

FARIA, Óscar
"Catorze galerias
portuguesas na ARCO".
In: *Público* (Lisbon),
14.2.2002, p. 37
(Portuguese).

"Portugal en ARCO".
In: *El Punto*. De las Artes
(Madrid), 15.2.2002, p. 28,
col. 5.
(Spanish).

ROCHA, Luís
"Porta 33 na ARCO em
Madrid: galeria pequena
mas sempre destacada".
In: *Diário de Notícias*.
Madeira. Funchal.
(15.02.2002); p. 26.
(Portuguese).

"A difícil função de ver".
In: *A União*, 04.2.2002.
(Portuguese).

RATO, Vanessa
"Uma colecção com alguma
singularidade".
In: *Público* (Lisbon),
20.4.2002, pp. 20–21.
(Portuguese).

FARIA, Óscar
"José Pedro Croft: a
educação do escultor".
In: *Público* (Lisbon),
4.5.2002, pp. 16–19,
col. 2, 4, 6, 8.
(Portuguese).

POMAR, Alexandre
"Exposições em Lisboa e
Porto mostram a nova
direcção da Colecção CGD e
três anos de compras".
In: *Expresso. Cartaz* (Lisbon),
4.5.2002, pp. 28–29.
(Portuguese).

"O protocolo: IAC e
Serralves juntos na Bienal
de Veneza".
In: *Público* (Lisbon),
1.6.2002, p. 41.
(Portuguese).

MARGATO, Cristina
"Portugal no Giardini: na
Bienal de Veneza de 2003 a
representação nacional quer
um lugar central para
Cabrita Reis".
In: *Expresso. Cartaz*
(Lisbon), 8.6.2002, p. 4.
(Portuguese).

CAVERNI, Gianni
«I nuovi "acquisti" del
museo Pecci"».
In: *Il Correre di Firenze*
(Florence), 11.7.2002, col. 2.
(Italian).

"Cortegio, I musei restano
aperti".
In: *La Nazione* (Prato),
7.7.2002, col. 1.
(Italian).

"Uma peça curiosa".
In: *Público* (Lisbon),
21.8.2002, p. 34.
(Portuguese).

POMAR, Alexandre
«"Os Dias de Tavira" e o
espírito do lugar: paisagens
do Sul».
In: *Expresso. Cartaz*
(Lisbon), 31.8.2002, p. 20.
(Portuguese).

"O evento: projectos
artísticos invadem Tavira".
In: *Público* (Lisbon),
31.8.2002, p. 36.
(Portuguese).

FARIA, Óscar
"Artes múltiplas na
paisagem de Tavira".
In: *Público* (Lisbon),
1.9.2002, p. 36, col. 3.
(Portuguese).

COELHO, Eduardo Prado
"O lugar: o banal. O
quotidiano".
In: *Público* (Lisbon),
21.09.2002, p. 11,
col. 1, 3.
(Portuguese).

MARTINS, Celso
"O sal da terra: a Ria
Formosa transformada em
palco de intervenções
artísticas".
In: *Expresso. Cartaz*
(Lisbon), 21.09.2002, p. 26,
col. 3.
(Portuguese).

FARIA, Óscar
"Iluminações em Tavira".
In: *Público* (Lisbon),
28.09.2002, p. 26,
col. 3, 4.
(Portuguese).

YOUNG, Peter
"Everyone's a Winner".
In: *Evening Chronicle
(Newcastle)*, 18.10.2002,
col. 1.
(English).

WHETTSTONE, David
"Pedro Puts His Work
Firmly on the Table".
In: *The Journal*
(Newcastle), 23.10.2002.
(English).

"Visit a Place like No
Other".
In: *Evenig Chronicle*
(Newcastle), 25.10.2002.
(English).

"Pedro's Baltic Debut Is A
Celebration of Life".
In: *The Northen Echo*
(Newcastle), 26.10.2002.
(English).

"Um português no The Baltic".
In: *Diário de Notícias*. Artes (Lisbon), 28.10.2002, p. 41.
(Portuguese).

"Show Lanched"
In: *Evening Chronicle* (Newcastle), 28.10.2002.
(English).

SEARLE, Adrian
"Pedro Cabrita Reis".
In: *The Guardian* (Newcastle), 4.11.2002.
(English)

GANDZ, Alexandra
"Der Schrott, aus dem die Träume sind: Baustelle ohne Menschen: der portugiesische Pedro Cabrita Reis in der Kestner Gesellschaft Hannover".
In: *Hannoversche Allgemeine* (Hanover), 30.11.02.
(German).

WHETSTONE, David
"Phew, No Howwellers at Baltic!"
In: *The Journal* (Newcastle), Nov. 2002, col. 3.
(English).

SEIBOLD-BULTMANN, Ursula
"Provisoriches Universum: Pedro Cabrita Reis in Hannover".
In: *Neue Zürcher Zeitung* (Zurich), 14/15.12.2002.
(German).

B.E.
"Pedro Cabrita Reis: A Place like That".
In: *The Art Newspaper* (London), no. 131 (Dec. 2002, p. 18.
(English).

2003 RATO, Vanessa
"O mercado nacional continua virado para a pintura".
In: *Público* (Lisbon), 25.1.2003, p. 40.
(Portuguese).

NICOL, Gillian
"Pedro Cabrita Reis: a place like that".
In: *A–N: Magazine for Artists* (London), Jan. 2003.
(English).

POMAR, Alexandre
"Dupla presença em Veneza: Cabrita Reis fará uma instalação nos jardins da Bienal".
In: *Expresso*. Factual (Lisbon), 8.2.2003, p. 7.
(Portuguese).

MARGATO, Cristina
"Veneza pode afundar: IAC não tem liquidez para responder a compromissos".
In: *Expresso*. Actual (Lisbon), 15.2.2003, p. 6.
(Portuguese).

SOUSA, Margarida Bon de
"Investidores na ARCO"
In: *Diário de Notícias* (Lisbon), 15.02.2003, p. 26.
(Portuguese).

RATO, Vanessa
"IAC e MC reúnem-se para discutir Veneza".
In: *Público* (Lisbon), 18.2.2003, p. 44.
(Portuguese).

FARIA, Óscar
"está tudo a correr como desejo".
In: *Público* (Lisbon), 8.3.2003, p. 40.
(Portuguese).

PINHARANDA, João
"Domus: teoria e prática da construção".
In: *Público* (Lisbon), 15.3.2003, p. 16.
(Portuguese).

POMAR, Alexandre
"Energia construtiva".
In: *Expresso*. Actual (Lisbon), 23.3.2003, p. 42.
(Portuguese).

FARIA, Óscar
"Quatro artistas Portugueses na Bienal de Veneza".
In: *Público* (Lisbon), 8.4.2003, p. 37.
(Portuguese).

RATO, Vanessa
"Pedro Cabrita Reis escolhe Pedro Gomes".
In: *Público* (Lisbon), 16.4.2003, p. 37.
(Portuguese).

5.2 MAGAZINE ARTICLES (selected)

1990 MELO, Alexandre
"Cabritas Reis".
In: *Galeria: Revista de Arte*, no. 19 (1990), pp. 52–55.
(Portuguese).

MELO, Alexandre
"Lisbon".
In: *Contemporanea* (New York), vol. 3, no. 2 (Feb. 1990), pp. 34–35.
(English).

MACHADO, José de Sousa
"Atitudes litorais".
In: *Artes e Leilões* (Lisbon), year 1, no. 3 (Feb./Mar. 1990), pp. 29–31.
(Portuguese).

MELO, Alexandre
"Tópicos de internacionalização".
In: *Artes e Leilões* (Lisbon), year 1, no. 3 (Feb./Mar. 1990), pp. 32–36.
(Portuguese).

PINHARANDA, João
"A exposição dos anos 80".
In: *Artes e Leilões* (Lisbon), year 1, no. 3 (Feb./Mar. 1990), pp. 20–28.
(Portuguese).

MELO, Alexandre
"Cabrita Reis".
In: *Galerias* (São Paulo), year 4, no. 19 (Apr./May 1990, pp. 52–55.
(Portuguese).

MELO, Alexandre
"Cabrita Reis".
In: *Juliet*, no. 48 (June 1990), p. 40.
(English).

ALMEIDA, Bernardo Pinto de
"Answers and Inquiries".
In: *Lapiz* (Madrid), no. 70 (summer 1990), pp. 41–47.
(English).

PINHARANDA, João
"Windows on a Decade".
In: *Lapiz* (Madrid), no. 70 (summer 1990), pp. 32–40.
(English).

RODRIGUES, António
"Carta de Lisboa".
In: *Colóquio Artes*. Lisbon: Fundação Calouste Gulbenkian, no. 86 (Sept. 1990), pp. 60–62.
(Portuguese).

COMI, Enrico R.
"Pedro Cabrita Reis's portfolio".
In: *Spazio Umano/Human Space*. Bregnano: Enrico R. Comi, no. 3 (Sept. 1990); pp. 129–163.
(Italian).

1991 TARANTINO, Michael
"Pedro Cabrita Reis".
In: *Arftorum International* (New York), vol. 29, no. 5 (Jan. 1991), pp. 140–141.
(English).

HEEZEN, Henriett
"Pedro Cabrita Reis".
In: *Metropolism* (Berlin), no. 1 (Feb. 1991), pp. 14–15.
(German).

BREA, José Luís
"The Poverty of Cynicism".
In: *Artscribe* (London), no. 86 (Mar./Apr. 1991), pp. 32–35.
(English, translated by Pattrick Camiller).

HOHMEYER, Jürgen
"Manie der blauen Laube".
In: *Der Spiegel*, no. 18, 29.4.1991.
(German).

MELO, Alexandre
"Trajectos na escultura em Portugal".
In: *Via Latina*. Lisbon: [Francisco Silvestre Tão-Lindo], vol. 3 (May 1991), pp. 117–118.
(Portuguese).

SARDO, Delfim
"Angelus Novus".
In: *Via Latina*. Lisbon: [Francisco Silvestre Tão-Lindo], vol. 3 (May 1991), pp. 146–147.
(Portuguese).

KOSKINA, Katerina
"Metropolis: Setting the
Stage?"
In: *Arti, Art Today* (Athens),
vol. 5 (May–June 1991),
pp. 114–127.
(English).

PINHARANDA, João
"Metrópolis, uma grande
exposição apenas interessante.
In: *Artes e Leilões* (Lisbon),
year 2, no. 10 (June/Sept.
1991); pp. 45–51.
(Portuguese).

MELO, Alexandre
"The House of Passion and
Thought".
In: *Artscribe* (London), no. 87
(summer 1991), pp. 44–47.
(English).

MESSLER, Norbert
"Berlin: 'Metropolis'".
In: *Artforum International*
(New York), vol. 29, no. 10
(summer 1991),
pp. 101–103.
(English, translated by
Joachim Neugrochel).

GALLOWAY, David
"'Metropolis': Crossroads or
Cul-de-sac".
In: *Art in America* (New York),
vol. 23 (July 1991),
pp. 46–51.
(English).

CORNET, Pascal
"Mit kunstcircuit in Porto en
Lissabon".
In: *Kunst & Cultur*
(Brussels), Sept. 1991,
pp. 77–78.
(German).

"Chicago in Review".
In: *Artsmagazine* (New
York), Oct. 1991, p. 100.
(English).

ALMEIDA, Bernardo Pinto de
"Visita rápida ao 'tríptico' no
Museu de Gand".
In: *Artes e Leilões* (Lisbon),
year 2, no. 14 (Oct./Nov.
1991), pp. 43–45.
(Portuguese).

VAN JOLE, Marcel
"Europélia Portugal 1991".
In: *Colóquio Artes* (Lisbon),
no. 91 (Dec. 1991), pp. 4–17.
(Dutch).

MATOSSIAN, Chake
"Tríptico em Gand".
In: *Artes Plásticas* (Lisbon),
year 1, no. 14 (Dec. 1991),
pp. 30–31.
(Portuguese).

1992 KUNSTFORUM
"Die Documenta als
Kunstwerk".
In: *Kunstforum* (Cologne), no.
119 (1992), pp. 232–233.
(German).

LOISY, Jean de
"Sur les pas d'un chercheur
d'art (entretien avec
Oscarine Bosquet)".
In: *Beaux Arts* (Paris), no.
86 (Jan. 1992), pp. 72–75.
(French).

COMI, Enrico R.
"Pedro Cabrita Reis's
Portfolio".
In: *Spazio Umano/Human
Space*. Bregnano: Enrico R.
Comi, no. 1 (Feb. 1992);
pp. 118–119.
(Italian).

SARDO, Delfim
"Pedro Cabrita Reis: House,
Silence. Melancholy, Vigil".
In: *Arti, Art Today* (Athens),
vol. 9 (Mar./Apr. 1992),
pp. 88–113.
(English).

VILLEN, Perez;
ANGEL, L.
"La vanitas neobarroca".
In: *Lapiz* (Madrid), vol. 10,
no. 87 (May/June 1992),
pp. 64–67.
(Spanish).

MELO, Alexandre
"Cabrita Reis, Croft,
Sanches: a complex attitude
in Portuguese sculpture".
In: *Flash Art. International*
(Milan), vol.25, no. 164,
(May/June 1992), pp.
93–95.
(English).

SANS, Jerôme
"Pedro Cabrita Reis,
oeuvre-blanche".
In: *Artpress* (Paris), no. 170
(June 1992), pp. 28–31.
(French).

GRAZIOLI, Elio
"A Documenta of suspension".
In: *Ottagono* (Milan), year
27, no. 104 (Sept. 1992), p.
140.
(English, translated by
Barbara Epstein).

PONTUAL, Roberto
"Carta de Kassel: Documenta
a grande celebração".
In: *Colóquio Artes*. Lisbon:
Fundação Calouste
Gulbenkian, vol. 34, no. 94
(Sept. 1992), pp. 62–64.
(Portuguese).

BOURRIAUD, Nicolas
"Reruns on Channel
Documenta".
In: *Flash Art. International*
(Milan), vol. 25, no. 166
(Oct. 1992), p. 131.
(English).

DANNAT, Adrian
"Anal Masochism".
In: *Flash Art. International*
(Milan), vol. 25, no. 166
(Oct. 1992), pp. 130–131.
(English).

BARDAGIL, Miguel;
DONAIRE, Lola;
RENAU, Clara
"De l'espai apropiat a l'espai
manipulat; l'espai significant;
activitats alternatives".
In: *Papers d'Art*
(Barcelona), no. 49
(Oct./Nov. 1992), pp. 12–13.
(Catalan).

DUARTE, Pedro Rôlo
"(Entrevista) to Rui Chafes
Interview Conducted by
Pedro Rôlo Duarte".
In: *Kapa* (Lisbon),
(Nov. 1992), p. 48.
(Portuguese).

1993 MELO, Alexandre
CABRITA REIS, Pedro
"[oito textos]".
In: *Artes e Leilões* (Lisbon),
year 4, no. 18 (Feb./Mar.
1993), pp. 30–34.
(Portuguese).

POWER, Kevin
"Pedro Cabrita Reis:
recordando com as coisas".
In: *Artes e Leilões* (Lisbon),
year 4, no. 18 (Feb./Mar.
1993), pp. 18–28.
(Portuguese).

METZGER, Rainer
"Pedro Cabrita Reis".
In: *Flash Art. International*
(Milan), vol. 26, no. 170
(May/June 1993), p. 89.
(English).

BREA, José Luis
"Pedro Cabrita Reis".
In: *Artforum International*
(New York), vol. 32, no. 2
(Oct. 1993), p. 106.
(English).

HANRU, Hou
"Our Dreams Construct the
World".
In: *Flash Art. International*
(Milan), vol. 26, no. 172
(Oct. 1993), p. 54.
(English).

ROSENGARTEN, Ruth
"O cerco de Óbidos".
In: *Visão* (Lisbon),
7.10.1993, pp. 88–89.

ZACHAROPOULOS,
Denys
"'Domaine de
Kerguehennec': The
Unknown Magnitude".
In: *Arti, Art Today* (Athens),
vol. 17 (Nov./Dec. 1993),
pp. 66–95.
(English).

BOLLER, Gabrielle
"Jimmie Durham, David
Hammons, Pedro Cabrita
Reis".
In: *Arte Factum* (Antwerp),
vol. 2, no. 50 (Dec. 1993/
Jan.–Feb. 1994), pp. 46–47.
(Dutch).

1994 CARLOS, Isabel
"The Óbidos Biennal".
In: *Flash Art. International*
(Milan), vol. 27, no. 174
(Jan./Feb. 1994), p. 57.
(English).

OSÓRIO, Helena
"Arte viva".
In: *Casa Cláudia*. Cultura,
year 6, no. 70 (Feb. 1994),
pp. 88–92.
(Portuguese).

PÉREZ, David
"Cámaras de fricción:
galeria Luis Adelantado".
In: *Lapiz* (Madrid), year 12,
no. 98 (Feb. 1994).
(Spanish).

"Lisbon '94: European Capital of Culture".
In: *Flash Art. International* (Milan), vol. 27, no. 176 (May/June 1994), p. 53.
(English).

TAVARES, Cristina Azevedo
"O predomínio da instalação".
In: *Colóquio Artes* (Lisbon: Fundação Calouste Gulbenkian), year 5 (July/Sept. 1994), pp. 68–69.
(Portuguese)

ROSENGARTEN, Ruth
"E depois do amanhã".
In: *Visão* (Lisbon), 29.9.1994, p. 89.
(Portuguese).

J.G.
"Interesante colectiva en Luis Adelantado, con obras de Pedro Cabrita Reis, Sophie Calle, Alizon Wilding y Juan Uslé".
In: *Tendencias*, year 1, no. 2 (Dec. 1994).
(Spanish).

SARDO, Defim
"Novas sobre el arte portugués reciente".
In: *Revista de Occidente* (Portugal: Artes y Letras; Madrid: Alfredo Taberna), no. 163 (Dec. 1994), pp. 67–69.
(Spanish).

1995 MELO, Alexandre
"Cumulus aus Europa: Transozeanexpress = Transoceanexpress".
In: *Parkett* (Zurich), no. 44 (1995), pp. 202–211.
(German-English).

OLIVARES, Rosa
"Cocido y crudo: el mayor espectáculo del mundo".
In: *Lapiz* (Madrid), year 13, no. 108 (winter 1995), pp. 42–50.
(Spanish).

ALIAGA, Juan Vicente
"Cuit et cru".
In: *Art Press* (Paris), no. 199 (Feb. 1995), p. 80.
(French, translated by Marie-France de Paloméra).

ARDENNE, Paul
"Paroles d'artistes, dialogues publics".
In: *Art Press* (Paris), no. 199 (Feb. 1995), p. 78.
(French).

"Construção das artes".
In: *Guia da Artes* (São Paulo), year 9, no. 137. (Mar./Apr. 1995), pp. 30–34.
(Portuguese).

PEDROSA, Adriano
"Worlds Apart".
In: *Frieze. Contemporary Art and Culture* (London), no. 21 (Mar./Apr. 1995), pp. 56–57.
(English).

OLMO, Santiago B.
"Museo de Badajoz: la frontera como punto de encuentro".
In: *Lapiz* (Madrid), year 13, no. 112 (May 1995), pp. 76–77.
(Spanish).

BENEZRA, Neal
"Collection Mordes: Le passé remis à jour = Changing Our View of the Past".
In: *Galeries Magazine* (Paris: Yves J. Hayat), no. 62, le dernier numéro/the last issue (summer 1995), pp. 107–113.
(French).

DAL BO, Giorgio
"La Biennale di Venezia 1895–1995: verso un nuovo secolo".
In: *Colóquio Artes* (Lisbon: Fundação Calouste Gulbenkian), year 6, (July/Sept. 1995), pp. 51–60.
(Italian).

LEPICOUCHÉ, Michel Hubert
"Os espaços de silêncio de Pedro Cabrita Reis".
In: *Spacio/Espaço Escrito* (Badajoz: Ángel Campos Pámpano), no. 11–12 (fall–winter 1995), pp. 153–159.
(Portuguese).

OLMO, Santiago B.
"Bienal de Valencia: la bienal de los cien años".
In: *Lapiz* (Madrid), year 13, no. 115 (Oct. 1995), pp. 16–31.
(Spanish).

1996 QUARESMA, Júlio
"Um dia, ainda na Escola Superior de Belas Artes,…"
In: *Caras* (Lisbon), 1.6.1996.
(Portuguese).

BARROS, Joana Leitão de
"Trajectos interessantes".
In: *Fortuna* (Fortuna), 1.6.1996.
(Portuguese).

MELO, Alexandre
"Ni centre ni peripherie: note sur la geographie de la legitimation artistique".
In: *Cahiers du Musée National d'Art Moderne* (Paris), no. 55 (spring 1996), pp. 106–107.
(French).

POSCA, Claudia
"[Pedro] Mário Cabrita Reis".
In: *Kunstforum* (Cologne), vol. 135 (Oct. 1996–Jan. 1997), pp. 406–408.
(German).

1997 "For Heiner Müller".
In: *Valor* (Lisbon), Jan. 1997.
(Portuguese).

MELO, Alexandre
"Transoceanexpress".
In: *Moskow Art Publication* (Moskow), no. 16 (1997), pp. 9–13.
(Russian)

BELO, Filipa
"Big Brother".
In: *Visão* (Lisbon), Jan. 1997.
(Portuguese).

JARDÍ, Paul
"Abstrakt/Real: abstracciones después de la utopia".
In: *Lapiz* (Madrid), year 16, no. 128–129 (Feb. 1997), pp. 96–101.
(Spanish).

MELO, Alexandre
"Letter: Alexandre Melo from Lisbon and Porto: Border Crossing".
In: *Arforum* (New York), Feb. 1997, pp. 33–35.
(English).

ROSENGARTEN, Ruth
"Pode a arte ser afirmativa?"
In: *Visão* (Lisbon), Apr. 1997.
(Portuguese).

SARDO, Delfim
"Troppo vero".
In: *Arte Ibérica*. Dossier Arte Pública (Lisbon), no. 8 (Oct. 1997), pp. 34–37.
(Portuguese).

COUTINHO, Rosário de Sá
"Ao sabor da vida".
In: *Casa Cláudia* (Lisbon: Cristina Cordeiro), year 10, no. 119 (Dec. 1997), pp. 156–164, 163.
(Portuguese).

ROSENGARTEN, Ruth
"Expressão corporal".
In: *Visão* (Lisbon), Dec. 1997.
(Portuguese).

"Exposições".
In: *Valor* (Lisbon), Dec. 1997, p. 7.
(Portuguese).

1998 BERTRAND, Rita
"Cultura a Norte".
In: *Factos* (Lisbon), Jan. 1998.
(Portuguese).

ALMEIDA, Pedro Dias de
"Arte de ser português".
In: *Visão* (Lisbon), Feb. 1998.
(Portuguese).

MELO, Alexandre
"Dossier: l'art au Portugal: Les noms, les images et les corps = names, images, bodies".
In: *Art Press* (Paris), no. 235 (May 1998), pp. 34–41.
(French-English).

"Reviver os 80, Lisboa".
In: *Rotas e Destinos* (Lisbon), May 1998.
(Portuguese).

ROSENGARTEN, Ruth
"Gotas num Oceano".
In: *Visão* (Lisbon), July 1998.
(Portuguese).

"Bolsa de cultura".
In: *Grande Reportagem*
(Lisbon), Aug. 1998.
(Portuguese).

"Amar a cidade".
In: *Arte & Construção*
(Lisbon), Dec. 1998.
(Portuguese).

1999 ALMEIDA, Pedro Dias de
"Vá para dentro, lá fora".
In: *Visão* (Lisbon), Apr.
1999.
(Portuguese).

"Auto-retratos: de quem
para quê e para quem?"
In: *Arte Ibérica* (Lisbon), no.
26 (Apr. 1999), pp. 26–30.
(Portuguese).

ROSENGARTEN, Ruth
"Auto-retratos na arte
portuguesa do séc. XX."
In: *City* (Lisbon), 1.4.1999,
pp. 66–67.
(Portuguese).

LUÍS, Sara Belo
"Pedro, o monumental".
In: *Visão* (Lisbon), no. 351
(2–8 December 1999), pp.
196–198.
(Portuguese).

"Pedro Cabrita Reis mostra
as suas obras aos amigos".
In: *Caras* (Lisbon), no. 225,
11.12.1999.
(Portuguese).

2000 "Obras memoráveis".
In: *Visão* (Lisbon), year 3,
no. 1, 6.1.2000, p. 24.
(Portuguese).

MACHADO, José Sousa
"Segunda geração".
In: *Arte Ibérica* (Lisbon), no.
31 (Jan. 2000), pp. 46–50.
(Portuguese).

MACHADO, José Sousa
"Arte e mercado: dez anos
de avanços e recuos".
In: *Arte Ibérica* (Lisbon),
no. 31 (Jan. 2000),
pp. 12–17.
(Portuguese).

MELO, Alexandre
"Anos 80, alguns artistas".
In: Arte Ibérica (Lisbon),
no. 32 (Feb. 2000),
pp. 34–40.

SHEFI, Smadar
"Retrained Installations,
Impersonal Memory".
In: *HA'ARETZ GUIDE*,
23–28 June 2000, p. 4.
(English).

"Portraits d'artistes
portuguais".
In: *Photo* (Paris), no. 371
(July–Aug. 2000), p. 4.
(French).

BOHN, Alexandre
"Pedro Cabrita Reis".
In: *Artpress* (Paris), no. 259
(July–Aug. 2000), pp.
77–78.
(French).

TANNERT, Cristoph
"On the
Compartimentalization of the
Experiment: The Roles of
Berlin – Residue of a
Territorial Division".
In: *Be Magazin*. Renitenzen
= Intractibilities (Berlin), no.
3 (Sept. 2000), pp. 51–54.
(German-English)

"The Vincent".
In: *De Witte Roaf*,
Sept./Oct. 2000, col. 1.
(Dutch).

"Aqueduto que vem de
nós…"
In: *Braga agora* (Braga), no.
2 (Oct./Dec.), pp. 64–66.
(Portuguese).

"Uma rua com vista para a
arte".
In: *Porto de encontro: revista
da Câmara Municipal do
Porto* (Porto: CMP), no. 33
(Dec. 2000); pp. 48–52, 51.
(Portuguese).

2001 "Stockholm Magazin 3".
In: *Tema Celeste*.
Contemporay Art, no. 83
(Jan./Feb. 2001), p. 123.
(English).

CERQUEIRA, João
"Arte e Ciência: a
experiência do lugar".
In: *Arte Ibérica* (Lisbon),
year 5, no. 45 (Apr. 2001),
pp. 14–18, 15.
(Portuguese).

SILVA, Paulo Cunha e
"Harmonia e dissonância
num percurso com 10
interrupções".
In: *OP* (Porto), year 1, no. 1
(spring 2001), p. 36.
(Portuguese).

SAFRAN, Yehuda E.
"Pedro Cabrita Reis passe-
partout".
In: *Prototypo*, year 3, no. 5
(May 2001), pp. 50–55.
(Portuguese-English).

GÓMEZ, Raúl Pereira
"Do que escribe ó que le =
Del que escribe al que lee".
In: *A Revista do CGAC = La
Revista del CGAC* (Santiago
de Compostela), no. 2
(May/Sept. 2001), pp.
120–127.
(Catalan-Spanish).

"On Pedro Cabrita Reis…"
In: *Lettre International*.
Europa Kulturzeitung
(Frankfurt), vol. 55, no. 4
(2001), pp. 5, 90.
Biography and drawings
Pedro Cabrita Reis.
(German).

ZEVI, Adachiara
"Pedro Cabrita Reis: Contra
a Claridade".
In: *L'architettura: cronache
e storia = Architecture:
Events and History.
Spaziarte = Artspaces.*
(Rome), year 47, no. 549
(July 2001), pp. 424–426.
(Italian-English).

"As verdadeiras boas
festas".
In: *Visão* (Lisbon), no. 457,
12.12.2001, p. 216.
(German).

2002 LUÍS, Sara Belo
"O que vale um artista
português?"
In: *Visão* (Lisbon), no. 467,
20.2.2002, pp. 110–114,
112.
(Portuguese)

"Pedro Cabrita Reis expôe
em Angra do Heroismo".
In: *Açores Magazine* (Angra
do Heroismo), 24–30 Mar.
2002.
(Portuguese).

MERCA, Luís
"Comportas".
In: Lux Deco (Lisbon), no.
20 (Oct. 2002), pp. 64–68.
(Portuguese).

2003 STOEBER, Michael
"Jonathan Meese, Pedro
Cabrita Reis".
In: *Kunstforum* (Cologne),
no. 174 (May 2003).
(German).

6. GENERAL REFERENCES

1985 GONÇALVES, Rui Mário
"Cabrita Reis".
In: *100 pintores portugueses
do século XX*. Lisbon: Alfa,
1985, pp. 256–257.
(Portuguese).

1986 PINHARANDA, João;
MELO, Alexandre
"Anos 80 = The Eightes".
In: *Arte contemporânea
portuguesa = Portuguese
Contemporary Art*. Lisbon:
[Alexandre Melo], 1986,
pp. 27–38.
(Portuguese-English)

PINHARANDA, João;
MELO, Alexandre
"Cabrita Reis".
In: *Arte contemporânea
portuguesa = Portuguese
Contemporary Art*. Lisbon,
1986, pp. 68–70.
(Portuguese-English)

1987 JORGE, João Miguel
Fernandes
"Um quarto cheio de
espelhos".
In: *Um quarto cheio de espelhos*.
Lisbon: Quetzal, 1987.
(Portuguese).

1988 PINHARANDA, João
"Condições para a criação
artística contemporânea".
In: *Congresso de arte
portuguesa contemporânea:
comunicações*. Funchal:
Instituto Português de Artes
Plásticas, 1988, pp.
153–161.
(Portuguese).

1990 PINHARANDA, João
"Anos 90: imagens de fim de século".
In: *História da arte portuguesa: volume 3.*
Lisbon: Temas e Debates, 1990, pp. 629–638.
(Portuguese).

1993 ALMEIDA, Bernardo Pinto de
"Nos caminhos dos anos 90".
In: *Pintura portuguesa no século XX.* Porto: Lello & Irmão Editores, 1993, p. 215.
(Portuguese).

1995 JORGE, João Miguel Fernandes
"A casa dos suaves odores".
In: *Abstract & tartarugas: luz e sombra visível.* Lisbon: Relógio D'Água, 1995, p. 96–98.
(Portuguese).

JUSTO, José M. Miranda
"Cabrita Reis".
(Coordinated by João Pinharanda, Helena de Freitas and Raquel Henriques da Silva).
In: *Dicionário de arte portuguesa no século XX.*
Lisbon: Editorial Presença, [1995].
(Portuguese).

POLITI, Giancarlo, [ed. lit.]
"Pedro Cabrita Reis".
In: *Dictionary of international contemporary artists.* Flash Art Books, 1995, pp. 67–68.
(English).

1998 GONÇALVES, Rui Mário
"Situação no final do século".
In: *A arte portuguesa no século XX.* [Lisbon]: Temas e Debates, 1998, pp. 136–139, 149.
(Portuguese).

MELO, Alexandre
"O país adiado ou a pesada herança".
In: *Artes plásticas em Portugal: dos anos 70 aos nossos dias.* [Lisbon]: Difel, (June 1998), p. 66.
(Portuguese).

MELO, Alexandre
"Pedro Cabrita Reis".
In: *Artes plásticas em Portugal: dos anos 70 aos nossos dias.* [Lisbon]: Difel, (June 1998), pp. 172–175.
(Portuguese).

PINHARANDA, João
"Lugares da Paródia, ausência e encenação".
In: *Alguns corpos: imagens da arte portuguesa entre 1950 e 1990.* [Lisbon]: EDP – Electricidade de Portugal, S.A., D.L. 1998, pp. 52–54.
(Portuguese).

PINHARANDA, João
"Observatorio: algunas imagines de lo real".
In: *Observatorio: fotografía contemporânea portuguesa.* [Madrid]: Dirección General de Patrimonio Cultural. Consejeria de Educación y Cultura. Comunidad de Madrid, D.L. 1998, pp. 16–17.
(Spanish-Portuguese).

1999 A.A.V.V.
"Pedro Cabrita Reis".
In: *Panorama da arte portuguesa no século XX.* Lisbon: Campo de Letras, 1999, pp. 308, 311–312, 321, 323.
(Portuguese).

"[Pedro Cabrita Reis: 'Ofício', 1991]"
In: OSÓRIO, António – *Barca do mundo I.* Lisbon: Quetzal Editores, 1999, book cover.
(Portuguese)

2000 "Pedro Cabrita Reis".
In: *La santé des restes.* Lyon: Paul Veysseyre, Antenne Éditorial, Rmn, 2000 (collection L'Intervalle, 96), pp. 26, 53.
(French)

AIP; FIL
"Pedro Cabrita Reis…"
In: *Feira de arte contemporânea: 2000 Lisboa.* Lisbon: APGA, 2000, pp. 32, 56, 106.
(Portuguese).

2001 "[Pedro Cabrita Reis]".
BORGES, Vera
In: *Todos ao palco!: estudos sociológicos sobre teatro em Portugal.* Oeiras: Celta Editora, 2001.
(Portuguese).

DRATHEN, Doris von
"Pedro Cabrita Reis".
In: *Künstler. Kritisches Lexicon der Gegenwartskunst.* München: Verlage Weltkunst und Bruckmann. vol. 56, no. 25 (4th quarter 2001), pp. 1–16.

GONÇALVES, Maria José
"Pedro Cabrita Reis".
In: OLIVEIRA, Paulo; HALL, Aline Gallasch; GONÇALVES, Maria José
Arte nas auto-estradas. [Lisbon]: Brisa, 2001, pp. 24–28.
(Portuguese).

TAVARES, Cristina Azevedo
"As Artes Plásticas em Portugal no século XX".
FERRARI, Sílvia; TAVARES, Cristina Azevedo; BOSSAGLIA, Rossana [int.] *Guia da História da Arte contemporânea: Pintura, Escultura, Arquitectura: os grandes movimentos.*
Translated by Maria Jorge Vilar de Figueiredo. Lisbon: Editorial Presença, 2001, pp. 186–208.
On Pedro Cabrita Reis, p. 204.
(Portuguese).

"[Pedro Cabrita Reis: obra sem título]".
LEIRIA E NASCIMENTO, LDA. [ed.lit.] *Antiguidades, objectos de Arte, pintura moderna e contemporânea.*
Exhibition catalogue. Lisbon: Leiria e Nascimento, Lda., 2001.
On Pedro Cabrita Reis, p. 150.
(Portuguese).

[Pedro Cabrita Reis].
In: FARIA, Nuno
A Fundação Luso-Americana e a arte contemporânea. Lisbon: FLAD, 2001. p. [35].
(Portuguese).

2002 ALMEIDA, Bernardo Pinto de
"Cabrita Reis".
In: ALMEIDA, Bernardo Pinto de
As imagens e as coisas.
Porto: Campo das Letras – Editores S.A., 2002, pp. 221–224.
(Portuguese)

A.A.V.V.
"Wien Collection: Cabrita Reis".
In: A.A.V.V. *ARS AEVI Collection: Museum of Contemporary Art Sarajevo.*
Sarajevo: Internatinonal Project ARS AEVI, 2002, esp. pp. 156–157.
(English)

A.A. V.V.
"Cabrita Reis".
In: A.A.V.V.
Eurpean Investment Bank: Art Collection. Antwerp: Mercatorfonds, 2002. pp. 120–121.
(English-German-French)

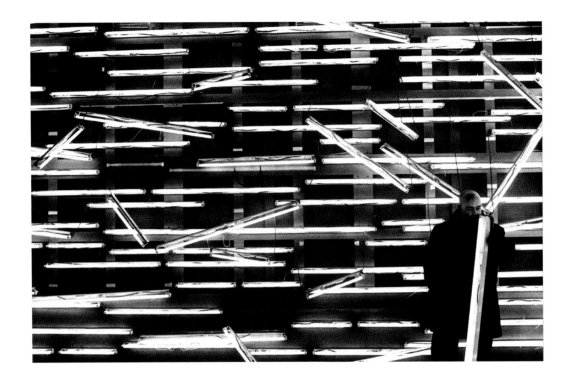

Pedro Cabrita Reis photographed by Paulo Nozolino, April 2003

AT TABLE «Deri vare Alle enige. Den hele Omgivelse skulde dannes fra ny, og Alt tilintetgjøres, ja førend man stod op fra Bordet maatte man endogsaa gjerne fornemme Tilberedelserne til Tilintetgjørelsen.»

S. Kierkegaard, *Stadier paa Livets Vei*

"Everyone agreed on that. The whole setting was to be a new creation, and then everything was to be demolished; indeed it would be all right if even before they rose from the table they were to notice preparations for the demolition."

S. Kierkegaard, *Stages on Life's Way*

Postscriptum by José M. Miranda Justo, Lisbon, April 2003

PHOTO CREDITS Cover photo from "SNAPSHOTS INDEX" series by PEDRO CABRITA REIS

ADRIANA FREIRE (endleaf)

PAULO NOZOLINO (p. 300)

PEDRO CABRITA REIS (pp. 252–253 and back endleaf)

Hervé Abadie

Claudio Abate

Manuel Aguiar

Concha Aizpuru

Victor Arnolds

Francisco Artigas

Lluis Bover

Giuseppe Bozzola

Vitor Branco/Campiso Rocha

Pedro Calapez

Claudio del Campo

Paulo Cintra and Laura Castro Caldas

Hughes Colson

José Manuel Costa Alves

Peter Cox

Fabien de Cugnac

Tony Cunha

Victor Dahmen

Colin Davison

Marc Domage

Carlo Fei

Luisa Ferreira

Adriana Freire and João Silveira Ramos

Fanny Fotografos

Martin Garcia Perez

Claude Gaspari

Dirk Geysels

Mathias Givell

Jacek Gladyrosowski

Neil Goldstein

Roland Gutierrez

Reni Hansen/Kunstmuseum Bonn

Anna Kleberg

Eliane Laubscher

Gunter Lepkowski/Lepkowski Studios

Joseph Loderer

Brunella Longo

P. F. Lorenzo

Daniel Malhão/Rosário Sousa

Attilio Maranzano

Christian Maricic

Vicente de Mello

Lado Mlekuz

Mário de Oliveira

Bill Orcutt

Eduardo Ortega

Dirk Pauwels

Matija Pavlovec

PCR Studio/Rodrigo Peixoto

Paolo Pellion

José Pessoa

Sebastian Schobbert

Laurent Sillian

PCR Studio/Tânia Simões

Mário Soares

Michael Tropea

Dominique Uldry

Werner Zelien

This book is also available in a Portuguese edition from the
Portuguese Ministry of Culture / Instituto de Arte Contemporânea
ISBN: 972-8560-25-7

CONCEPT PEDRO CABRITA REIS

EDITED BY MICHAEL TARANTINO

TEXTS MICHAEL TARANTINO
ADRIAN SEARLE
JOSÉ MIRANDA JUSTO
JOÃO FERNANDES

COPY EDITING ADELAIDE GINGA TCHEN
HELENA CARDOSO

GRAPHIC DESIGN VERA VELEZ

TRANSLATIONS DAVID PRESCOTT
VICTORIA HARTNACK

COPY-DESK VASCO PIMENTEL

PCR STUDIO HUGO CANOILAS
EDGAR MASSUL
FERNANDO MESQUITA
TÂNIA SIMÕES

REPRODUCTION REPROMAYER, REUTLINGEN

PRINTED BY DR. CANTZ'SCHE DRUCKEREI, OSTFILDERN-RUIT

PUBLISHED BY Hatje Cantz Verlag
Senefelderstrasse 12
73760 Ostfildern-Ruit
Germany
T. + 49/7 11/4 40 50
F. + 49/7 11/4 40 52 20
www.hatjecantz.com

Distribution in the US
D.A.P., Distributed Art Publishers, Inc.
155 Avenue of the Americas, Second Floor
USA-New York, N.Y. 10013-1507
Tel. +1/212/627 1999
Fax +1/212/627 9484

ISBN: 3-7757-1373-5

Printed in Germany

SUPPORTED AND PRODUCED BY

 FUNDAÇÃOSERRALVES

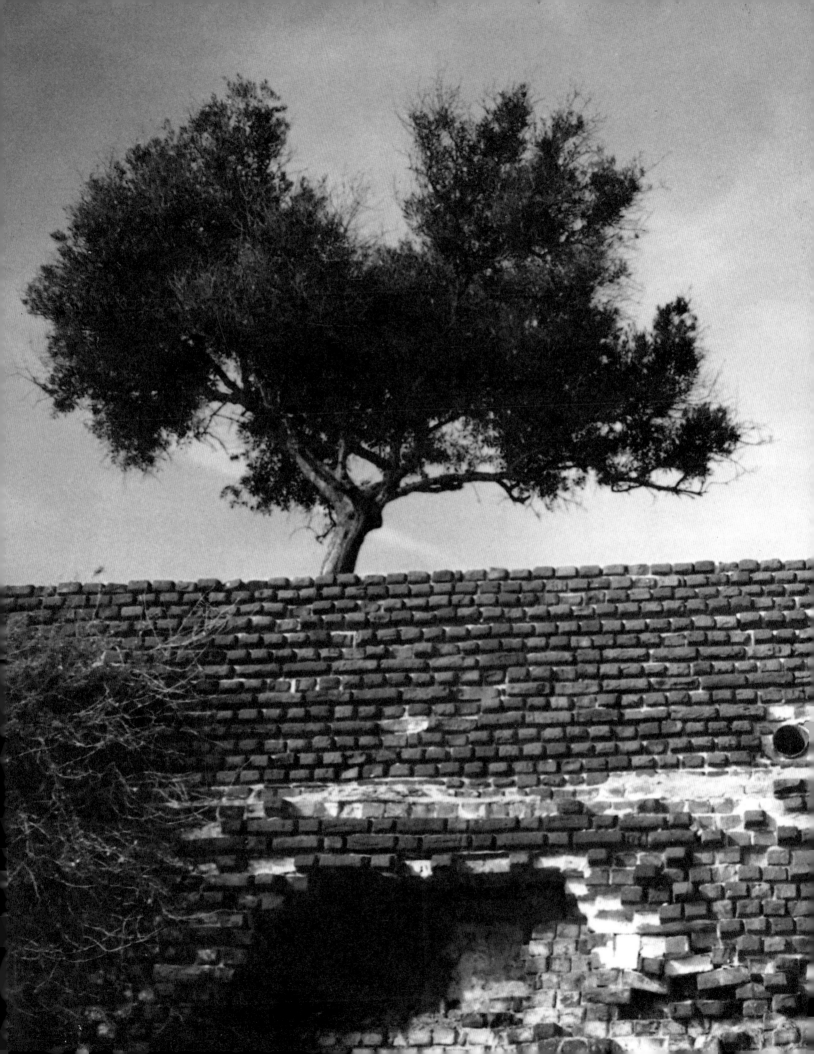